THE WORD IN THE WILDERNESS

 PIETIST, MORAVIAN, AND ANABAPTIST STUDIES

EDITOR

Craig D. Atwood
Director of the Center for Moravian Studies, Moravian Seminary

Volumes in the Pietist, Moravian, and Anabaptist Studies Series take multidisciplinary approaches to the history and theology of these groups and their religious and cultural influence around the globe. The series seeks to enrich the dynamic international study of post-Reformation Protestantism through original works of scholarship.

ADVISORY BOARD

Bill Leonard, *Wake Forest University*
Katherine Faull, *Bucknell University*
A. G. Roeber, *Penn State University*
Jonathan Strom, *Emory University*
Hermann Wellenreuther, *Georg-August-Universität Göttingen*
Rachel Wheeler, *Indiana University–Purdue University Indianapolis*

ALEXANDER LAWRENCE AMES

THE WORD IN THE WILDERNESS

Popular Piety and the Manuscript Arts
in Early Pennsylvania

The Pennsylvania State University Press
University Park, Pennsylvania

Library of Congress Cataloging-in-Publication Data

Names: Ames, Alexander Lawrence, 1987– author.
Title: The word in the wilderness : popular piety and the manuscript arts
 in early Pennsylvania / Alexander Lawrence Ames.
Other titles: Pietist, Moravian, and Anabaptist studies.
Description: University Park, Pennsylvania : The Pennsylvania State
 University Press, [2020] | Series: Pietist, Moravian, and Anabaptist
 studies | Includes bibliographical references and index.
Summary: "Examines the history of Fraktur (illuminated religious
 manuscripts created and used by Pennsylvania Germans in the eighteenth
 and nineteenth centuries) and explores its role in early American popular
 piety and devotional culture"—Provided by publisher.
Identifiers: LCCN 2019059654 | ISBN 9780271085906 (cloth)
Subjects: LCSH: Illumination of books and manuscripts, Pennsylvania
 Dutch. | Fraktur art—Pennsylvania—Pennsylvania Dutch Country. |
 Pennsylvania Dutch—Religious life. | Pietism—Pennsylvania—History.
Classification: LCC ND3035.P4 A44 2020 | DDC 745.6/709748—dc23
LC record available at https://lccn.loc.gov/2019059654

Copyright © 2020 Alexander Lawrence Ames
All rights reserved
Printed in the United States of America
Published by The Pennsylvania State University Press,
University Park, PA 16802-1003

The Pennsylvania State University Press is a member of the Association
of University Presses.

It is the policy of The Pennsylvania State University Press to use acid-free
paper. Publications on uncoated stock satisfy the minimum requirements of
American National Standard for Information Sciences—Permanence of
Paper for Printed Library Material, ANSI z39.48–1992.

The root of wisdom is to fear the Lord,
and the branches thereof are long life.

Ecclesiasticus (Wisdom of Sirach) 1:20 (KJB)

CONTENTS

List of Illustrations ix

Preface: "The Quill Is My Plow" xi

Acknowledgments xix

Note on Sources, Methods, and Abbreviations xiii

Introduction: "Pages of a Mystical
Character"; German Manuscripts
in American History 1

1 "Heaven Is My Fatherland": Manuscript
 Culture in an Age of Evangelical Piety 15

2 "The Spirit of the Letter": Calligraphy
 and Spirituality During the Long Era
 of Manuscripts 46

3 "Worship Always the Scripture":
 Teaching Literacy and Pious Wisdom
 in German Pennsylvania. 83

4 "Incense Hill": Song, Image,
 and Ambient Manuscripts 112

5 Marching to "Step and Time":
 Text, Commemoration, and the Rituals
 of Everyday Life 134

 Conclusion: "Errand into the Wilderness";
 Making Meaning from Manuscripts 166

Notes 177

Bibliography 201

Index 224

ILLUSTRATIONS

Figures

1 Vorschrift of Jacob Strickler, 1794 xii

2 Vorschrift beginning "By this everybody will know," circa 1800 xiii

3 Detail of Vorschrift for Hans Theiß, 1741 xiv

4 Cover of *Der Neue, gemeinnützige Landwirthschafts Calender*, 1794 xv

5 Representation of the five-part understanding of the Word 11

6 Title page of manuscript regarding cochineal production, 1777 17

7 Johan Leonhard Tauber, leaf with Lutheran devotional design, 1752 21

8 Nockamixon Reformed Church, financial record book, 1787–1844 36

9 Polly Collins, *A Gift from Mother Ann to the Elders at the North Family*, 1854 ... 42

10 "Emblema in laudem Artis scriptoriae," 1655 53

11 Thomas Earl, *The Marriner's Compass*, exercise book, circa 1727 55

12 Samuel Kidder, drawing and description from school exercise book, 1795 56

13 Gottfried Arnold, *Die Erste Liebe*, 1712 70

14 Anonymous scribes, *Der Christen ABC*, 1750 72

15 Herman M. Ache, attr., Vorschrift, 1768 73

16 Heinrich Brachtheiser, attr., Vorschrift for Philip Markley, 1787 74

17 "Bedencke was du fliehen must," religious text, circa 1800 75

18 Jacob Hümmel, Vorschrift, 1815 75

19 Susanna Heebner, religious text, 1809 81

20 Henry Chapman Mercer, photo of schoolhouse, built 1842 91

21 Classroom verse and scene, circa 1800 92

22 Vorschrift for Maria Reist, 1811 94

23 Johann Adam Eyer, Vorschrift for Jacob Seitler, 1782 96

24 Heinrich Brachtheiser, attr., detail of Vorschrift, circa 1785 102

25 Ephrata community hymnal, *Paradisisches Wunderspiel*, 1754 114

26 *Zionitischer Weyrauchs Hügel*, 1719 115

x ILLUSTRATIONS

27 Psalm 119 in *Whole Booke of Psalmes*, 1640 118

28 Johann Adam Eyer, bookplate for Elisabetha Eyer, 1821 122

29 Notenbüchlein for Elisabetha Kolbin, 1787 129

30 Carl Friedrich Egelmann, Geburts und Taufschein
of Sara Anna Huber, 1835–40 136

31 Birth and baptism certificate for James Latimer Banning, 1850 141

32 Geburts und Taufschein for Annora Emma Scheirer, 1871 149

33 Manuscript copy of Psalm 150, "Lobet Gott im Himmel-reich,"
circa 1760 .. 156

34 Henry S. Bower, Vorschrift, 1853 164

35 Henry S. Bower, Vorschrift, 1855 165

Tables

1 Selected symbols from John Joseph Stoudt's
Pennsylvania Folk-Art .. 52

2 Selected influential schoolteacher-scribes
from Mennonite schools, 1747–1836 97

3 Selected penmanship-sample pictorial imagery 103

4 Tune-book title-page decoration and pictorial imagery 131

5 Selected imagery commonly found on birth
and baptismal certificates 147

PREFACE: "THE QUILL IS MY PLOW"

In 1743, in the tiny Swiss village of Feldis, high in the Alps in Graubünden, a canton just over the mountains from the Republic of Venice, a calligrapher created a large, colorful, and ornately detailed religious manuscript. The document featured excerpts culled from the holy scriptures, along with other devotional texts. On this vibrant manuscript the artist also included a verse that likened calligraphy and the making of manuscripts to an activity well known by many German speakers of the era: farming. "Paper is my field, therefore I am so valiant. The quill is my plow, therefore am I so smart. The ink is my seed that brings me fortune, honor, and good name," the calligrapher wrote, evoking the intense physical labor of pushing a plow through a field to describe the intellectual labor and hand skills required to write beautifully with a quill on paper.[1] The inclusion of so many biblical and spiritual quotations on the document suggests that, for this Swiss scribe and many other people across the German-speaking world, the manuscript arts also possessed the power to open one's heart to salvation.

This very same verse likening the quill to a plow, and variations on the text, also enjoyed popularity several thousand miles away, in North America, where German-speaking central Europeans had been settling in sizable numbers since the late 1600s. Calligrapher Andreas Kolb of Montgomery County, Pennsylvania, wrote the "quill is my plow" text in a manuscript hymn-tune book created for Anna Funk in 1788.[2] Several years later, in February 1794, a young Mennonite man of Swiss parentage named Jacob Strickler, of Shenandoah County, Virginia, included a portion of the verse on his colorful penmanship sample (fig. 1).[3] An unsigned, undated penmanship sample probably made in Pennsylvania also features the verse (fig. 2).[4] And Christian Charles, a calligrapher in rural Lancaster County, Pennsylvania, copied the verse onto a small manuscript of his own in 1832.[5]

Clearly, the idea of penmanship as a laborious yet ultimately rewarding task, similar to pushing a plow to cultivate the soil with hopes of enjoying a rich harvest, resonated during this era, as both a meditative reflection and a teaching tool. The idea was not specifically German: it appeared in English Puritan literature as well. He who wished to find salvation "put his hand to

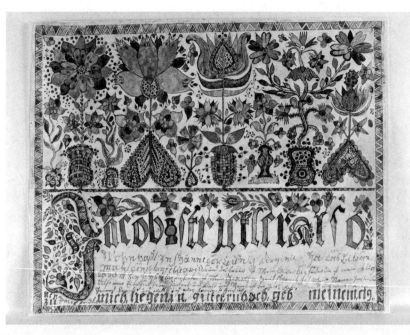

Fig. 1 Jacob Strickler, scrivener and decorator, Vorschrift, Massanutten, Shenandoah County, Virginia, February 16, 1794. Ink and watercolor on laid paper, 12.3 × 15.2 in. 1957.1208 A. Courtesy of the Winterthur Museum, Winterthur, Delaware. Bequest of Henry Francis du Pont.

the Plough: If he never worke himself, he will never be a wise-man," wrote theologian James Ussher in the seventeenth century. You must labor toward grace "with the sweat of thy brows," Ussher attested.[6] For some Germans in both America and Europe in the 1700s and 1800s, reading and writing beautiful calligraphy constituted the kind of work that could help them get in touch with their spiritual selves. Another verse included on that manuscript made in Feldis, Switzerland, in 1743 captures an attitude toward art and religious devotion that infused manuscript culture in early German America:

> All arts are just as dust in vain
> Where faith in Christ would fail to reign
> For when Christ Jesus fills one's heart
> One has mastered the most precious art![7]

(A variation of this verse also appeared on a Swiss penmanship sample dating to 1741; see fig. 3.)[8]

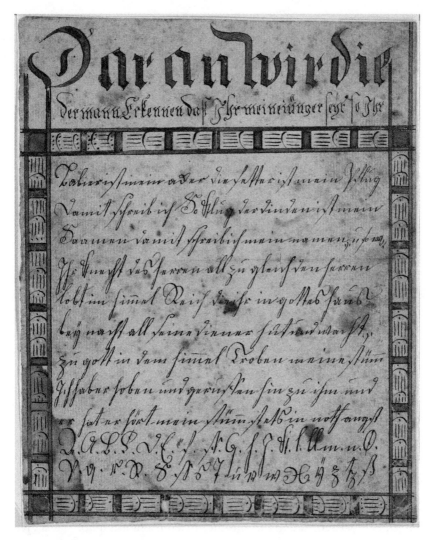

Fig. 2 Vorschrift beginning "By this everybody will know that you are my disciples," undated and unsigned, circa 1800. The "quill is my plow" quotation appears in the first three cursive lines below the top horizontal border—that is, lines 3 through 5 of the text. Approximately 8 × 6⅝ in. Pennsylvania German Collection of Fraktur Manuscripts and Imprints, Rare Book Department, FLP 513. Courtesy of the Free Library of Philadelphia.

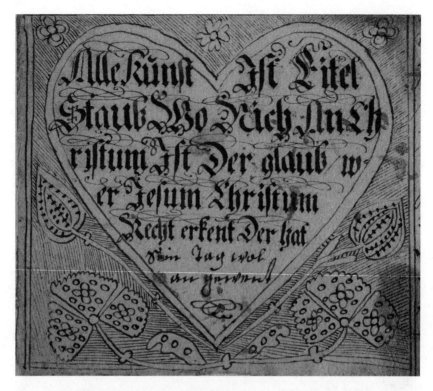

Fig. 3 Detail of Vorschrift for Hans Theiß, February 28, 1741. The second half of the poem diverges from the text as it appears in figure 1. It does not refer to the relationship between faith and art but rather notes that one who knows Christ rightly has spent one's day well. Approximately 4 × 4 in. 1971.891. Courtesy of the Rätisches Museum, Chur, Switzerland. Photo: author.

In our modern era of digital technology, when creating and printing words on paper or disseminating them in the virtual realm is a quick and simple enterprise, it can be easy to overlook that, for much of history, text creation and ornamentation was a slow, deliberative process that required creative vision and no small dose of talent and artistic skill on the part of scribes. Like agricultural practice—itself a form of labor unfamiliar to most modern Americans—writing devotional religious manuscripts by hand took work, skill, patience, and even faith. Given Christianity's focus on holy scripture as God's revealed truth on earth, it is unsurprising that calligraphy and manuscript illumination should rank as privileged art forms, especially when scribes used the arts to depict the Word of God. What may surprise some is that manuscript production retained its importance in Europe and America long after the development of print publishing and deep into the nineteenth

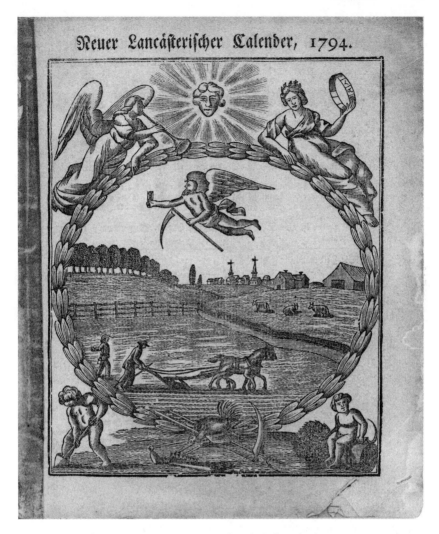

Fig. 4 Cover of *Der Neue, gemeinnützige Landwirthschafts Calender*, 1794. 8¼ × 6¾ in. Courtesy of Franklin and Marshall College, Lancaster, Pennsylvania.

century—especially, it seems, among German speakers in Pennsylvania, who wielded the manuscript arts as part of their popular piety practices. A farmer on the cover of a 1794 almanac printed in Lancaster, Pennsylvania (and seen in fig. 4), tilled the earth with intense labor of horse and plow, with hopes of one day harvesting the fruits of the soil. So too could scribes till the inner recesses of the human heart with the labor of hand and quill, hoping one day to harvest the fruits of the soul.

Illuminated religious manuscripts like those featuring the "quill is my plow" quote are today considered an important part of folk-art practices in early America and especially in Pennsylvania. They are commonly known as *Fraktur* for their broken, or "fractured," letter forms, and much has already been written about the Pennsylvania manuscripts since formal study of them began in the late nineteenth century.[9] But the perspective that this book takes on the documents—and the religious traditions of which they were a part—is different from what has come before. The reason is not because I disagree with what has previously been written about the manuscripts but rather because I have chosen to ask different questions of the sources, and I bring different theories and methods to bear on their analysis.

Whereas most previous studies of Fraktur have focused on their decorative, folk-art qualities, I interest myself in the spiritual texts on the documents and what the manuscripts reveal about lived religious experiences among their makers and readers in an age famed for its evangelical piety. As an intellectual and cultural historian, I engage with the Pennsylvania Germans' spiritual artworks in order to illuminate the literary and religious lives of an understudied and frequently misunderstood group of early Americans by linking their spiritual and textual experiences to those of other people from different places and periods. The purpose of this study is neither to celebrate the manuscripts' folksy aesthetic charm nor to decode symbolic meanings of illuminated manuscripts' rich pictorial imagery—two tasks that have occupied many previous commentators on the sources and produced admirable results. Rather, the purpose here is to place the documents' written texts within the framework of Protestant belief systems of the time when the manuscripts were created and consider how the documents, as visual artworks and material artifacts, fit within Pennsylvania Germans' popular piety and devotional practices. The book offers a proof of concept for the utility of interpreting the manuscripts as artifacts of American religious history.

I hope the insights contained in the coming chapters equip you, the reader, with a set of interpretive tools and sufficient background knowledge about makers' and users' religious beliefs to appreciate the documents as spiritual objects. The book will help you understand how Germans fit into an early American religious landscape populated by other, perhaps better-known groups, including the New England Puritans and Pennsylvania Quakers. I hope it also brings Pennsylvania Germans to the attention of readers who have not encountered them before, while challenging scholars of decorative arts and material culture to compare the Pennsylvania documents to religious texts of other communities in early America and beyond. The book does not provide all the answers, as far as the spiritual underpinnings of text

veneration are concerned, but it offers promising leads for other researchers and enthusiasts to follow, as they engage with Pennsylvania devotional texts in new and creative ways.

"All arts are just as dust in vain / Where faith in Christ would fail to reign," wrote a Swiss scribe in ornate calligraphy many years ago.[10] This same attitude toward faith, art, and devotional texts resulted in a vibrant manuscript culture in early German America.

ACKNOWLEDGMENTS

This project began life in the Winterthur Program in American Material Culture at the University of Delaware and Winterthur Museum, Garden and Library and then at the University of Delaware's Department of History. I extend my appreciation to Consuela Metzger, Winterthur's former conservator of books and library materials; the faculty of the University of Delaware Department of History, especially James Brophy, in addition to Christine Heyrman, Jennifer Van Horn, Anne Boylan, J. Ritchie Garrison, and Lawrence G. Duggan; and James N. Green, librarian of the Library Company of Philadelphia, for their support, insights, and assistance. Ronet Bachman and Anne Bowler of the University of Delaware Department of Sociology and Criminal Justice advised on my mixed-methods research design, and I thank them for their guidance. I am now and will always remain deeply grateful for the education in history and material culture studies that I received at the University of Delaware, which did so much to shape this book.

I offer sincerest gratitude to the senior scholars and professionals who shared advice when needed, especially Craig D. Atwood of the Moravian Seminary, who is editor of this book series; and two anonymous readers of the manuscript, whose feedback vastly improved the quality of this work. Kathryn B. Yahner of the Pennsylvania State University Press ushered this project from manuscript to published book with expertise and efficiency. Copyeditor Susan Silver helped burnish the final product. Jeff Bach of Elizabethtown College offered critical guidance at an early stage. Lisa Minardi, the modern-day maven of Pennsylvania German material culture studies, has been unflaggingly supportive and helpful, and her guidance was critical. John Ruth and Mary Jane Ledearch Hershey kindly advised me in this project's early stages.

Numerous collecting institutions supported my work. At the Winterthur Museum I thank current and former staff members, including Susan Newton, James Schneck, Linda Eaton, Joan Irving, Rosemary Krill, and John Krill. At the Winterthur Library I thank Emily Guthrie, Linda Martin-Schaff, Jeanne Solensky, and Laura Parrish. The resources of the

XX ACKNOWLEDGMENTS

Schwenkfelder Library and Heritage Center figure prominently in the book, and I thank Candace Perry and Allen Viehmeyer for their generosity and graciousness in helping me access their organization's resources. At the Mennonite Heritage Center, Joel Alderfer offered constant assistance. Paul M. Peuker and Thomas J. McCullough of the Moravian Archives taught me how to read German script, helped me identify useful sources in their collection, and always offered assistance when I was in need of transcription help. Carolyn Wenger and Steve Ness of the Lancaster Mennonite Historical Society provided unfailing support and assistance in my employment of their institution's holdings. Caitlin Goodman, Karen Kirsheman, and Joe Shemtov of the Rare Book Department at the Free Library of Philadelphia and Will Echevarria of the Free Library of Philadelphia Digital Collections cheerfully helped me navigate their organization's vast resources. My colleagues Judith M. Guston, Elizabeth E. Fuller, and Jobi Zink at The Rosenbach helped me gather relevant sources at that institution and supported the completion of this project. I thank all of my mentors, colleagues, and friends at The Rosenbach and Free Library of Philadelphia for the support they have shown as I have brought this book to completion and for the opportunity to collaborate with them every day in the exciting work of information access and cultural-heritage preservation. Thanks as well go to the University of Delaware Library interlibrary loan staff for making available to me books and articles that otherwise would have been beyond my reach.

I extend my gratitude to Kerry Mohn of Ephrata Cloister; Alison Mallin of the Evangelical and Reformed Historical Society; Carl Klase of Pennypacker Mills; Cornelia King, Sarah Weatherwax, and Ann McShane of the Library Company of Philadelphia; Cory Amsler, Sara Good, and Melissa A. Jay of the Mercer Museum/Bucks County Historical Society; Matthew Heintzelman of the Hill Museum and Manuscript Library; Bruce Bomberger of the Landis Valley Museum; Paul Gehl of the Newberry Library; Leigh Rifenburg of the Delaware Historical Society; Curt DiCamillo of the New England Historic Genealogical Society; Margaret Bendroth of the Congregational Library; Sarah Margolis-Pineo and Lesley Herzberg of Hancock Shaker Village; Kaitlyn Pettengill of the Historical Society of Pennsylvania; Sarah Horowitz of Haverford College; Helmut Hinkel, Damian-Emanuel Moisa, and Martina Pauly of the Martinus-Bibliothek; Christian Scheidegger of the Zentralbibliothek Zürich; the staff of Ursus Books of New York; the late Don Yoder of the University of Pennsylvania; and all the other librarians, archivists, curators, and bookish professionals with whom I worked. I also thank Edward Quinter for his able assistance with various translations from the German.

The research undertaken for this project has resulted in two journal publications. I wish to thank the editors of those journals, Amy Earls and Catherine Dann Roeber of *Winterthur Portfolio* and John D. Roth of the *Mennonite Quarterly Review*, as well as the peer reviewers who critiqued my essays, for their feedback on my work and their permission to reuse it here.

Thanks go to the Peter Wentz Farmstead Society for awarding me the Albert T. and Elizabeth R. Gamon Scholarship in 2013; the Delaware Public Humanities Institute and Center for Material Culture Studies at the University of Delaware for a 2013 graduate research fellowship in material culture studies; the Office of Graduate and Professional Education and Institute for Global Studies at the University of Delaware for an International Travel Award; the Office of Graduate and Professional Education for a 2017–18 university doctoral fellowship; and a graduate research travel award from the Center for Material Culture Studies. I also thank the University of Delaware for awarding this project the Wilbur Owen Sypherd Prize.

My late grandmother, Ruth Anderson; my late father, Roger Ames; my mother, Candice Ames; and my brother, Andrew Ames, and his family steadfastly supported my academic work for many years, so to them I dedicate this book. Its shortcomings remain entirely my own.

NOTE ON SOURCES, METHODS, AND ABBREVIATIONS

The source materials consulted for this study fall into four primary categories: illuminated German-language manuscripts found in European and American archives, with a special focus on Pennsylvania collections; German-language printed theological and devotional treatises, used here to lend religious context to the Pennsylvania manuscripts; English-language manuscripts, artworks, and printed devotional texts, which serve as useful comparisons to the German sources; and the vast secondary scholarly literature on European and early American religious history.

The key findings presented in the book were derived from quantitative content analyses of the first of these four types of research materials: illuminated Pennsylvania German manuscripts and print-manuscript hybrid documents. Random samples of fifty of each type of document considered at length in the text were assembled at collecting repositories in southeastern Pennsylvania. Consideration of each sample helped establish broad themes in document design and text contents, which guided further inquiry into their spiritual meaning and informed the analysis of particular examples of different document genres highlighted in the narrative. To preserve ease of readability, only the results of these statistical analyses are presented in the text, along with a few tables of data relating to the documents' pictorial contents, included to provide an illustration of research methods. A more robust statement of method, as well as tabular summaries of further quantitative data about the visual and textual contents of the primary sources, may be found on this book's companion website, www.wordinwilderness.com.

As a study of visual and material culture, the book relies heavily on analysis of pictorial evidence and includes photos of many of the manuscripts and other artifacts considered in the work. The reader can find color images of many of the items pictured in this volume—as well as other relevant artifacts—on the book's companion website. The details of many of the manuscripts presented for consideration as illustrations in the book appear too small on the printed page for close examination, so readers are advised to view the documents online if possible. Making primary sources available for

closer study will offer pathways for continued exploration of the themes addressed in the book.

Many of the early printed works cited in the book contain lengthy titles, which have been abbreviated in the footnotes and bibliography to conserve space. Original spellings of, and punctuations within, historical book titles have been maintained wherever possible, including in bibliographical entries. Abbreviations for institutional repositories and frequently cited works can be found at the beginning of the endnotes. For the most part, translations from German into English found in the book are original, though some were taken or adapted from other sources. Refer to the notes for details.

A few scholarly works, most notably Mary Jane Lederach Hershey's *This Teaching I Present* and Dennis K. Moyer's *Fraktur Writings and Folk Art Drawings of the Schwenkfelder Library Collection*, have been especially helpful in providing German-to-English translations, along with those translations included in the digital collection of Pennsylvania German manuscripts belonging to the Free Library of Philadelphia. While many texts quoted in the book were poetical in nature in the original German, in most cases no attempt was made to render them in English verse. Rather, they are presented as unrhyming prose in an effort to adhere as closely as possible to individual words' meanings. German words that appear frequently in the text have for the most part not been italicized. Also, please note that spellings of Pennsylvania German names vary across time, especially as families anglicized their surnames. Generally, period usage as encountered on individual documents is maintained in the text, with complications addressed in the notes.

Abbreviations
AAS American Antiquarian Society
ERHS Evangelical and Reformed Historical Society
FLP Free Library of Philadelphia
HSP Historical Society of Pennsylvania
LCP Library Company of Philadelphia
LMHS Lancaster Mennonite Historical Society
MAB Moravian Archives
MHC Mennonite Heritage Center
PMA Philadelphia Museum of Art
RM Rätisches Museum
SLHC Schwenkfelder Library and Heritage Center
WL Winterthur Library
WM Winterthur Museum

INTRODUCTION

"Pages of a Mystical Character": German Manuscripts in American History

Between approximately 1750 and 1850, German-speaking settlers of south-eastern Pennsylvania and their descendants cultivated a distinctive art form with many centuries of history in Europe: calligraphy and manuscript illumination, mostly of a religious nature. The manuscripts, commonly referred to as *Fraktur* by collectors and historians today, evoke connections to Christianity's ancient and medieval roots and frequently feature scriptural and devotional texts written in an ornate Gothic script, known in German as *Frakturschrift*, along with decorative illustrations depicting religious imagery or elements from the natural world. Most often created by members of Pennsylvania's separatist German religious communities, the documents survive in large number. Curious visitors can expect to encounter thousands of examples in the many historical and cultural institutions that populate southeastern Pennsylvania and the greater region.[1] Since serious study of the illuminated manuscripts began in the 1890s, scholars who specialize in the subject have observed the transatlantic significance of the Pennsylvania Germans' manuscript culture and the uniqueness of the art form in its early American context.[2] Despite these efforts, the manuscripts and, more important, the people who made and used them often remain absent from popular accounts of colonial and early national history.[3] In pursuit of the New England Puritans or Virginia Anglicans, historians of early American religion frequently pass over the libraries, museums, and archives in southeastern Pennsylvania that burst at the seams with primary sources of the Pennsylvania Germans' popular religious life.[4] The Germans were far fewer in number than English settlers, to be sure, but a brief glance at these artifacts reveals

2 THE WORD IN THE WILDERNESS

the diversity—linguistic, theological, and cultural—that infused the early American religious experience.

Understanding the theology behind Pennsylvania German spiritual manuscripts means delving deep into continental Europe's religious history, into the devotional life of the late Middle Ages, into the upheavals of Martin Luther's Germany, and into the violence and bloodshed of Ulrich Zwingli's Switzerland. But before these topics can be explored, even more fundamental questions must first be answered, about why Pennsylvania German illuminated spiritual manuscripts should matter to us as relics of early American religious life and how the documents can be studied as historical evidence. The best place to begin to look for answers to those questions is not with the manuscript makers and users themselves but rather, one hundred years after their time, in the country library of an eccentric Gilded Age gentleman, where tables and bookshelves creaked and groaned under the weight of hundreds of cumbersome leather-bound volumes, as a bearded, bespectacled book collector feverishly translated a venerable old manuscript of a decidedly mystical character. A visit there can set the stage for developing new approaches to the manuscripts in question.

Samuel Pennypacker: Country Collector and Pennsylvania Historian

Samuel Whitaker Pennypacker (1843–1916) was an unusually accomplished man. Like other well-born, well-to-do gentlemen in the late 1800s and early 1900s, the southeastern Pennsylvania lawyer, politician, and author cultivated a panoply of hobbies and scholarly interests. Unlike many others, he distinguished himself in almost all of them and left an indelible imprint on the civic and cultural life of his native Pennsylvania in the process. Pennypacker fought in the Civil War, attended the University of Pennsylvania, practiced law in Philadelphia, served as a judge on the Pennsylvania Court of Common Pleas, and was elected governor of the commonwealth in 1902.[5] If this résumé secured his status as a civic leader, it was the governor's "picturesque personality," historical research, and literary talents that garnered him "more than State-wide fame" and secured him a singular role in American culture.[6]

Samuel Pennypacker's great passion was history, especially the history of the commonwealth he governed. From the library in the mansion on his 170-acre ancestral estate in rural Montgomery County named Pennypacker Mills, he composed seminal works of history and served as the Historical Society of Pennsylvania's president.[7] A book collector of considerable renown,

Pennypacker was also president of Philadelphia's Philobiblon Club, one of the nation's oldest bibliophilic societies.[8] Pennypacker was a product of the ethnic and religious diversity of the southeastern corner of the state he called home, including the region's German-speaking sectarian settlers. As a collector and scholar, he relentlessly pursued books and manuscripts his own ancestors and other Germans had used to nourish their spiritual lives. Deciphering these texts did not come naturally for Pennypacker, who had to teach himself German to transcribe and read them.[9] Spiritual books and documents that for his parents' and grandparents' generation had been tools of active spiritual faith had, for Pennypacker's generation, entered a different stage of their life cycle, having transformed into artifacts ripe for historical analysis. Though the artworks had cycled out of active use by the time Pennypacker collected them, they all pointed to southeastern Pennsylvania's spiritually rich early heritage. And they found an apt interpreter in the governor.

For Pennypacker, Pennsylvania's multiethnic, multilingual, religiously and spiritually pluralistic colonial society constituted the wellspring of the state's contribution to the American body politic. The governor's mid-Atlantic heritage provided for a more diverse genealogical inheritance, he explained. "Substantially all of my American ancestors were residents of Pennsylvania, save a few from New Jersey, and in almost all of my lines they came to the country among the earliest settlers. But among them were Dutch, English, Germans, Welsh, Swedes, Scotch-Irish and French Huguenots."[10] Pennypacker's collecting of early Pennsylvania spiritual books and manuscripts functioned as both a scholarly mission and a personal recovery effort of a piece of his family and cultural heritage that was receding into the past.[11] The bibliophile harvested the region's artifacts of early modern cultural life to understand his state's origins in the ethnically and linguistically porous early modern Atlantic world, as well as his own place in that narrative—not a difficult link to forge, given how many of his own family members had made and used spiritual manuscripts and other religious texts. An astute historian, Pennypacker noted the changes affecting the region. It fell to antiquaries and scholars like him to preserve and study the records of bygone days.

Rural southeastern Pennsylvania proved fertile soil for Pennypacker's ambitious book-collecting project in the last decades of the nineteenth century and the early years of the twentieth. Descendants of the very settlers who used religious manuscripts and books offered them up for sale. As a well-known figure in the region, Pennypacker dressed in disguise during his visits to country auctions and sales, where he and an associate scoured lots for "out-of-the-way treasures" they hoped to secure at discount prices. "Often I went 'incog' [incognito] in an old suit and broken hat . . . to the sales of the

German farmers in the country and I have bought as many as a three-bushel-bag full of books at a sale," he noted. "The auctioneer would hold them up at a window, half a dozen at a time, and knock them down for a few pennies."[12]

Such collecting occasionally proved personal. One day in 1872, he traveled to the farmstead of a relative who had invited him to dine. The austere old farmer "entertained me at dinner sitting on a long bench before a table without cloth or napkins," Pennypacker reminisced. "He gave to me an old Bible which he said was of no use to him and which had been thrown with some other stuff into a worn-out clothes basket in the garret. It proved," Pennypacker soon learned, "to be the Bible which belonged to my great-great-great grandmother's grandfather, printed at Heidelberg in 1568, containing a family record and many interesting manuscript notes, which has now been in the family for ten generations and much antedating every other family possession."[13] Some of Pennypacker's own radical pietistic and sectarian German-speaking ancestors had carried this large folio Bible across the seas to Penn's Woods in 1685, and 187 years later Samuel Pennypacker pulled the book from the rubbish of an old man's attic.[14] The Bible was just one of many intriguing acquisitions made by Pennypacker. Another family piece was a lengthy bound manuscript bearing an inscription in Samuel Pennypacker's hand: "A book in MSS [manuscript]—of 876 pages of a mystical character. The cover is a gothic vellum MSS at least a thousand years old." The book belonged to Hendrick Pannebecker (1674–1754), surveyor for the Penns, Pennsylvania's proprietary family.[15] The governor also owned an intricate penmanship sample (or *Vorschrift*) made for twelve-year-old Simon Pannebecker by Pennsylvania German schoolteacher Herman M. Ache. Filled with colorful calligraphy and excerpts from religious texts, the document still hangs on a wall at Pennypacker Mills.[16] Across the region, Pennsylvania Germans discovered illuminated spiritual manuscripts folded and tipped into religious books, pasted onto the covers of painted chests, or stashed into the nooks and crannies of old farmhouses and then placed them onto the open market for collectors like Pennypacker to acquire.[17] In the mid-eighteenth century, illuminated devotional manuscripts and printed early modern spiritual tracts were vital to Pennsylvania German popular piety. A little more than a century later, it fell to the region's antiquaries to gather them up and preserve them as historical artifacts. What changed in the intervening years?

The story of Samuel Pennypacker's early collecting illuminates two important points that can guide inquiries into the manuscripts as artifacts of popular piety and spiritual life that enjoyed changing resonance over time. First, the years of the Pennsylvania Germans' vibrant manuscript culture mirror the heyday and evanescence of German pietistic and sectarian traditions in

Europe and Pennsylvania between the late seventeenth and mid-nineteenth centuries. Pennsylvania Germans' religious traditions were shaped by late medieval and early modern spiritual controversies and faith practices, and those traditions survived deep into the "modernity" of nineteenth-century America, though they eventually faded among most of the population. Second, the vibrancy of Pennsylvania manuscript culture reflects the continued importance of manuscript text production for many centuries after the development of the printing press in Germany circa 1450. European and American manuscript culture declined only after 1850 or so, because of the emergence of industrial publishing around that time. In early America, handwritten text production could still function as a viable (and in some cases preferable) alternative to print, or simply as a method of text making complementary to more formal print publication.[18] Rather than accepting a tendency to interpret Pennsylvania German manuscripts primarily as rustic, folk artworks, scholars should read the texts as evidence of the coexistence in early America of centuries-old traditions and practices in popular piety and text making alongside cutting-edge innovations in the realms of religion, civil society, and printing technology. "Interpretation," wrote theologian Rudolf Bultmann, "always presupposes a living relationship to the subjects which are directly or indirectly expressed in the text."[19] We must strive to engage with the manuscript makers and users on their own terms, reconstructing the spiritual and communication networks that the artifacts once helped to constitute.[20] This effort requires a new paradigm for studying the history and meaning of manuscript making, one grounded in early modern theology, devotional practice, intellectual history, and history of the book.

Manuscript Studies and Early American Religion:
Toward a Pietist and Sectarian Paradigm

Regional scholars have produced a rich body of literature about Pennsylvania German decorative arts, largely interpreted through the lens of folk-art studies and the field of material culture, an approach to the study of artifacts of past human life familiar to most people through the work of museums that employ collections to interpret history and culture.[21] Unfortunately, academic historians have not been quick to fill interpretive gaps left by local histories as well as decorative-arts and collector-oriented publications. Perhaps because of language barriers, the Germans' small population compared to English-speaking settlers, or the sheer complexity of the continental European religious traditions that gained a foothold in the mid-Atlantic,

Pennsylvania Germans garner little attention from academic historians of early American religion, who focus instead on touchstone English traditions that shaped the American experience, including Puritanism in New England, Quakerism in the mid-Atlantic, Anglicanism in the South, and Methodism on the frontier. German Lutherans, Reformed, and sectarians, notes one Anglo-focused historian, seem to "pass fleetingly" through the historical record, compared to the more numerous, and presumably more influential, Anglophones.[22]

The English Puritans in particular have dominated academic historical scholarship. Perry Miller, the great patriarch of New England Puritan studies, claimed to have found a "working model for American history" in the religious culture of early New England.[23] Noting that Puritans saw "God's fingerprints" across the New England landscape, Miller's most famous student, Edmund Morgan, sought to unlock the "meaning of New England" through studies of the region's spiritual life.[24] Indeed, a "Puritan paradigm" has long held sway over early American religious history, as if the entirety of early American spiritual life can be traced to the New England experience and as if a coherent ethos of American national life derived from Puritanism.[25] Overviews of early American religion often make only passing mention of Pennsylvania's patchwork of German spiritual traditions.[26] Such peoples, and their manuscript texts, have never been placed near the center of the story of early American spirituality. Historians who emphasize the most influential early Anglo-American religious and intellectual movements risk smoothing over the cultural variety present in the colonies' and early nation's formative days and oversimplifying the spiritual forces active in the Americas. Considering nondominant stories of life in early America lends valuable context to the familiar Anglo-American narrative.[27]

In particular, study of Pennsylvania German popular piety offers a much-needed antidote to Anglocentric perspectives on American religious history. But how to go about that study? We need only look to Perry Miller for inspiration. One of Miller's most famous writings, an essay titled "Errand into the Wilderness," began life as a speech to accompany an exhibition of early New England books and manuscripts at the John Carter Brown Library in Providence, Rhode Island, on May 16, 1952.[28] Just as this exhibition, in the words of its catalog, "set forth, as far as might be done with such materials, the New England experience, body and spirit," so too can the books, manuscripts, and calligraphic artworks of Pennsylvania illuminate connections between the material and spiritual worlds in another vitally important region of early America.[29] Pennsylvania Germans, through their books and manuscripts,

offer a way to nuance the tone and tenor of the intellectual history of religious and literary life in early America.

Some of Pennsylvania Germans' devotional ethos derived from German Pietism, an eighteenth-century renewal of Protestant faith practice that resulted in a flood of Christian devotional literature, as well as other sectarian and primitivist religious movements that offered alternatives to the mainstream Protestantism of the day. If a "Puritan paradigm" has undergirded Anglo-American studies of religious culture, spiritual books, and devotional art, then a "Pietist and sectarian paradigm" grounded in the cultural history and devotional practices of early German-speaking settlers of the mid-Atlantic could lend coherence to Pennsylvania German manuscript studies and shed new light on the religious foundations of early America. To understand the great variety inherent in early American religious history and devotional culture, one must understand Pietism and aligned movements that shaped spiritual culture in the German-speaking world.[30]

Arguably the most influential movement within Protestantism since the days of Martin Luther, Ulrich Zwingli, and John Calvin, Pietism reshaped the practice of Christianity both within and beyond the German-speaking world.[31] With roots in the private devotional culture of seventeenth-century Germany, the movement emphasized inward experience of faith and personal engagement with scripture. Scholars have long acknowledged Pietism's influence over radical sectarian German Protestant peoples, including the Moravians and Anabaptists, but the movement possessed a decidedly diverse and ecumenical character.[32] Pietistic emphasis on personal engagement with scripture and the action of the Holy Spirit on the hearts of believers infused transatlantic religious literature of the period and shaped how Pennsylvania Germans interacted with religious manuscripts. Pietism is not a perfect model for the text practices of the Pennsylvania Germans, seeing as many prominent approaches to Christian spirituality (including mysticism and Anabaptism) predate Pietism by centuries, but the movement did figure centrally into the Protestant spirit of the age in both the German- and English-speaking worlds. A Pietist and sectarian paradigm reminds us that, despite the many differences separating the German Protestant denominations and sects, a common spiritual movement worked on all of them, one focused squarely on the centrality of the Word for nourishing the spirit. But what exactly does bringing a Pietist and sectarian paradigm to the study of early Pennsylvania and American history entail?

The Puritan paradigm explained the history of New England Puritanism by means of a narrative that explored how the Puritans' strict social values

and civic structure governed New England society for a short period but then managed to infuse American society with the idea of the country as God's chosen land.[33] The Puritan New Englanders' interpretation of Calvinism, which underscored human depravity and powerlessness before an angry God, infused their social lives and tinged their culture with a fear of secularism and religious plurality, not to mention strict controls on acceptable forms of Christian devotion.[34] The paradigmatic story of Pietists and sectarians including Anabaptists and mystics in Pennsylvania as proposed here is quite different. It is one of confident religious pioneers, of diverse backgrounds and sensibilities, who sought emotive, liberating, and at times even mystical spiritual experience in a colony premised on the idea of religious toleration and radical individualism. They lived in a colony in which Christian pluralism, rather than strict religious control, was the organizing spiritual principle.[35] They cultivated a freedom of knowing and loving God still reflected today in the manuscripts they created and used as part of their personal spiritual exploration. Where the theology of the New England Puritans was fearful, that of the Pennsylvania Pietists was hopeful. If the Puritans felt deprived of spiritual agency, the Pietists cultivated a radical level of agency over their own religious lives. The Pietist and sectarian paradigm encompasses a vast swath of transatlantic Protestant religious history—early modern mysticism, Anabaptism, continental European Pietism, evangelicalism, revivalism—as it came to rest in Pennsylvania, a colony-turned-state where the outlines of many later features of American life were most clearly drawn. While it would be easy to read chaos, confusion, and lack of cultural-historical coherence into the history of religious traditions practiced in early Pennsylvania, a Pietist and sectarian paradigm instead finds meaning in the theological diversity of the region—and the artifacts that diversity produced, including illuminated German-language manuscripts. "Whatever was poetical in the lives of the early New-Englanders had something shy, if not sombre, about it," noted James Russell Lowell in an article in the *North American Review* in 1865. "If their natures flowered, it was out of sight, like the fern."[36] It was quite different for the Pietists and sectarians of Pennsylvania, whose radical faith practices flowered figuratively and literally on the ornately decorated devotional manuscripts they produced and stowed away for future generations.

Placing the textual artifacts of Pietism and radical sectarian traditions in the foreground of a study of Pennsylvania German devotional practices offers an opportunity to view early American history from a different geographic, theological, and cultural lens than that usually brought to the topic, to uncover common threads uniting movements, and to trace cultural transfer across linguistic, imperial, denominational, and sectarian boundaries. New

Englanders and Pennsylvanians shared many theological connections, as coming chapters show, but the divergent manifestations of Protestant Christian practices in the two regions merit comparison. Diarmaid MacCulloch, a prominent historian of Christianity, has come as close as anyone to unearthing the essential meaning of Pennsylvania in its American spiritual and cultural context by bringing a long transatlantic view to the colony's early denominations and sects. "No one religious group could automatically claim exclusive status, unlike nearly all the other colonies," he wrote. "This was the first colony to evolve the characteristic pattern of religion of the modern United States of America: a pattern of religious denominations, none claiming the exclusive status of Church."[37] In MacCulloch's narrative, Pennsylvania emerges as just as important in the American context as Puritan New England. Scholars who work within narrower timeframes and geographic expanses should take note.[38]

"The Word" in Pennsylvania Popular Piety: A New Method for Manuscript Study

How can the Pennsylvania Germans' illuminated religious manuscripts enhance analyses like that put forward by MacCulloch? How can they help unlock the significance of German Pietism in its American context and form the foundation of the Pietist and sectarian paradigm? They can do so by revealing how everyday Pennsylvanians participated in a transnational Protestant community, imbued with centuries of continuity, rooted in an ages-old desire to know God. Although they are artifacts of a religious, linguistic, and cultural minority, the manuscripts demonstrate that early modern spirituality survived—even thrived—deep into the eighteenth and nineteenth centuries. When studied in relation to transatlantic German religious history, print culture, and manuscript traditions, the Pennsylvania manuscripts seem far more complex—and far more important—than their "primitive" illustrations may initially suggest. They reveal how a German Protestant literary canon, approach to spirituality, pedagogical method, and set of aesthetic norms infused community members' everyday lives. Pennsylvania German spiritual manuscripts equip historians with the sources they need to articulate a new theory of popular piety and the place of text in spiritual life. They are artifacts of a rich intellectual and aesthetic tradition informed by centuries of religious belief, time-tested methods of text production and use, and a system of visual aesthetics drawing on traditions of the late Middle Ages and German baroque. The documents reveal a coherent theological

and devotional foundation for why the artful presentation of letters and words figured in Pennsylvania German spiritual life, an insight that proves useful in making sense of the manuscripts' cultural resonance. For several generations the production, exchange, and use of spiritual texts exercised tremendous influence over Pennsylvania Germans' individual and collective spiritual experiences. "One basic fact must be underscored in studying these documents—the illumination was auxiliary to the text," wrote Pastor Frederick S. Weiser in 1973.[39] Illuminated manuscripts demonstrate the power of "the Word" in Pennsylvania German life—that is, how the scriptural and devotional texts presented on the manuscripts nourished the Pennsylvania German spirit.

The Word in its many forms served five main purposes in Pennsylvania German faith communities, which must be appreciated when studying their religious manuscripts (see a visual summary in fig. 5). First, Protestants viewed the words of scripture not primarily as *descriptive* of the reality of their religion but as *creative* of its truths here on earth. The essence of Christian faith resided in the text, which was the revealed wisdom of God. This elevated the status of the Word and infused Protestant devotional life. Second, grounded in this approach to scripture and the theology of the Protestant Reformation, the principle of personal engagement with holy texts was a fundamental tenet of Pennsylvania German religious life. To be a Christian was to know and engage with holy scripture and other devotional texts. Third, the Word remained a language-based sign system that required careful study and interpretation to understand. As an informational medium, written text could obscure as easily as it could enlighten. Careful training was required to equip individual Christians to use the Word effectively. Fourth, through neo-Gothic calligraphy, manuscript illumination, and Fraktur typography, the Word became a form of visual artwork capable of deep spiritual expression and the subject of intense veneration.[40] (Print and manuscript enjoyed a fluid and often symbiotic relationship in early German Pennsylvania, and printed texts could certainly exude their own evocative artistry.) Fifth, religious texts in print and manuscript form were artifacts of social exchange and community relationship building—that is, material commodities that figured in a regional pietistic and sectarian spiritual economy.

Pennsylvania Germans viewed their illuminated manuscripts as suited to bringing about spiritual experiences rooted in both personal introspection and community fellowship. While few of the texts included on manuscripts were "original" compositions, as their makers pulled their text excerpts from other sources, the scribes' visual presentation of various interlocked scriptural and literary excerpts were truly authorial and artistic compositions

The Word in Pennsylvania German Devotional Life

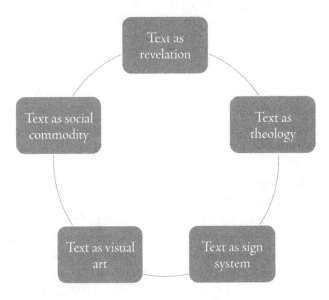

Fig. 5 A visual representation of the five-part understanding of the Word adopted in this book.

imbued with a level of talent, creativity, and spiritual agency unique in early America.[41] Studied for their importance as objects as well as texts, religious manuscripts underscore the material dimension of spiritual experience among certain German-speaking communities in early Pennsylvania, experiences bound up with rendering, transmitting, engaging with, and sharing the Word.[42] In Christianity, "invisible grace is rendered in visible signs." Text artifacts offer tangible evidence of conceptions of grace.[43] The Pennsylvania documents comprised an "art system" that allowed for creativity and agency on the part of makers and users but relied on a socially conditioned set of aesthetic standards for their communicative ability.[44]

Artifacts still found at Governor Pennypacker's country estate tell us much of what we need to know about the place of the Word in Pennsylvania German life. On young Simon Pannebecker's writing sample, schoolteacher Herman Ache wrote a poem that describes the place of religious text in his pupil's education: "This writing shows me [Simon Samuel], correctly, / Which way I should go, / Which is good for me and eternally sound, / Through your spirit, Lord, teach me, / That I may know you genuinely / At all times in the way I go, / To that this writing guides me." The scribe intended

the verses found on Pannebecker's writing sample to guide the youngster on his spiritual journey. Ache's text was both visually engaging and instructionally rich.[45] This combination of text as pragmatic communication tool and as artistic embodiment of faith characterized Pennsylvania German manuscript culture. Readers could venerate the grandeur of holy words while they internalized valuable, and often very practical, spiritual lessons. Calligraphy and manuscript illumination were essential activities to Pennsylvania German spiritual culture. Studying Pennsylvania German manuscripts and printed texts for their spiritual qualities reveals the documents' significance within a long line of Christian traditions that sought to balance the evocative power of images with the revelatory function of words, in the hope of creating a transporting religious experience, yet one grounded in the spirit of the letter. That quest is as old as Christianity itself.

This understanding of the place of the Word in Pennsylvania German spiritual life recasts the nature of illuminated manuscript study, and a few more interpretive concepts can help us in this effort. When interpreted first and foremost as devotional texts, the documents reemerge as a materialized quest toward *spiritual literacy*, which was a fundamental devotional skill for Pietist and other spiritualists of sectarian persuasion that emphasized effective engagement with spiritual texts through functional skills in decoding words as well as a set of interpretive tools to unlock holy texts' meanings. It was an essential skill for Pennsylvania German popular piety. Pennsylvania German literacy education undertook training in these competencies, which readers employed throughout their devotional lives.

A community organized around the acquisition and use of spiritual literacy skills was sustained by a culture of creating and exchanging texts based on *scribal authorship*. By combining scriptural and literary texts from various sources and linking them together on manuscripts through calligraphy, illumination, and creative design and layout, scribes in effect authored "new" texts designed to meet the needs of devotional readers for whom the texts were produced. Not unlike the Europeans and Americans who assembled selections of texts in the form of scrapbooks or commonplace books, this scribal method resulted in not only literary and visual artworks derived from a rich context of source material but also original and unique to their makers.[46] Describing the creation of the Hebrew Bible in ancient Israel, Karel van der Toorn observed that the "very notions of books and authorship were very different from what they are today. The writings of the ancient Near East were created in a world in which there were neither books nor authors in the modern sense of those terms. Instead of books," Van der Toorn explains, "there was the stream of tradition; instead of authors, there were scribes."[47]

While the textual world of early America was by no means as different from modern times as was the ancient Near East, concepts as foundational as books and authorship have evolved dramatically over time.

The key concepts of spiritual literacy and scribal authorship help explain how the five approaches to the Word outlined earlier exercised social influence over early Pennsylvania German culture. In an era when calligraphy and manuscripts still played a prominent role in the world of text making and use, Pennsylvania Germans laced their manuscripts with traces of their search for the divine. The purpose of the chapters that follow is to demonstrate how the five-point understanding of the Word in Pennsylvania German life, along with the concepts of spiritual literacy and scribal authorship, can lend a coherent foundation to study of the devotional calligraphy and manuscript tradition. Chapter 1, titled "Heaven Is My Fatherland," considers how Protestants embraced the Word as an abstract theology of religious life, situating Pennsylvania German devotional manuscript culture in a global context before tracing the movement of German-speaking Protestants across Europe and the world in the sixteenth, seventeenth, and eighteenth centuries. Chapter 2, "The Spirit of the Letter," considers the Word as medium for spiritual experience, presenting a detailed analysis of early modern manuscript culture before doing a deep read of Pennsylvania German spiritual literature to uncover the theological and devotional basis for manuscript culture. The remainder of the book explores how calligraphy and manuscript illumination turned words into artworks, and artworks into social commodities. Each of the final three chapters combines formal analysis of individual manuscript artworks with contextual data about the documents' social and spiritual significance. Chapter 3, "Worship Always the Scripture," analyzes manuscripts produced in and for German community schools, demonstrating that a school tradition of wisdom acquisition through pious living characterized much Pennsylvania German curriculum. Chapter 4, "Incense Hill," reveals connections between hymns, manuscript culture, and spirituality. The fifth chapter, "Marching to 'Step and Time,'" explores the role of calligraphy and manuscript culture in how Pennsylvania Germans documented important life occasions (most notably birth and baptism), built a network of text production and exchange, and cultivated a vibrant text-based Protestant community. Finally, a conclusion places the manuscripts in broader perspective, considering the role of Pennsylvania's German speakers in the popular narrative of early American history.

"The texts must translate us before we can translate them," wrote the twentieth-century German theologian Ernst Fuchs.[48] Making sense of Pennsylvania German spiritual documents requires resurrecting a worldview that

shaped their makers' and users' earthly and spiritual lives. The pages that follow reveal the existence of an American spiritual culture of a decidedly mystical character, a culture of intense spiritual introspection and experience of the divine that many modern observers may be surprised to learn existed on these shores. They open a long-vanished spiritual world and yet stay close to home, in the rolling hills and valleys of rural southeastern Pennsylvania, a landscape rich with meaning for those who linger long enough to seek it.

1

"HEAVEN IS MY FATHERLAND"

Manuscript Culture in an Age of Evangelical Piety

The great antiquary Samuel Pennypacker was not alone in his early interest in Pennsylvania German spiritual books and documents. Another forward-thinking manuscript aficionado was Henry Chapman Mercer (1856–1930), a rough contemporary of the governor who, like that distinguished statesperson, wielded Ivy League credentials (having attended Harvard and the University of Pennsylvania) but parlayed his privilege and inheritance into an antiquarian pastime grounded in the arts, crafts, and culture of his native region of rural southeastern Pennsylvania. And, like Pennypacker, Mercer's interests took a turn toward the eccentric. Though a lawyer by trade, he devoted most of his adult life to archaeology, collecting early American material culture and designing and building distinctive poured-concrete architectural marvels in Doylestown, Bucks County, including his home (called Fonthill Castle) and a museum that today bears his name.[1] He even worked as a curator at the University of Pennsylvania's archaeological museum.[2] Mercer was a progenitor of Pennsylvania German manuscript studies, having inaugurated the scholarly field with a presentation to the American Philosophical Society in Philadelphia in 1897. Hailing "these glowing relics of the venerable stone farmhouses of eastern Pennsylvania," Mercer underscored the manuscripts' transatlantic character. "A study of these fugitive examples of a venerated handwriting leads the investigator by sure steps from the Germany of Pennsylvania to the valley of the Rhine, from the backwoods schoolhouse to the mediaeval cloister," he wrote. "In the fading leaflets we recognize prototypes of the glowing hand-made volumes that illuminated learning in the Middle Ages and still glorify the libraries of the Old World."[3]

From his castle in Doylestown, Mercer articulated a point about the Pennsylvania German manuscript tradition, which, while accepted among

16 THE WORD IN THE WILDERNESS

students of Fraktur since Mercer's own time, has never been fully explored: the place of Pennsylvania German calligraphy and manuscript traditions in the long transatlantic history of manuscript and print. Mercer was charmed by the Middle Ages, as a stroll through the winding Gothic hallways of his home and museum quickly reveals. But his line of inquiry inadvertently points to two other critical areas in need of further consideration by Pennsylvania German scholars. First, *many* cultures have made use of calligraphy and manuscript illumination—not just medieval Europeans and their Pennsylvania descendants. Second, the Pennsylvania art form was not some vestigial survival of an otherwise extinct medieval manuscript enterprise. Rather, manuscript culture survived in Europe and the Americas far longer than most people realize, meaning Pennsylvania manuscripts were not necessarily medieval or backward-looking in character.

Since Mercer's time, scholars of Pennsylvania German material culture have tended to view manuscript culture in the communities they study as a unique regional folk art, evidence of the flowering of a preindustrial, agrarian peasant culture. If investigated solely from their American context, such a characterization may be accurate. The documents bear scant resemblance to the manuscript texts and visual artworks produced in neighboring Anglo-American settlements, and the brief renaissance of the art form in the Americas, from roughly 1750 to 1850, parallels the slow evanescence of America's oft-romanticized rural, agricultural life and the onset of urban industrialism. What is more, the nonacademic, two-dimensional quality of the manuscripts' pictorial imagery fits the characterization of the artworks as folkish, even primitive. Early scholars who transcended this local perspective and sensed the significance of the documents' literary contents—most notably the historian John Joseph Stoudt—often sought to "decode" pictorial imagery on the manuscripts as if they composed some sort of universally shared hieroglyphic system among Pennsylvania's German Protestants.[4] These two approaches to the manuscripts have thus resulted in either too little or too much interpretation of the artifacts' meanings.

A useful antidote to the dilemmas faced by both camps is to place the Pennsylvania German manuscripts in the context of other cultures who created similar art forms and consider the meaning and significance of the manuscript arts writ large, especially within religious communities. Calligraphy and manuscript illumination have been valued as important art forms through many centuries and across many cultures, as vehicles of religious communication and even spiritual-devotional enterprises in and of themselves. Situated within the context of other global traditions, the Pennsylvania documents seem less unique but also more sophisticated, like an early

American iteration of a well-worn artistic, literary, and spiritual enterprise. In China and Japan, for example, calligraphy has long been regarded as one of the highest forms of artistic expression.[5] An elegant manuscript created in Mexico in 1777 shows that calligraphy enjoyed wide resonance in the eighteenth-century Atlantic world, as part of a vibrant manuscript culture that spanned languages, regions, and continents (fig. 6).[6] In the Middle East, the religion of Islam placed a ban on visual representations of God and the

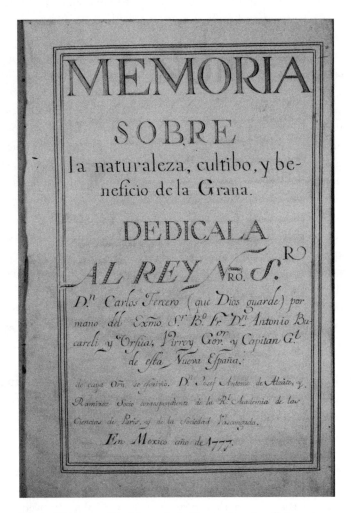

Fig. 6 Title page of José Antonio de Alzate y Ramírez, "Memoria sobre la naturaleza, cultibo, y beneficio de la Grana [...]" (Mexico, 1777), a manuscript regarding cochineal production. 11¾ × 8 in. 755/23. Courtesy of The Rosenbach, Philadelphia. Photo: author.

prophet Muhammad, meaning that the most ornate features of scriptural and devotional Islamic writings were often letters and words themselves.[7] Judaism also frowned on pictorial religious imagery and embraced calligraphy.[8] Some traditional Jewish manuscript forms, especially the ketubah, or marriage contract, bear marked similarities to the Pennsylvania German tradition of producing ceremonial manuscripts to commemorate important life events and ceremonial rites of passage.[9] In India, two-dimensional portrayals of meditative spiritual experiences resonated among Hindus and Buddhists, who employed the mandala, or a symbolic representation of the universe often drawn or painted on paper or cloth, as part of their meditative practice.[10] Medieval Roman Catholics created illuminated manuscripts that make up one of the finest bodies of surviving art from the Middle Ages.[11] Word-based art and two-dimensional conceptualizations of spiritual experience thus enjoy a long history. Even as print publication reshaped the European intellectual world, handwriting enjoyed cultural prestige. German settlers brought a strong sense of the importance of calligraphy, penmanship, manuscript illumination, and the proper adornment of important texts with them to Pennsylvania. These were highly valued arts and crafts in the community, cultivated by educated figures, including clerics and schoolteachers, who presented artworks to their pupils.[12]

Historical studies of calligraphy and manuscript illumination have clustered around medieval European and Islamic topics, as many of the studies cited in the previous paragraph suggest. As practiced in Pennsylvania, however, calligraphy and the manuscript arts constituted an important part of Protestant Christian devotional tradition, specifically as an element of German pietistic and sectarian spiritualist popular piety. While they were not *only* a religious art form, nor one, for that matter, embraced by all German Protestants, it proves most effective to study Pennsylvania German illuminated spiritual manuscripts as religious texts. Understanding the spiritual significance of the manuscripts necessitates understanding the spiritual mentalities of the people who made and used them. Those mentalities were shaped by the central tenets of Protestantism, as well as pietistic and sectarian devotional practices, literary traditions, and visual culture. Pennsylvania Germans embraced the Word as an abstract theology of religious life, a trait they shared with other Protestants of the era. This understanding of the Word infused their interaction with holy texts. "To study lived religion entails a fundamental rethinking of what religion is and of what it means to be 'religious,'" Robert Orsi notes.[13] Artifacts like German spiritual manuscripts orient our attention to the material dimension of religious faith. To grasp the significance of their contents, however, requires a broad understanding of the religious age in which they were made.

Following an introductory assessment of the place of the Word in Reformation thought, our attention in this chapter turns to how Pennsylvania's German Pietists and sectarians made use of the Word in their devotions. An overview of some of the Christian denominations and sects present in early America, with a special focus on the mid-Atlantic region, reveals that a culture of evangelical piety blossomed on the American continent between the seventeenth and nineteenth centuries in which both English Puritanism and German Pietism figured prominently, alongside older mystical, Anabaptist, and other sectarian traditions. Establishing the transatlantic history of the denominations and sects that made spiritual manuscripts—and those that did not—points to an important variable in determining who embraced the devotional-calligraphic art form in early America. Engagement in a quest to access the divine through the invisible work of the Holy Spirit seems to have been a necessary, but insufficient, condition in determining which Christian traditions employed calligraphy and manuscript illumination as part of spiritual practice. The pursuit of such a quest, combined with Germans' long-standing acquaintance with Gothic and baroque calligraphic traditions and aesthetic styles peculiar to their culture, predisposed them to spiritual application of the manuscript arts.

It is exceedingly important to give this much attention to the religious context of eighteenth- and nineteenth-century America because doing so shows how significant the Pennsylvania Germans' illuminated manuscripts are to understanding the era's spiritual diversity. In an age of evangelical piety, when Christians in Europe and up and down the American coast experimented with various forms of devotion, Germans tested out radical ideas of personal spiritual agency rooted in Anabaptism, mysticism, and continental European Pietism.[14] With their emotional fervor and focus on the personal search for God, these German ideas paralleled the revivalist "awakenings" that historians have often studied in relation to Anglo-American communities. German and English Americans embraced similar evangelical tendencies in the early nineteenth century because they both drew on a common heritage of continental European Pietism.[15] Evidence of the license for spiritual exploration that Germans enjoyed appears vividly on their illuminated manuscripts.

"Captive to the Word": The Germans and English
in an Age of Evangelical Piety

The story of the Protestant Reformation is a familiar one. But it is often treated as part of a different era in world history than the settlement of North

America and the rise of the United States. Despite this periodization scheme, the Reformation's impact was not limited to early modern Europe. Rather, its long-term consequences for ecclesiastical organization, theological strife, popular piety, and scriptural-interpretive practice shaped the settlement of early North America and infused the daily existence of Christian settlers. To place early Pennsylvania German spiritual texts in proper perspective requires taking Henry Mercer's advice and beginning our investigation in the German lands during the late Middle Ages, on the eve of the Reformation.

The Reformation overtook German-speaking central Europe in the early sixteenth century under the leadership of Germany's Martin Luther, Ulrich Zwingli of Zürich, and John Calvin in Geneva, who sought to rejuvenate the spiritual life of the Christian church through modified understandings of the nature of faith, justification, and grace centered on rigorous exegesis of biblical texts.[16] Retreating from the "externalization of piety" that had characterized a late-medieval devotional culture focused on relics, pilgrimages, and ritualistic exhibitions, Martin Luther famously proclaimed himself "captive to the Word of God" at the Holy Roman Imperial Diet of Worms in 1521, advocating for a religious life founded on scripture itself, not flawed institutional interpretations thereof. Highlighting abuses of ecclesiastical authority and the ritual culture of late-medieval Roman Catholicism, Protestant reformers urged Europeans to look inward for faith's inspiration.[17] While Luther, Zwingli, Calvin, and numerous other, less prominent theologians and activists vigorously debated the optimal alternative to Roman Catholicism, almost all agreed that the answer must emerge from scripture. Acolytes of reform sought to place scripture where once the church itself had stood unchallenged.[18] Central to Luther's theology was revelation through God's Word.[19] For early acolytes of reform, scripture reading itself was like an act of prayer.[20] Lutheranism proved conducive to text exploration by means of word-based arts. In 1752 a gravel crusher from Nuremberg, Germany, named Johan Leonhard Tauber created an image of the orb of the Holy Roman Empire with lines of text drawn from Luther's catechism and other Christian devotional writings. The Lord's Prayer is in the rose at the center of the image, virtually indecipherable without magnification due to its diminutive size (fig. 7).[21]

With its grounding in personal interpretation of scripture, the Reformation unleashed more powerful forces than the movement's early leaders could control.[22] Individuals and groups pursuing more radical reforms were not content to replace Roman Catholicism with a new draconian Protestant state church; instead, they sought to offer spiritual agency to the common people while, at least in some camps, fomenting a political revolution with the

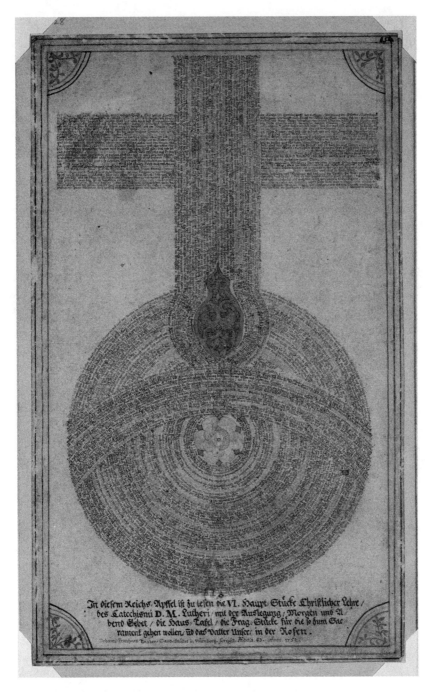

Fig. 7 Johan Leonhard Tauber, single leaf with Lutheran devotional design, Nuremberg, Germany, 1752. Ink and thin paper mounted on board, 13 9/16 × 8¼ in. W.728. Courtesy of the Walters Art Museum, Baltimore.

22 THE WORD IN THE WILDERNESS

potential to unravel the social bonds of Europe.[23] Comparatively conservative authorities of Protestant churches and states sought to quash such zealous efforts, but they never succeeded in stifling the revolutionary potential inherent in Luther's evangelical theology.[24] The specific issues that drove the splintering of Protestantism into discrete movements outside the confines of the orthodox confessions were many, but they derived from varying opinions on the source of faith and conflicts surrounding interpretive authority over scripture. How did the Word of God become meaningful and open the heart to conversion and grace? Who possessed the wisdom to judge scripture's true meaning—learned clerics alone or the everyday believer? An early Martin Luther had more liberal answers to these questions than he did in later life, relying heavily in those former days on medieval mystical ideas encountered in the writings of Johannes Tauler and the famous tract *Theologia Deutsch* (German theology).[25] As the process of confessionalization divided the German lands based on political adoption of this or that Reformation tradition and subordinated control of the church to the state, even the reformers who had fomented revolution against Roman Catholicism staunchly defended orthodoxies that proved just as restrictive on laypeople's spiritual freedom as had the old church—or so critics claimed.[26] Before too long some felt that the Reformation churches themselves needed reforming.[27] The seventeenth- and eighteenth-century movement for a warmer, more personal and introspective Protestant faith experience in the German-speaking lands eventually became known as Pietism.

Pietism owed a deep debt to Europe's centuries-old Christian theological and devotional heritage. Late-medieval mystical and spiritualist movements, the Anabaptist (or "rebaptizing") uprisings that emerged across Europe early during the Reformation, and learned critiques on Protestant orthodoxy launched in the seventeenth century all blended together as Europeans searched for a pathway to interior faith during the period.[28] Radical, mystical spiritualism found renewed popularity under the guidance of Caspar von Schwenckfeld (1489–1561), a Silesian noble who parted ways with Luther and established a small band of followers that eventually made its way to Pennsylvania.[29] Gottfried Arnold, who published histories of the Christian faith that inspired generations to turn toward inward religious experience and the tenets of ancient Christianity, found enviable virtues in the primitive church.[30] Jakob Böhme (1575–1624), a cobbler, published works of mystical theology that influenced Jane Leade and her London-based Philadelphian Movement.[31] Most important was Johann Arndt (1555–1621), whose monumental *Vom wahren Christenthum* (On true Christianity) changed the face of German Protestantism forever. Arndt developed a spiritualist approach to

interior Christianity that sat precariously between orthodox Lutheranism and dissidence, earning him legions of followers for centuries. British, French, and Dutch religious authors all contributed to the German Protestant renewal's burgeoning literary canon as well. English Puritan authors in particular found a receptive audience in the German-speaking lands.[32] (The English Calvinist teaching of "signs of election" entered pietistic discourse as "signs of new birth," for example.)[33]

Pietism commonly understood—as a movement toward personal spiritual introspection and emotionally sentient religious community—first took root in German society with the formation of conventicles for prayer, study, and mutual encouragement under the guidance of Johann Jakob Schütz and Philipp Jakob Spener in Frankfurt and then to northern parts of Germany, Württemberg and the Rhineland.[34] These movements took spiritual experience out of the privileged domain of the church service and into self-organized, domestic fellowships. Spener's *Pia Desideria* (Pious desires) of 1675 provided a programmatic statement for the movement, based on Spener's central idea of transformation through spiritual rebirth. Christian faith is a felt and lived experience contingent on new birth in the Holy Spirit, Spener and followers believed. A philosophy of religion as practice found cogent expression in Spener's heir as the leader of German Pietism: August Hermann Francke, who established an orphanage and other social services at Halle that became the envy of Europe in the eighteenth century.[35] (Francke carried on correspondence with the famous New England Puritan Cotton Mather.)[36] Thomas J. Müller describes the foundational tenet of Pietism as a "personal relationship with God" and the "simple biblical word" as the "center of faith." These core beliefs had deep roots in the Lutheran church but found renewed expression among Pietists.[37]

The pietistic movement contained two competing elements: church Pietists, who remained loyal to the orthodox Lutheran church but sought more feeling relationships with God and their fellow congregants, and radical Pietists, who pursued their spiritual programs outside the auspices of established churches. Both varieties wended their way across the Atlantic.[38] Together they constituted a diverse group of religious seekers. "What united Pietists, despite their differences, was the attempt to make Christianity a more vital presence in society and in individual lives," noted historical theologian Craig D. Atwood.[39] While never dominant over Lutheran spiritual practice in Germany or as frequently discussed in American historical contexts as Puritanism, Pietism was an important ingredient in the mixture of spiritual cultures that took root in early America.[40]

The continental Pietism that germinated and blossomed largely from German Lutheran soil was but one nodal point of a movement toward a more vibrant and introspective faith experience in the seventeenth and early eighteenth centuries. Similar impulses shaped Protestantism in England during the period, marked most notably, as far as early American religious history is concerned, by the rise of Puritanism. And, later, as the eighteenth century wore on, elements of both the old English and German nonconforming traditions contributed to transatlantic upswings in Protestant religious fervor, often referred to as an evangelical revival or, in its North American context, the "Great Awakening."[41] The connections between these various Protestant spiritual-devotional movements are so strong and the outcomes of the efforts so closely aligned that German historian Hartmut Lehmann has recently called on scholars to abandon their tendency to study them as separate entities and instead view early modern evangelical piety as a conceptual unit of analysis rather than a basket of discrete national traditions with independent genealogies.[42]

Not all agree with this broad assessment. As scholar Sünne Juterczenka has noted, many authorities in the field of Pietist studies have sought to prevent the "uncontrolled expansion" of the concept of Pietism, seeking to draw lines between groups that were and were not influenced by the movement, doubtless partly in an effort to preserve the term's utility as an analytic tool.[43] The origins, characteristics, and transatlantic impact of Pietism thus remain a subject of debate. While it is difficult to assess to what extent and degree the spiritual life of each German speaker in Pennsylvania was influenced by Pietism, the theological and devotional practices of virtually all the German denominations and sects present in the colony bore some connection to the movement. This includes not just radical sectaries such as Anabaptists and mystics but adherents of the mainstream confessions as well. Clergy in the early German Lutheran and Reformed churches had pietistic educational and professional backgrounds.[44] According to Mark Häberlein, "Continental European pietism remained a pervasive influence" after the American Revolution and into the 1800s, "but it was a pietism that affected Lutherans, Reformed, and Moravians in distinct ways and was tempered by an overriding concern for stability and order."[45] Not every branch of European Pietism wended its way to Pennsylvania, but values such as self-driven, emotionally rich devotional experiences that united the different branches of the Pietist family tree were important to German Protestant life.[46] As religious scholar F. Ernest Stoeffler observed decades ago, continental Pietism "became an important aspect of the total matrix of religious beliefs, values, understandings, and attitudes in which Protestant church life in America had its origins."[47]

The relationship between German Pietism and English Puritanism, in the age of evangelical piety, is well established. Consideration of the traditions' interconnections and key divergences places the panoply of denominations and sects present in early America in a useful transatlantic context. Just as German Pietists sought to reform the Lutheran establishment, English Puritanism took shape in the mid-sixteenth century as a reaction against High Church Anglicanism. It thrived and evolved on both sides of the Atlantic for two centuries thereafter.[48] (Anglicanism also found a foothold in North America, most notably in the southern colonies.)[49] Puritans of the sixteenth and seventeenth centuries wished to rid the Church of England—the kingdom's established Protestant confession—from the insidious vestiges of Roman Catholic pomp and ritual that, in their reckoning, continued to contaminate the nation's Christian life. They grounded their beliefs in the theology of John Calvin of Geneva, especially his doctrines of predestination and conversion, both of which removed agency over personal salvation from the hands of the believer and placed it squarely in the hands of God. Like German Pietism, the Puritan movement soon broke into two camps: those who wished to undertake reform within the ecclesiastical structure of the Church of England and those who wished to separate entirely from what they viewed as an irredeemably corrupt institution. And, not unlike the German Pietists, Puritanism struck supporters of the status quo as an attempt to overthrow ecclesiastical *and* civic norms.[50]

Just as German radical Protestants faced persecution and expulsion from their homelands, so too did the English radicals, many of whom made for New England to establish colonies where they could live out their religious principles. Like so many spiritual categorizations of the early modern period, the term "Puritanism" lacks clear definition and has been employed as a catchall for a variety of British dissenting theological approaches and religious groups. From the vantage point of American history, the term usually refers to the Calvinist religious traditions of the founders of Plymouth, Massachusetts Bay, Connecticut, and New Haven, though its meaning is at times broadened to include Presbyterians of the Scottish tradition and even other varieties of dissenters, such as the spiritualist Quakers. (Such usage is rare.)[51] The Puritans of Great Britain and New England famously embraced a "covenant theology" that emphasized the centrality of contractual relationships to their religious and social lives. God, they believed, had entered into a contract with humankind, which provided a model for social and political relationships on earth, which some scholars have held as a model for self-governing civil polities.[52]

Called "American Pietism" by one scholar, Puritanism and continental European Pietism developed concurrently within their distinct ecclesiastical

spheres, enjoyed considerable cross-pollination through translation and exchange of works of theology and devotional literature, and thus shared important similarities.[53] Both movements emphasized their desire to return to the early days of the Christian church.[54] And both the pietistic and Puritan movements were introspective in nature, based on an internal experience of faith.[55] "Keep the door of thy Heart fast shut, that no earthly Thought may enter, before that God come in first," wrote Lewis Bayly in his famous Puritan devotional tract *The Practice of Piety*, a book that also enjoyed wide popularity in the German-speaking lands.[56] Puritans paid special attention to understanding the nature of grace.[57] They were, in essence, "a 'hotter sort' of Protestant, and what kept them bubbling was a religious sensibility intimately bound up with conversion," wrote historian Charles Lloyd Cohen. Puritans "excelled at dissecting the psychology of religious experience."[58] The Germans who inspired Pietism likewise sought interior spiritual metamorphosis.[59] Both British reformers and German Pietists believed in the importance of the conversion experience, though Anglo-American Puritans and revivalists were more inclined to write and publish autobiographical conversion accounts than were the German Pietists.[60] Both movements boasted learned supporters, but elite clerics often occupied the periphery of theological circles.[61] And emotion-laden daily devotion figured prominently in Puritan life, as it did for Pietists.[62] Pietistic devotional literature influenced English Puritanism, and English Puritan works by Daniel Dyke, Lewis Bayly, Richard Baxter, Joseph Hall, John Bunyan, and Edmund Bunny flowed into German pietistic circles in the seventeenth and eighteenth centuries.[63]

The famous New England historian Perry Miller was inclined to view Puritanism as a scholarly, rather than emotional, movement, calling it "one of the major expressions of the Western intellect."[64] Nonetheless, both Puritan and pietistic devotional practices offered avenues of personal liberation for adherents rooted at least partly in the emotion and psyche.[65] They shared a quest toward an introspective spiritual experience grounded in the letter of scripture and the inner working of the Holy Spirit. Like Pietists, Puritans developed a culture of both personal and social reading, speaking, and praying.[66] Meditation—what one Puritan author referred to as "heavenly business" in a tract that enjoyed popularity in Germany—figured prominently in Puritan devotional discipline and aimed to carry the spirit from intellectual understanding of God's will to emotional experience of repentance and grace.[67] All that said, a doctrinaire Calvinist asceticism marked Puritan devotion, which perhaps lent an air of rigidity to the English movement that contrasted with German Pietism's warmth, feeling, and open invitation for

personal spiritual exploration. "A Faire face needs no painting, nor good Wine a bush," begins one well-known Puritan devotional text. Puritans focused themselves squarely on useful work in both their spiritual and devotional lives: "Neither stands this little booke in need of Rhetoricall Flowers to set it out, and make it lovely in thy sight. . . . In this booke are six wholesome Dishes of spirituall meat presented to thee, though the brims of the platters are not strewed with suger, nor set out with Barberries."[68] Spiritual meat, savory, not sweet—such was the Puritans' wholesome fare.[69] The ideal form of spiritual and earthly work for Puritans was practical in nature. "Suffer not thy *Mind* to feed it self upon any Imagination, which is either *impossible* for thee to do, or *unprofitable* if it be done," admonished the Puritan Lewis Bayly, "but rather think of the *World's Vanity*, to condemn it; of *Death*, to expect it; of *Judgment*, to avoid it; of *Hell*, to escape it; and of *Heaven*, to desire it."[70] English Puritans were less inclined to emphasize the importance of the Holy Spirit than their German Pietist counterparts.[71] Perhaps in light of their Calvinist asceticism, as well as English culture's embrace of up-to-date, classically inspired letter forms in lieu of their old-fashioned Gothic counterparts by the late seventeenth century, the Puritan affinity for spiritual introspection and godly reading did not translate into calligraphy and manuscript illumination.

Like the Puritans, Pietists viewed "the reading of Scripture as the key to the Spirit's work" and sought to remove their minds and spirits from the distractions of the world to allow for the working of the Holy Ghost, but they cultivated a movement more emotionally taken with the search for the divine mystery.[72] Whereas Pennsylvania Germans encased the holy Word in aesthetic grandeur, the New England Calvinists preferred rigid austerity, an emptiness of visual aesthetic that required one's attentions to focus inward. Established in the first decades of the 1600s, the Puritan colonies of New England diverged dramatically in their social and cultural character from life in Great Britain and the other British colonies, in no small part because of the early religious uniformity of the region.[73]

Whatever distinctions separated the movements, both English Puritanism and German Pietism laid the foundation for evangelical revival movements that reshaped American Christianity beginning about 1730 and stretching through the mid-nineteenth century. The evangelical spirit, it must be conceded, was not new to Protestantism; at its simplest the word *evangelical* means "of or pertaining to the gospel" and has been employed with some consistency since Luther's time to denote those Christians who adhere closely to biblical teachings and seek to spread the Gospels' good news.[74] This is how the term was generally employed until the eighteenth century—not as

a reference to any cohered theology or denomination.[75] One encounters evangelicalism at almost every turn from the early days of the Reformation through the mid-nineteenth century, in both the discourse of the period and secondary literature discussing the religious movements.[76]

Despite evangelicalism's presence throughout Protestant history, the term became increasingly associated with the revival movements of the mid-eighteenth century onward. English historian David W. Bebbington famously outlined four universal qualities of evangelical Christianity: "*conversionism*, the belief that lives need to be changed; *activism*, the expression of the gospel in effort; *biblicism*, a particular regard for the Bible; and what may be called *crucicentrism*, a stress on the sacrifice of Christ on the cross."[77] More recently, Mark Hutchinson and John Wolffe offered their own five qualities central to evangelicalism: first, "the inherent sinfulness of unredeemed human beings"; second, "justification by faith alone"; third, "the work of Christ as the means for the salvation of humankind"; fourth, "the active work of the Holy Spirit in the life of the believer"; and, fifth, "the importance of the Bible as the authoritative guide to faith and devotion."[78] Seventeenth-century German Pietists and English Puritans by and large shared these qualities, leading one to question what, if anything, truly changed in the coming years to amount to a new evangelical movement in the eighteenth century. The issue may simply be a matter of the degree to which various Protestant groups embraced the emotional opening of the heart to the spirit as a tool for conversion along with the power of the individual to bring about one's own conversion.[79] In presaging modern evangelicalism, the German Pietists may have outpaced the Puritans. Whereas the latter clung to Calvin's belief in predestination and human futility, the warmth inherent in German Pietism previewed the empowering, emotional fervency of later evangelicalism, which offered a powerful sense of emotion-laden spiritual agency and dignity in the personal nature of religious experience.[80] A major revelation of later Anglo-American evangelicals is that they moved past the old Puritan focus on Calvin's doctrine of predestination, but radical German Pietists seem never to have been especially concerned with this issue as it related to their own spiritual agency.[81] Pennsylvania German faith practices possessed elements that would have felt very familiar to New England Calvinists but also included warmer traits associated with what later became thought of as the evangelical movement.

Scholarship of the past several decades has unearthed networks of English- and German-speaking Evangelicals and Pietists, demonstrating widespread overlap between movements.[82] (Pennsylvanians also kept in close contact with Pietists back in Europe.)[83] German-speaking Moravian

sectarians exercised considerable influence over the theologies of John and Charles Wesley, founders of Methodism, a denomination grounded in old Puritanism and infused with mysticism that did most to stoke evangelical religious fervor in the early republic.[84] At Halle, John Wesley visited Francke, who maintained active connections to English evangelical enterprises.[85] And the sermons of the great Anglican evangelizer George Whitefield, who attracted attention from Pennsylvania's German speakers, were published in German in Philadelphia.[86] What is more, the influence of Methodism and its famous camp revivals exerted itself on the Germans; Pennsylvania clergyman Martin Boehm, of Mennonite background, was friendly with many Methodists and translated important Methodist works into German. His son even became a Methodist minister.[87] "True evangelical faith is of such a nature that it cannot lie dormant, but manifests itself in all righteousness and works of love," wrote Dutch cleric and Anabaptist leader Menno Simons. The spread of evangelical Protestantism around the world in the early modern period confirms Simons's assertion of evangelicalism's peripatetic nature.[88]

This view of the spiritual context in which early Americans lived suggests the importance of German speakers to the broader evangelical story, one stretching back centuries before the Great Awakening. Clearly, the German speakers who settled Pennsylvania inhabited a spiritual world of tremendous diversity, yet one with considerable overlap among Protestant traditions, even when separated by language barriers. Scholars have long noted the importance of a "textually defined community" in constructing evangelical Protestant identity in the nineteenth-century age of print.[89] Equipped with the Reformation's long heritage, pietistic theology, and much older sectarian spiritual traditions such as mysticism and Anabaptism, as well as a rich scribal tradition, German-speaking southeastern Pennsylvanians helped construct a text-based Protestant spiritual community long before the rise of industrial publishing in the mid-nineteenth century. That calligraphic and manuscript-based fellowship fit neatly into a global Protestant-evangelical tradition.

German Protestants in a Quaker Colony: Devotional Life
in a Pluralistic Society

"Johann George Bertsch bin ich es genannt im Himmel ist mein Vatterland" (Johann George Bertsch is my name, [and] in Heaven is my fatherland), wrote calligrapher Sebastian Hinderle on the front pastedown of Johann Bertsch's German Bible in 1768. He quoted, in part, from a hymn about a

weary Christian's journey on earth.[90] Bertsch, like many German-speaking settlers of early Pennsylvania, sought refuge and opportunity in America but considered his true home to be with God, in heaven. The Protestant Reformation, German Pietism, and a resurgence of interest in ancient and medieval Christian spiritualistic traditions during the period precipitated an explosion of Protestant denominations and sects in early modern Europe.[91] A number of these Protestant groups have figured prominently in American myth and legend, whereas some others, including many of those that settled in the mid-Atlantic region, have not. Early America's non-English-speaking settlers have suffered especially in this regard. But, as the previous review of Reformation and pietistic impulses suggests, the early modern flowering of pious evangelical traditions may best be considered as a single, if diverse and multifaceted, phenomenon, not one governed by linguistic boundaries.[92] The diaspora of early modern Protestant dissenters around the world brought remarkable religious diversity to colonial North America and to the mid-Atlantic region in particular.[93] Pietism and radical sectarian culture broadly conceived played a pivotal role in the populating of Pennsylvania with Europeans of German background.[94] It influenced the spiritual practices of the wide variety of Germans who settled Pennsylvania, ranging from radical sectaries to the adherents of orthodox confessions.[95]

The renaissance of devotional art among German speakers in Pennsylvania owes a debt to a prominent member of an English spiritualist sect known as Quakerism: a man who founded the colony, established a civic culture of toleration of religious diversity, and personally marketed emigration to continental Europeans bereft of a permanent earthly home. William Penn, who lived from 1644 to 1718, was the son of Sir William Penn (d. 1670), an admiral in the English navy. Penn the younger was by birth a man of rank, fortune, and political leverage. He converted to Quakerism in the 1660s and thereafter collaborated with Quaker founder George Fox to generate theological principles for the sect.[96] Quakers were markedly biblicist in their devotional persuasions and, compared to rigid Calvinists who settled New England, avoided establishing their own exclusionary orthodoxy. They instead adopted a belief that every human being possessed some of Christ's "inner light." Unlike Puritans, the Quakers believed people could work toward achieving their own salvation in Christ. In this they resembled German Pietists, who likewise embraced the idea of individual agency in spiritual matters, alongside the importance of emotion in religious experience. As all peoples possessed some of Christ's inner light, then it is unsurprising a Quaker colony became a home for great diversity.[97]

William Penn's American story began in 1682, when he accepted a charter for land in America in payment of a debt owed to his father by the Crown, which led to the founding of Pennsylvania. Inspired by his experiences as a politician and leader of a group of dissenters, Penn enacted the values of religious toleration in his colony. His interest in spiritualism and search for settlers led him to Holland and the German Palatinate, where he had established cordial relations with the philosophically minded Princess Elizabeth Palatine and made trips through the region in 1671 and 1677.[98] The Pietism and Mennonitism practiced there aligned to a greater or lesser extent with Penn's own nonconforming perspectives. What is more, strains of Quakerism even existed in the region, with one having been brought there by English preacher William Ames in the 1660s.[99] Following a network of Friends communities established in the region, Penn recruited Mennonites and other sectarian radicals to undertake the journey to the Americas during his 1677 trip.[100] Significant theological differences (most notably on the nature and uses of the sacraments) divided the Quaker and Mennonite perspectives, and the relationship between Quakers and Mennonites in the German-speaking lands was often strained.[101] Nonetheless, their commonalities as dissenting traditions linked the two groups in American history. Penn's embrace of spiritual freedom laid the foundation for a distinctive culture in Pennsylvania in which settlers pursued both economic and spiritual prosperity.[102]

The first group of German migrants arrived in Pennsylvania in 1683, followed by many more in succeeding years and decades.[103] Thus, Pietists and sectarians account for some of the first German speakers to settle in Pennsylvania.[104] Though they lacked a calligraphy and manuscript culture comparable to that of their Palatine recruits, the Pennsylvania Quakers shared with the German speakers an impetus toward Protestant community, interior spirituality, and divine experience beyond the text of scripture. (In their theology of direct, unmediated access to God, they presented a stark contrast to the more conservative Puritans, who emphasized closer adherence to scripture and balked at Quakers' seemingly fanatical spiritualism, unhinged, so they thought, from the teachings of the holy Word.) In welcoming and indeed encouraging German settlement of Pennsylvania, the colony's proprietary family nurtured the development of a distinctively diverse American subculture as they modeled values of religious toleration. It would be an exaggeration to hail Penn as "modern" in his outlook because he, like the Puritans, looked backward to the early Christian church for utopian inspiration and not forward to a diverse, secular society. Yet clearly his policy of tolerance, coupled with the rich economic opportunities in Pennsylvania, helped set in

motion a settlement pattern quite different from those that had shaped other regions of North America.[105] That Quakers and Pietists both embraced a radical level of spiritual agency lent a religious dimension to their social experiment.

Historian Aaron Spencer Fogleman estimates that, between 1683 and 1775, some 80,000 German-speaking central Europeans flowed into Pennsylvania as they fled culturally and economically inhospitable conditions in their homelands.[106] Marianne S. Wokeck places that number substantially higher, suggesting that 111,000 German immigrants came to America during that same period.[107] Whatever their precise number, German-speaking central Europeans arrived in a colony that in some ways resembled the social structure of Puritan New England. Both were grounded in theological principles. Both enjoyed low mortality and high fertility rates. Settlement patterns in both regions resulted in agriculturally based communities, villages, and towns. And both New England and Pennsylvania fostered a level of social equality remarkable for the era. While the Christian theological missions to which the two regions were committed were quite variant, the holy experiments to which they set themselves fit into the broader Christian motivations of the era and created distinctive societies. Nonetheless, the level of ethnic, linguistic, and spiritual diversity in Pennsylvania quickly set the mid-Atlantic apart from the religious uniformity and community-oriented civic spirit of New England. As Jack Greene explained in his classic survey of American colonial history, *Pursuits of Happiness*, "Largely a collection of individuals organized into nuclear families, the residents of the Middle Colonies . . . displayed no strong commitment to the communal mode that typified early New England. They were characterized by little civic consciousness, slight concern for achieving social cohesion, high levels of individual competitiveness and public contention, and probably eventually, as befitted societies composed of such diverse parts, a pragmatic, accommodative, and tolerant approach to one another."[108] In this individualistic, enterprising spirit, the mid-Atlantic may have presaged the American spirit of later years far better than the Puritan colonies.

What of the Pennsylvania Germans' homelands? Most of the emigrants left a region of central Europe rife with economic, political, and religious pressure. The southwestern corner of the German-speaking lands, encompassing territories such as the Palatinate, Baden, Württemberg, and Alsace, occupied a unique geographic and political position in central Europe that made it a hotbed for religious and social tension. The region lacked strong, centralized leadership, as it fell outside the direct influence of Prussia, Austria-Hungary, or the Swiss Confederation. The Palatine Electorate and

Baden-Durlach, the area's most prominent political authorities, were weak compared to the Habsburg Empire and Prussia. Given this political power vacuum, none of the early modern period's three major faith traditions—Catholicism, Lutheranism, or Calvinism—established a dominant foothold in the region in the era. Even within the area's orthodox Lutheran and Reformed churches, a conservative Pietism made its presence felt and bred internal controversy. What is more, its central location rendered southwestern Germany an epicenter of the Thirty Years' War, ravaging the agricultural landscape, killing many inhabitants, and driving countless others to new lands. Radical Pietism and apocalyptic movements found fertile soil in this war-torn landscape. Those small but potent sects, which cultivated such incendiary beliefs as pacifism and adult baptism, contributed to the religious character and ethnic diversity of the region. In the late seventeenth century, regional leaders sought to repopulate the landscape with sectarian migrants from the cantons of Bern and Zürich, among other places. This resettlement, coupled with natural population growth, soon led to overpopulation. By the mid-1700s, after several decades of repopulation, early modern patterns of agrarian village life proved unsustainable, as lack of sufficient amounts of farmland forced younger generations of peasantry out of their home territories in search of economic opportunity. The region was a logical recruiting ground for continental European nobility as well as British imperial authorities seeking settlers for underpopulated territories in both eastern Europe and the Americas.[109] Promotional publications about the opportunities of life in America played a key role in attracting German speakers who faced economic, political, social, and cultural challenges in their home territories to Pennsylvania.[110] Reasons for emigration often included both economic and religious-freedom motives.[111]

The "Pennsylvania Germans" were not a monolithic community, though they are sometimes discussed as a cultural bloc today. Even from the earliest days of settlement, certain patterns emerged that shaped later cultural development. American settlement proceeded in three waves, as historian Aaron Spencer Fogleman has elucidated: first, 1683–1709; second, 1709–1714; and third, 1717–1775.[112] Each wave featured immigrants of different religious backgrounds who settled in various colonies. The first wave, from 1683 to 1709, was characterized by the arrival of radical sectarians into the port of Philadelphia and from there into the sparsely populated lands beyond the city. The sectarians, many of whom farmed, sought to pursue utopian social experiments in the geographic and political isolation of Penn's Woods. Germans migrated during the years of the second wave, from 1709 to 1714, in large part because of agricultural underperformance in central Europe and a

settlement experiment funded by the British Crown. Many during this period settled in New York and North Carolina, where a vibrant manuscript culture eventually thrived in ways that paralleled that in Pennsylvania.[113] The third wave, from 1717 to 1775, during which the vast majority of German-speaking immigrants arrived, varied drastically from the earlier two. Relatively few of this group were radical Pietists, and few had left Europe primarily for reasons of religious freedom. (A major exception were the mystical Schwenkfelders, who arrived as late as 1732.) A greater number opted for the harrowing journey across the Atlantic in light of socioeconomic stresses and political oppression making life in central Europe—and particularly the southwestern German-speaking lands—unbearable for the agricultural peasantry.[114] Of course, not all the German speakers who arrived in Pennsylvania and their descendants stayed in place. The movement of confessional and sectarian Protestant German speakers continued, even out of Pennsylvania. Lutherans and Mennonites, for example, followed the Great Wagon Road from Pennsylvania through the Appalachian Valley to Virginia and North Carolina, where, as it were, the Moravians also established a significant settlement.[115] Some even went to Ontario, Canada, during the American Revolution and continued making manuscripts there.[116] Thus the tradition became infused into the material culture of other colonies, regions, and even nations. (Germans in New Jersey also made manuscripts associated with the Pennsylvania tradition, as, for that matter, did some New Jerseyites of Dutch and English extraction.)[117]

Southwestern German settlement of Pennsylvania was part of a much larger pattern of eighteenth-century outmigration from that region of Europe. Most of the central European German speakers who left their homelands in the seventeenth and eighteenth centuries settled in eastern Europe, not Pennsylvania.[118] The British, who eagerly sought agrarian settlers for their American colonies, faced a disadvantage in luring Germans on a lengthy, dangerous, and expensive sea voyage to an unfamiliar land. Only about 15 percent of German emigrants opted to travel to British North America. Those who did were likely dazzled by the vast amounts of land available in the American colonies as compared to other common destinations for settlers, as well as the colonies' freedom from oppressive governmental and religious hierarchies.[119] Many transatlantic settlers probably viewed continental European empires' promises of freedom on European soil suspiciously and interpreted the American colonies' distance from centralized governments as a distinct and attractive advantage. Pennsylvania's proprietors did little to demarcate settlement patterns by ethnicity, meaning that, at least during the first waves of settlement, different nationalities and religions occupied close

quarters near Philadelphia.[120] Most Germans who arrived at the port of Philadelphia either stayed in the city or settled in the immediate outlying area, chiefly in Philadelphia, Montgomery, Chester, Bucks, Northampton, Berks, and Lancaster Counties. Settlement in the hinterland surrounding Philadelphia, while offering some level of engagement with the urban center, was sparse and agrarian, reinforcing the separatist tendencies of small sectarian groups.[121] German speakers came to exercise considerable influence over the entire colony-turned-state.[122]

Lumped together by contemporary English speakers under the monikers "Palatines," "Pennsylvania Germans," or "Dutch," the German speakers who populated southeastern Pennsylvania probably lacked any affinity with an ambiguous concept of "Germanness," which, given the absence of a unified German state back in Europe, remained as yet a politically insignificant designation.[123] The settlers' language background and religious adherence may have contributed to their sense of personal and community identity, in terms not only of narrow denominational and sectarian membership but also of membership in a worldwide Protestant and Christian body. Around 90 percent were members of Lutheran or Reformed churches, while approximately 10 percent adhered to sectarian, dissenting, separatist communities.[124] Some of the earliest arrivals were millennialists who fled to the Pennsylvania wilderness to await the end times.[125] More numerous were the "plain" peoples, including Anabaptists (both Mennonites and Amish), as well as Dunkers, or members of the Church of the Brethren, who adhered to a version of the Anabaptist tradition that embraced full-immersion baptism.

The Anabaptists are especially important to the history of manuscript illumination in Pennsylvania. Hailing from Switzerland, the Netherlands, and elsewhere, Anabaptists modeled their faith practices on the early Christians, strictly followed biblical law, emphasized inner faith experience, and sought to live piously in everyday life.[126] Swiss Anabaptists in particular were noted for a "profound biblicism," which their descendants carried to Pennsylvania.[127] (Many Swiss Anabaptists whose descendants settled in America hailed from the area around Bern, a city, interestingly enough, that had been influenced by Pietism.)[128] The Dunkers immigrated to America in 1719 and 1729, and they shared close theological ties to the Mennonites. Other sectarian groups included the Moravians, who settled Bethlehem, Pennsylvania, in 1741; the Schwenkfelders, a small band of mystics who arrived in 1734; and the residents of Ephrata, a monastic community founded in Lancaster County in 1732. Numerous other movements contributed to the variety of Pennsylvania's faith traditions.[129] The prevalence of devotional calligraphy and manuscript practices varied widely among these groups. For

many radicals, including Anabaptists, Schwenkfelders, and residents of Ephrata, it was a vital component of spiritual life. Indeed, those communities produced much, if not most, of the corpus of the art form surviving today. For Lutherans and Reformed, it exercised less importance, though the orthodox confessions did employ Fraktur script and typography on an array of manuscripts and artfully composed printed publications and documents. See, for example, the calligraphed and illuminated title page of the financial record book of the Nockamixon Reformed Church, dating from 1787 to 1844, which exhibits well-executed letter forms and lavish floral illustrations (fig. 8).[130] Its

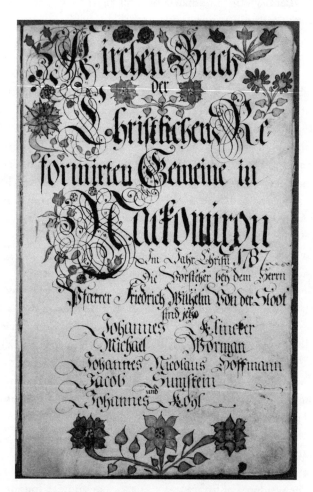

Fig. 8 Nockamixon Reformed Church, financial record book, 1787–1844. 12¾ × 8 in. Nockamixon Reformed Church (Nockamixon Township, Pennsylvania) records, folder 12, box 1, RG 370. Courtesy of Evangelical and Reformed Historical Society, Lancaster, Pennsylvania. Photo: author.

presence in an official church records book, and the relative paucity of such documents made for personal consumption by Reformed Germans, however, suggests that the art form functioned differently among nonsectarian Pennsylvania Germans.

Despite the seemingly infinitesimal diversity of German Protestant groups, at a general level most of them (mainstream and sectarian alike) agreed on fundamental principles of faith and drew inspiration from the same scriptural, theological, and devotional sources. The orthodox German denominations in Pennsylvania shared connections to Pietism and the evangelical spirit of the age but seemed generally less interested in artful manuscript presentations of holy text than their sectarian counterparts, perhaps due to theological and devotional distinctions and the groups' different geographic and cultural origins.[131] The sectarian makers of spiritual manuscripts by and large lived in rural areas, where they were free to farm and practice their faiths far from exposure to what they viewed as the corrupting influences of the world.[132]

How did German Protestant religious culture establish and sustain itself? Ideas, of course, do not travel across oceans and persist through generations on their own. Books and people carry them, preserve them, refine them, and transform them.[133] Remnants of the library of German Lutheran pastor Johann Christoph Kunze (1744–1807), preserved today in the Winterthur Library, illustrate the process by which Pietism infused Pennsylvania's German-language spiritual life. Kunze was born in Saxony and, following training in classics and theology at Rossleben, Merseburg, and Leipzig, was called by the Pietist theology faculty at Halle to fill a vacant pastorate at Saint Michael's and Zion Lutheran in Philadelphia, where he arrived in September 1770, seemingly carrying a number of recent German religious publications with him. He also taught at the University of Pennsylvania (which awarded him a master of arts in 1780 and, in 1783, a doctorate of divinity) before moving to New York in 1784, where he served as a pastor and taught at Columbia University.[134] Volumes bearing Kunze's book label on the front pastedown include publications such as a devotional volume by Carl Heinrich von Bogatzky titled *Tägliches Haus-Buch der Kinder Gottes* (Daily housebook of the children of God) and printed in 1766 on Halle's own press; Johann Jakob Hess's *Geschichte der drey letzten Lebensjahre Jesu* (History of the last three years of Christ's life), published in Zürich, Switzerland, in 1774; and an elegantly bound, multivolume collection of the works of preeminent pietistic poet Christian Fürchtegott Gellert.[135] (Gellert's poems also appeared in locally published hymnals.)[136]

Unsurprisingly, once established in his new environs, Kunze put his pietistic pedigree to good use and began producing devotional literature of his

own. He titled one such book *Ein Wort für den Verstand und das Herz vom rechten und gebanten Lebenswege* (A word for the intellect and the heart on the right and humble way of life), published by Melchior Steiner in Philadelphia in 1781. The volume opens with an epigraph drawn from the book of Proverbs: "In the way of righteousness is life; and in the pathway thereof there is no death."[137] In his exhortations to the reader, Kunze offers a typical pietistic understanding of the nature of faith. "Through the power of faith one gains all the strength of a new life, and one should not regard this as a condition under which one is supposed to live, but as an inevitable fruit of faith—as an inexpressible benefaction on the [faithful] lifestyle," he wrote.[138] Such comments echo Kunze's own European pietistic theological training as well as the sentiments found on many Pennsylvania German illuminated manuscripts.

Sectarians in Focus: Mennonites, Schwenkfelders, and Anglo-American Comparisons

Most of the German religious and spiritual traditions present in early Pennsylvania appear to a greater or lesser extent in the story of manuscript culture and text veneration as practiced in the colony and state. But two of the communities—the Mennonites and the Schwenkfelders—figure especially prominently, probably because of rich manuscript traditions in the geographic regions where their faith traditions originated. Thus, their historical and theological lineage merits detailed attention.

Anabaptists were harshly persecuted radical German Protestant dissenters. The term "Anabaptism," which means "to baptize again" in Greek, points to the most derided practice adopted by the sect: adult baptism. Anabaptists justified this subversive act with their belief in the exegetical power of the Holy Spirit and the authority of laypeople to interpret God's Word. Drawing on their personal knowledge of scripture, Anabaptists cited the lack of infant baptism in the Bible as justification for adult baptism. Their movement forged a direct link between spirit and letter, in which the Holy Spirit provided access to scriptural meaning by working within the heart of the believer.[139] Anabaptists gave their attention to inner emotion incited by the holy Word rather than academic erudition, and Pennsylvania's Anabaptists were not renowned for high levels of learning.[140] Yet they recognized the Word of God as a central means of inciting the emotional spirituality they sought. Lay scripture study germinated and sustained the Anabaptist movement, as

dissenters solidified their confidence in the ability of those with basic educations to access meaning through the Word.[141]

Scholars have determined that three Anabaptist groups emerged around the same time in Europe: one in Switzerland, one in Austria and southern Germany, and one in the Netherlands and northern Germany. Originally followers of the iconoclast Ulrich Zwingli (1484–1531), the Swiss Anabaptists carried the Zürich Reformation further than their leader or local officials wished.[142] Zwingli and his radical followers parted ways in 1523, the latter to endure much persecution. In 1671 seven hundred Swiss Anabaptists, who eventually took the name of "Mennonite" after the Dutch Anabaptist cleric Menno Simons, left their hostile homeland and settled in Alsace and the Palatinate. In 1711 five hundred more sailed down the Rhine.[143] Their political situation in the Palatinate looked uncertain when English William Penn arrived to market his North American colony and its principle of religious toleration to the radicals. Anabaptists soon sailed for Pennsylvania's more tolerant climes.[144] The Amish, perhaps today's best-known Pennsylvania Germans, were a conservative branch of Swiss Mennonites who emerged in 1693 as followers of the religious leader Jakob Ammann. They generally did not make the types of documents under consideration here.[145] The Anabaptist interest in everyday piety belies its deep and abiding focus on spiritual introspection, which its practitioners derived from centuries of Christian teaching and carried with them to the Americas. Prominent early Anabaptists cultivated a mystical approach to faith, and Swiss Anabaptists influenced by Andreas Karlstadt and Thomas Müntzer strove to unlock meaning and spiritual awakening from texts, even as they rejected the latter's calls for violence and other aspects of his controversial theology.[146] Anabaptism is well known for leitmotifs of martyrdom and community identity but has long emphasized the role of the "living spirit" in religious life.[147] Adherents interpreted Luther's principle of *sola scriptura* (scripture alone) to mean that the Holy Spirit and the letter of scripture had to come together to render a holy text meaningful—a belief that echoed mystical theology.[148]

The Schwenkfelders of Silesia were a smaller sect, more spiritual (and certainly more mystical) than the Anabaptists. Mysticism was a radical theory of faith that unhinged the temporal and spiritual worlds from logical coherence and esoteric speculation in favor of a quest toward unity with the divine. Around 1519 Caspar Schwenckfeld experienced a religious epiphany inspired by Martin Luther's early mystical writings. He became well known in Protestant circles for his spiritualism, characterized by his belief in the work of the "inner Word," which facilitated communication between God

and man.[149] Schwenckfeld grew frustrated by Lutheranism's doctrinal focus and disinterest in rejuvenating Christian spiritual and moral life. Aspects of Schwenkfeldian thought and practice—primarily adherents' refusal to attend Lutheran worship services, baptize children, or receive Communion—led to persecution. After a brief stay on the estate of the Moravian Count von Zinzendorf, 180 men, women, and children left for Philadelphia, where they arrived on September 22, 1734.[150] Like the Anabaptists, Schwenkfeldian beliefs complemented the creative and dynamic use of devotional manuscripts as part of lay spiritual practice. Writing became a tool on the path toward knowledge of, and union with, God. "Inscribe, Lord, your will in my stone heart," wrote one Schwenkfelder on an illuminated manuscript made circa 1774, echoing a common theme.[151]

Early sectarian settlers, including the Mennonites, Schwenkfelders, Amish, residents of the Ephrata community, and Moravians, found welcome in a state dominated by the Quakers, possibly the Anglophone world's best-known quasi-mystical spiritualists. In Penn's Woods, where dissenters reveled in far remove from hostile European governments, the Pietists' embrace of tolerance became even more pronounced.[152] Cross-pollination among languages, cultures, and religious groups could only increase in such an environment. A German translation of John Bunyan's *The Pilgrim's Progress*, which had originally been published within just a few years of Spener's *Pia Desideria*, flew off the press of the Ephrata community in 1754.[153] The sermons of famous English evangelizer and revivalist George Whitefield appeared in German translation in 1740, published by the same press that produced many of Pennsylvania's early editions of German-language mystical and pietistic texts.[154] Pennsylvania's German-speaking residents thus practiced a set of central European Protestant spiritual traditions that drew freely on English and Anglo-American influences and, in turn, infused Anglo-American revival movements. Indeed, during the era of the Great Awakening, some German evangelists engaged in itinerant preaching not unlike that of their more famous Anglo-American counterparts. One German Reformed clergyman even made the acquaintance of the future Methodist leader Francis Asbury of Baltimore.[155] Moravians in particular adopted the itinerant preaching model.[156]

Broad categories thus emerge in the religious diversity of early Christian America: Anglicans, with their pomp and ritual; Puritans, with their intense introspection and quest for conversion; Quakers, with their faith in direct, spiritual access to God; German-speaking Pietists and radical sectarians, with their complex and creative efforts to unlock meaning from the Word; and adherents of the evangelical revival traditions that sprang from early

modern Christianity's fertile soil. What of scribes and manuscripts among American Protestants? Anglicans in early America seem not to have cultivated devotional calligraphy and manuscript illumination traditions directly comparable to those of the various German sects represented in Pennsylvania; neither, for that matter, did the more theologically similar New England Puritans or the spiritualist Quakers, suggesting that introspective, spiritualistic theology was not the causal variable in determining which religious groups embraced the media. Broader linguistic, aesthetic, and cultural traditions likely exercised greater influence in this regard than theology or devotional practice.

Despite the apparent lack of any direct North American corollaries to Pennsylvania German spiritual manuscript production, perhaps the most similar manifestation of devotional manuscript artwork in Anglo-America was the product of a religious community as highly spiritualistic, utopian, and separatist in character as were many of the German sectarians so skilled in the writing of Frakturschrift. The "Shaking Quakers," or Shakers, a millennialist sect founded in eighteenth-century England and noted for its pacifism, spiritualism, and communitarian lifestyle, established settlements in New England, New York, and various other locales. The Shakers created manuscripts known variously as "gift drawings" and "spirit drawings," which combined text and image to represent the creators' ecstatic spiritual experiences. The 1854 example in figure 9 combines spiritual text with simple drawings of trees and plants—a combination familiar on Pennsylvania German manuscripts, though this particular artwork dates to the end of German Pennsylvania's epoch of devotional manuscript illumination.[157] Like many Protestant denominations and sects, Shakers frowned on overreliance on pictorial imagery. Construction of the gift drawings represented a compromise between spiritual interiority, textual primacy, and visual stimulation. A scholarly analysis, published in 1962, of the Shaker drawings could well be mistaken for how early scholars viewed Pennsylvania German manuscripts. "These inspirational drawings are primitive in the sense given the word today. They tend to be linear in execution and are resolved in flat pattern, simple color combinations, and frequently incorporate supporting text in the design," this early commentary on the drawings noted. "The technique is explained by the fact that they were not done by artists, as such, but by highly skilled penman [sic] who had intense respect for order in all things."[158] But, in the words of a more recent and spiritually sensitive scholar: "The charm of these spirit drawings, described by some critics as folk art, is the product of more than simply the visual effect."[159] In Shaker communities, spirit drawings were visual representations of the work of the Holy Spirit, a tangible

Fig. 9 Polly Collins, *A Gift from Mother Ann to the Elders at the North Family*, 1854. Ink and watercolor on paper, 19 x 12 in. Collection of Hancock Shaker Village, Pittsfield, Massachusetts, 1963.114.

rendering of the spirit's ethereal realm.[160] Along with related manuscript forms, including spirit messages and songbooks, Shaker spirit drawings created an experiential devotional culture in which works on paper facilitated the nurturing of piety among the sect's members.[161] These documents differ from many Pennsylvania German manuscripts in that the Shaker pieces were not created for music or literacy-instructional purposes. Nonetheless, they demonstrate that Shakers shared a spiritual manuscript culture with pious Pennsylvania Germans.

Some "Wholesome Dishes of Spirituall Meat": Pennsylvania Germans in Comparative Context

"Future studies of the German Reformation, in order to comprehend the significance of the event, will read more and more like general histories of the age," wrote C. Scott Dixon in *The Reformation in Germany*.[162] The same can also be said for the religious and cultural history of early America, which in some respects can be understood only in the context of the Reformation's long theological, political, social, and cultural aftershocks. The transatlantic story of evangelical Protestantism draws together various strands of early modern European and American life and suggests a coherent and thought-provoking perspective through which to view the kaleidoscope of Protestant traditions found in Pennsylvania and the impetus behind their devotional traditions. Martin Luther's Reformation-era focus on personal experience of holy texts resonated across the Christian world, becoming a central trope of Protestantism and finding expression in theology, popular devotional literature, and visual artworks. But Protestantism's famous focus on *sola scriptura* can obscure the fact that many Protestants, including the Pennsylvania Germans, heavily mediated reader experience with holy text by means of aesthetic text design and presentation.

Pennsylvania Germans did not invent the art form of spiritual calligraphy, nor were the manuscripts they made in the rural counties surrounding Philadelphia unprecedented in their stylistic composition or literary contents. They stood, rather, in a long line of calligraphic, manuscript, and text-manipulation traditions that for centuries had played important roles in Asian, Middle Eastern, and European religious and art-historical traditions. Pennsylvania manuscripts lose none of their significance when contextualized within this common heritage. On the contrary, acknowledging the documents' commonalities with other traditions only serves to enhance their value as historical source materials. They allow us to situate early Pennsylvania's German

speakers into the millennia-old story of Christian spiritual practice. Many of the manuscripts are best understood as elements of popular piety and personal spiritual devotion, created by adherents of denominations and sects whose theological doctrines, worship practices, literary proclivities, and social lives often overlapped. The documents resonate as local elements of an international pious evangelical community characterized by remarkable theological and linguistic diversity. Considering the transatlantic history of the religious groups that made the manuscripts—and those that did not— suggests an important variable in determining which communities embraced the art form. Engagement in a quest to achieve access to the divine through the invisible work of the Holy Spirit seems to have been a necessary but insufficient condition in determining which Christian traditions employed calligraphy and manuscript illumination as part of their spiritual practice. The embrace of such a quest, combined with Germans' long-standing acquaintance with certain calligraphic traditions, penmanship standards, and aesthetic styles, predisposed them to spiritual application of the manuscript arts.

While Perry Miller found "incalculable advantages to be gained from considering New England intensively and alone," placing that region and its inhabitants in a wider analytic framework—and especially one that emphasizes German Pietism and other radical approaches to Protestant spiritual experiences—proves a valuable tool.[163] Viewed from a wide perspective, the various evangelical movements afoot in the eighteenth- and early nineteenth-century Atlantic world all sought to encourage believers to pursue personal relationships with Christ grounded in the emotional experience of faith.[164] During this age of evangelical piety, when Christians around the world experimented with various forms of devotion, Germans tested out ideas of radical personal spiritual agency rooted in Anabaptism, mysticism, and continental European Pietism that presaged and paralleled the revivalist awakenings that historians have often studied in relation to Anglo-American communities of the same and later periods. The manuscripts made in Pennsylvania provide remarkable firsthand evidence of how ordinary early Americans nourished their spiritual well-being through biblical literature and devotional texts.

Henry Mercer, the Bucks County antiquary, understood the significance of Pennsylvania German illuminated spiritual manuscripts when he addressed the American Philosophical Society in 1897 and gathered examples of the art form for his collection. His vision for the place of the documents in American history and culture was informed by a wide analytic perspective that accounted for the documents' linkages to centuries of European manuscript tradition. Expanding this perspective further, to compare calligraphy and manuscript culture across languages, cultures, religions, and

epochs further underscores the artworks' tremendous usefulness as cultural artifacts. A sense of spiritual pilgrimage pervaded Pennsylvania German religious culture long after the era of early settlement. In the words of one hymn, "I know that my fatherland and my inheritance / Which I have with God above, in Heaven / Awaits me now in death, / Oh, Heaven's joy and festive gown."[165] Not all German Protestants in Pennsylvania embraced manuscript arts as part of personal piety, but those who did wielded them to great effect. Knowing who the Pennsylvania Germans were, why they ended up in America, and how they compared to other Protestant groups both near and far helps place the specifics of their faith traditions and manuscript practices in useful context. Heaven may indeed have been "fatherland" for many German speakers who settled in early Pennsylvania, but the illuminated manuscripts they produced contributed markedly to the spiritual culture of their temporary, earthly home.

2

"THE SPIRIT OF THE LETTER"

Calligraphy and Spirituality During the Long Era of Manuscripts

After its development in Mainz, Germany, by Johannes Gutenberg around 1450, movable type spread like wildfire across Europe. The importance of the new technology was immediately evident, but it nonetheless garnered some detractors. The printing press disgruntled Johannes Trithemius (1462–1516), abbot of the Benedictine abbey at Sponheim, Germany, located just a short distance from Mainz. Remembered today as a controversial magician, scholar, and quite literally an all-around German "Renaissance man," from his hilltop abbey Trithemius also emerged as a stout defender of pious monastic scribes, whose profession faced an existential threat from the new method of text production. In 1491–92, he penned *De laude scriptorum* (*In Praise of Scribes*), which hailed handwritten texts as superior to the printed word—and the work of the scribe as more honorable than that of the printer. "It is the scribes who lend power to words and give lasting value to passing things and vitality to the flow of time," Trithemius declared. "The printed book is made of paper and, like paper, will quickly disappear. But the scribe working with parchment [i.e., writing on animal skin] ensures lasting remembrance for himself and for his text." Manuscripts, in other words, may have taken a long time to produce, but the results proved highly effective in preserving information for future generations. Copying was also a meditative exercise, a physical and spiritual labor. The abbot highlighted the church fathers' passion for copying religious texts by hand and noted the suitability of copying to monastic life. "He who gives up copying because of the invention of printing is no genuine friend of holy Scripture. . . . The simple reason is that copying by hand involves more diligence and industry."[1] The manuscript

arts were well suited to a reflective life and had a place in an age of print—at least in one abbot's estimation.[2]

With the gift of hindsight, we know that, despite Trithemius's protestations, printing eventually did surpass manuscript production in both functionality and cultural prestige. But the process took much longer than many today assume. Indeed, the abbot of Sponheim would have been pleased to know that handwritten text production retained a significant role in European society for centuries after his death, a matter both of pragmatic necessity and cultural preference. Handwriting remained a tool throughout the period not only for personal purposes like letter writing and record keeping but also for manuscript publication—that is, the composition, presentation, and distribution of literary works in handwritten rather than letterpress-printed form. What is more, in the early modern era the arts of calligraphy and manuscript illumination thrived, imbuing handwritten texts with aesthetic merit and social esteem. In keeping with medieval tradition, scriptural and other spiritual texts frequently received ornate calligraphic treatment at the hands of European scribes, who created visual art out of the holy Word of God.

This chapter considers how early modern Europeans and Euro-Americans employed the Word as a medium for spiritual experience. It begins by welcoming the reader into the world of manuscript-text production in the early modern era and explores the aesthetic norms of this period in history and how they bore on manuscript production. Then it excavates the theological, literary, and devotional foundation for Pennsylvania's spiritual manuscript arts from German American settlers' rich corpus of printed and manuscript devotional texts. Articulation of the governing principles of the theological system in which the manuscripts operated can be helpful to modern onlookers in unlocking their meaning. The intricate and colorful manuscripts, it becomes clear, pulsated with the very same passion for the Holy Spirit's living presence that drove many of the German speakers to American shores.[3]

"In Praise of Scribes": The Long Era of Manuscripts

The years 1450–1850 witnessed dramatic changes to European Christianity. During those centuries the preeminence of Trithemius's Roman Catholic Church gave way to Protestant theological diversity and sectarian schism. German Pietism, nonconforming traditions, and the evangelical awakening fanned flames of spiritual rejuvenation and evangelical piety across Europe.

A Reformation followed by subsequent, interrelated bouts of Puritanism, Pietism, and other evangelical revivals kept Christendom in a continual state of flux. Zealous followers of Christ settled the Americas to practice their faiths freely and proselytize to indigenous peoples. Protestants of the era delved deep into Christianity's ancient heritage to articulate new forms of devotion, which they deemed suited to their word-based faith. Ages-old theological positions and devotional practices infused the Protestant traditions to which many settlers adhered. And, as noted by Trithemius, those same years also witnessed technological and social advances in the production, dissemination, and consumption of texts. Yet just as Christianity's oldest devotional methods found new life and reemerged as paths forward in an age of spiritual innovation, so too did long-standing practices of manuscript production flourish in an era better known for the rise of print culture. German-language spiritual calligraphy and manuscript culture thrived in Pennsylvania between 1750 and 1850, when Pietism and meditative spirituality held sway over much of German Protestantism, and manuscript arts remained culturally privileged genres of text creation and consumption. Understood within the context of German Protestant popular piety, and with the material realities of text making and use during that time, Pennsylvania German spiritual manuscripts seem a logical form of spiritual expression and popular piety for their makers and users.

Manuscript and printing technology did not exist in opposition to each other during the period, though the latter did eventually overtake the former in prevalence.[4] On the contrary, they fulfilled different and often mutually reinforcing purposes.[5] Whereas print could supply large numbers of identical (or at least similar) copies of a text, manuscript production was better suited to distribution within a smaller circle of readers from which critiques and comments could be efficiently gathered, what one scholar calls "social authorship."[6] And where access to the printing press was restricted by geography, profession, economic status, and gender, manuscript publication allowed for a wider array of literate people to become "published" authors. Indeed, "scribal publication" remained a suitable option for many authors deep into the supposed age of print.[7] What is more, publishers, writers, and readers themselves often blurred the line between print and manuscript texts.[8] Manuscript interventions in printed works could take many forms, from corrections of printed texts to decoration and ornament. The application of print and manuscript technology on the same objects underscore the hybridity of the media in the years following the development of movable type.[9] The scribe who created an eighteenth-century Roman Catholic prayer book likely

made and used in Mainz, Germany, cut out printed images to embellish the handwritten text, for example.[10]

The relationship between the various forms of text and image production available in the period was not simply functional; it attracted cultural veneration at the time. It found symbolic expression, for example, on a printed eighteenth-century penmanship sample by Jacob Brunner, which depicted a scribe's quill, an engraver's burin, and a portcrayon (pencil holder) intertwined with a vine, representing unity among media. Brunner intended his metal-engraved sample for use by students, who could copy the text as they honed their handwriting skills. Notably, the quill in Brunner's image writes out a Bible verse in the German script known as Frakturschrift, which lent its name to Pennsylvania German Fraktur manuscripts.[11] The art of engraving and technology of printing by plate allowed booksellers to distribute penmanship samples far and wide, meaning that engraving offered key support to calligraphic activity during the period. Calligraphy enjoyed artistic status at the time and also sat at the center of a vibrant publishing industry. Printed writing manuals provided scribes with fodder to demonstrate their own prowess; the Pennsylvania German Lutheran Johannes Bard made a whole book of copies from a writing manual published in Germany in 1780, for example.[12]

Letter forms resonated in eighteenth-century Europe for more than just their aesthetic value. They also held historical, cultural, and spiritual significance. A 1782 German-language penmanship manual by Johann Merken features lengthy introductory text that builds an argument for linguistically based scripts on contemporary theories of linguistic development following the destruction of the Tower of Babel. Noting scriptural knowledge that several tongues emerged at Babel out of one common root language, Merken suggests that scripts associated with written forms of those tongues originated from one root script. Merken's scribal typology reinforces German's aggrandized status as one of four diasystemic languages to emanate from Babel while underscoring the level of difference he and others ascribed to the Latin and German scripts—or, in his terminology, their distinct "alphabets." "All nations have something peculiar to their writing," Merken wrote.[13] Culturally loaded theories of linguistic origins often claimed primeval origins for the German language. German commentators had applied terms like *lingua materna* or *mütterliche Sprache* (mother tongue) and *lantsprachen* (language of the country) to the German language since the fourteenth and, especially, the fifteenth centuries.[14] Some scholars of the age postulated a German-speaking Adam, while others traced "König Deutsch" (King German) to "Abrahams

50 THE WORD IN THE WILDERNESS

Zeiten" (Abraham's time).[15] Merken's explorations of typographic and scribal typology represent a broad European interest during the era for tracing the origins and development of global languages.[16]

The long era of manuscripts in Europe and America lasted until about 1850, when industrial printing technologies vastly increased the output of printed texts and decreased the cost of printed works for consumers.[17] Of course, handwriting and ephemeral manuscript production have survived to the present day, though, after the mid-nineteenth century, manuscript publication lost its prominent status. But the role of the scribe as an intermediary between author and reader for much of history must be appreciated if the history of texts is to be properly understood. "Permanent meaning is, and can be, nothing other than the author's meaning," wrote literary scholar E. D. Hirsch Jr.—an easy enough point to accept, assuming authorship itself is simply defined.[18] Scribal reconfiguration, representation, and redistribution of texts adds a third character to the author-reader dynamic: the hand copyist. During the era of evangelical piety in the eighteenth and nineteenth centuries, when devotional manuscript production thrived in German Pennsylvania, scribes and readers possessed considerable flexibility and creative agency within this visual-literary system. Viewing the documents through the lens of this communication system reveals much about their utility as spiritual artifacts. The very act of making manuscripts could possess spiritual and cultural resonances. "Great, therefore, are the benefits to be harvested from this sacred art which proclaims the will of God not only to the living but also to those who are still to come," wrote Abbot Trithemius of manuscript production in 1491. The scribe must "proclaim the will of God, pen in hand, to all generations to come."[19] Three hundred years later, German Protestant scribes in Europe and Pennsylvania still agreed.

The Gothic Baroque: Sensory Stimulation and Accessing the Divine

The clear continuity between the manuscript practices of late-medieval Europeans and those of early German-speaking Pennsylvanians does not imply that the traditions remained static during the intervening years. Quite the contrary, they changed in important ways. Stylistic developments in seventeenth- and early eighteenth-century Europe added new elements to script styles and manuscript layout. Pennsylvania German religious manuscripts came to embody a "Gothic baroque" style, which, while grounded in late-medieval calligraphy aesthetics, also reflected the stylistic priorities of a later period. The European baroque stretched from the end of the sixteenth to the

middle of the eighteenth century.[20] The term is often associated with the fine arts, though one scholar has noted the applicability of baroque aesthetics to the study of Pennsylvania illuminated manuscripts.[21] In its German calligraphic iteration, the baroque expanded and elaborated on earlier letter forms but remained grounded in a Germanic tradition stretching back to the monasteries of the Middle Ages.

But the baroque was far more than a new decorative style. It constituted, in the thinking of literary scholar William Eggington, a "problem of thought" expressed aesthetically as modernizing western European society attempted to systematize access to knowledge.[22] Theoreticians conceptualized the existence of a universal wisdom, which humans could obliquely access through the senses. This wisdom was distorted and misconstrued by unreliable sense organs, presenting an epistemological dilemma: the senses veiled the very knowledge humans relied on them to unlock. In response, the arts retreated from classical theories of balance and order toward a pragmatism centered on inciting emotional response that would open their souls to wisdom. As all the arts sought to expose the same truth, boundaries separating genres blurred, and artists could wield multiple genres as a single unit toward arousal of affect.[23] One can be made to "feel" the same way after reading verse, hearing music, or seeing a painting, for example.[24] A verse written in ornate Frakturschrift by a scribe in Bern, Switzerland, in the late seventeenth century articulates the multimodal links between spirituality, speech, and text: "Oh God / my help and / dearest treasure, control my heart, speech, and quill, / to use them for your honor."[25] This multimodality defined baroque art.[26]

The baroque appealed to the pleasure of sensory experience, a position that naturally lent itself to ornament and spectacle, as well as the use of word and picture to evoke larger themes of interest to reader-viewers. It was "spatially invasive" and "polycentric," pushing designs beyond rational frames.[27] Disruption and disorientation unbalanced receivers' sensibilities and opened them for reorientation toward truth. "Curvature," visual "polyphony," and a "marvelous spectacle of abstract dynamism" undergirded Frakturschrift calligraphy and the aesthetics of manuscript illumination.[28] Artistic process as spiritual exercise was a leitmotif of devotional manuscript text. "Rule my senses, and orient them quite to you," an American manuscript asks God, using the art of writing to stir the senses and awaken the interior workings of the spirit's invisible master.[29] Pennsylvania German scribes embraced colorful, intricate, highly ornamented designs as a strategy to capture reader interest and focus attention on key texts. Allegory figured prominently in baroque aesthetics, and scholars of Pennsylvania illuminated manuscripts, most notably John Joseph Stoudt, have pointed out the religious symbolism of

52 THE WORD IN THE WILDERNESS

many pictorial images that appear on the documents.[30] While it is unreasonable to assume, as Stoudt did, that all makers and users of illuminated manuscripts would have recognized the same meanings in various common pictorial symbols, it is clear that pictures often played a key role in constructing manuscripts' meanings.[31] "Emblems," or pedagogical images often attached to short moral verses or sayings, were common during the baroque. See a German baroque emblem in figure 10; it extols the virtues of handwriting skill and presents what it calls "Latin," "Italian," and "German" alphabets in the process.[32] This "allegorical habit of mind" that shaped much baroque art infused Pennsylvania German manuscript artwork for years later.[33] Table I offers a summary of selected emblematic symbolisms that Stoudt asserted for the Pennsylvania manuscripts. While a complex and much-debated art-historical concept, the baroque is a useful analytic tool to apply to the study of Pennsylvania German manuscripts.[34]

By the time the radical separatist Germans in Pennsylvania began making their devotional manuscripts, German- and English-language text presentation styles possessed strikingly different visual qualities, but this had not always been the case. The visual aesthetic of German and English scripts had begun to diverge during the centuries preceding European settlement of North America, a process that witnessed its final stages in America. Late-medieval scribal heritage and baroque design had influenced

TABLE I Selected symbols from John Joseph Stoudt's *Pennsylvania Folk-Art*

Symbol	Selected scriptural references	Meaning and employment in Pennsylvania German manuscripts
Dove	Mark 1:10; Luke 3:22; John 1:32	(New Testament) Holy Spirit
Flowers	I Kings 6–7	Christ
Heart	—	Heart of God, Christ's love for humankind
Lily; tulip	Hosea 14:5–7	Christ and sometimes his community of followers
Peacock	Job 39:13	The resurrection
Pelican	Psalms 102:6	Piety
Rod of Jesse	Isaiah 11:1–3	Metaphors for the coming of the Messiah
Rose of Sharon	Song of Songs 2:1; Isaiah 35:1	Christ
Unicorn	Numbers 23:22	Purity

Source: Adapted from Stoudt, "Symbol, Image and Literary Expression," in *Pennsylvania Folk-Art*, 101–19.

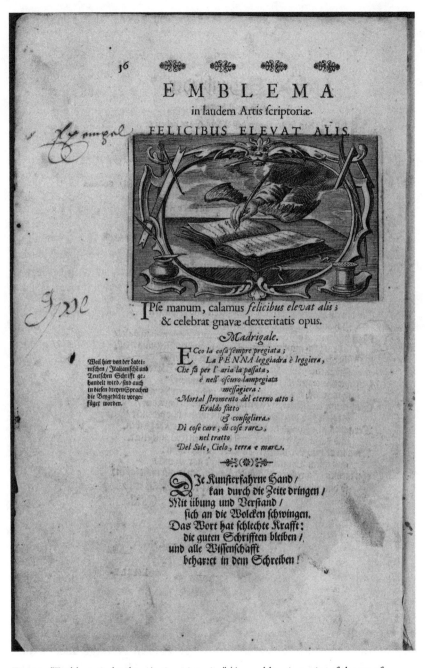

Fig. 10 "Emblema in laudem Artis scriptoriae" (An emblem in praise of the art of writing), in *Kunstrichtige Schreibart*, 1655, 16. Entire page measures 12³⁄₁₆ × 7¾ in; the engraved image is 3³⁄₁₆ × 5 in. Old Imprints Department. Courtesy of the Zentralbibliothek Zürich.

54 THE WORD IN THE WILDERNESS

English calligraphy during the 1600s and early 1700s, and manuscripts written in English and German during these years often bore notable similarities. Manuscript sources of the New England Pilgrims dating from the sixteenth and seventeenth centuries, for example, made use of an array of medieval secretary hands, Graeco-Roman–derived hands considered appropriate to the Latin language, and calligraphic ornamentation similar to what would be used on Pennsylvania German manuscripts more than a century later.[35] But classical Graeco-Roman scripts similar to those we use today slowly overtook all the earlier hands among the English, as British culture embraced classicism in the mid-eighteenth century. This means that English documents ended up looking quite different from their German counterparts.

Sample manuscripts from the mid-Atlantic region offer a case study of this evolution. The circa 1720 texts and illuminations in the schoolbook of New Jersey Quaker teacher Thomas Earl, for example, use capital letters that resemble Pennsylvania German calligraphy made a hundred years later (fig. 11).[36] Baroque aesthetics and neo-Gothic letter forms lost sway over English and Anglo-American manuscript culture and typography long before the Germans gave them up. Less than one hundred years after Earl made his schoolbook, Pennsylvania Quaker student Catharine Morris created a copybook replete with alphabets of Graeco-Roman derivation commonly in use among English speakers, as well as neo-Gothic alphabets explicitly labeled "German Text," indicating how associated the Gothic had become with the German language.[37]

Quakers of the mid-Atlantic region were not alone in this development. A similar pattern held in New England, where classical and Gothic scripts co-existed throughout the seventeenth and eighteenth centuries, but the latter eventually receded in use and were employed primarily as ornament and even then not in the same Fraktur style used by the Pennsylvania Germans. The school exercise book of Samuel Kidder, probably made in 1795 at the Medford School in Massachusetts when its pupil-calligrapher was likely fourteen years old, suggests how classical aesthetics could parallel pictorial and text content (fig. 12). The texts make use of sweeping Graeco-Roman cursive letter forms as well as intricate Gothic letters for titles. The contents of the drawing and calligraphy exercises, however, reflect a fixation on classicism, with discussions of ancient architectural orders and literary figures such as Virgil and Homer. Notably, Kidder's exercises lack the strong religious element that characterized Pennsylvania German pedagogical manuscripts. Odes to George Washington and John Jay, moral maxims, and a quotation from Shakespeare's *The Merchant of Venice* figure more prominently in this New England teenager's

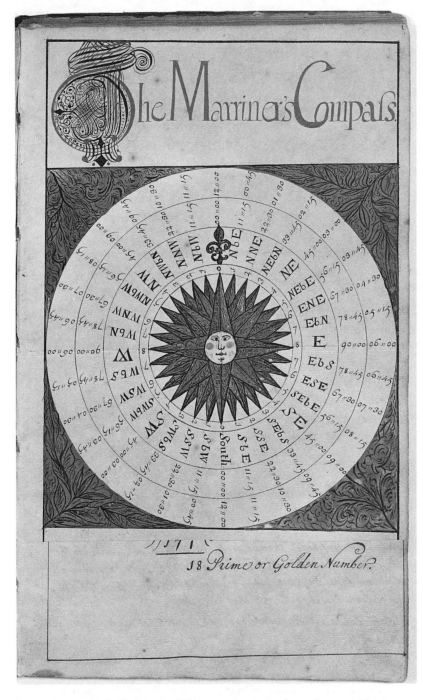

Fig. 11 Thomas Earl, *The Marriner's Compass*, exercise book, southwestern New Jersey, circa 1727. 12⅜ × 7¾ in. Doc. 735. Courtesy, the Winterthur Library: Joseph Downs Collection of Manuscripts and Printed Ephemera, Winterthur, Delaware.

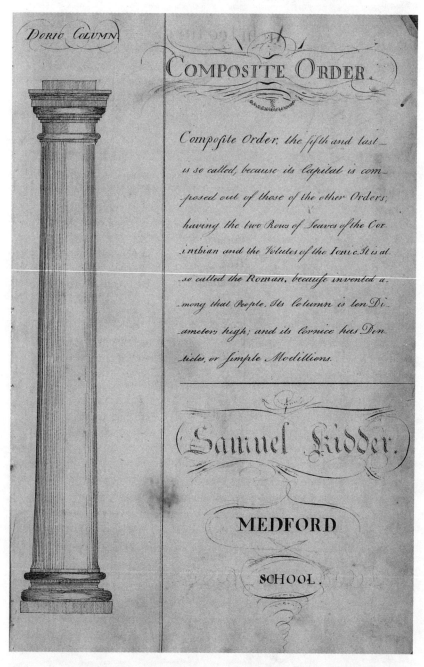

Fig. 12 Samuel Kidder, drawing and handwritten description of elements of the architectural orders, school exercise book, probably Medford, Massachusetts, March 31, 1795. 17¾ × 11 in. Fol. 348. Courtesy, the Winterthur Library: Joseph Downs Collection of Manuscripts and Printed Ephemera, Winterthur, Delaware.

substantial calligraphic repertoire than pietistic hymn texts and apocryphal wisdom literature, which were common fare for Pennsylvania German calligraphers.[38]

The Germans' style of writing thus became associated with their language. Ornate, whimsical Fraktur, a script (and letterpress type) in common use among German speakers from the end of the Middle Ages through World War II, was a product of the interaction of print and manuscript text and emblematic of the transition from medievalism to modernity. Frakturschrift is one of a family of scripts best called "neo-Gothic." The three members of the family developed out of scripts commonly used in German-speaking Europe in the late-medieval period. An updated version of the Textura script common on high-Gothic monastic manuscripts, Frakturschrift is characterized by the broken (or "fractured") nature of its letter forms, which are constructed from separate strokes of the pen, and its long, spindly ornament. The style's emphasis on seemingly continuous, looping lines became a well-utilized feature in devotional calligraphy.

As the head of the neo-Gothic family, Frakturschrift is an ornamental hand that draws attention to important texts. It first developed around the turn of the sixteenth century, likely in the court of Holy Roman Emperor Maximilian I, where it also found life as a printing type.[39] The other two neo-Gothic scripts—*Currentschrift* (also spelled *Kurrentschrift*), a cursive hand, and *Cantzleischrift* (also spelled *Kantzleischrift*), a mixture of elements of both Frakturschrift and Currentschrift—developed around that time as well. They found use in the Holy Roman Empire's growing bureaucratic structures. Between the end of the Middle Ages and the eighteenth century, England and France also made use of types and scripts based on medieval antecedents, but in the mid-1700s they abandoned those forms for scripts grounded in Graeco-Roman aesthetics, the ancestors of the types and scripts commonly employed today. (In English-language parlance, the term *blackletter* is often used to characterize neo-Gothic scripts and related printing types, as well as medieval hands themselves.)[40] Following western Europe's adoption of classically inspired types and scripts, the neo-Gothic family thereafter became associated with the German language and people.[41] David W. Bebbington, the great chronicler of the British evangelical movement, asserted that eighteenth-century evangelicalism "was formed by a cultural shift in the English-speaking world, the transition from the Baroque era to the Enlightenment."[42] That same transition also saw a drastic shift in the aesthetics of text presentation, which bears on the divergent styles of early American religious manuscripts in the English and German languages.

Manuscript Spirituality and Devotional Reading: Unlocking Meaning from the Word

So much for the design of letters, but what of their spiritual significance? In the context of early modern theology, popular piety, and intellectual history, calligraphed letter forms could be far more than simple decoration meant to enhance the visual appeal of literary works and scriptural passages. They could also possess the power to awaken a reader to a text's meaning and facilitate spiritual experience through words. The spiritual-devotional value attached to letter design seems not to have been explicitly articulated by theologians, or scribes or printers, for that matter. Rather, artful presentation of letters seems to have been a consequence of the great weight many German denominations and sects placed on personal experience of faith by means of religious literature and the thirst they felt for a personal, emotional experience of the divine. (The familiarity of the baroque may have predisposed them toward ornament.) Published works of Pennsylvania German theology, devotion, and popular piety across the theological spectrum offer context for how early German-speaking settlers may have thought about letters, words, and texts in relation to their Christian faith.

"All texts can become mere sources of research because they were language," noted theologian Ernst Fuchs in 1964. "But they should now and then speak again. How does one make them talk, indeed bring out *their* word?"[43] Our goal in manuscript interpretation is, as Fuchs describes, not to impose an interpretation on Pennsylvania German manuscripts but rather to allow them to speak in their own spiritual language, to reveal their own meaning. Perhaps the best place to begin such a quest for meaning is not in the print shops, bookstores, or pious classrooms of early southeastern Pennsylvania, where European religious traditions with centuries of provenance found new vibrancy, but rather in the city of Cologne, 125 years before the first German-speaking sectarian stepped foot in William Penn's colony, in the era when Protestant denominations and sects were beginning to take shape. That year, a young man, a book printer by trade, sat in a dark, dank prison cell in the city, scribbling away with quill on paper as the final days and hours of his short life drew ever closer.

Twenty-five-year-old printer Thomas von Imbroich had become leader of a local band of Mennonites in the German Catholic city of Cologne. Given his dissenting movement's perceived status as a threat to civic stability, Imbroich was imprisoned and tortured in December 1557. While captive,

"THE SPIRIT OF THE LETTER" 59

he wrote a confession of his faith designed to question the validity of infant baptism. The manuscript was smuggled out of prison, and the unfortunate Imbroich was beheaded in March 1558. While the passionate young printer and religious dissenter's life was thus cut short, his confession was soon printed and entered the canon of Anabaptist literature, eventually published in Pennsylvania at the behest of the colony's Mennonites in 1745 as part of a compendium of devotional tracts titled *Güldene Aepffel in Silbern Schalen* (Golden apples in silver bowls).[44] The unidentified compiler of the volume appended an editorial note to Imbroich's work that urges readers to look past the "mere letters" (*blossen Buchstaben*) that constitute a text to reveal a literary or scriptural passage's true meaning: "God-loving reader, just as you have read through the afore-mentioned writings and exhortations with diligence and understanding, so penetrate into your innermost soul and compare the writings with one another . . . and with the eyes of the spirit in all fear of the Lord and godliness, look at the writings, and understand them not as the mere letters that one finds everywhere else, but rather judge them in the sense of Christ and the exegesis of the Holy Spirit." If this process were followed, "then one should completely understand the text through the letters," the conclusion asserts. "God hid his secret will and word *underneath* the letters."[45] In the thinking of the compiler of this volume, and many other German speakers in early Pennsylvania, letters and words were gateways to meaning that a spirit-filled heart could unlock, but this process required exploration and introspection on the part of the reader to decipher. Pennsylvania German spiritual text makers were practitioners of religious movements that struggled to unlock meaning from holy texts, and they used calligraphy and manuscript illumination to do so. Entering the spiritual-literary world of those printers, scribes, and readers help us make sense of the texts they left behind.

All of Pennsylvania's early German speakers dealt with similar questions of how to know God and achieve salvation. In many cases they plumbed similar sources for answers. Such sources often included writings influenced by eighteenth-century German Pietism and mysticism, both of which, as we have seen, predicated personal salvation on the believer's inner experience of faith. With these and other source materials in hand, settlers explored how to generate spiritual meaning and experience from their religious texts. Six underlying conceptual commonalities in the German speakers' interpretive approaches to scripture and other devotional literature make sense of the manuscripts. Together they represent the fundamentals of a system of literary and spiritual meaning making linked to documents' visual design, which

60 THE WORD IN THE WILDERNESS

allowed word-centered theology to transform spiritual texts into devotional artworks and artifacts.

The six interpretive approaches are as follows. First, all Pennsylvania German religious groups sought to unlock meaning from, and cultivate faith through, engagement with the written word—an elementary but essential point to bear in mind when interpreting text-based documents as more than visual decoration. Second, they considered how the human senses informed and obstructed experience of the divine. Third, like other early modern Europeans, they viewed religious knowledge as part and parcel of understanding the entire world, so religious writings often addressed how to access wisdom in addition to faith. Divine wisdom was secret or hidden from view, so humans could not find it through their own cognition. They had instead to rely on "the fear of the Lord" to open wisdom to them.[46] Fourth, this focus on sense perception and hidden wisdom figured in a dichotomy that structured much theological and devotional writing of the period: the gap between interior and exterior lives. True spirituality was an internal experience, and an embrace of "inward religion" united the Pennsylvania Germans.[47] The affairs of the world distracted the spirit from its work. Fifth, many writings employed metaphors of geography and spatial dimension (such as gardens, paths, and gateways) when describing spiritual experience, implying that faith and wisdom acquisition were immersive and processual. Salvation involved exploration across both space and time. Sometimes scribes and printers reflected this journey on the written and printed page, abandoning linear presentation of text and image to take readers on a text-based two-dimensional adventure that evoked the immersive spiritual process. Schwenkfelders and the Ephrata community especially seemed to embrace this spatial creativity, though other communities used it as well.[48] Sixth, meditative engagement with God by means of prayer, singing, reading, and writing constituted prime strategies to open the heart and mind to texts' meaning. These interpretive points found expression outside of the world of German Pietism and other radical sectarian traditions; they populate Puritan devotional texts as well, for example.[49]

In sum, these six points show that "the Word" resonated among German speakers as both a conceptual approach to faith and a medium for devotion bound up in texts' visual composition. "We must distinguish between the grammatical and outer meaning of the divine Word and the spiritual, inner and divine meaning," wrote seventeenth-century Lutheran theologian Johannes Andreas Quenstedt. "The first can be grasped even by any unregenerate man, the latter, however, cannot be received except by a mind which has been enlightened."[50] German-language religious literature dating from the late Middle Ages through the eighteenth century underscores the attention

theologians paid to clarifying the place of words in faith and grace. Touchstone theological texts for understanding Pennsylvania German spirituality, analyzed later, reveal how the six themes previously outlined acted together to stir spiritual experience.

An important influence in Pennsylvania German devotional culture was medieval mysticism, an approach to spirituality possessing ancient roots and one often on the fringes of theology and devotional practice but continually present throughout the history of Christianity, including during and after the Protestant Reformation. While a comparatively small number of Pennsylvania Germans were mystics, mystical ideas and language infused Protestantism and certainly influenced spiritual practice among many. Long before Luther's time, Christians had searched for methods of devotion that eschewed external sensory stimulation in favor of internal faith experience. In the Middle Ages some embraced mysticism as a reaction against rigid scholasticism and the externalism of late-Gothic popular piety.[51] Mystics sought to find wisdom by closing out the world and opening the mind and heart to God's action from within.[52] An influential text called *Theologia Deutsch* (German theology), a highly popular tract written in the late fourteenth century, articulates the mystical perspective. Mortals wonder if they can enter God's wisdom through earthly study, the *Theologia* asks. "If the soul is to attain [eternal happiness], it must be pure and free from all images and detached from all created things, especially from itself."[53] Indeed, the soul must "sink" into sadness.[54] "A man is made new when he turns inward, and enters into the temple of his own soul with all his faculties," wrote the German medieval mystic Johannes Tauler, whose works were known in Pennsylvania.[55] In this perspective, external images hindered the ability of the Holy Spirit to act on the believer. "God needs no aid of images or instruments at all, not even of one," wrote Tauler. "Be assured that when the soul is freed from all images and intermediaries, God can for that reason join it to Himself directly. . . . God acts upon the soul directly, without image or figure; yea, upon the soul's deepest depths, into which no image has ever penetrated."[56] While mysticism may seem to be in tension with the emphasis of German speakers on the Word's role in spiritual enlightenment, in fact its focus on pensive reflection infused Protestantism with the use of interiority in unlocking divine experience, which necessitated personal cultivation of faith through language. Mystical ideas enjoyed relevance throughout the late-medieval and early modern periods. Martin Luther himself studied both Tauler and the *Theologia Deutsch*.[57] Early Anabaptists made good use of mysticism; seminal figures such as Hans Denck and Hans Hut embraced aspects of mystical teaching updated for the Reformation.[58]

The inward-looking devotion encouraged by mysticism also posited a strategy for the acquisition of wisdom—the third interpretive point mentioned earlier. Mysticism embraced a theosophy of ecstatic experience toward a "divine and secret wisdom of God and godly things enlightened through the sensibility of a reborn person," wrote early modern mystic Gottfried Arnold, whose works were known and even published in Pennsylvania.[59] In other words, mysticism offered access to God and to knowledge of God's creation. The purpose of the Word, in Arnold's estimation, was to illumine the path toward grace and wisdom.[60] The writings of German mystic Jakob Böhme (1575–1624), whose works were influential in early Pennsylvania, echo this connection between faith and wisdom, identifying God's Word as the blueprint of the universe.[61] Drawing on alchemy and astrology, Böhme, a cobbler by trade, peered through the veil of the observable world to a latent divinity that held the universe together.[62] The life of humankind in the world was the "consecrated word of divine knowledge" and thus reflected divine will. "The hidden God didn't only reveal Himself in nature but also resides there," Böhme claimed.[63]

The mystical idea of latent divinity shrouded by observable reality bears on Böhme's understanding of scripture's role in faith experience. As part of observed reality, the texts of scripture were imperfect representations of God's truth. Meaning was hidden in scripture; scripture was not meaning itself. The believer's task was to follow traces of the divine in scripture beyond the veil of observed reality to truth. "Just as there is no true sight without the spirit, so can there be no true spirit without sight." Human perception of the divine emanates from one's own "center or heart, whence the sight of eternity always comes," Böhme explains.[64] "What humans hear, desire and see is a barrier from truly seeing or hearing God."[65]

The quest for divine meaning in which the mystical cobbler Böhme engaged was radical and controversial among the mainstream church authorities of his day. Nonetheless, a desire for interior knowledge and experience of the divine occupied many other German speakers, even if they would have disavowed Böhme's radical impulses. Even comparatively middle-of-the-road nonsectarians in Europe and Pennsylvania sought a rich devotional interiority rooted in a desire for spiritual experience. This was particularly the case among Lutheran Pietists headquartered at the University of Halle in Germany, whose movement toward a Lutheran religious experience grounded in feeling, sentiment, and service exercised considerable influence over early Pennsylvania by means of the pastors and missionaries Halle sent to North American shores. (Henry Melchior Mühlenberg, the most notable early American Lutheran clergyman, was a Halle-trained

Pietist succeeded by numerous other clergy of similar background and persuasion. He held harsh attitudes toward the beliefs and practices of radical sectarians at work in Pennsylvania, including the Moravians, Anabaptists, and Quakers.)[66]

The Lutheran August Hermann Francke, who led Pietism as articulated at Halle and contributed to the evangelical awakening across the Atlantic world, organized his book *Manuductio ad lectionem Scripturae Sacrae (A Guide to the Reading and Study of the Holy Scriptures)*, published in 1693, around a distinction between the letter and spirit of the Word.[67] "All Reading . . . respects either the LETTER or the SPIRIT of the Inspired Writings," Francke asserted. "Separate from the latter, the former is empty and inconsistent; but when both are united, the study of Divinity is rendered complete." The Holy Spirit rouses emotions that help reveal scripture's meaning as believers become immersed in faith. Francke warns against an overly logical approach to scripture that detracts from the power of the Word to impress reader sensibilities.[68] The book *Licht Der Weisheit* (Light of wisdom), written in 1726 by German Lutheran theologian Martin Musig, articulates a similar distinction between divine and human wisdom.[69] "That [one] takes its origin from the revealed word of God; this [one] from the light of nature: that [one] has an oppositional purpose, principally godly and eternal things, this [one] has for its purpose that which is more visible and temporal," Musig writes. Cold intellect alone cannot lead the human mind to understanding. "That [one] is not a correct skill, if the Holy Spirit itself has not enflamed it through God's word in our hearts."[70] Scholars may debate how widespread mystical thought was in Pennsylvania, but the letter/spirit dichotomy articulated by early mystics and Anabaptists infused many Protestant groups, including mainstream confessions.[71]

Mystical and spiritualist perspectives found rich expression in popular devotional literature. No work better illustrates the relevance of such thought on Pennsylvania Germans than Johannes Arndt's *Vom wahren Christenthum* (On true Christianity), composed 1605–10, the most popular German Protestant book ever written and a text emblematic of eighteenth-century Lutheran beliefs.[72] Indeed, the tome was so beloved by German speakers that, for a time, its popularity threatened to outpace that of the Bible itself.[73] Scholars recognize Arndt as the "most important figure in the history of modern Protestantism, surpassing even Luther," and who exercised significant influence on the development of Pietism.[74] Benjamin Franklin printed the first American edition of *Vom wahren Christenthum* in 1751.[75] It was widely read by early Pennsylvania Germans.[76] Arndt grounded *Vom wahren Christenthum* in mystical ideas of yieldedness to the Holy Spirit, rebirth as a

64 THE WORD IN THE WILDERNESS

follower of Christ, and union with the divine, arguing that faith emanated from within the believer.[77]

Advocating interiority and introspection as the gateway to salvation (the fourth interpretive point described earlier), Arndt's tome comes replete with contemplative prayers and devotional imagery designed to facilitate interior spirituality and open hearts to Christ.[78] One image places Arndt's approach to faith on clear display, granting us vision into two young women's hearts. In one of the hearts appears Adam, the Tree of Knowledge, and Satan in the form of the snake. "I slay him daily," the woman says, pointing a long knife directly at the Adam in her heart, referring to her overcoming of original sin. Christ appears in the other woman's heart. "I live not," she says, "but rather Christ lives in me." Adam should be "killed with the knife of daily repentance," reads further explanatory text. Indeed, the text states, "in the death of the old Adam and the coming into being and growth of the new person originates true Christianity."[79] The new birth is engendered by "faith, word, and sacrament," with the Word at the center of the process. "This word awakens faith, and faith adheres to this word." But word and faith must exist within the believer. "Since the Word is the seed of God within us, thus it must grow in us into a spiritual fruit," Arndt explains. "Otherwise it is a barren seed and bears no fruit." Arndt concludes that "God did not reveal the holy Scripture that it should lie as a dead letter on the paper; rather it should live within us in spirit and faith, and should emerge from a new inner person, or the Word is of no use to us." He continues, "What the Scripture reveals outwardly . . . that must be in me through faith. What it writes of the kingdom of God externally in letters, it must be in me in faith." In Arndt's estimation, "And so it is with the true comprehension of God, for it resides not merely in words, or in a bare science, but rather in a living, loving, charming, strong trust, by which one tastes the sweetness, joy, love, and grace of God in the heart, through faith."[80]

A similar theme is echoed in *Güldene Aepffel in Silbern Schalen*, the book that contains Thomas von Imbroich's confession.[81] It emphasizes the importance of cultivating "living" and "active" faith by means of scripture.[82] A prayer in the book, for example, asks God to make his word "enlivened, strong, and truly within all of our hearts."[83] Similar musings found expression in printed ephemera. Germantown printer Christoph Sauer published a broadside titled "Gründliche Anweisung zu einem Heiligen Leben" (Foundational instruction to a holy life) in 1748. The passage offers advice on reading strategies: "We should often read such books that are useful to our condition, and often under the reading wait a little and be silent, to allow a

place for the spirit, which pulls the mind inward; two or three meaningful and simple words, which are full of the spirit of God, they are the secret manna, and though we already forget the words, so they work in secret, and the soul is fed and nourished." Such reading encourages "union of the souls with God," a concept central to the mystical books Sauer himself published.[84]

Pennsylvania German spirituality was thus predicated on the fundamentally flawed tool of language. "The Word" provided an external catalyst for cultivation of internal faith but, because it existed outside the believer, could not complete the process of spiritual union with Christ. What is more, once the inner working of the Holy Spirit has been achieved, words cannot depict the regenerative process that had occurred within the believer. "O that I had but the pen of man, and were able therewith to write down the Spirit of knowledge," wrote Jakob Böhme. "I can but stammer of the great mysteries like a childe that is beginning to speak; so very little can the earthly tongue expresse what the Spirit comprehendeth."[85] The Lutheran Johann Arndt articulated the same thought: "All words of which I speak are but a shadow, for the most precious thing I feel in my soul, I cannot express adequately in mere words."[86] And so did Reformation-era mystic Sebastian Franck, who called inner truth "the spirit that no one can write."[87] As philosophy, theology, and devotional medium, the Word always fell short. Why, then, did German-speaking spiritualists embrace, and indeed privilege, the Word-centered arts of calligraphy and manuscript illumination as tools for salvation?

Letter Forms as Devotional Images: Approaches, Evidences, and Interpretations

The very imperfection of letters and words in communicating the will of God recommended calligraphy and manuscript illumination as a means of spiritual exploration. Because accessing God's truth through written or printed words was an intellectual, senses-driven process at odds with interior spiritual experience, calligraphy and manuscript illumination sought to bring writer and reader closer to the Word's truth by using visually captivating designs to stimulate the sensory and emotional state necessary to render text meaningful and open the soul to God. To invoke a period metaphor, scribes used devotional texts and artful letters to stir the interior flames of faith kindled by the Holy Spirit. The quest to unlock spiritual experience from words represents a basic function of Pennsylvania German devotional calligraphy. It directed a meditative mind toward clearing that "place for the spirit" which

66 THE WORD IN THE WILDERNESS

Christoph Sauer's long-dead spiritual teacher had described.[88] Language both fascinated and frustrated the settlers, who had no significant alternative path to wisdom and grace.

To value the role that scripture-based calligraphic artworks played in Pennsylvania German society, it is important to bear in mind that, for Protestants of that era, scripture texts were direct revelations from God. It makes sense, then, that many German scribes chose to present holy texts and other devotional literature in a form that honored the visual presence of the Word as a reflection of the divine. This understanding of the Word has roots in the theology of Martin Luther. "The Word is constructive of reality," notes church historian Carl R. Trueman. "The proclamation of the Word is God's creative activity that makes reality what it is. It's not simply a conveying of information, it is not simply a careful and clever exposition of what the Bible is saying, a descriptive exercise. . . . For Luther, the Word is powerful and creative."[89] This theological perspective certainly resonated with early Pennsylvania Germans. "Space and time is the book of God within which all the deeds of men, and indeed all the events of the universe, stand written before the eyes of the eternal God," Carl Friedrich Egelmann wrote on an ornate engraved penmanship sample in his famous publication *Vorschriften für die Jugend* (Penmanship samples for the youth) circa 1831, echoing the theme.[90]

"Regardless of their semantic meaning, words and—by extension—sacred texts exist in and through their material, mediated forms," wrote art historian S. Brent Plate.[91] The Word, as Plate suggests, was an inescapable aspect of Christian life. Even radical dissenters who questioned scripture's ability to bring about salvation also plumbed its depths for meaning. "The sweet source (or fountaine) which is generated in the centre from the light, it is the Word or heart of God. . . . In this you must dwell, if you will be in paradise," wrote Jakob Böhme. Early modern German speakers developed numerous strategies to access the meaning pent up in holy text. The most extreme was rooted in the Jewish practice of kabbalah, or mystical letter interpretation. An English translator of Jakob Böhme, who was deeply influenced by kabbalah, offered an overview of the practice in 1648: "The *Cabala* [consists] in knowing how the words and formes of Things express the Reality of the Inward Mysterie. . . . There is no tittle of any Letter, that is proceeded from that Eternall Essentiall Word." The fundamental premise of kabbalah, as the quote suggests, is that the wisdom God poured into scripture also structures the natural world. Thus, understanding one could open understanding of the other. To understand the language of nature, one must unlock the "Spirit of the Letter," the editor of Böhme's *Concerning the Three Principles of the Divine*

Essence explains.[92] While of ancient and distant origin, kabbalah inspired some of the earliest German speakers in Pennsylvania.[93]

The "spirit of the letter" occupied a fundamental place in early modern German conceptions of language beyond the activities of mystical cobblers and radical millennialists. Contemporary theories of language's origins and its letter forms' "secret meanings" share commonalities with Böhme's understanding of divine wisdom, as they embraced language and written text as a cryptological key to meaning far beyond language and words themselves. Period religious and linguistic tracts shared a basic assumption that languages functioned because they represented a universal truth grounded in the Christian God. One publication, titled *Grammatologia, oder hinlängliche Untersuchung der Geheimnißvollen Buchstaben-Wissenschaft* (Grammatologia, or sufficient examination of the secret-filled science of letters) by the Roman Catholic Ignatius Dominicus Schmid of Bavaria, published 1773, teaches religious lessons through secret meaning supposedly bound up in letters. It begins with overviews of the history of letter forms and provides riddles and poems based on each letter of the alphabet. Next, Schmid offers readers devotions, including a "spiritual ABC," a "golden alphabet for Christian perfection," a "sin and vice list," and a "virtue alphabet."[94] At least one of the texts was known in German-speaking Pennsylvania, where it was quoted on a manuscript.[95]

Manuscripts made by German-speaking scribes underscore just how widespread Schmid's assumptions about letters as devotional tools were. A manuscript written in 1730 in Graubünden, a region of Switzerland with mixed Catholic and Protestant populations bordering on what was then the Republic of Venice, utilizes the same logic as Schmid's book. Called a revelation from the "Himmels Register" (or Book of Life) by its scribe, the text is a key to scripture's teachings about how to enter heaven, grounded in a procession through the alphabet. The recto of each leaf features Frakturschrift capitals and religious words that begin with the depicted letters. The letter *A*, for example, begins "Abrahams Shoßling" (Abraham's shoot) and *P* begins "Paradieß" (paradise). Each letter and associated term is followed by a scripture citation. Final pages offer moral maxims.[96]

Devotional manuscripts made for everyday German speakers rarely quoted the types of high-minded early modern theological sources discussed in the previous section, instead focusing on more familiar texts drawn from scripture and hymnals. Nonetheless, the documents emanate the brand of spirituality modeled by important theologians of the period. Some manuscripts and simple printed devotional texts showcase their theological and

68 THE WORD IN THE WILDERNESS

spiritual underpinnings more explicitly than others and can be viewed as illustrative of the religious underpinnings shaping text interaction among Germans in the period. Take, for example, elaborate, alphabet-based devotional manuscripts that proliferated in early modern German-speaking Europe. Many proceeded page by page or line by line through the alphabet, offering scriptural or devotional verses beginning with each letter. One such piece, called a Vorschrift (penmanship sample) by its scribe and perhaps made and used in the southern German-speaking lands around 1730, features a dedication that asks readers "to regulate life and work after the Word's example" before it proffers moral guidance from biblical and apocryphal texts.[97] A "golden ABC" (more formally known as an acrostic alphabet, in which the first letter of each statement in the text spells out the alphabet) made by Jakob Hutzli in Bern, Switzerland, around 1700 features religious writings rich in "moral exhortations." The scribe of another early eighteenth-century golden ABC likely made in Graubünden clearly intended the texts for devotion. At the top of each leaf, the scribe wrote supplications such as "In the name of God the father, the son and the Holy Spirit, Amen," which appeared above John 3:16, or the shortened "In the name of God, Amen," which appeared above a supplication asking God for constancy in faith.[98] These calligraphic artworks are thus framed as prayers—the "daily bread" of pious Christians.[99] Given their resplendent, colorful calligraphy, the prayers possess both visual and verbal components.

The attention lavished by Pennsylvania German printers and calligraphers on golden ABCs suggest that they, like their European counterparts, also held faith in the alphabet as a tool to structure and reveal divine wisdom. A golden ABC printed in Pennsylvania between 1770 and 1800 offers instructions on use of the document. The verse confirms the devotional alphabet genre as a spiritual-contemplative device that looked to the ABCs for structure and guidance. The poem reads, "In this German alphabet / are written many wonderful teachings. / It is arranged with much diligence / in short and lovely rhyming maxims. / Therefore everyone should gladly read it / And learn from without that which is written within it." The document teaches not the alphabet but spirituality by means of the alphabet.[100] Similar ABCs were made in Pennsylvania in manuscript form.[101]

Language was an unavoidable part of spiritual cultivation, so striving toward its effective use became a fixture of German Protestant spiritualism. The drive toward verbal expression of God's message underlies spiritual calligraphy and devotional manuscript making. "I will venture to try . . . to goe about to seek the pearle [of faith and divine wisdom], whereby also I might labour in the works of God in my Paradisicall garden of Roses: for the

longing of the eternall matrix driveth me on to write and exercise my selfe in this my knowledge," wrote Böhme.[102] German mystic and kabbalist Georg von Welling, who was influenced by Jakob Böhme and was known in Pennsylvania, noted that God sent his law to earth in the form of *lebendige Buchstaben* (living letters).[103] The term is an apt descriptor not just for Christ himself but for the holy writings that carried his message. These words were unavoidable, if flawed, vessels of God's message to earth.

An evocative exposition of the power of living letters to deliver God's message is found in a 1712 edition of Gottfried Arnold's *Die Erste Liebe* (The first love), a book about early Christianity. The capital *E* that opens the text offers visual articulation of the place of letters in pious writings. The Fraktur letter is set in sylvan surroundings; mountains and a body of water appear in the background, and a solar logos, or sun with a face, casts rays on the letter. A heart with wings, probably representing the Holy Spirit, flutters between the sun and the letter, perhaps representing the vesting of the letter with meaning. In the upper-right corner, an eye gazes at the letter, from which sprouts a flower, another symbol of the letter's capacity to nourish the reader's spirit. The very existence of an instructional image centered on a letter demonstrates the power early modern German speakers invested in words to reveal the route to faith. The text that the letter begins reveals that the publisher wished to emphasize the importance of close study of the book's lessons. "God give you all much mercy and peace through Jesus Christ in the Holy Spirit!" it reads. "You all who are truly born of God, and really overcome the world through faith, should put before your eyes this testimony of a throng or assemblage of the first Christians. You all should examine, and after the examination know, what the will of the Lord is for his body, for those who live in this time. Indeed only the person who walks in the light is capable of knowing the manifold wisdom of God as did the first Christians" (fig. 13).[104] Gerhard Tersteegen's *Geistliches Blumen-Gärtlein Inniger Seelen* (Little spiritual garden of the inner souls) features an epigraph that echoes the visual metaphor of the blossoming letter seen in Arnold's book. "These little flowers [of faith] proudly stand, as planted on the page," Tersteegen writes. "May God himself create them, / Then water and also tend them. / In His heart the best soil lives / And every single flower thrives / And leads toward wisdom, strength, and character / In all who read this verse!"[105]

Pennsylvania German illuminated manuscripts underscore the extent to which American settlers embraced the power of holy words. Many documents feature ornamental letter forms and supporting pictorial images that celebrate letter designs' contemplative value. Scholars have traditionally highlighted the work of scribes at the Ephrata community as the most salient

Zuschrifft
An alle und jede lebendige Gliedmaßen
Der unsichtbaren heiligen
GEMEINE
JESU CHristi/
So viel ihrer in dieser und folgender Zeit/
An allen ihren Orten/ aus allerley Volck/
Dem HErrn JEsu und seinen ersten
Gemeinen in der Wahrheit nachwandeln.

GOtt gebe Euch viel Barmhertzigkeit und Frieden durch JEsum CHristum in dem Heiligen Geist!

Uch Allen/ die Ihr aus GOtt wahrhafftig gebohren seyd/ und die Welt noch durch den Glauben wircklich überwindet/ stellet dieses Zeugniß eine gantze Wolcke oder Schaar der Ersten Christen vor Eure Augen. Ihr sollet prüfen/ und nach der Prüfung erkennen/ was da sey des HErren Wille an seine Gemeine/ die in dieser Zeit lebet. Denn diejenigen nur/ die im Licht wandeln/ sind in demselben fähig/ die mannigfaltige Weißheit GOttes an seinen Erstlingen zu erkennen. Wer in GOtt und in der Liebe bleibet/ der wird inne werden/ daß dieses die Erste Liebe sey/ welche anfänglich zwar sehr brünstig gewesen/ aber so bald verlassen worden. So tretet nun heran/ ihr Kinder der Warheit/
† und

Fig. 13 Gotfried Arnold, *Die Erste Liebe*, 1712. "Zuschrifft" (Epistle), l. 13¼ × 8 in. Courtesy of the Rare Books and Manuscripts Library of the Ohio State University Libraries, Columbus.

examples of calligraphy and manuscript illumination laden with spiritual significance.[106] Manuscripts made there comprise the earliest extant Pennsylvania pieces. Religious manuscripts, often referred to as wall charts, covered the walls of Ephrata's rooms. The writings "served them on the path to sanctification for the crucifixion of nature," according to a period source. In the community's Schreib-Schule, or "writing school," scribes spent hours creating the manuscripts they pinned to the walls, gave or sold to outsiders, or, in the case of musical manuscripts, used in singing. Indeed, residents considered writing and singing comparable in their ability to bring them to God. Conrad Beissel, the leader of the Ephrata community, himself personally pointed community members toward both activities.[107] According to Beissel, "each [scribe] has the birthing work in himself" after mystical awakening.[108] One eighteenth-century Ephrata manuscript in particular implements to great effect the epistemological system diagrammed in the letter engraving in Arnold's tome, revealing how community members presumed letters to support devotion and cultivate spiritual wisdom. Indeed, with their calligraphy, the anonymous scribes who crafted Ephrata's *Der Christen ABC* (The Christian ABC) in 1750 recorded with every stroke of their quills the extent to which the Ephrata residents embraced letter designs and associated manuscript illuminations as a form of all-encompassing, immersive iconography, a metaphor for how holy text surrounded and structured spirituality.

While it functions on an elementary level as a calligraphic style or exemplar book, the *Christen ABC* scribes vested their designs with intrinsic contemplative and spiritual value.[109] Indeed, they expressed their devotional aims in the manuscript's full title: *Der Christen ABC ist Leiden, Dulden, Hoffen, Wer dieses hat gelernt, der hat sein Ziel getroffen* (The Christian ABC is suffering, patience, and hope: He who has achieved these has reached his goal). The manuscript proceeds through seven Frakturschrift upper- and lower-case alphabets of various sizes and levels of detail, as well as arabic and roman numerals.[110] The *Christen ABC* scribes used many of the large capital letters in the manuscript as works of contemplative iconography, often incorporating human figures and devotional symbols and scenes into their designs. The presence of angels, biblical characters, and even Ephrata community brothers and sisters ensconced deep within the curves of the Frakturschrift designs underscores letters' primacy as devotional tools and the utility of letters' and words' visual form to the process of spiritual exploration. In effect, letters become metaphorical and actual windows into biblical tales and Ephrata's lived worship experience. They tie scriptural lessons and personal piety together through looping and cyclical calligraphic forms (fig. 14).

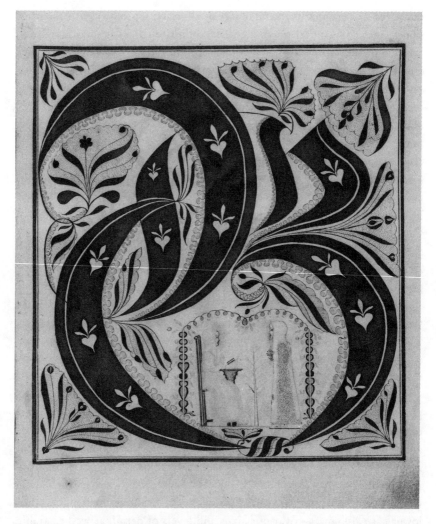

Fig. 14 Anonymous scribes, Frakturschrift capital letter G, *Der Christen ABC* [...] (The Christian ABC [...]), Ephrata community, Pennsylvania, 1750, leaf 10. Iron gall ink on laid paper, approximately 12⅝ × 14⅛ in. EC75.4.16. Courtesy of Ephrata Cloister, Pennsylvania Historical and Museum Commission, Ephrata, Pennsylvania.

Non-Ephrata Pennsylvanians' employment of similar aesthetic motifs on spiritual manuscripts confirms that a wide cross-section of Pennsylvania's German speakers held high regard for letters' revelatory power. The Lutheran schoolteacher-scribe who made a penmanship sample for a Mennonite student in 1768 quite literally pointed to letters as a prime teaching tool in his composition. He employed a manicule (or pointing finger) to urge the student,

in Latin, to *mende morum*, possibly meaning "mind your manners" or "watch your behavior." Both the manicule and the maxim appear within a historiated *I*, the first letter in the Word that opens the manuscript's main text. Inclusion of the manicule pointing toward a maxim ensconced even deeper within the letter's design underscores the scribe's intention to catalyze engagement with the initial itself, not just with the Word to which it is attached, as a spiritual object.[111] The design includes numerous other pictorial elements as well, such as rabbits, a swan, and various floral motifs (fig. 15). On a penmanship sample created for a fourteen-year-old student, schoolteacher-scribe Heinrich Brachtheiser (1762–88) used a creative letter design combining the figures of a snake and a dove to reinforce scriptural teaching. The manuscript quotes Matthew 10:16: "I am sending you out like sheep among wolves. Therefore be as shrewd as snakes and as innocent as doves." Brachtheiser included part of the scripture text inside the very letter depicting the two animals, placing the biblical message at the very heart and center of the manuscript's visual design and thus seamlessly combining picture and text (fig. 16).[112]

On another manuscript a letter takes on human qualities and offers its own spiritual guidance and advice to the reader. Probably made by a Mennonite in the late eighteenth or early nineteenth century, the manuscript begins with the lines, "Reflect on what you must flee, that is all sin; on what you

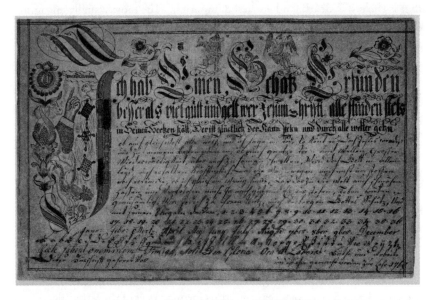

Fig. 15 Herman M. Ache, attr., Vorschrift, Skippack/Salford, Pennsylvania, 1768. Ink and watercolor on laid paper, 7¹⁵⁄₁₆ × 12½ in. 2013.68.1. Courtesy of the Mennonite Heritage Center, Harleysville, Pennsylvania. Photo: author.

Fig. 16 Heinrich Brachtheiser, attr., Vorschrift for Philip Markley, 1787. 8 × 12¹⁵⁄₁₆ in. 1998.8.1. Courtesy of the Mennonite Heritage Center, Harleysville, Pennsylvania. Photo: author.

must do, that is to follow the commands of God; and on what you must fear, that is the cross, death, and eternal damnation." The most visually engaging element of the manuscript is an elaborate initial *B*, beginning the word *bedencke*, or "reflect." The scribe incorporated two human figures into the letter's design, one wearing a long buttoned coat and both wearing tricorne hats. One of the men speaks to the reader-viewer, saying the word *thut*, or "do," and pointing to the word *Busse*, or "repentance" (fig. 17). This call to repent complements the longer admonishment for reflection.[113]

While human figures on manuscripts are relatively rare, angels do sometimes appear.[114] The top line of a writing sample made by a scribe in Montgomery County in 1815 is carried by two angels. The imagery is appropriate, as the German-language line consists of an abbreviated version of perhaps the most famous words ever spoken by angels: "Fear not: for, behold, I bring you good tidings of great joy, which shall be told to all people. For unto you is born this day in the city of David a Saviour, which is Christ the Lord."[115] Nonscriptural text below the verse reinforces the lesson: "He has found a treasure better than Arabian gold. That gift is this Jesus." An angel embraces the capital *S* on *Schatz*, or "treasure," thus forming part of the letter (fig. 18).[116]

All of this is not to imply that *only* letters with human figures incorporated into their designs could convey impactful lessons about the importance

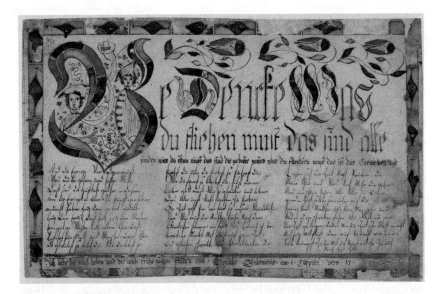

Fig. 17 "Bedencke was du fliehen must [. . .]," religious text, circa 1800. Approximately 8½ × 13 in. German Collection V80, DAMS 12561. Historical Society of Pennsylvania, Philadelphia.

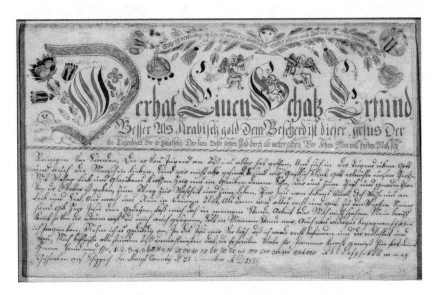

Fig. 18 Jacob Hümmel, Vorschrift, Skippack Township, Montgomery County, Pennsylvania, December 31, 1815. Writing ink and watercolor on laid paper, 7⁶⁄₈ × 12⁹⁄₁₆ in. 1961.0209 A. Courtesy of the Winterthur Museum, Winterthur, Delaware.

76 THE WORD IN THE WILDERNESS

of the Word to Protestant faith experience. Quite the contrary, most Pennsylvania German manuscripts did not feature such designs. But this in no way lessened their spiritual potency. In some instances letters and words seem to have assumed totemic, fetishistic, even magical qualities among Pennsylvania Germans, and they need not possess any special beauty to do so. A small, rusted, and battered tin box now owned by the Winterthur Library contains the magical charms of Jacob Masser (1812–1895), which date to approximately 1840 and feature manuscript and printed spells intended to prevent affliction and cure sickness in humans and animals.[117] (Winterthur Museum also owns a desk made or used by Masser, where the charms might once have been stored.)[118] Masser's box of charms contains two copies of a popular folk-medicinal book supposedly written by a man named Georg F. Helfenstein. It seems that one of the versions of the book was intentionally unbound so that individual printed leaves, with magically potent arrangements of letters, could be displayed around the home or folded and carried on one's person as part of German Pennsylvania's "powwowing" tradition.[119] That Masser, an adherent of the Reformed Protestant tradition, made use of these charms reflects the lingering of folk magic and spirituality deep into the nineteenth century and its intermingling with orthodox Christian practice.[120]

Numerous leaves of the Helfenstein text show signs of active use by Masser, who resided with his family in the rural Upper Mahanoy Township in the Mahantango Valley of Northumberland County, Pennsylvania. The spells and Helfenstein's explanations reveal links between Christianity and folk practices. One, for example, features the following text: "These are the most useful writings for a Christian to have in the home—'Whoever has these writings, no fire shall break out there, no flames will arise, no plague or pestilence will attend his people or cattle, and it will be beneficial to humans and cattle and be so useful as to be almost indispensable to the owner, and he will proclaim with me: great are the works of the Lord.'" The verso of the printed sheet reads, in Latin, "Soli Deo Gloria" (glory to God alone), seemingly the side of the text that could be posted in the home.[121] While an enterprise somewhat removed from spiritual calligraphy, Jacob Masser's charms bear on the discussion of spiritual letter forms. At least some rural Pennsylvania Germans occupied a world in which Christian texts, and the letters that composed them, could possess magical qualities bound up in their material presence in a space or carried on one's person. That paper, ink, and words could possess such properties suggests the great power that texts were thought to confer. The text in its physical form merited carrying on the body or displaying in the home.[122]

At times highly decorated pieces of furniture like Jacob Masser's desk became canvases for the presentation of devotional texts. Some documents found their way pasted onto Pennsylvania German furniture, especially painted chests. A printed and hand-illuminated document found in a chest crafted at the turn of the nineteenth century offers pious messages to whoever opened it up—a household reminder of the Fall, in this case. The text recounts the story of Adam and Eve and ends with a stern summation of the price humankind continues to pay for the original sin. Appropriately enough, the document features colorful illustrations of Adam, Eve, the Tree of Knowledge of Good and Evil, and Satan in the form of a serpent.[123]

This embrace of the Word as a contemplative device could even infuse Pennsylvania German architecture. Moravians, for instance, did not generally cultivate a prominent tradition of ornate manuscript making, but the sect venerated text in conceptually similar ways. Just as Conrad Beissel plastered the walls of the Ephrata chapel with calligraphy, the Moravian leader Count von Zinzendorf had covered the walls of the chapel at Lindsey House in London, the headquarters of the Moravian church in the 1750s, with ornately written names of hundreds of historical Christian leaders, in hopes that reading the names would evoke the virtue of history's admirable Christians among chapel visitors. This spirit of text contemplation found application in Pennsylvania. In Bethlehem, Moravians wrote key words of their faith on an architectural post located in the worship hall (or *Saal*) in the *Gemeinhaus*, the sect's central meeting place. Different words, including *blood, justice,* and *lamb*, were visible on the post to different sections of the congregation.[124] And, as Craig Atwood and Paul Peucker have described, the Moravians did make manuscripts at least somewhat similar to those at Ephrata and among the Anabaptists and Schwenkfelders: small personal devotions called "side hole cards" (*Seitenhöhlchenkarten*), which presented illustrations or short religious verses drawn or written within a curvilinear border that referenced the supposed shape of the side wound of the crucified Jesus. The cards often featured handwritten devotional verses and were used to decorate a Christmas tree in the *Saal* in Bethlehem in 1748; children were then given the cards as presents. The Moravians also used the small artworks as playing cards.[125]

Germans frequently embraced the maze or labyrinth as an instrument of faith, sometimes in the form of an actual garden, sometimes on paper. The radical Protestant Harmonist sect in New Harmony, Indiana, created a labyrinth circa 1815 that took passers-through on a spiritual-contemplative quest to a stone temple.[126] The Ephrata community also produced many examples

of the labyrinth, but on paper. Indeed, the community is widely known today for a genre of devotional prints commonly called the "spiritual labyrinth." Historian Jeff Bach writes that such devices "lead readers on a visual pilgrimage to the New Jerusalem. Text and images unite to create a visual allegory for the intended religious life of Ephrata. The labyrinth invites readers to lose themselves from their visible world and reason in order to find their way into God's presence and become priests."[127]

The Ephrata labyrinth's letterpress text is complemented by colorful illuminations, which surround and intermingle with print. The intended use of the document is spelled out in a description above the maze: the labyrinth contains "four wellsprings of grace," which make four different points. First, the labyrinth teaches humanity's good fortune before the Fall. Second, the "inverted reading" required by the physical presentation of the text reminds readers of the "afflictions and distresses of this life." Third, the fact that the reader "begins and ends at the same place [on the page] shows, just as all the water in the sea flows into itself, so a person . . . again rushes with his body back to his source, and to his mother the earth"—that is, all are doomed to die. "But the soul," the text continues, "should open to Christ daily through penance, faith, and prayer, until you can reach God, your source, and reach into his joy and possession." Fourth, the labyrinth teaches "how a person travels to sin through Satan." These four lessons poise the reader for grace. "Therefore call to God, who guides you, and through his holy Word revealed through Christ, and through true faith by which one is brought to the right path in life, come out of this [labyrinth] blessed, toward the joy of eternal life." The nonscriptural poetry that composes the twists and turns of the labyrinth leads to colorful, hand-drawn flowers and Bible verses coded to certain points in the text by means of a letter-based citation system. The document's material and visual requirements—turning the page to follow the text, correlating passages on the document to scripture citations, enjoying colorful illuminations that evoke the flora and fauna of an actual garden—initiate a slow, deliberate, meditative sensory and spiritual journey to unlock the text's secrets.[128] Other Pennsylvania German printers created spiritual labyrinths, though the form is most closely associated with Ephrata.[129] Circa 1813 a Pennsylvania German scribe created a maze resembling a Celtic knot, the borders of which were filled with meandering and intersecting text drawn from Gerhard Tersteegen's *Geistliches Blumen-Gärtlein*. "Do you want to travel the footpath?" the text asks. "On the way stand many crosses; and the way of crosses is lonely."[130] Other "word puzzles" that required physical manipulation of the page also figured in the Pennsylvania manuscript tradition.[131]

Artifacts such as these seem like examples of how Protestants creatively employed letter forms and ornaments to sidestep a long-standing theological dilemma.[132] Whatever mystical or magical properties they believed letters and words to hold, early modern German-speaking scribes clearly appreciated the spiritual meaning of their work and the extent to which that meaning was bound to texts' material condition. German speakers on both sides of the Atlantic—be they professional scribes, accomplished amateurs, or simply readers of calligraphed and illuminated texts—invested artful letters with cultural and spiritual significance in an era when text production was often a prolonged and highly personal activity.

Manuscript Culture in Practice: A Schwenkfelder Case Study

The theological positions and approaches to letter design and use described earlier held consequences for the material reality of Pennsylvania German spirituality, popular piety, and text engagement. Perhaps no scribes better exemplify the spiritual potential of the manuscript arts than those who hailed from one family: the Heebners of Montgomery County. As documented by Dennis K. Moyer in his 1997 study *Fraktur Writings and Folk Art Drawings of the Schwenkfelder Library*, the Heebners, who were members of the Schwenkfelder sect, produced intensely spiritual manuscripts, and their works survive in large number.[133] The manuscripts reveal how calligraphic skills could turn scribes and readers into their own spiritual agents. Given the volume, not to mention the literary and visual sophistication, of their manuscript output, it does not seem unrealistic that, for the Heebners, literary *transcription* amounted to literary *interpretation*—a way to experience, frame, and configure holy messages bound up in texts. That they possessed skills as visual artists means that the transcriptions they created also functioned as visual art by means of the documents' well-executed letters and numerous pictorial illuminations. The family truly sat at the nexus of print culture, manuscript culture, and popular piety in German Pennsylvania. The patriarch of the family was Hans Christopher Heebner of Worcester Township, a well-known scribe as well as hymn writer and compiler. His son, Abraham (1760–1838), and daughter, Susanna (1750–1818), along with numerous later descendants, produced a sizable number of spiritual manuscripts that secure their makers' own well-regarded reputations in early American spirituality and popular piety.[134]

A student of prominent Pennsylvania German schoolteacher Huppert Cassel, young Abraham produced artworks like those often made by teachers

for their students. As a teenager, for example, he made penmanship samples, which offered moral guidance such as "Patiently bear your affliction on earth or else you will not be worthy of the Lord" and "From your Lord, Jesus Christ, learn to be gentle, mild and obedient."[135] Abraham's works seem modeled closely on penmanship samples he would have seen as a student. He produced numerous other religious texts around the same time, perhaps while still under the tutelage of his mentors. But the gifted scribe carried manuscript production into his later life, creating birth certificates (personal family documents that served no governmental purpose) for the children born to him and his wife, Christina Wagner, whom he married in 1790.[136] "Write your will, Lord God, in my stone-cold heart," inscribed Abraham on one penmanship sample, inviting the Word of God into the human body. This metaphor of human depravity comparing hearts and stones enjoyed resonance among Anglo-American Puritans.[137]

Abraham's sister, Susanna, was also a gifted scribe, though her output varies from that of Abraham in that it seems to date almost entirely from her older age, not her youth.[138] Susanna never married; in all likelihood she remained a resident of the family farm where she had spent her childhood, of which her elder brother eventually took over management. (She seems to have made manuscripts for her nieces and nephews.)[139] No surviving artworks made by Susanna predate her late fifties, meaning she may have begun to practice the art form rather late in life compared to her brother.[140] Though biographical details are scarce, Susanna's Frakturschrift calligraphy and illuminative artistry resonate with their maker's personality and spiritual persuasions. If her literary and artistic sources may be taken as evidence, Susanna may truly be said to have possessed "mystical" inclinations in her devotional practice: she hand-copied spiritual symbols and labyrinths from an edition of medieval German mystic Johannes Tauler's *Helleleüchtender Herzens-Spiegel* (Bright-shining mirror of the heart).[141] An acrostic alphabet (or golden ABC text) Susanna crafted in 1809 carries on the European tradition described earlier of proffering spiritual guidance in the form of a succession through the letters of a Frakturschrift alphabet.[142] The rhyming text begins with the letter *A*: "Am Ersten solst du Gottes Fürcht han, / so wird aus dir ein Weiser Mann" (First of all you should have fear of God / thus you will become a wise man) (fig. 19).[143]

In a large and vibrantly colored manuscript made that same year, titled "Die Sieben Regeln Der Weißheit" (The seven rules of wisdom), Susanna articulated guidance on pious living in the form of a word game well known and popular among Pennsylvania's Schwenkfelders. The colorful Frakturschrift text was scrambled, requiring readers to carefully trace the text's

Fig. 19 Susanna Heebner, religious text, acrostic alphabet / The golden ABC, Worcester Township, Montgomery County, Pennsylvania, 1809. 13⅜ × 8⅛ in. 2-029a, 1920.25.125. Courtesy of the Schwenkfelder Library and Heritage Center, Pennsburg, Pennsylvania. Photo: author.

structure to uncover its meaning. Susanna's surviving artworks help document the spiritual life of an early American Schwenkfelder woman and reveal the utility of manuscript art in providing an opportunity for self-expression to people who might not otherwise figure in the story of theology and literature.

Growing up in a household so immersed in Frakturschrift calligraphy and the manuscript arts, it comes as no surprise that some of Abraham's children followed in their grandfather's, father's, and aunt's footsteps to become spiritual scribes themselves. As Dennis Moyer describes, David Heebner (1805–1823) made several manuscripts, though his career was cut short by an early death. His longer-lived sister, Maria (1807–1868), and brother, Abraham W. Heebner (1802–1877), made many more pieces, carrying the family's manuscript production into the mid-nineteenth century, by which time the Pennsylvania German manuscript enterprise had begun to fade from active cultivation. Henry Heebner, a grandson of Abraham Heebner, donated many of the family's manuscripts to the collection of the Schwenkfelder Library, founded in 1885. Currentschrift text in a heart on Susanna Heebner's 1809 "Die Sieben Regeln Der Weißheit" (The seven rules of wisdom) manuscript reads, "If you seek the gifts of true wisdom, these you may obtain from Jesus."[144] Such words seem a fitting encapsulation of the Heebner family's impressive opus, which they created on their journeys to know God and achieve salvation. While perhaps not typical of Pennsylvania's German speakers in their artistic or spiritual proclivities, the Heebners' creative output underscores the power that spiritual calligraphy could vest in laypeople during the long era of manuscripts.[145]

While folk art scholars have long studied Fraktur artworks as rustic early American handicrafts, when contextualized within manuscript culture of the early modern period they appear less organically American and less charmingly folkish than they initially seem. Drawing on the rich and varied traditions of German Protestantism for the introspective searching of religious literature for divine meaning, the documents facilitated personal engagement with the holy. The artistic output of the mystical Heebners exemplifies how calligraphy and manuscript text production nourished Pennsylvania German religious life as early settlers and their descendants made their homes and pursued their artistic and spiritual interests. Though the dream of Johannes Trithemius, abbot of Sponheim, for manuscript making in an age of print eventually faded, he was quite right in 1491 to highlight the power of manuscript production as an act of devotional piety. It filled just this role in German-speaking Pennsylvania for more than one hundred years.

3

"WORSHIP ALWAYS THE SCRIPTURE"

Teaching Literacy and Pious Wisdom in German Pennsylvania

The Moravian Johann Arbo (1713–1772) shared several traits in common with the medieval Roman Catholic Johannes Trithemius, abbot of Sponheim, though he was born almost two hundred years after the German abbot and manuscript devotee had died. Like Trithemius, Arbo belonged to an international community of Christian faithful. Like Trithemius, he was a polymath. Arbo amassed a vast library, experimented with electricity, and was elected to membership in the American Philosophical Society in Philadelphia.[1] And, like Trithemius, he understood the value of handwriting in a world of print. By Arbo's lifetime print had long since established itself as a central medium of communication among Europeans, and the vast number of books Arbo collected (many of which are now housed at the Moravian Archives in Bethlehem, Pennsylvania) suggests that he held no ill will toward print publication, as had Trithemius so many years earlier. But manuscript technology played a critical role for Arbo and his Moravian brothers and sisters in maintaining the complex and geographically expansive bureaucracy of the Moravian church.

During the age of intense evangelical piety in the eighteenth century, no pietistic sect within German Protestantism was more successful in pursuing missionary work than the Moravians, who developed a sophisticated system of manuscript note taking and sharing among the church's various settlements to facilitate communication among congregations.[2] This sprawling communication network necessitated the training of a vast team of competent scribes. As a practicing congregational scribe and renowned church leader and teacher, Arbo appreciated the functional importance of handwriting skills to the cohesion of the worldwide Moravian mission and felt

84 THE WORD IN THE WILDERNESS

invested in penmanship instruction.[3] He owned a book titled *Methode, nach welcher in den Neustädtischen Knaben-und Mägdlein-Schulen so wohl publice als priatim im Schreiben informiret wird* (Method, according to which private and public writing in the Neustadt Boys and Girls Schools can be instructed), possibly written by Moravian bishop Paul Eugen Layritz (1707–1788), who served as rector of the town school at Neustadt, Germany.[4] But like so many works published during the long era of manuscripts, the *Methode*—or at least the copy preserved in Arbo's personal library—presents a mix of both printed and handwritten texts: typeset instructions on proper handwriting techniques, along with elegant examples of handwritten basic strokes, letters, and words, seemingly in the hand of Arbo himself, who employed the book in his teaching. This mix of genres seems appropriate to the text, given the purpose of the publication and the nature of Arbo's own work. It also suggests the importance of handwriting education to the sustenance of the transatlantic Pennsylvania German spiritual world.

Pennsylvania German literacy instruction, and penmanship training in particular, reveals much about the social role of manuscript production in the eighteenth and nineteenth centuries and the resonance of letters and words in many Pennsylvania Germans' spiritual lives. The printed and manuscript texts crafted for the instruction of Pennsylvania German youth, especially artworks handmade by schoolteachers for individual students, offer a remarkably personal glimpse into the transmission of theological dogma and devotional praxis across generations. Through spiritual calligraphy and illuminated manuscript production, religious words became religious artworks, and those religious artworks became highly valued social commodities that helped stitch together a text-based German Protestant community. This chapter considers pedagogical theories that structured Pennsylvania German classrooms, as well as the spiritual significance of the schoolteacher-scribe, making a special focus of literacy education among the Mennonites and Schwenkfelders, whose communities produced much of German Pennsylvania's surviving manuscript art. The chapter closes with a detailed content analysis of one of the most prominent forms of Pennsylvania German illuminated spiritual manuscript art: the penmanship sample, or Vorschrift. "Worship always the Scripture, which is your good fortune on earth," reads a verse on the title page of a book of penmanship samples published in Switzerland in the eighteenth century.[5] This call to venerate the Word shaped the education of Pennsylvania German youth, as they learned to engage with artistically rendered holy texts in both manuscript and print.

The Scribe as Wisdom Teacher: Spiritual Literacy in the Pennsylvania German Classroom

In ancient Israel there lived a class of wise men who taught the youth, reflected on piety, and extolled the virtues of religious life. Neither temple priests nor prophets, they often found paid work as scribes but, at least partly through their deftness with the written word, also played a key role shaping the religious life of the Jewish people as they produced and transmitted wisdom through the ages. "The Jewish sage is never purely utilitarian," wrote Richard Henry Malden. "His maxims," that is, the religious sayings a sage wrote, "are not entirely the product of experience or common sense, but have been shaped by his belief as to the character of God."[6] To ancient Jews, wisdom occupied a realm between the earthly and divine. Distinct from formal theology but inspired by God's message, wisdom "covered the earth like a mist," according to one wisdom text, offering practical instructions on how to lead pious lives and make sense of the world.[7] Many centuries later Pennsylvania German schoolteachers pursued similar goals.[8] Like the Jewish scribes, they occupied a liminal spiritual and social zone between cleric and layperson and ranked as vital members of the religious community, teaching lessons of spiritual salvation and personal conduct. The fondness that some schoolteachers held for the scriptural and apocryphal wisdom books written by ancient scribes and other teachers (Proverbs, Job, Ecclesiastes, Song of Songs, Ben Sira, and Wisdom of Solomon) rendered concrete this connection between biblical times and early Pennsylvania.[9] Pursuing knowledge through fear of the Lord by means of popular devotional texts, Pennsylvania's German teachers taught lessons that empowered readers in their own spiritual lives.

German-speaking schoolchildren filed into their classrooms across early rural southeastern Pennsylvania to learn to read, write, do arithmetic, and worship God in accordance with their families' Protestant faith. As they took their seats in churches, small schoolhouses, and makeshift schoolrooms and received instruction from German-speaking schoolteachers, the pupils also entered into the social realm in which many of the region's famous illuminated spiritual manuscripts were designed to do their work. Pennsylvania German schoolteachers were educated purveyors of knowledge and skills deemed essential to students' earthly and spiritual lives, most notably the ability to read and interpret the holy scripture. These were the key components of "spiritual literacy," defined here as the pragmatic skills and religious mindset necessary to seek spiritual nourishment and acquire faith through engagement with holy texts. Many among their number—especially teachers

who worked for the Mennonite and Schwenkfelder communities—designed manuscripts intended to further student literacy while urging them on a path toward a pious lifestyle. Joining Pennsylvania German boys and girls for their lessons in reading, writing, and praising God suggests that their schools were far more than clearinghouses for elementary academic skills. They were crucibles of religious identity formation and a wellspring of inspiration for manuscript culture in the neo-Gothic, Fraktur style. "Speech is not simply the expression of meaning but also the interpretation of meaning, each pole existing through and for the other, and each completely pointless without the other," wrote literary scholar E. D. Hirsch.[10] Understood in spiritual context, the interactions of schoolteachers and pupils as embodied in their manuscript artworks emerge as an important node on a "communications circuit" that transmitted literacy skills and religious values across generations.[11] During the long era of manuscripts, students learned to venerate visually evocative letters and words and even to reproduce them with their own hands. Thus they learned to engage spiritual literacy toward their own salvation. In the schoolteachers' hands, letters and words became pupils' access points to God's wisdom and grace. These learners were, in a sense, American heirs of an ancient Judeo-Christian pedagogical tradition.

Pennsylvania Germans, it must be said, had no monopoly on spiritual literacy education in early America. Many Anglo-Americans pursued a similar agenda, though literacy education enjoyed unequal status across the colonies. In Pennsylvania reading and writing instruction was overseen by the colony's various Christian denominations, among English as well as German speakers.[12] The Puritans of New England developed wide-reaching programs and policies supporting children's literacy that made the region arguably the most literate in the early modern world, while in the south no such program took hold. Curriculum materials comprising the well-known English and Anglo-American "ordinary road" of reading acquisition supported generations of New Englanders' first formal exposure to the written word and offers the finest comparative example to the Pennsylvania Germans. The ordinary road toward literacy consisted of the hornbook (a single-page text adhered to a board and secured with horn, which introduced very young readers to letters and words); the primer (a book that introduced students progressively to the alphabet, syllables, words, and religious texts; the psalter (or Book of Psalms); and the Bible. The spelling book, an eighteenth-century advancement that emphasized literacy acquisition through oral acquaintance with letter and word sounds, reshaped Anglo-American literacy education and found parallels in Pennsylvania's German-language literacy publications.[13] All these texts, along with those published for Pennsylvania Germans, made use of an

"alphabetic method" that emphasized training in individual letter and sound recognition before progressing to content and meaning.[14] (The approaches to literacy acquisition and exploration of holy writings manifested in early American Protestant publications bear marked similarities to Roman Catholic publications of the same period.)[15]

Among the English and Anglo-Americans, penmanship instruction had long been presented as an enterprise grounded in both artistry and commerce, a pleasure for the eye and a necessity for the pocketbook.[16] The Pennsylvania German embrace of ornate calligraphic design associated with the educative process was unique in the lands that later became the United States in that Pennsylvania German schoolteachers clearly intended their students to study (and to some extent create) texts as both literary and visual devotional art. Ornate Frakturschrift lacked much practical application in the business world. There were no clear equivalents to this ornamental form among the Puritans, Quakers, or other early Anglo-Americans. Generally speaking, while Anglo-American penmanship instructional materials emphasized exposure to refined culture, rehearsal of elegant handwriting, copying of moralistic phrases, and even discussions of Christian faith, they lacked their German counterparts' explicit association with grandiloquent and emotive intake of the holy Word.[17]

While it seems the Anglo-American ordinary road and Pennsylvania German literacy traditions diverged in terms of letter aesthetics, it merits pointing out that, among both English and German speakers, literacy instruction extended beyond the boundaries of the book's traditional codex form, doubtless owing in no small part to the tender age of typical learners. Early Americans employed a wide range of media to instruct children in the principles of reading, from books and manuscripts to textile needleworks depicting the alphabet and other devices that lent dimensionality and durability to text-based lessons—most notably the wooden hornbook.[18] Comparatively few hornbooks have survived the long centuries, but it is well documented that early Anglo-Americans widely employed the devices for the education of young children—and not just in New England.[19] Benjamin Franklin advertised the sale of hornbooks at the Philadelphia post office in 1742, in the same advertisement in which he hawked "fine Mezzotinto and grav'd Pictures of Mr. [George] Whitefield," the great evangelical preacher.[20] Often made with a wooden base featuring a handle, craftspeople employed a thin, transparent sheet of horn fastened down with metal tacks, to display a printed or manuscript leaf featuring the alphabet, syllabary, Lord's Prayer, and other texts of a religious nature. Designed to be hung at the waist or otherwise carried on the body, the little devices could also feature abacuses

88 THE WORD IN THE WILDERNESS

and various other symbols and ornaments.[21] In communities where they were employed, hornbooks constituted a child's entry point into the realm of literacy and Christian reading. They could also deliver more sophisticated religious messages, as does one featuring what seems to be a printed page from the Anglican *Book of Common Prayer*: Latin text from the seventy-third Psalm and English-language commentary, followed by psalm-hymn text in blackletter type.[22] Among English speakers as among Pennsylvania's German speakers, the path from basic literacy acquisition to text-based spiritual devotion was a short one.

Little evidence suggests that Pennsylvania Germans regularly employed the hornbook but, like their English and Anglo-American counterparts, they did make use of books and manuscripts at home and in the school that underscored connections between individual letter forms and spirituality instruction. Of course, for the Germans those letters were depicted in Fraktur. Young children would likely encounter such Fraktur letters in "ABC Books," a teaching tool with roots in Europe and a long history of publication in eighteenth-century America.[23] An 1816 Pennsylvania publication titled *Hoch-Deutsches Reformirtes A B C- und Namen-Büchlein für Kinder welche anfangen zu lernen* (High-German reformed little ABC and name-book for children, with which to begin to learn) appeared in form and content almost identical to a publication intended for Lutherans printed some decades later.[24] Both texts reflect a standard progression in literacy education, beginning with presentation of large Frakturschrift upper- and lower-case letters before proceeding to lists of single syllables composed of two letters, lists of words, and finally religious texts including the Lord's Prayer, Apostle's Creed, the Ten Commandments, and a selection from the Wisdom Books titled "On the Fear of God from Where True Wisdom Is Attained."[25] The book also offers "Twenty-Five Biblical Sayings, after the A B C."[26] This embrace of the wisdom books and the perspective on divine experience they espouse may seem somewhat surprising, especially among Germans belonging to mainstream denominations. After all, the wisdom books supported a model of devotion that offered considerable agency to the individual believer in pursuing a relationship with God, which ran contrary to the teachings of Luther and Calvin, both of whom insisted on man's helplessness in the process of salvation. The apocryphal status of most of the books attests to the suspicion with which many held the perspectives they fostered. That wisdom literature enjoyed popularity among sectarian groups and even found its way into mainstream schoolbooks suggests that church orthodoxy and schoolroom praxis operated with different objectives and support materials. The image that emerges is that teachers and others who instructed youth in spiritual

literacy enjoyed greater theological flexibility than a typical church cleric in spelling out just how his flock could access divine understanding and grace.

Of course, books and manuscripts alone could not confer spiritual literacy skills on the youth. Formal educational institutions and instructors were also required. The Germans who settled Pennsylvania had to create educational opportunities in their new home, which often necessitated collaboration among various denominations and sects during an era before easy access to printed penmanship instructional materials. In 1727 Lutheran and Reformed pioneers of Montgomery County constructed a log building to house worship services for both congregations and also serve as a schoolhouse for the congregations' youth.[27] Around the same time, Mennonite and Schwenkfelder communities also collaborated to support schools for their children through subscription: students' families paid attendance fees. Such institutions flourished through the first few decades of the nineteenth century and became primary sites for illuminated manuscript production before changes in civic education policy closed the era of sectarian-run schooling.[28] The schools were truly local, community affairs. Organizers maintained a schoolhouse and contracted a teacher. Itinerant schoolmasters sometimes divided their time between communities across the region, encountering different denominations and sects as they taught. Between 1779 and 1787, for example, Lutheran schoolmaster and manuscript illuminator Johann Adam Eyer taught Anabaptist students in three subscription schools in Bucks County, rotating between them on a quarter system, as historian Joel Alderfer's research has shown.[29]

Stated motivations for the establishment of schools for youth shed light on their pedagogical imperative. In 1764 Schwenkfelder Christopher Schultz outlined the case for community schools. The Protestant Christian life relied on possessing the wherewithal to interpret scripture, Schultz asserted: "Is it not true, or in what manner is it going too far, if one says that just as learning and the science of language cleared and blazed the way for the Reformation, so on the other hand ignorance, lack of judgment, and simple crudeness on the part of our people have cleared and blazed the way that our people have so shamefully fallen away from the truth and have so blindly turned to error? What a pity!"[30] Pennsylvania German schoolteachers fulfilled a dual service, transmitting both pragmatic reading and writing skills, along with spiritually cultivated sensibilities, to their students. An 1815 subscription school teacher contract read, "The above-mentioned schoolteacher promises by God's grace and help . . . to regard the children as precious pledges made to him and to instruct them with untiring diligence in reading, writing, singing and reckoning to the end of each child's salvation, and further to acquaint

90 THE WORD IN THE WILDERNESS

them with good and Christian morals." Another such document, contracting Jacob Oberholtzer for the Hilltown Township school in 1823, adds prayer as an area of instruction. Notably, in this multilingual, culturally fluid society, lessons sometimes took place in both English and German.[31]

Unfortunately, no eighteenth-century purpose-built Pennsylvania Mennonite schoolhouses survive, but a series of photos taken by Henry C. Mercer in 1897 and arranged by him in a photo album depict a Mennonite schoolhouse dating to the 1840s, which probably resembled earlier, cruder log structures in approximate size and spatial dimension and certainly in sylvan setting (fig. 20).[32] The classroom environment was dedicated to religious devotion and praise of God. An illustration of a Pennsylvania German classroom likely made in Lancaster County in the early nineteenth century—one of few such depictions known to exist—features handwritten verses asking God to support the educative process. The opening lines quote the first portion of Psalm 71:23: "My lips / and my soul are happy / and sing praise to you," continuing with an excerpt from Psalm 31, "Thou hast redeemed me, O Lord God of truth." Next come lines from a contemporary hymn: "Help, God, that the child-rearing, / happens always with utility and / Fruit that out of the children's mouths you / will prepare a praise to the world."[33] The manuscript's last three lines correspond to a hymn included in a 1749 hymnal, designated to be sung before the *Schul-Predigt*, or "school sermon": "We praise you, we thank / you, with our children forevermore."[34] Interposed in the text is a scene of eight happy schoolchildren gathered around a table, studying their books and praising God, all surrounded by spectacular decoration. The words on the manuscript underscore the richness of the classroom spiritual world (fig. 21). Under the teachers' guidance, students learned to read and write scriptural and devotional text as well as to extract spiritual guidance from the text in question. This goal imbues the most famous source on early education in German Pennsylvania: *Eine Einfältige und gründlich abgefaßte Schul-Ordnung [. . .]* (A simple and thoroughly prepared school management [. . .]), written by the well-known Montgomery County Mennonite schoolteacher Christopher Dock (ca. 1698–1771) and first printed in 1770. Dock grounded his pedagogy in the working of the Holy Spirit in his students' lives. "I see that it is beyond human power to exterminate the root" of human iniquity, Dock admitted. "God alone through the power of His Holy Spirit must do this." Teachers, clergy, and parents can only strive to encourage and cultivate moral and religious rectitude among the children.[35] Scribal training was bound up in a classroom environment centered on the reading, recitation, recall, and interpretation of texts meant to stimulate the purifying action of the Holy Spirit.

Fig. 20 Henry Chapman Mercer, photo of the Deep Run Mennonite Schoolhouse, Bedminster Township, built 1842. Photographed by Mercer in 1897. Original is approximately 2½ × 4 in. BCHS photo album, Archaeology / Colonial History, 42. Courtesy of the Mercer Museum Library of the Bucks County Historical Society, Doylestown, Pennsylvania.

A typical day in Dock's classroom underscores the primacy he, and presumably others, assigned to spiritual literacy acquisition, which was truly an essential skill during their age of evangelical piety, when English Puritans, German Pietists, diverse radical sectarians, and evangelical revivalists all cleaved to the Word in their search to experience God and receive salvation. Based on his description in the *Schul-Ordnung*, it seems that Dock oversaw several classes of students within a schoolroom, the walls of which were adorned with examples of the teacher's calligraphy. Each class engaged in a different stage of learning. A class of beginner students was occupied with learning the alphabet, an intermediate class worked its way through the spelling book, and an advanced class engaged in reading the Bible, mostly the New Testament.[36] In the morning the boys and girls "sing a psalm or a morning hymn"—the very kinds of verses Dock wrote on penmanship samples—"and I sing and pray with them." After they rehearsed the Lord's Prayer, the day proceeded with study of the alphabet, teacher-led quizzes on letters and

Fig. 21 Classroom verse and scene, Fraktur, Lancaster County, Pennsylvania, circa 1800. Watercolor and ink on paper, 6⅜ × 3⅞ in. 2013.0031.092 A. Courtesy of the Winterthur Museum, Winterthur, Delaware. Museum purchase with funds provided by the Henry Francis du Pont Collectors Circle.

spelling, and, among more advanced students in the Bible class, rumination on the New Testament message. Students who could do so were "allowed to write" passages for Dock using the words and scripts they had learned. Dock also instructed students at his two different schools in Skippack and Salford, Pennsylvania, to compose letters to one another, thus honing their writing skills. After reading from the New Testament and "consider[ing] the teaching therein," students moved on to other scripture passages. "As it is the case that this thought is also expressed in other passages of Holy Writ, these are found and read, and then a hymn is given containing the same teaching"—just as penmanship samples often featured scripture clarified with excerpts from hymn texts. "If time remains, all are given a short passage of Scripture to learn." Writing and spelling often concluded the day. Students who did well in their studies might receive a handmade drawing of a flower or bird.[37] Pupils also received lengthier penmanship samples from their teacher as their literacy skills progressed, which seemingly functioned simultaneously as awards for achievement, tokens of remembrance, and practical learning tools.[38]

Some scribes offered useful summations of the ceremonial significance of their works. One of the most clearly articulated statements about the intended use of the penmanship sample appears on a manuscript created for student Maria Reist on February 27, 1811 (fig. 22). On the document the schoolteacher wrote:

> Take this penmanship sample, I give it to you with love, because you have learned so well, and with a good motivation. Continue to practice more, and learn the art of writing, so that it cannot be said that your writing is too bad. Yes, remember one more thing, and think of it often, that I, Matthaus Fuchs, now an old man, have written this writing exercise for you with a trembling hand, and I am still living in Ruscombmanor Township. This writing exercise belongs to Maria Reist in Oley Township. It was written for her in the year of our Lord 1811, on the 27th of February.[39]

The presentation of penmanship-based tokens of achievement was not unique to Pennsylvania Germans, including the sectarian Mennonites and Schwenkfelders. The New England writing master Joseph W. Pierce gave Marcella L. Brown a copy of an autograph album titled *The Scriptural Album with Floral Illustrations* upon her completion of his writing school in Ballard Vale, Massachusetts, in 1852. The ornately bound, brightly colored volume paired religious references with sentimental imagery and a series of ornate

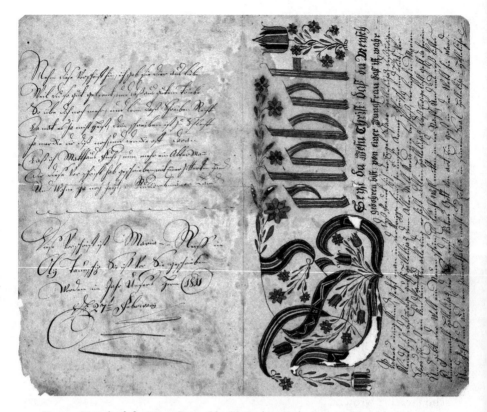

Fig. 22 Vorschrift for Maria Reist, Oley Township, Berks County, Pennsylvania, February 27, 1811. The description of the sample's purpose appears on the left-hand, undecorated side of the document. Approximately 16⅝ × 13⅝ in. Pennsylvania German Collection of Fraktur Manuscripts and Imprints, Rare Book Department, FLP 67. Courtesy of the Free Library of Philadelphia.

inscriptions by the teacher himself, as well as autographs from Brown's acquaintances. The teacher's drawing includes an illustration of a bird, in this case holding what presumably is one of its own feathers, perhaps a reference to the calligrapher's traditional reliance on a quill for his or her work. The book certainly possessed spiritual overtones in that many of its pages featured biblical scenes and scripture citations.[40]

The early Pennsylvania German documents differed quite significantly from Marcella Brown's sentimental, Anglo-American Victorian-era artifact in that they relied for much of their visual power on ornate neo-Gothic letter forms and offered far greater amounts of spiritual text than Brown's book. Whereas inscriptions in the *Scriptural Album* often presented pious, loving

messages in elegant text, Pennsylvania German pieces made during the preceding one hundred years offered dense amounts of scriptural and devotional texts in intricate, ornate Frakturschrift. In this the German documents encapsulated the lessons in spiritual text engagement, scriptural interpretation, and veneration of the Word that characterized the pious classroom learning environment.

A penmanship sample made by schoolteacher Johann Adam Eyer in 1782 embodies the devotional and pedagogical spirit of this manuscript genre and showcases the visual ornament that some scribes brought to the manuscript art. Produced for student Jacob Seitler, whom Eyer calls a "schreiber an der Tieffronn" (writer on the Deep Run, a tributary of Bucks County's Tohickon Creek), the colorful document is divided into different visual sections that house different texts.[41] The most prominent text on the document, written in large and colorful Frakturschrift that is also adorned with pictorial illuminations, is a Bible verse: Philippians 1:23, "I desire to depart and be with Christ." The two text boxes below this verse feature hymn texts urging readers to prepare for death, suggesting that Eyer consciously assembled this document as a scripture-commentary piece. The lengthiest text selection on the document is a hymn by Michael Francke written in Cantzieischrift and Currentschrift that reads, "No hour goes by but that it is in my mind, wherever I am, that death will put me in my last misery."[42] In the lower left-hand corner of the piece is hymn text in alternating black and red Frakturschrift, asking the reader to think frequently of death and live in pious accordance with God's precepts.[43] Why combine such a dark message with colorful floral imagery? The short-lived nature of beautiful blooms may have reinforced the text's message of the fast passage of life. In the words of Psalm 103:15, "As for man, his days are as grass: as a flower of the field, so he flourisheth."[44] Perhaps the site of lovely, though short-lived, blooms alongside warnings of death evoked similar messages in Pennsylvania German viewers.

Fulfilling its purpose as a penmanship instructional tool, the document also features alphabets and a number line at the bottom of the piece, thus combining a stark lesson in the importance of contemplating death with its functional quality as a literacy instrument, all within the context of a colorfully illuminated calligraphic masterwork (fig. 23).[45] The first two lines of figure 23 are Frakturschrift. *Cantzleischrift*, represented in the third line of figure 23, is a *bastarda* hand that mixes elements of Currentschrift and Frakturschrift. Currentschrift, the German cursive script, had roots in medieval secretary hands. The long series of text under the Frakturschrift and Cantzlei in figure 23 (eleven lines) are written in Currentschrift. Christopher Dock and Johann Adam Eyer rank as two of the best-remembered

Fig. 23 Johann Adam Eyer, Vorschrift for Jacob Seitler, "Schreiber an der Tieffronn" (Writer on the Deep Run [a tributary of Bucks County's Tohickon Creek, Pennsylvania]), 1782. 8³⁄₁₆ × 13⅜ in. Collection of Pastor Frederick Weiser. 2013.0031.078. Courtesy of the Winterthur Museum, Winterthur, Delaware. Museum purchase with funds provided by the Henry Francis du Pont Collectors Circle.

Pennsylvania German schoolteachers, but there were many others. A selection of schoolteacher-scribes is presented in table 2, derived substantially from the pioneering work of scholar and author Mary Jane Lederach Hershey.

Through classroom instruction and engagement with pedagogical manuscripts such as the one described earlier, students of schoolteachers like Dock and Eyer practiced instruction grounded in the Protestant imperative for personal engagement with scripture. Dock may not have taught a catechism in his schoolroom (in light of the diversity of denominations and sects represented in his classes), but his lessons and manuscripts were "catechetical" in nature in that they required pupils to be able to apply biblical passages to various religious questions and themes. "This locating of biblical evidence to support doctrine was another feature of Protestant education that crossed denominational and linguistic boundaries," notes E. Jennifer Monaghan.[46] But the manuscript component of Dock's education possessed pre-Reformation roots, connecting Dock and his colonial classroom to a long heritage of Christian text interpretation. "Pre-modern scholars thought of remembering as a process of mentally visualizing signs both for sense objects

TABLE 2 Selected influential schoolteacher-scribes from Mennonite schools, 1747–1836

Name	Lifespan	Biography
Herman Ache	ca. 1724–1815	A Lutheran, immigrated to America in 1752 and lived and taught in the Mennonite community of Salford.
Heinrich Brachtheiser	1762–1788	Hessian mercenary during the revolution, settled in Pennsylvania, taught at Salford.
Huppert Cassel	1751–1774	Studied under Christopher Dock at the Skippack school, taught Abraham Heebner.
Christopher Dock	ca. 1698–1771	Immigrated to America in 1714, becoming a schoolteacher in Skippack. Widely hailed as the progenitor of the schoolroom manuscript illumination tradition.
Johann Adam Eyer[a]	1755–1837	Born in Bucks County, taught in Lutheran and Mennonite schools. Made many penmanship samples and music books.
Jacob Gottschall[b]	1769–1845	Bishop in the Mennonite church, student of Johann Adam Eyer, taught at Mennonite meetinghouses in Skippack and Franconia.
Jacob Hümmel	?–1822	Member of the Mennonite congregation at Salford.
Andreas Kolb	1749–1811	Lived in Skippack as a youth and may have studied under Christopher Dock.
Christian Strenge[c]	1757–1828	Member of the Reformed Church in the Hessian village of Altenhasungen, fought for the British in the revolution before deserting. Settled in Lancaster County, pursuing a career as a schoolteacher and scribe among the Mennonites.

Source: Derived mostly from Hershey, *This Teaching I Present: Fraktur from the Skippack and Salford Mennonite Meetinghouse Schools, 1747–1836*, Studies in Anabaptist and Mennonite History 41 (Intercourse, PA: Good Books, 2003). For more detailed information, see her "Schoolmaster Biographical List," 168–74, in that volume.

[a] See Wertkin, *Encyclopedia of American Folk Art*, 186.
[b] Hess, *Mennonite Arts*, 113.
[c] Weiser, "Johann Christian Strenge."

98 THE WORD IN THE WILDERNESS

and objects of thought," observes Mary Carruthers, scholar of the Middle Ages. The same held true in German Pennsylvania. "The shapes of letter forms are memorial cues" to access wisdom schoolteachers sought to impart, Carruthers explains.[47] Dock and those who followed in his footsteps took joy in cultivating a student spiritual literacy that responded verbally and visually to artful letter forms. Dock penned this verse in 1765: "Then quickly come, all children dear, / In Jesus' school enrolling, / Here sit and learn; his judgment fear, / His truth revere, / His wisdom great extolling."[48] The rural classroom thus connected to a much wider spiritual realm. One Moravian missionary wrote a poem dedicated to schoolchildren that calls handwriting an activity inspired by the Holy Spirit. Just as Jesus wrote letters on the ground with his blood, so too should the schoolchildren apply ink to paper, the poet asserted.[49] Exquisite penmanship samples offered their users a taste of universal Christian wisdom through the diversity of text excerpts they presented, as well as the ornamental rendering that lent them an air of cosmic majesty.

"Art and understanding are precious gifts," wrote Swiss calligrapher Jacob Hutzli on a seventeenth-century penmanship sample. "Strive also to have them / especially in the time of youth / when everything is easy to learn." The scribe included on the document a rabbit nibbling away at the ornate letter *K* that opens the piece. Perhaps the scribe's choice was a reflection of the fact that one of the German words for "rabbit" is *Konninchen*, though he may have been motivated by more than mere whimsy.[50] The concept of eating text has scriptural precedent. "Thy words were found, and I did eat them; and thy word was unto me the joy and rejoicing of mine heart: for I am called by thy name, O Lord God of hosts," reads Jeremiah 15:16. Similar statements appear in Ezekiel and Revelation.[51] The metaphor of eating texts offers a visceral image of the intake of God's Word. Clearly, the reception of God's message formed the central aspect of Pennsylvania German literacy education. Just as the rabbit on Hutzli's manuscript eats the letter *K*, children's eyes can feast on God's wisdom when it is presented in neo-Gothic calligraphy.[52] Literacy resonated as a practical as well as spiritual skill, and calligraphed documents could function as material artifacts of faith experience.

Picturing Wisdom: A Content Analysis of Penmanship-Sample Visual Design

The organizing principle of all Pennsylvania German manuscript penmanship samples was to combine visually pleasing letter forms with morally uplifting texts. Artists in Europe and early America often quite explicitly detailed the penmanship-sample art form's spiritual significance as it appeared

in both its engraved-and-printed and manuscript forms. A 1710 metal-engraved penmanship sample produced by Georg Heinrich Paritius in Regensburg, Germany, for example, features God himself on it, floating in the clouds above a verse drawn from the apocryphal wisdom book of Sirach, a text well known and well loved by Pennsylvania Germans. "Princes, leaders, and judges are great, but not as great as he who fears the Lord," reads the text in grandiose Frakturschrift. Appropriately enough, the engraver included images of a crown, two coronets, and two scepters lying at God's feet.[53] While few manuscript penmanship samples in early America made their religious messages quite this obvious, almost all operate on an assumed relationship between piety, spirituality, reading, and writing. The samples served as hand-writing models, which students could use as exemplars as they practiced writing in various scripts. Given that students would have to write *something* as they tried to reproduce letter forms and words, it only made sense that they should copy pious maxims that would enhance their moral character. The Reading, Pennsylvania–based schoolmaster, engraver, and printer Carl Friedrich Egelmann made this point in his dual-language, English-German printed book of penmanship samples, writing in English: "From Art and Study true Content must flow / For tis a God-like Attribute to know / He most improves who studies with Delight / And learns sound Morals while he learns to write." Titled "An Admonishment to the Youth," the sample on which this verse appears also features pictures of scribes at work and a dia-gram of how to hold one's hands while writing.[54] Students at the Moravian girl's seminary in Bethlehem, Pennsylvania, likewise copied pious verses from metal-engraved penmanship samples printed on paper and pasted onto boards. A verse on one such document dating to circa 1820 offers advice as use-ful today as it was nearly two hundred years ago: "Be sparing with three things: your time, your money, and your pleasures."[55] Printed and manuscript pen-manship models composed of pious messages and religious texts "designed for imitation" pervaded handwriting and calligraphy education in the early mod-ern period across national, cultural, and linguistic boundaries.[56]

The penmanship-sample aesthetic by Mennonites and Schwenkfelders in America seems to have been common in seventeenth- and eighteenth-century Switzerland, was likely transferred to Pennsylvania with the Swiss-Palatine Mennonite settlement between 1683 and 1775, and thereafter imbued the literacy-acquisition process with a sense of ceremony, spiritual ritual, and text veneration.[57] Schoolteachers who worked in Mennonite and Schwenk-felder schools produced manuscript penmanship samples to present to stu-dents engaged in the spiritual literacy–acquisition process. The complex arrangements of spiritual texts, supporting illuminations, alphabets, and number lines they created offer detailed insight into the spiritual world in

which Pennsylvania German schooling immersed students. Not only do the manuscripts preserve texts of significance to the community but their artful layout and careful composition reveal the instructional logic behind scribes' efforts and how teachers conditioned students' minds to receive and dwell on religious messages.[58]

The making of manuscripts including penmanship samples was a lengthy and involved process. The skills to craft devotional manuscripts using Frakturschrift calligraphy and other neo-Gothic scripts were demanding and attained only with careful study and much practice. The task required precision, focus, technical proficiency, and no small dose of creativity on the part of the scribe, who drew on centuries of European manuscript techniques but made good use of modern supplies commercially available through an Atlantic-world market. Making use of a variety of visual inspirations and literary sources, the scribe carefully planned manuscript layout and content; scored a sheet of high-quality imported writing paper; drafted ornate letter designs; documented layout and other features with graphite; cut a feather quill; mixed commercially available color pigments; and, finally, applied iron-gall ink and colorants to the page.[59] Given that they produced so many documents for their pupils, schoolteacher-scribes may have developed methods to maximize efficiency of manuscript production, such as employing standard design templates and text contents on documents crafted for multiple recipients.[60] Nonetheless, the physical and intellectual labor with which they imbued each document shaped the manuscripts' meanings. Both scribe and recipient would have understood the objects as products of skilled, intense, and prolonged labor.[61]

What do Pennsylvania German manuscript penmanship samples look like, in terms of design and layout? During the century in which Pennsylvania scribes produced the form, they employed five closely related designs to construct the manuscripts. Each bears some relationship to the intent of the manuscript and the nature of the text included on the document. The simplest designs feature only one script type (often Currentschrift, the German cursive script) and no internal division with decorative borders. In other words, the penmanship sample lacks much artful ornamentation at all and generally resembles any other neatly composed handwritten document. A second type of penmanship sample features the same free-text layout but employs multiple scripts, most often modeling the hierarchy of neo-Gothic scripts, presenting Frakturschrift first, followed by Cantzlei and then Currentschrift. Third, a small number of Pennsylvania German penmanship samples employ a circular design, in which the scribe presents text in the center of the page and adds ornamentation around it in a circular pattern. Fourth, many penmanship samples are bifurcated, with decorative borders used to separate texts

from one another. These borders often divided different scripts and could support a scripture-commentary approach to composition, in which the scribe writes a key text at the top of the page in Frakturschrift, followed by other supporting texts in Cantzlei, Currentschrift, or smaller-sized Frakturschrift on the lower half of the document. The fifth major layout type arranges text excerpts (often taken from different sources) in discrete blocks around the page by means of decorative borders and other design elements. These five types of layouts structured penmanship-sample aesthetics, gave shape to the text contents with which scribes populated the documents, and lent contour to the documents' meanings as literary-spiritual works.

A systematic study of fifty examples of manuscript penmanship samples reveals that, within these general templates for design and layout, the documents' visual style changed dramatically over time. Between circa 1755 and 1855, Pennsylvania penmanship-sample design evolved from baroque-influenced, neo-Gothic calligraphic design, as discussed in chapter 2, with its focus on "abstract," "dynamic" Frakturschrift letter forms, to manuscripts that embody what many view as a rustic "Pennsylvania Dutch" style consisting of brightly colored flowers, birds, and other pictorial images seemingly divorced from the texts' religious contents. Early Pennsylvania manuscript penmanship samples resembled high-baroque printed European penmanship models that had helped set calligraphy standards for centuries. These scribes focused their artistic efforts on intricate, baroque Frakturschrift letter forms that spelled out religious messages. Later pieces almost completely departed from those models' aesthetic traditions, devoting more attention to decoration and pictorial imagery. Pennsylvania scribes moved the penmanship-sample art form in new directions, perhaps out of necessity, as printed writing manuals were scarce in early America, or perhaps just because tastes changed.

This visual design evolution of Pennsylvania German penmanship samples occurred in four distinct periods: the domination of the baroque form from roughly 1750 to 1779, with its decisive focus on complex letter forms and precisely rendered calligraphic texts in keeping with European antecedents; a modified baroque from circa 1780 to 1799, which began to explore other forms of decoration, most notably pictorial imagery and vibrant colors; a Pennsylvania Dutch style from about 1800 to 1829, with an increased focus on pictorial imagery rather than classically designed neo-Gothic letter forms, which, while present on the manuscripts, lacked the skillful sophistication of earlier works of calligraphy; and, finally, an era of antiquarian production of the documents from roughly 1830 to 1849 that was, so it seems, a revivalist undertaking by individuals modeling their work on the local history of the manuscript form more than baroque European antecedents.

Almost three-fourths of manuscripts included in this statistical analysis antedated 1800, meaning that the decline in manuscript making after the turn of the nineteenth century parallels the stylistic breakdown of the old penmanship-sample form.[62]

Variations in penmanship-sample literary content across time mirrors this aesthetic shift. Early manuscripts focus squarely on scripture verses, especially the Psalms and Old Testament wisdom literature, while later manuscripts embrace more general "life advice" and worship themes using contemporary German texts. It only makes sense that visual design would reflect shifting literary and devotional aims. Pictorial imagery seems to have become more important on the documents as time passed, but such images could and often did possess iconographic and pedagogical qualities. An unsigned penmanship sample that was likely made by schoolteacher Heinrich Brachtheiser in the 1780s, for example, features a familiar trope of a bird feeding its young with its own blood, symbolic of Christ's sacrifice for his people on earth (fig. 24).[63] As John Joseph Stoudt notes, this allegorical imagery

Fig. 24 Heinrich Brachtheiser, attr., detail of Vorschrift, circa 1785. Samuel W. Pennypacker Fraktur Collection, 00.262.13. Courtesy of the Schwenkfelder Library and Heritage Center, Pennsburg, Pennsylvania. Photo: author.

TABLE 3 Selected penmanship-sample pictorial imagery

Image type	Number of penmanship samples	Percentage of total sample
Floral vines	26	52
Flowers (including tulips)	23	46
No pictorial imagery on manuscript	20	40
Birds (nonpelican)	8	16
Hearts	7	14
Angel	1	2
"Pelican in Her Piety"	1	2
Stars	1	2

Note: This table is based on a sample of fifty documents. More data about penmanship samples are available on this book's companion website, www.wordinwilderness.com.

depicting self-sacrifice for others, which is a well-known Christian motif and is quite common in Pennsylvania German art, has its roots in Psalm 102:6: "I am like a pelican of the wilderness." Explains Stoudt, "In ancient Christian art the pelican in her piety is one of the most widely used and striking symbols of the atonement."[64] Not all images on penmanship samples were this explicit in their religious connotations, but, clearly, scribes used both pictures and words to deliver their pious messages. What may today even seem like simple naturalistic decoration on the manuscripts might have exuded poignant spiritual resonances to viewers. "Baroque naturalism, though a powerful force, was qualified by a fundamentally metaphysical view of the world," art historian John Rupert Martin reminds us. "Side by side with the growing scientific mode of thought, the old emblematic and allegorical cast of mind still persisted."[65] On the Pennsylvania manuscripts, naturalistic themes connected devotional messages to well-worn aesthetic norms. Table 3 presents a summary of common penmanship-sample pictorial imagery.

Words of Wisdom: A Content Analysis of Penmanship-Sample Literary Contents

Study of penmanship-sample texts has lagged behind exploration of their visual qualities in the Pennsylvania German scholarship. Language barriers, difficulty decoding neo-Gothic scripts, the obscurity of many of the nonscriptural texts quoted on the manuscripts, and the lack of an interpretive framework for the texts' religious messages likely account for this difference.

But interrogating the manuscripts' literary contents, word by word, is vital to understanding their spiritual meaning, as well as scribes' and readers' creative agency. A useful case in point is a penmanship sample made in 1788 for Marthin Däthweihler. Its scribe not only laid out numerous texts on one manuscript in a carefully planned visual design but also may have modified one of the texts to better suit its young reader. The penmanship sample features the hymn "Lord, What Do You Have in Mind?," by German hymnist Paul Gerhardt, who penned the song upon seeing a comet in 1664. "Father, what do you have in mind? After what new trouble should we ask Heaven? ... What should the new star mean to us poor people? ... Burning comets are sad prophets."[66] The text on the sample adheres to Gerhardt's original, except for one word. Whereas Gerhardt hailed the comet as a sign to awaken the "entire world," to God, the Pennsylvania scribe hails it as a sign to awaken "America" to the Lord.[67] The scribe (or some earlier German American) must have reconfigured Gerhardt's sentiments for American settlers who watched the skies for astronomical "prophets," much as Gerhardt had.[68] "Christians are involved in theologizing at every turn," wrote Gordon Kaufman.[69] Penmanship-sample scribes certainly were, as they constructed artistic compositions out of a shared set of devotional texts and imagery.

Aggregate study of penmanship-sample text content (using the same sample of manuscripts studied in the preceding section) uncovers patterns that parallel those that shaped the documents' visual design and can help us place interesting individual examples like the Däthweihler piece in meaningful interpretive context. The general themes of penmanship-sample text content remained constant through the century of penmanship-sample production—devotion to God, good behavior, and so on. But over time the manuscripts moved away from an explicitly articulated grounding in the texts and ideas of the Old Testament wisdom tradition to a looser focus on faith, devotion, and spiritual experience.

Some basic characteristics unite penmanship-sample text content across design periods. Almost all penmanship samples feature scriptural and contemporary devotional literature that praised God and offered directives on living piously.[70] The sparseness of New Testament quotations on the Pennsylvania pieces contrasts with some European penmanship samples. One bound set of European manuscript penmanship samples from the period, for example, included texts from Colossians, Ephesians, James, and Isaiah, none of which appear in the Pennsylvania sample.[71] A full 82 percent of manuscripts that figured in this study feature popular devotional literature: hymns found in printed hymnals of the day, spiritual poetry, and the like. Most penmanship samples include model alphabet lines, and occasionally

"WORSHIP ALWAYS THE SCRIPTURE" 105

number lines, at the bottom of the document, to teach students to read and write the letter forms they encounter in the texts. The vast majority feature texts that admonish readers toward pious behavior or offer examples of such a lifestyle.[72] Scribes sometimes paired admonishments toward proper behavior with prayers, speaking to the documents' prescriptive and user-centric nature.[73]

All penmanship samples that featured both text excerpts and model alphabets embraced the two related skills the manuscript was designed to teach: first, basic literacy, and second, how and why to live a pious life according to God's Word. According to penmanship-sample texts, keys to piety were meditating on God's Word, submitting to his will, contemplating death, and preparing for judgment. In keeping with the penmanship sample's focus on the perception of God's will, a vast majority of manuscripts in the sample features language addressing sensory input: seeing, hearing, and so forth, and 40 percent feature language addressing communication output: speaking, singing, and praising. Despite this preoccupation with the technicalities of communication, not all penmanship samples sought to articulate the logical premise on which the linkage of spiritual literacy to divine wisdom was based: the idea that God revealed his knowledge to those who tuned their senses toward his will as revealed in the Word, shut out the corrupting influences of the world, and followed his pious dictates in everyday life. Manuscripts that elucidated this point keyed into the early modern Protestant focus on revelation through God's Word, using scriptural and other devotional texts to fuse literacy, faith, and everyday piety.

This notion of acquiring wisdom through scripture-based, meditative spiritual practice seems like a convoluted concept to explain to children, which is perhaps why many penmanship samples do not explicitly address it. But scribes took pains to present the idea in ways relatable to young penmanship-sample readers. A manuscript attributed to Christopher Dock advises that, just as the ant, swallow, and turtledove collect food during the summer months to sustain themselves through the winter, so too must children nourish their spirits during their youth to prepare for eternal life: "Lord Jesus, stir our hearts and senses and grant us wisdom that we here in this time of grace, stay always best prepared and have our foodstuffs ready here, for they will nourish us in eternity."[74] Not coincidentally, scribes who embraced this learning model often placed aesthetic emphasis on creating ornate, abstract, dynamic Frakturschrift letters to help deliver their messages.

To further instructional ends like those taught by this parable of the ant, swallow, and turtledove, many penmanship samples quote ancient holy texts that explicate the linkages between literacy, piety, and wisdom. Most

important were the Psalms and Old Testament scriptural and apocryphal wisdom books. The appearance of psalms on the manuscripts comes as no surprise, as they were (and are) staple devotional pieces. The 150 psalms found in the Bible had diverse origins in the early years of Judaism and were collected as Israel's hymnbook. They apply abstract religious teachings to everyday life, offering practical messages of hope and faith. The psalms often take the form of prayer. They encouraged "conversation" with the Lord, presenting dialogue in the first- and second-person narrative voices—a trait they shared with almost all penmanship samples.[75]

Perhaps more surprising is that Old Testament wisdom literature enjoyed particular resonance among penmanship-sample makers. The search for divinely authored wisdom was a fundamental occupation of the early modern era, and Old Testament wisdom books were favorite sources. The definition of Old Testament wisdom—a way of perceiving the world, conducting one's self, and knowing God—possesses an active dimension centered on daily experience. The literature gives meaning to the patterns of life by situating them within the context of the divine order.[76] Many of the wisdom books were apocryphal—that is, not formally considered to be books of the Holy Bible—though this was of little concern to Anabaptist manuscript makers of the time.[77] Wisdom literature and the ancient sages who wrote it served as intermediaries between the worldly and divine.[78] Some penmanship samples even feature quotations from "Lady Wisdom" herself—meaning "Sophia," God's female alter ego.[79] Directed toward pious living, the lessons of the wisdom books fit perfectly with families' and educators' desires for their children's lifestyles.

Of the five books widely accepted as part of the wisdom tradition (Proverbs, Song of Songs, Ecclesiastes, Wisdom of Sirach, and Wisdom of Solomon), all but Song of Songs appeared in the sample of manuscripts studied here.[80] One elegant document to make use of the wisdom books was crafted for Abraham Maÿer of Bethel Township in Dauphin (now Lebanon) County, Pennsylvania, on March 13, 1807. The document begins with a verse from Ecclesiastes ("Keep thy foot when thou goest to the house of God, and be more ready to hear, than to give the sacrifice of fools") before offering quotations from Sirach and, of course, alphabet and number lines.[81] Use of the wisdom books was not confined to manuscript literacy-instructional material, nor to use by sectarians. Recall that the Lutheran and Reformed spelling books referenced earlier each featured a text titled "On the Fear of God from Where True Wisdom Is Attained" featuring content from Sirach, including such lines as, "The fear of the Lord is the root of wisdom, the branches of which are eternally green."[82] In an era when Anglo-American writing

manuals might emphasize the virtues of republican government or the admirable qualities of an American citizen, the German samples' wholehearted embrace of Old Testament wisdom literature appears even more notable.[83]

Perhaps more than the other wisdom books, the content of Sirach, or "Wisdom of Ben Sira," encapsulates the curricular imperative and educational style of calligraphed penmanship samples.[84] The book was penned by the scribe Ben Sira, who was also a noted wisdom teacher, circa 195 BCE, to help Jewish youth maintain connections to their spiritual heritage.[85] In Jewish culture a scribe was just the person to offer such lessons. "The scribe's profession increases wisdom," Sira wrote.[86] The book praises the task of the "priestly scribe" and wisdom teacher.[87] He who seeks God's wisdom and "meditates on his mysteries" will be praised by his fellows, Sira wrote, and his understanding would never be "blotted out"—a metaphorical reference to the process of writing as a step toward wisdom acquisition.[88] That same metaphor found frequent expression on penmanship samples, such as one that asks God to "inscribe" his will on the writer's heart.[89] Almost all penmanship samples make use of the wisdom books' linkages between pious living and scriptural revelation. The Jewish scribe and wisdom teacher applied God's teachings to everyday life, a task not so different from that of Pennsylvania's German schoolteacher-scribes.[90]

Emphasis on the nature of wisdom acquisition declined over the century of Pennsylvania penmanship-sample production.[91] This movement away from the theme may have influenced other aspects of manuscript composition. As instruction in the nature of wisdom, teaching, and learning lessened in importance, so too did the prevalence of scriptural quotations, which were most common during the baroque in the mid-1700s, diminishing thereafter.[92] Use of scriptural texts directly related to the nature of wisdom, teaching, and learning—namely, the psalms and wisdom books—was closely associated with eighteenth-century, rather than nineteenth-century, penmanship-sample production.[93] Moreover, first-person narration was most common in the baroque but dropped precipitously thereafter, highlighting a decline in the samples' prescriptive, dialogical nature.[94] Over time the manuscripts' incisive focus on wisdom teaching and letter veneration seem to have weakened as their visual design evolved.

These changes to manuscript design and text content do not suggest that scribes became less religious or their manuscripts less skillfully made. Many late pieces exude great religious sentiment and feature abundant, beautiful decoration. Earlier pieces simply articulated a way to wisdom and grace that seems to have undergirded the penmanship sample from its earliest germination in Europe, where ornamentation in the form of intricate letter forms was

closely linked to the process of wisdom instruction carried out by the documents' texts. Many later pieces did not actively address the topic. The absence of such information from later examples may point to reasons for the disappearance of the form in Pennsylvania around 1850. The value of the early modern penmanship sample rested in its ability to combine the functional—that is, penmanship instruction—with higher-order wisdom acquisition brought about by sensory stimulation, religious piety, and divine revelation. No such need for the devotional penmanship sample existed if scribes and readers did not perceive spiritual text, scribal process, and ornate Frakturschrift letters as a unified tool to unlock divine wisdom. By the mid-nineteenth century, cultural tradition and historical interest may have been all that remained of the once-potent penmanship sample.

Exploration of the penmanship-sample form and the educative process in which it figured poses modifications to the traditional narrative about literacy education in early America. During most of the colonial period, wrote E. Jennifer Monaghan in her landmark book *Learning to Read and Write in Colonial America*, "reading was conceptualized as a receptive tool—the vehicle for listening to the pronouncements, whether religious or secular, of one's elders and betters." Student writing, in Monaghan's estimation, offered little more opportunity for creativity. "Writing meant penmanship, a definition that excluded what we consider the primary purpose of writing—self-expression," she asserted.[95] Perhaps Monaghan's assessment was true for some Americans, but not necessarily for Pennsylvania's German speakers, who made and received ornate manuscripts as part of their literacy education experience. While to modern eyes an education grounded in religious texts, moral advice, and fine calligraphy and penmanship may seem rigid and uncreative, it was appropriate to a culture that viewed scripture and faith as the source of *all* wisdom, both earthly and divine. Why focus on anything else, much less try to create new, undoubtedly inferior wisdom?

"Reading is not a direct 'internalization' [of meaning], because it is not a one-way process," literary scholar Wolfgang Iser observed, drawing attention to the role of the reader in constituting a text's resonance and, in the case of Pennsylvania German manuscripts, inflaming a spiritual experience.[96] The process of devotional manuscript making constituted a spiritual act, as did reading those manuscripts, viewing their associated illuminations, and following the texts' dicta of wisdom through pious living. By making, sharing, and using devotional manuscripts, Pennsylvania German readers and scribes were agents in shaping their own spiritual lives. Scribes employed layout, illumination, nontextual decoration, letter design, and subtle literary cues to reinforce their devotional manuscripts' messages, which were tailored to the

spiritual needs of their youthful recipients.[97] Theologian Gordon Kaufman wrote that "Christian theology is the critical analysis and creative development of the language utilized in apprehending, understanding, and interpreting God's acts, facilitating their communication in word and deed."[98] It is unlikely that Pennsylvania German scribes considered themselves theologians in a formal sense. Yet when analyzing manuscripts as spiritual artifacts, scholars ought to treat scribes much as they would theologians who authored "new" texts.[99] German-speaking denominations and sects infused with the teachings of Pietism, mysticism, and other radical devotional approaches to know God viewed artistic renditions of holy texts as access points to a remarkable degree of spiritual freedom emanating from *within* the believer.

"Shrewd as Snakes and as Innocent as Doves": An Example of Manuscript Analysis

The 1787 penmanship sample made for Philip Markley, seen in figure 16, chapter 2, offers a striking case study of the perceived spiritual value Pennsylvania Germans attached to text-based devotion—one that allows us to examine many aspects of the penmanship sample's spiritual resonances at work in a single document. The scribe organized the document in a manner typical of penmanship samples of the period, offering in resplendent Frakturschrift a scripture verse from the book of John that expounds the value of love: "By this everyone will know that you are my disciples, if you love one another."[100] Other texts are arranged in blocks around the page. After the Bible verse comes hymn text composed by the great German Pietist poet Christian Fürchtegott Gellert, which expands on the scripture message: "If someone says, 'I love God,' and yet hates his brothers, he is making a mockery of God's truth, and he tears it asunder. God is love and wants that I love the neighbor as I love myself. Whoever enjoys plenty on this earth, and sees the brethren suffer, and does not make the hungry full, does not let the naked be clothed, is an enemy of the first commandment and has not the love of God."[101] This hymn passage is succeeded by alphabet and number lines. Written in black-and-red Frakturschrift in the lower right corner of the manuscript are famous words from First Corinthians 13:13: "And now these three remain: faith, hope and love. But the greatest of these is love."[102] All in all, the text presents a cohesive lesson centered on Christ's message of love, guided and enhanced by striking Frakturschrift imagery. But the historiated initial itself—the text's most visually striking feature—also admonishes the reader to prepare for the

IIO THE WORD IN THE WILDERNESS

dangers and obstacles of a life of Christian service. Words incorporated into the scribe's ornate majuscule *D* come from Matthew 10:16: "I am sending you out like sheep among wolves. Therefore be as shrewd as snakes and as innocent as doves," reads the entire verse. (The scribe included only the second sentence of the verse in the letter's design.)[103] Written toward the end of the eighteenth century, the manuscript reflects the transition then under way from baroque calligraphic orthodoxy, with its focus on intricate letter forms and abstract ornament, toward the colorful flowers and other pictorial imagery that characterized later pieces that embodied a Pennsylvania Dutch aesthetic. The manuscript's featuring of scripture quotations fits with general trends in penmanship-sample text contents, but that it draws excerpts from the New Testament is slightly unusual, at least in the American context. Like the vast majority of penmanship samples, the texts the scribe included offer the reader admonishments toward a proper lifestyle. While the theme of wisdom acquisition is not explicitly addressed on the document, the texts do embody a scripture-commentary model that utilizes script type and layout to structure the reader's pedagogical experience.

The text arrangement on the penmanship sample, as the summary suggests, is complex in its construction. In addition to word and pictorial image, the scribe employed layout, line, color, and calligraphic ornament to render the message concise and comprehensible. Floral imagery and dramatic color combinations, in addition to the Frakturschrift letters' traditional swirls and flourishes, leave little doubt as to the penmanship sample's key text, which was drawn from scripture and positioned at the top of the page. The hymn, presented in Currentschrift, lacks the scripture excerpt's visual prominence but, as far as length is concerned, constitutes the majority of the penmanship sample's message. The scribe clearly delineated boundaries between texts by means of bold and colorful lines; the hymn is separated from the scripture quotations and the alphabet and number lines by these means. The scripture quote in the bottom right-hand corner of the manuscript loses none of its prominence by means of its location, as it, too, appears in colorful Frakturschrift. The scribe's rendering of the historiated majuscule *D* anchors the entire reading experience. The dove composing the lower half of the letter perches on a calligraphic ornament made of at least five colors, which serves as the left-hand border for most of the text, except the inscription of the student-owner's name to the far left of the manuscript. Clearly, the scribe who created this document felt no qualms about carefully guiding the pupils' experience of devotional text.

This seems to sum up the significance of the manuscript. But there is even more to the document. Perhaps its most important contribution to Pennsylvania German manuscript study comes not from its visual design or literary

contents but rather its material qualities and artifactual context. Surviving along with the penmanship sample itself is a decidedly less beautiful piece of paper long associated with the artwork. The maker of Markley's manuscript inscribed the words "Vorschrifft vor Philippus Märkel Jung" (Writing sample of the boy Philippus Märkel) on the center of this otherwise blank, separate sheet. The same size as Markley's writing sample, it seems that this other sheet served as a cover to protect the writing specimen, suggesting the significance and ceremony associated with the manuscript.[104] Of course, just because students received handmade documents replete with religious messages does not mean that they opted into the documents' intermingling of text presentation and spiritual wisdom. But the documents clearly operated within a framework of spiritual literacy education and text veneration. Studying such manuscripts within a contextual framework of early modern German spirituality and popular piety illumines their role as tools in active Christian devotional life. In writing of the creation of the Hebrew Bible in ancient Israel, Karel van der Toorn notes, "Until the dawn of modernity, neither theologians nor lay people had any great interest in the individual authors who wrote down the Bible texts. The Bible was the Word of God; whichever humans had been its making were looked upon as mere channels for a heavenly voice."[105] An idea of a scribe as an instrument of divine communication seems to have pervaded early German Pennsylvania, where calligraphers lavished time and energy to present God's message in artful ways.

"Omnia conando docilis solertia vincit" (A docile disposition will conquer all difficulty), wrote the Moravian Johann Arbo in Latin in his copy of an eighteenth-century writing method.[106] Arbo's call for docility of mind informed much of early modern penmanship education, which focused heavily on re-creating preestablished texts in an effort toward perfection of letter form and elegance of page. But, as Pennsylvania German penmanship samples suggest, this pedagogical approach to reading and writing, and the intellectual world for which such training prepared students, ought not to be dismissed as oppressive and anti-intellectual. Quite the contrary, in the hands of German-speaking schoolteachers such skills became entry points into an active, involved, and self-driven spiritualistic enterprise to be undertaken by young students in the southeastern Pennsylvania hinterlands. In the context of a set of related religious traditions in which the Word reigned supreme, the ability to render text neatly and beautifully and then venerate it as a work of art equipped the Christian with a powerful tool of personal piety. Such a tool could nourish the spirit for a lifetime.

4

"INCENSE HILL"

Song, Image, and Ambient Manuscripts

In 1826 printer S. E. Merrihew published the second volume of a religious quarterly titled the *Berean* on Shipley Street in Wilmington, Delaware, a small but prosperous port city on the banks of the Delaware and Christiana Rivers six miles north of where William Penn first set foot on North American soil in New Castle and thirty-two miles south of Philadelphia. A miscellany, the *Berean* featured an assortment of texts of a spiritual and religious character, drawn from various sources. Local lore ascribes authorship of one verse included in the publication to a local figure of renown: Francis Hopkinson, who was among the signers of the Declaration of Independence and once served as customs collector in the trading center of New Castle.[1] The poem thought to be Hopkinson's begins on a cynical note, calling into question the sincerity of most Christians' supplications to the Lord. "Thousands and twice ten thousands every day / To Him a feigned or real homage pay: / Like clouds of incense rolling to the skies, / In various forms their supplications rise," the verse reads. "Their various forms to Him no access gain / Without the heart's true incense, all are vain." Troubled by the feigned homage that characterized much Christian worship, the poet took a journey to a mystical, unfamiliar place, where he found pious people who, in utter seclusion in the wilderness, came as close as possible to the true nature of God. "In sable weeds you dress the heaven born maid, / And place her pensive in the lonely shade; / Recluse unsocial, you your hours employ / And fearful banish every harmless joy."[2] Where was this bastion of piety discovered by the poet? Was it in a Roman Catholic monastery in faraway France, Italy, or Ireland or in a pious Protestant congregation in distant, German-speaking central Europe?

It was neither of those. On the contrary, the poet traveled only fifty miles northwest of Wilmington, to the Ephrata community, where Christian mystics had inhabited the "lonely shade" since 1732. "In Ephrata's deep gloom you fix your seat / And seek religion in the dark retreat," he recorded. The residents of Ephrata meditated on God in three primary ways: prayer, hymn singing, and calligraphy and manuscript illumination. Sometimes they could wield those activities as a single enterprise. Hymns were, in a sense, prayers set to music, and scribes at Ephrata (as elsewhere in German Pennsylvania) lavished time and calligraphic skill to create visually appealing musical manuscripts that blurred the line between aural and visual sensory experiences.[3] The poet so fond of Ephrata states admiringly, "Tis true devotion—and the Lord of love, / Such prayers and praises kindly will approve, / Whether from golden altars they arise, / And wrapt in sound and incense reach the skies; / Or from your Ephrata so meek and low, / In soft and silent aspirations flow."[4] Ephrata may have seemed soft and silent to Hopkinson or whomever wrote this flattering poem, but the community's large surviving oeuvre of printed and manuscript hymn tunes and texts suggest that evangelical piety assumed sung form in this famous mystical community. Reading calligraphed texts in the Ephrata hymnals, such as that in figure 25, which urge users to raise horns and voices to God, it seems that even the most pensive of Pennsylvania Germans viewed spiritual devotion as, at least in part, an aural enterprise.[5] Throughout the history of Christianity, song and intense spiritual life have gone hand in hand.[6]

The *Berean* poet's lush imagery captures a sentiment around prayer, hymn singing, and manuscript culture that characterizes devotional life at the Ephrata community and, for that matter, among other pious Pennsylvania Germans during the age of evangelical piety. Whether worshipping alone or in community, contemplative praises, offered humbly and meekly, wended their way to God's attention. Indeed, the metaphor of incense employed by the poet was long associated with Ephrata. Christoph Sauer published a collection of hymns used at the community titled *Zionitischer Weyrauchs Hügel oder: Myrrhen Berg* (Zionistic Incense Hill or Myrrh Mountain) in 1739 (fig. 26). Hymnody was a prime way to praise and supplicate God, one, as we have seen, that provided literary material for many Pennsylvania German manuscripts, including penmanship samples. But as a sung, aural art form, music itself was invisible. And, unlike incense, which hung in the air for a short time, visible to the eye at least for a moment before disappearing forever into the sky, music never even took material form. Given the penchant for visual splendor Pennsylvania Germans brought to the Word of God and other devotional literature in crafting their spiritual texts, it is unsurprising that hymnals and tune

Fig. 25 Ephrata community hymnal, *Paradisisches Wunderspiel* (Paradisiacal wonder music), 1754, recto of leaf 6. 9¾ × 7½ in. Col. 318, 57.68.4 65x60. Courtesy, the Winterthur Library: Joseph Downs Collection of Manuscripts and Printed Ephemera, Delaware.

books became prime sites for calligraphy and manuscript illumination, as they sought to render the invisible visible. Just as German speakers sought to capture the glory of God's message of faith and grace through artful, calligraphic renderings of holy words, embellishment of musical manuscripts helped turn hymnody—or at least the print and manuscript artifacts that

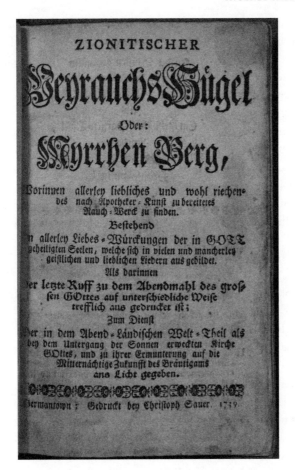

Fig. 26 Zionitscher Weyrauchs Hügel, 1719. 6 × 3⅝ in. A 739z. Courtesy of The Rosenbach, Philadelphia. Photo: author.

preserved and transmitted spiritual songs—into objects of spiritual significance, tools of personal piety, and tokens of membership in a Protestant community.

The focus of the following analysis of manuscripts associated with the world of hymn singing is neither musicological nor literary; that is, neither the musical tunes themselves nor an interpretation of hymn lyrics are of main concern here. Rather, it focuses on the calligraphic, illuminative, and material tools at the disposal of musical manuscript creators and users to transform musical texts into works of visual splendor and artifactual significance. This act exercised important influence in shaping the nature of German Protestant community in southeastern Pennsylvania. Musical notation was,

in a sense, just another kind of text with which Pennsylvania Germans engaged on their spiritual journeys—another symbolic vessel of meaning in which the message behind the Word found expression, in this case through hymn lyrics set to melodious tunes. A content analysis of a well-known type of Pennsylvania German musical manuscript, the *Notenbüchlein*, or hymn tune book, explores the significance of illuminated manuscripts in the Pennsylvania German spiritual experience. The relevance of the manuscripts discussed later to the study of neo-Gothic calligraphy and manuscript culture derives primarily from their "packaging"—that is, their bindings, decoration, and so forth. Just as the residents of Ephrata embraced incense as a metaphor to visualize music's ambient devotional quality, so too did calligraphy and manuscript illumination make hymnody a spiritual feast for the eyes as well as the ears.

"Singer, Book, and Temple": Hymnody in the Protestant Tradition

"Hymns are both a fascinating and an irreplaceable type of primary source document for both intellectual and social religious history," wrote theologian John D. Witvliet.[7] Part poetry, part music, part theology, hymns sit at the nexus of diverse artistic genres and modalities, offering multisensory insight into personal spiritual experience. But, for this very reason, hymns have long occupied an uncertain position in scholarly circles, owing in large part to the diversity of people who take an interest in their study.[8] Scholars have recently come to recognize that hymns present a useful body of source material to investigate lived religion, especially among evangelical Protestants in Europe and America, for whom hymn writing and hymn singing were central vehicles of faith expression.[9]

The material culture of Christian singing presents a rich area for research into Pennsylvania German life. First, however, we must consider matters of definition. A hymn is a "lyric poem expressing religious devotion." A "congregational hymn" is the most familiar type (and that which primarily concerns us here): one intended to be sung by a group in the context of a worship service as a devotional exercise.[10] Hymns have long played a central role in Christian worship tradition, especially in medieval Roman Catholic monasteries, where sung liturgies figured prominently in daily life. But just as Martin Luther reconfigured the nature of Christian scriptural interpretation, theories of grace, and demonstrations of piety, so too did he change the focus of Christian hymn culture. This shift, in fact, paralleled Luther's other

redesigns of worship, by placing the layperson at the center of the experience and thus at the center of hymn singing.

The project of the Protestant Reformation, simply stated, was a movement of personal spiritual agency away from church officials toward everyday believers, in terms of access to religious texts, kindling of faith, and experience of grace. Similarly, Luther the liturgist and hymn writer moved the art of hymnody away from chants delivered by priests and choirs to songs sung by congregants.[11] He published numerous collections of hymns during his lifetime, many of which have become standards of the Protestant musical tradition.[12] Luther was not alone in his musical enterprise; Protestant hymn writing took off all over Europe during and after the Protestant Reformation, and hymns became central vessels through which the Protestants delivered their message.[13] Hymn singing became a staple of the German Lutheran church as well as other German-language denominations and sects represented in early Pennsylvania, perhaps most notably the Moravians and Anabaptists.[14] The turbulent late sixteenth and seventeenth centuries, during which German-speaking central Europe roiled amid denominational conflict and the Thirty Years' War, also became a golden age for German hymn writing. In this period Paul Gerhardt (whose lyrics appeared on Pennsylvania German manuscripts) surpassed even Luther's reputation for sentient hymnody.[15] Pietism inspired yet another outburst of hymn composition. The mystical Gerhard Tersteegen, correspondent of Germantown printer Christoph Sauer, whose devotional texts were well known in Pennsylvania, for example, was an accomplished writer of hymns.[16]

Like so many other devotional customs during the age of evangelical piety between the seventeenth and the nineteenth centuries, the love of song was shared across language and nationality. English-speaking Protestants also embraced hymn singing in the early modern period, though to varying degrees, based on denominational or sectarian adherence. The New England Puritans published a psalter in 1640, making it the first book published in what later became the United States (and which is known informally today as the Bay Psalm Book; see figure 27).[17] They gradually overcame their Calvinistic predisposition against other, more expressive, forms of hymnody to embrace contemporary compositions, not just the psalms.[18] The psalter remained the primary hymnbook for Calvinists until the evangelical awakening of the late seventeenth and eighteenth centuries, when evangelical hymns increased in popularity.[19] In the rich and ever-evolving spiritual world of early American Protantism, hymn popularity did not abide by strict boundaries between religious groups. Quite the contrary, many were held in common

PSALME Cxviii, Cxix.

28 Thou art my God, & I'le thee prayſe,
my God I'le ſet thee hye.
29 O prayſe the Lord, for he is good,
and aye laſts his mercy.

Pſalme 119.

א (1) Aleph

ALL-bleſt are men upright of way:
walk in Iehovahs law who do.
2 Bleſt ſuch as doe his records keepe:
with their whole heart him ſeek alſo.
3 And that work no iniquitie:
but in his wayes doe walke *indeed.*
4 Thou haſt giv'n charge, with diligence
unto thy precepts to give heed.
5 Ah that to keepe thy ſtatutes:ſo
my wayes addreſſed were by thee.
6 VVhen I reſpect thy precepts all,
then ſhall I not aſhamed bee.
7 Whē I thy righteous judgements learne
with hearts uprightnes I'le thee prayſe.
8 Forſake thou mee not utterly:
I will obſerve thy ſtatute-wayes.

ב (2) Beth

9 By what may ſ young man cleanſe his way?
by heeding it as thy word guides.
10 With my whole heart thee have I ſought:
thy lawes let mee not goe beſides.
11 I in my heart thy word have hid:
that I might not againſt thee ſin.
12 Thou o Iehovah, bleſſed art:
thine owne ſtatutes inſtruct mee in.

13 All

Fig. 27 Psalm 119 in *The Whole Booke of Psalmes Faithfully Translated into English Metre* [. . .] (Cambridge, Mass.: Day, 1640). This volume is commonly known as the Bay Psalm Book, the first book printed in what later became the United States. 7 × 4½ in. A 640w. Courtesy of The Rosenbach, Philadelphia.

across denominational, sectarian, and even linguistic and cultural boundaries. Translated Moravian hymns entered the Anglo-American canon, for example, and the great evangelist George Whitefield published a hymnal featuring the compositions of Methodist Charles Wesley, who had been deeply influenced by Moravian piety, and Nonconformist Isaac Watts, who was one of the most revered hymn writers of his day.[20] Hymn writers and readers saw value in the genre for children; Watts himself wrote that the learning of hymns provided "a constant furniture for the minds of children, that they may have something to think upon when alone, and sing over to themselves."[21]

Pennsylvania German scribes drew on hymn lyrics from a variety of traditions for literary material to use on their text-based devotional manuscripts. And, of course, manuscripts featuring musical notation became canvases for calligraphy and illumination, which is unsurprising, given the importance of hymnody to Protestant devotion. The hymn-singing tradition infused Protestantism for the long term; it was "almost sacramental" for later evangelicals.[22] Much like the other forms of spiritual literature encountered on Pennsylvania German devotional manuscripts, hymn texts (whether sung aloud, read as poetry, or calligraphed as visual artworks) offered everyday believers palatable doses of theology that culled the Christian message down to its fundamental, most resonant components. It also blurred lines between denominations and sects.[23] Hymns—as literary texts and musical compositions, as well as bibliographical and material objects—present an ideal opportunity to assess the performance of religious life outside of the pronouncements of more formal theological sources.[24] "Historians have only just begun to describe the profound connections that hymnody sustains to other spheres of existence," wrote theologian Richard J. Mouw. Among those spheres is the material world of printed books and illuminated manuscripts.[25]

Pennsylvania Germans were not alone in creating visually engaging early American musical manuscripts. The Shakers, among whom musical composition and singing were central features of spiritual life, also created elegantly written songbooks.[26] One, made sometime between 1847 and 1856 by Mary Hazard of the Shaker community in New Lebanon, New York, included lyrics of a hymn written in the pattern of a leaf, echoing the Pennsylvania German focus on rendering spiritual literature, including hymn texts, in aesthetically enticing forms. Another leaf design on the back of the page explains why Hazard created the image. "Mother Lucy [a leader of the Shaker community] said she thought it would please Molly to receive this

leaf, and be able to see its form; and, how completely the song borders the leaf," she wrote. "She says Molly likes to see pretty things; and the name of this leaf is, Emblem."[27] Hazard titled her songbook "A Collection of Extra Songs of Various Kinds: Written and Pricked for the Purpose of Retaining Them, by Mary Hazard; Beginning February 7th, 1847." These explicit revelations of Hazard's motivations illuminate the connection between the visual and the ambient in hymnody and spiritual life. But compared to Pennsylvania German musical manuscripts, Shaker songbooks generally lack color, imagery, and grandiose calligraphic design. English-language songbooks could possess much of the aesthetic charm commonly seen on Pennsylvania German manuscripts, as was the case for a tune book made by a scribe named Thomas Collins in 1771.[28]

"Text is rarely presented in an unadorned state, unreinforced and unaccompanied by a certain number of verbal or other productions, such as an author's name, a title, a preface, illustrations," wrote Gérard Genette in *Paratexts*, his classic work of literary theory. "Although we do not always know whether these productions are to be regarded as belonging to the text, in any case they surround it and extend it, precisely in order to *present* it." The devices that authors, publishers, and bookmakers use to present their literary works are called *paratexts*, or features that enable a "text to become a book and to be offered as such to its readers and, more generally, to the public."[29] They are, in a sense, bridges that text producers can use to render their works meaningful to their audiences. Pennsylvania's musical books and manuscripts were rarely presented in a completely "naked state" (i.e., unadorned hand copies of musical notation or hymn lyrics alone) but rather came equipped with adornment and personal inscription that turned the books into meaning-laden spiritual artifacts as well as functional singing tools.[30]

As a form of written language, musical notation played a special role in Pennsylvania German spiritual life, aiding pious German speakers in participating in one of Protestantism's most important devotional activities: singing. Musical books and manuscripts frequently possessed totemic qualities. They served as practical guidebooks for participation in Protestant ritual, offering pithy advice on how to use the texts while symbolizing membership in a venerable Protestant hymn tradition. A fine example is the ornate binding on printer Henrich Ludwig Brönner's edition of the *Marburg Hymnal*, published in Marburg, Germany, in 1775.[31] It was a favored hymnal among Mennonites of the time and one frequently used in the creation of their manuscript hymn tune books.[32] Quite aside from the contents of the hymnal

itself—which includes an ornate title page and frontispiece depicting Martin Luther at work in his study—the book communicates much about the celebrated and venerable place of song in the Christian devotional experience by means of the words and designs stamped onto the binding.

A man named Johannes Eister acquired the copy of the book referenced here at a sale in or around York, Pennsylvania, in 1792, an inscription on a front endpaper reveals. Before Johannes even opened the volume, his eyes would have feasted on a sumptuously stamped and painted binding covered with flowers, hearts, and religious verses, one a verse from Ephesians 5:19: "Singet und spielet dem Herrn in eurem Hertzen" (Sing and play joyous melodies to the Lord in your hearts).[33] The book makes a bold statement of faith and membership in a Christian community before its interior contents are even visually encountered, much less sung.

A bookplate designed in another hymnal by the scribe Johann Adam Eyer for Elisabetha Eyer in 1821, which suggests that a pious Christian could "single-handedly be the singer, book, and temple," both personalizes the printed text in question and offers its own compelling spiritual lesson (fig. 28).[34] A less colorful but no less interesting or calligraphically impressive bookplate-like inscription is found in an 1804 edition of a Mennonite hymnal published in Lancaster, Pennsylvania, by Johann Albrecht. The volume's front pastedown features a lengthy inscription in intricate Frakturschrift, indicating that the father of Maria Hostetter of Lancaster Township purchased the book for eight schillings and three pence on January 15, 1805. Beneath the inscription, the scribe (presumably Maria herself or her father) included the first two verses of Psalm 81: "Sing for joy to God our strength; shout aloud to the God of Jacob! Begin the music, strike the timbrel, play the melodious harp and lyre."[35]

Examining the material and aesthetic mechanisms by which Protestants employed and transmitted their hymns can inform our understanding of their devotional culture and reveal how a musical manuscript's tangible, material presence contributed to its significance as a spiritual object. Clearly, their printed hymnals held considerable artifactual significance to Elisabetha Eyer and Maria Hostetter—a resonance musical books and manuscripts enjoyed widely among Pennsylvania Germans, and especially Mennonites, of the time. One of the most common forms of musical manuscript made in German Pennsylvania, the Mennonite Notenbüchlein, likewise made use of material signals of the documents' spiritual utility and figured prominently in the school tradition of spiritual literacy training alongside penmanship samples.

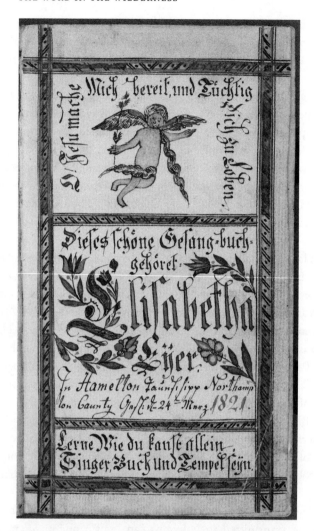

Fig. 28 Johann Adam Eyer, bookplate for Elisabetha Eyer, in *Erbauliche Lieder-Sammlung* (Edifying collection of songs) (Philadelphia: Billmeyer, 1821), Hamilton Township, Monroe County, Pennsylvania. Writing ink and watercolor on laid paper, 3½ × 7⅜ in. 2012.0027.012. Courtesy of the Winterthur Museum, Winterthur, Delaware.

Hymn Tune Books: The Elements of Analysis

Not unlike penmanship samples, bookmarks, and other documents of a pedagogical nature, Mennonite tune books were made by schoolteachers and presented to accomplished students in their classrooms, though in this case

to gifted singers.[36] Singing was a central component of education in Pennsylvania German and especially Mennonite classrooms, and, like proficiency in neo-Gothic calligraphy, musical ability was a required skill of the schoolteachers Mennonites employed. Just as proficiency in German language facilitated personal engagement with holy texts, proficiency in music facilitated participation in congregational singing. In at least one Pennsylvania German schoolroom, shape notes were known to have been drawn onto the ceiling beams to facilitate group musical experience.[37] But the tune books were more than simple teaching aids. Just as penmanship samples sought to teach literacy and penmanship while acknowledging students' advancement through school curriculum and proffering moral lessons, tune books acquainted students with the fundamentals of reading music while providing hymn singing as yet another portal into exploring God's message. Most of the books employed notational conventions common to German hymnals since the 1600s.[38]

Whereas printed hymnals often offered only the lyrics of hymns and not the tunes to which they should be sung, it seems that manuscript tune books like these served to instruct students in some of a community's important devotional tunes. No source has yet been found that clarifies if students had to pay schoolteachers for the tune books they received, though it is known that students sometimes had to pay teachers for the paper they used in the classroom. Given the time, skill, and materials necessary to create tune books, it seems unlikely that the documents were freely given.[39] The documents represented the writing down of hymns and tunes that had been perpetuated orally in Mennonite communities for years.[40] What is more, tune books themselves document change over time, as it is evident that, in some instances, more than one schoolteacher wrote hymns in individual students' tune books. The tune-book genre was most predominant among Mennonites in Bucks County, though it spread outward from there.[41] By transforming ambient culture into manuscript culture, the music also became a form of historical document and visual artwork. Three elements of tune-book design bear on the manuscripts' aesthetic, material, and artifactual qualities: binding structure, design and textual and pictorial contents of illuminated title pages, and the presence of calligraphy and pictorial illuminations on pages of musical notation. Each of these three elements suggests how scribes intended the documents to be used and how owners employed the books in their piety.

Tune-book binding structures vary widely and range from the utilitarian to the lavish. On the utilitarian end, some tune books come equipped with simply sewn paper covers, most often of a thicker grade than the paper used for the booklets' contents, or thicker covers decorated with pasted-down blue sheets. Others feature decorated, marbled sheets pasted onto the covers,

124 THE WORD IN THE WILDERNESS

which lend an air of elegance to the small volumes. Lengthier, and seemingly more expensive and prized, volumes might be bound entirely in leather. Some elegant examples of the form are bound in leather and covered with decorated marble paper pasted to the covers. These different binding methods reflect the panoply of options available to scribe and student for support of their singing endeavors.

In most cases title pages bearing owners' names and descriptions of book contents are a tune book's most visually extravagant feature. Many bear imagery that underscored the volumes' status as devotional tools and tokens of piety, as well as short verses and mottoes that offered users simple instruction in the importance and value of singing. "Sing, pray, and go in the way of God," reads one; another quotes words from the New Testament book of James: "Is any among you afflicted? Let him pray. Is any merry? Let him sing psalms."[42] They seem, for the most part, to have been created *by* teachers *for* students, though some title pages and other owner inscriptions were written by the books' student owners themselves. (In other cases calligraphers made the books for personal use.) Scribes frequently included the tune-book owner's name on the title page or on another early page in the document. Fortunately for modern observers, the title pages also frequently report the date when the books were made. Ornate, colorful Frakturschrift calligraphy populates many title pages. Colorful and decorative imagery abounds on the documents, including patterned borders and flowers. Hearts, angels, bunches of grapes, birds, and bars of music sometimes appear. Some tune books lack illuminated title pages, but unfortunately in many cases this dearth may be because they were removed from the volumes at some earlier date. There is also evidence that schoolteachers may have added the fancy illuminated title pages to tune books after students had owned the volumes for some time, perhaps as a reward for mastery of the musical contents contained therein.[43] (One title page refers to the tune-book's owner as *Ein Geübter singer,* or "an experienced singer.")[44] Usefully, some title pages specify the printed hymnals to which the manuscript books correlate. While scribes included much of this content on illuminated title pages alone, in some cases they spread it out over several of a tune book's early leaves.

Musical notation presented an opportunity for scribes to link hymn tradition to Pennsylvania Germans' much-loved culture of calligraphic and illuminative ornament. Not all the manuscripts included pictorial illumination into the bars of music in the style of an Ephrata manuscript. But many do make explicit the connection between visual and aural understandings of piety. In some cases pictorial illuminations quite literally stem from the bars of music themselves, such as flowers or vines growing out of music notes. This

suggests that Pennsylvania German scribes and readers viewed musical notation not unlike the written German language: as a sign system capable of enhancement with embellishment and ornamentation. The three elements—bindings, title pages, and illuminations—represent broad generalizations about the tune-book form, requiring more careful analysis and illustration.

Goose Quill and Candlelight: A Content Analysis
of Hymn Tune Books

In the early twentieth century, the owner of a Schwenkfelder tune book likely created around one hundred years prior wrote a note about the volume's provenance, which today is adhered to the inside of the book's front cover. "This book was written by a farmer's lad 19 years of age," the note reads. "The pen used was a goose quill and the work done by candle-light."[45] Whether or not the scribe, a "farmer's lad" named Melchior Schultz, truly wrote the text at night by candlelight, this romantic reminiscence affixed to the book succeeds in conjuring an image of a young man scribbling away on a document that is as much a visual artwork as it is a musical text. From its intricate leather and decorated paper binding to its ornate title page and heavily illuminated musical melodies, the book demonstrates how some Pennsylvania Germans' embrace of calligraphy and the manuscript arts spilled over into the world of Protestant hymnody and music-based worship. Quite apart from the actual tunes preserved in the pages of tune books, which reflect musical culture of the time and fill out our picture of the German Protestant devotional and worship experience, the material artifacts suggest how visual and aural stimulation interacted to create a multisensory devotional experience for the books' makers and owners.

Like most Pennsylvania German illuminated spiritual manuscripts, tune books remain shrouded in a fair bit of mystery, as far as their historical underpinnings, making, use, and general spiritual significance are concerned. Scholars have identified no explicit articulation of their purpose written during the era when schoolteachers and students popularly employed them. As with penmanship samples, modern observers must turn to the material texts themselves for clues as to the tune books' intellectual foundation and social function. A spectacular example of the manuscript genre on deposit at the Mennonite Heritage Center in Harleysville, Pennsylvania, offers valuable clues as to the pious devotional underpinnings of the tune-book form. The book in question was made by Mennonite schoolteacher Henry Johnson for his own use and perhaps as a sourcebook for the tune books he made for his

students. (Johnson also served as a Mennonite preacher and bishop, under-scoring the quasi-clerical role of the schoolteacher in Mennonite society of the time.)[46] Bound in leather with marbled-paper exterior pastedowns, the book's rather lavish cover hints at the intricate artistry contained therein. The first leaf features a full-page rendition of an American eagle surrounded by clouds and thirteen stars (representing the thirteen original colonies). The eagle grips arrows and an olive branch with its talons as it hovers over a sylvan landscape. On the verso appears an exotic, tropical scene, featuring palm trees and Johnson's name, followed on the next page by more typically Pennsylva-nia German floral designs and Frakturschrift reading, "Dieses Noten Buch Gehört mir Henrich Johnson, A.D. 1826" (This tune book belongs to me, Henry Johnson, A.D. 1826). Revealingly, on the next two pages Johnson included a lengthy quotation from Martin Luther, on the place of music in Christian worship. "There is no doubt that many seeds of glorious virtues are to be found in such minds as are affected by music," Luther's text reads, in part. "I have always loved music; whoso has skill in this art, is of a good tem-perament, fitted for all things. We must teach music in schools; a schoolmas-ter ought to have skill in music, or I would not regard him."[47]

The presence of this lengthy quotation is significant from another per-spective, in that very few Pennsylvania German devotional manuscripts featured quotations from what might be considered "high" theological sources, such as Luther, other important Protestant leaders, or earlier com-mentators on Christian life such as Saint Augustine. Given that most man-uscripts, including penmanship samples and tune books, were made for children, this dearth of complex extrascriptural material seems logical. And the presence of Luther in Johnson's own book reflects the teacher's firmly Protestant motivations for his pedagogical methods. The rest of Johnson's text presents a panoply of hymns, in both German and English, some of which Johnson included in a similarly designed tune book for one of his students.[48]

So much for a teacher's personal music book—what do we know of stu-dents' copies? Few, if any, pupils' tune books were as large and ornate as John-son's personal version. The teacher seems to have lavished incredible energy on his own treasured text, which was probably also a source book for his manuscript copying. Student tune books do, though, often possess their own brand of elegance and ceremony. One made in Montgomery County for Anna Funck by schoolteacher Andreas Kolb in 1788 features the usual trappings of the genre—ornate title page, tunes of various hymns, and pic-torial illuminations stemming from the bars of music—but also includes a telling introductory poem that makes use of two verses already familiar to us to explain the importance of the tune book to the educative process by linking

its visual beauty to the scribal culture of which Anna and other students of her day were a part. "Anna Funck I am called, Heaven is my Fatherland," the verse begins, using the same line as that on Johann George Bertsch's bookplate dating from 1768, described in chapter 1. "In Montgomery County I am born, as your scholar I am chosen. / The paper is my field; it makes me prudent and brave. / The quill is my plow; it makes me wise and prudent. / The ink is my seed; with it I write my name. / Anna Funck the 24th of February in the year 1788."[49] Even tune books, which were supposedly centered on ambient, musical devotion, resonated also as distinctively calligraphic enterprises.

A quantitative consideration of tune books can help establish some generalities about this variety of Pennsylvania German text artifact. This analysis is based on a sample consisting of fifty tune books of Mennonite and Schwenkfelder heritage. The manuscripts under consideration here were made between 1784 and 1830, though nine of the books included in the sample were not dated by their makers or users. More than half of the dated pieces were made in the first three decades of the nineteenth century. Unsurprisingly, most tune books made for students included in the study are shorter in length and less expensively bound than the luxe Henry Johnson piece. The manuscripts more frequently come equipped with simple paper covers into which leaves bearing musical notation were sewn. Twenty-seven of the fifty books examined for this study, or slightly more than half of the total, feature soft paper covers. Of course, documents with only a small number of sheets do not require a more substantial binding for structural stability—nor, we may assume, did scribes deem such treatment necessary for the objects' utility as spiritual learning devices. On many examples with paper covers, scribes left covers completely blank and undecorated. The others, often of greater length than paper-bound examples, could boast more elaborate bindings with leather components and some decoration. Some tune books, including those that bear the goose quill and candlelight description, were bound in leather and then decorated with colorful, patterned paste paper. Thus, much like the other manuscript artworks of the Pennsylvania Germans, tune books came in a range of sizes and aesthetic forms.

In many cases the tune books' assemblers used waste paper for the volumes' endpapers (that is, the normally blank pages that appear before and after a book's contents), including sheets that seem to have been used by students for penmanship practice. This material evidence underscores the tune book's association with literacy instruction and suggests that neither scribe nor patron saw the presence of such obviously recycled paper as detrimental to the books' beauty or spiritual value. (The cover of one tune book was made from an unfolded box of eighteenth-century "Super Fine London Pins.") The composition of the books' covers and endpapers provides clues as to just how

ornate the book's makers presented the musical content inside. Whatever the binding apparatus, however, most scribes seem to have viewed the tune-book's title page as the prime place for embellishment. Perhaps not coincidentally, title pages were also frequently where scribes highlighted book owners' names, linking individual Christians to hymn culture through the text artifact itself.

Title pages on tune books echo the aims of many other spiritual manuscript types—namely, a focus on urging readers toward praise of God—and offer clues as to the spiritual resonance of the form. Tune books exist "Ihr zur Lehr und Gott zu Ehr" (to teach you and to praise God) wrote a scribe on the title page of Sarah Schättinger's tune book in 1822.[50] An earlier piece, dating from 1784, placed similar sentiments in the mind of the reader: "I have in mind to sing to praise and honor God."[51] "Sing deep notes all correctly so you are a faithful servant," reads another.[52] The title page of Anna Geissinger's 1815 tune book features a humorous warning against theft as well as an invocation of the book to facilitate spiritual experience. "Listen, little book, to what I want to tell you," the verse begins. "If anyone wants to carry you away, then say, let me lie in good peace. I belong to Anna Geissinger for use in good instruction and to praise God, to whom belongs honor."[53] "Sing and play to the Lord in your hearts," another tune book advises.[54] Eight title pages feature the verse, "Learn how you can singlehandedly be the singer, book, and temple."[55] Though they generally contain little text content compared to penmanship samples, through verses such as these, tune-book title pages offer much in the way of Christian instruction in their role as entry points into the world of Protestant hymnody.

While most of the religious verses on tune-book title pages focus on instruction in the virtues of singing, another familiar theme found expression on some examples: death. The theme of life's brevity and the coming of death was articulated on an 1805 title page written for Jacob Meyer, which reads, "As a little flower soon passes, so too our life fades away."[56] This verse appeared on five title pages in the sample.[57] A verse on the title page of Johannes Friedrich's 1806 tune book reads, "O precious heart, reflect on your end."[58] The title page of Joseph Schleifer's 1806 book features that same verse, as well as the lines, "If your heart is given as a gift, correctly ornamented with devotion, this book then affirms to you, quite entirely the Word and wisdom."[59] Admonishments to reflect on death doubtless aimed to put singers in the right mindset as they prepared to engage with Christian song.

The religious and spiritual verses quoted earlier offer insight into the resonance of the manuscript form as a devotional tool (and singing as a spiritual occupation), but such verses do not appear on all tune books. In fact, only fourteen of fifty total tune books bear such religious verses on the title

page.⁶⁰ Other kinds of texts appear much more frequently on the title pages and reflect the extent to which scribes designed the manuscripts to convey details about book ownership, especially owners' names, an identification of the owner as a *Sing-Schüler* (singing scholar), *schuler/n* (scholar), or "singer"; the date the tune book was created (often down to the very day); some sort of title for the book or a description of the contents; and what school a student attended or where the owner of the book lived. Only three tune books explicitly name the scribe who created them, though it is possible to infer the maker of many surviving tune books by their design attributes. Thus, most bear some sort of manuscript personalization for their owners, who were often students in Mennonite "singing schools."

Of course, text is only one component scribes employed on tune-book title pages. Other, just as important, elements are calligraphic decoration and pictorial imagery, both of which dramatically enhanced the sense of ceremony and religious meaning associated with the little books. Almost all title pages feature highly decorative exterior borders, created to frame the design within, and present text in ornate Frakturschrift calligraphy. The vast majority feature interior borders that further structure text presentation within the design. Flowers, hearts, angels, occasional human faces incorporated into other designs, and even palm trees all appear in designs on the documents. One tune book, that pictured in figure 29, includes musical notation on the title page.⁶¹ While not all explicitly tied to religion (angels being the major

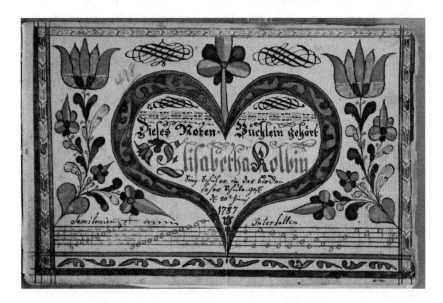

Fig. 29 Notenbüchlein for Elisabetha Kolbin, 1787. 3¾ × 6⅜ in. 1920.09.124. Courtesy of the Schwenkfelder Library and Heritage Center, Pennsburg, Pennsylvania. Photo: author.

130 THE WORD IN THE WILDERNESS

exception), such designs do underscore the significance associated with this form among schoolteacher-scribes and the students and families who received the documents, and many may have possessed emblematic meanings laden with spiritual significance.

The paratextual elements discussed thus far—binding structures and title-page design—figuratively and literally encase the contents tune books were designed to deliver: hymn tunes. The third element comes closer than the prior two to the musical notation itself. Thirteen of the tune books included in the sample feature pictorial illuminations on pages depicting musical nota-tion.[62] Often these illuminations are simply decorative elements (often flow-ers) employed between bars of music to separate different tunes, but other illuminative elements grow out of the music itself, fusing the aural and the visual through the Pennsylvania Germans' penchant for calligraphy and the manuscript arts. The Schwenkfelder Melchior Schultz includes a fine exam-ple of this kind of design in his tune book, picturing a bunch of grapes growing on a leafy vine extending from the tune's final note. Pages of music in other booklets feature simple decorative heart designs, intricate floral patterns, and multiple colors designed to enhance the utility and instructional effective-ness of the volume. Introductory pages, which scribes used to explain scales and matters of musical notation, frequently became sites for such visual dis-plays, as employing various colors and pictorial designs could help explain the mechanics of interpretation to the texts' users.[63] Tune books that did not include pictorial imagery on music pages often featured nonpictorial, calli-graphic decoration to enhance the documents' aesthetic appeal.[64] And occa-sionally, letter-based calligraphy emerged as just as prominent a focus on the tune book's pages as musical notation.[65] See table 4 for a summary of design features and pictorial imagery often encountered on tune-book title pages.

Recall that some Schwenkfelder families, most notably the Heebners, adopted the penmanship-sample form common in Mennonite schools and used it in the home as a spiritual-devotional exercise. It seems that the tune book also found use in Schwenkfelder hands as more than a schoolteacher-made classroom tool. Tune books made by and for members of the Schultz family, including the goose quill and candlelight piece for Melchior Schultz described earlier and an example made for his brother Isaac, are larger and more ornate than most teacher-made Mennonite examples and offer more in-depth treatment of musical issues. Isaac's, for example, provides nine pages of instruction on musical matters before proceeding to the tunes themselves.[66] Even more intriguing, the front pastedown of Isaac's tune book features a drawing of a walled garden in a clear reference to the wisdom book Song of Solomon.[67] The design is based on a known source: a print in a 1622 edition

"INCENSE HILL" 131

TABLE 4 Tune-book title-page decoration and pictorial imagery

Image type	Number of tune books	Percentage of total sample
Frakturschrift (fancy calligraphy)	39	78
Exterior border: rectilinear	38	76
Flowers	37	74
Calligraphic flourishes (nonfigurative)	35	70
Interior border: circular and curvilinear	17	34
Interior border: rectilinear	12	24
Interior border: heart	5	10
No title page present	5	10
Birds	3	6
Heart shapes	3	6
Human faces	3	6
Angels	1	2
Musical notation	1	2
Palm trees	1	2

Note: This table is based on a sample of fifty documents. More tune-book data are available on this book's companion website, www.wordinwilderness.com.

of the writings of the German mystic Daniel Sudermann, whose hymns figured prominently in the Schwenkfelder singing repertoire. Even in a manuscript committed to musical devotion, a pictorial reference evokes the Pennsylvania Germans' beloved world of Old Testament wisdom literature.

The book that served as source for the image, titled *Hohe geistreiche Lehren/vnd Erklärungen: Vber die fürnembsten Sprüche desz Hohen Lieds Salomonis* (High spiritual doctrines and explanations: On the most solemn sayings of the high song of Solomon), presents verses from Song of Solomon, alongside engraved prints depicting scenes from the book, as well as poetry and further scriptural references that explicate the verse of focus.[68] The page from which the Schultz tune-book scribe drew the source image meditates on the verse from chapter 4 of Song of Solomon, which finds King Solomon reflecting on the sexual charms of his bride—read by Christians as an allegory for God's love of his earthly church. "Behold, thou art fair, my love; behold, thou art fair; thou hast doves' eyes within thy locks: thy hair is as a flock of goats, that appear from Mount Gilead," the chapter begins. "Thy lips are like a thread of scarlet, and thy speech is comely: thy temples are like a piece of a pomegranate within thy locks." Solomon references a garden in the

verse quoted at the top of the page featuring the image in question: "A garden inclosed is my sister, my spouse; a spring shut up, a fountain sealed."[69] The image shows Solomon and his bride standing outside a lush, gated, walled garden. Accompanying explanatory text elucidates the meaning of the scripture quote. "All kinds of trees grow in this pleasure garden. That is, in the holy Christian churches and temples of God." The 1622 edition of Sudermann's *Hohe geistreiche Lehren / vnd Erklärungen* was a popular text among Pennsylvania Schwenkfelders, as the multiple copies of the text in the Schwenkfelder Library's collection attest.[70] The copy of the book referenced here may well have been the very one from which the Schultz tune-book scribe copied the image. An inscription on the title page reveals that it was once owned by a Schwenkfelder named Matthüs Jäkel, who arrived in Pennsylvania in 1734, and Isaac's mother was born a Yeakle (an anglicization of "Jäkel").[71] No matter to which precise copy of the book the scribe referred, the rich literary culture of the Schwenkfelders certainly would have put a version of this text and its associated images at the hands of many bookish community members, including gifted artist-scribes.

This evocation of a piece of mystical wisdom literature so well regarded by Schwenkfelders ties manuscript tune books like those of Melchior Schultz, Isaac Schultz, and others to a much older and wider spiritual world. It also reminds us of the wider visual, literary, and text-making culture in which hymnody and manuscript tune books figured—one centered on cultivating an enveloping experience of faith. A walled garden served as a particularly appropriate metaphor for an immersive, spiritual-meditative state associated with the rich Protestantism of these and other Pennsylvania Germans.

Interpreting the Threshold: Musical Manuscripts and Devotional Culture

Accessing the history of shared musical experience—the history of spiritual sound and aural culture more generally—presents notable challenges, and it behooves the interpreter to remember that musical books and manuscripts themselves convey only the visual and tactile aspects of the musical experience, not the aural.[72] If modern onlookers must strive to become the "immediate reader" of a written text to understand it properly, then they must also seek to understand how the ambient experience could shape popular piety.[73] Physical objects like books, manuscripts, artworks, and artifacts can linger for centuries after their active life has ended, but, like incense drifting into the air, sound is invisible and quickly becomes irretrievable, at least in the original form. The musical manuscripts previously described suggest that

material and artifactual evidences can offer intriguing insight into musical life among Pennsylvania Germans, who connected aural culture to calligraphy, manuscript illumination, and the work of the Holy Spirit.

Decorative bindings, illuminated title pages, calligraphic text, and pictorial illuminations abound in Pennsylvania German musical manuscripts and contributed in important ways to their function among religious readers. Far from simple embellishments to, or ornaments on, the documents, all those elements undergirded the manuscripts' holistic meaning and usability, rendering them meaningful as both information sources and spiritual instruments. As is the case with other Pennsylvania German devotional manuscripts, such features were not extraneous decoration but rather key communicative signposts to help the text's creator achieve a devotional purpose.[74]

"Ephrata! Of all the words and names in the vocabulary of Pennsylvania none embraces so much of what is mystical and legendary as the word Ephrata," wrote Julius Friedrich Sachse in a history of the community in 1899.[75] To be sure, Ephrata has exercised a powerful hold over the collective memory of Pennsylvania Germans because of the artifacts they created and the prayerful, mystical world such artifacts evoke today. The Ephrata manuscripts and Mennonite and Schwenkfelder tune books demonstrate that illuminative decoration and owner inscriptions served as thresholds to meaning making and spiritual experience for the documents' readers. Just as calligraphic ornamentation of holy texts represented a compromise between the invisible, internal work of the Holy Spirit and a thirst for a visual, material witness of faith, so too embellished musical manuscripts helped render visible and tangible the Christian devotional activity of hymn singing. "Oh! let the Christian bless that glorious day / When outward forms shall all be done away; / When we, in spirit and in truth alone, / Shall bend, O God! before thy awful throne," proclaimed the pious Anglo-American poet who visited the Ephrata community and whose work was reprinted in the *Berean* in 1826.[76] Despite this supposed urgency for the passing away of outward forms, scribes at Ephrata and across German Pennsylvania combined their desire for introspective spirituality with a deep affection for engaging with visual representations of faith, through text, calligraphy, musical notation, and manuscript illumination.

5

MARCHING TO "STEP AND TIME"
Text, Commemoration, and the Rituals of Everyday Life

"Paper is my field, therefore I am so valiant," wrote a Swiss calligrapher on an illuminated manuscript in 1743. "The quill is my plow, therefore am I so smart. The ink is my seed that brings me fortune, honor, and good name."[1] As previous chapters have shown, German speakers viewed calligraphy, manuscript culture, and the reading of Fraktur documents as an important part of their daily lives, both temporal and spiritual.

Just as the seasons of the year dictated patterns of agricultural labor, so too did the seasons of life dictate the contents of spiritual documents scribes and printers produced. Many Pennsylvania German illuminated spiritual manuscripts and printed texts deal in some way with passage through a life stage or entry into a spiritual community. On birth and baptismal certificates, the documents under consideration in this chapter, scribes wrote a child's name and lineage into a visual and textual narrative of the centuries-old, global Christian experience. Other types of documents in common use among Pennsylvania Germans did similar work. Ornately written or sometimes simply scrawled onto the endpapers of Bibles and other devotional texts, family registers placed family members in a line of their ancestors, recorded genealogical details for future generations, and inserted personal and family stories into the very religious books that sustained a family's faith. With epitaphs, another manuscript form possessing transatlantic roots, scribes commemorated the dead. In these ways spiritual calligraphy, illuminated manuscripts, and printed ephemera were both personal and social. They were intimate artworks of individual faith expression and personal rites of passage but also links to a wide-ranging, text-based community of believers in an age of intense evangelical piety.[2]

Not all Pennsylvania Germans made use of each and every one of the spiritual manuscript types at their disposal, of course; as we have seen, many varieties of documents found favor among certain religious traditions and not others. But in its entirety, the corpus of surviving manuscripts and associated printed texts discussed in this book reveals much about the seasons of life through which Pennsylvania Germans passed on their faith journeys. The spiritual texts that families assembled over time trace life's ebb and flow in southeastern Pennsylvania during the long era of manuscripts. This chapter begins with a content analysis of Pennsylvania German birth and baptismal certificates before it considers some of the other document types Germans employed to mark important life milestones. It continues with an in-depth look at books, prints, and illuminated manuscripts once owned by three agrarian families whose spiritual lives beckon the modern observer into the spiritual world on the rural Lancaster County farmsteads the families once called home. The chapter closes with a discussion of why the manuscript tradition eventually faded from prominence in Pennsylvania German culture.

The Pennsylvania German Life Cycle: Birth
and Baptismal Certificates

Carl Friedrich Egelmann (1782–1860), engraver of penmanship samples and birth and baptismal certificates, led a varied and peripatetic life, traipsing across professions and scholarly disciplines quite as deftly as he traversed oceans, nations, and American states. Born in Neuenkirchen, Germany, he had traveled to Baltimore by 1802 to work as a coach and chair maker before settling later in Pennsylvania, where he found employment variously as a schoolteacher, church organist, choirmaster, and finally engraver, printer, and publisher. (All the while, he pursued his interests in mathematics, astronomy, and poetry.)[3] A man whose intellectual depth and aesthetic sensibility was matched by an intense business ambition, Egelmann brought skilled artistry to the birth and baptismal certificate, which he produced in large number.

The certificates Egelmann made were works of art and spiritual texts, not bureaucratic records. In fact, despite the use of the English word "certificate" in their name as commonly translated, the texts served no civic function but were used by families to record vital data about offspring while situating the child into a paper landscape of Christian devotion, thus serving as testament to membership in God's family.[4] A rather remarkable document designed and engraved by Egelmann and used by Jonas and Maria Huber to commemorate the birth of their daughter in 1835, pictured in figure 30, combines

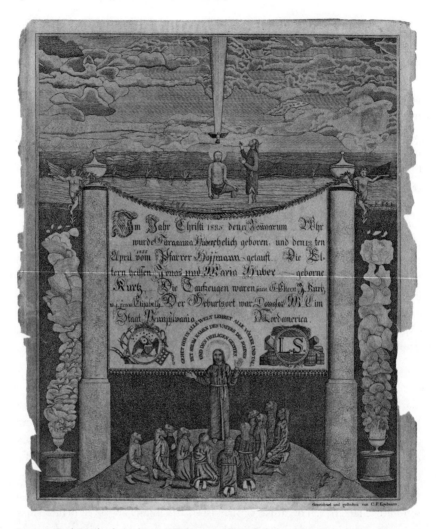

Fig. 30 Carl Friedrich Egelmann, Geburts und Taufschein of Sara Anna Huber, Reading, Berks County, Pennsylvania, and Douglass Township, Montgomery County, Pennsylvania, 1835–40. Note the presence of the plow and other farm implements surrounding the Great Seal of the United States. Ink and paper, $11^{15}/_{16} \times 9^{11}/_{16}$ in. 1980.0048. Courtesy of the Winterthur Museum, Winterthur, Delaware.

various elements of print and manuscript culture of the era—printed and handwritten Frakturschrift letter forms, contemplative imagery, and carefully selected scriptural quotations—to produce a document that probably pleased the Huber family with its Christian imagery and quotations. Today it serves as a fine exemplar of the role of such certificates in spiritual and family existence.

A variety of printed documents figured in Pennsylvania Germans' secular and spiritual daily lives, meaning that birth and baptismal certificates were just one take on a familiar paper-based medium. Like illuminated manuscripts, some scholars have turned to these artifacts to peer into Pennsylvania German daily life.[5] Settlers used printed broadsides to announce and commemorate a wide variety of important events, traditions, and community functions.[6] Birth and baptismal certificates filled an important and familiar role in a society that relied on both print and manuscript culture for communication and cohesion, recording family data within a printed template tinged with Christian allegory. The event such documents symbolized—baptism— sat at the crux of German Protestant church life, faith experience, and theological disputation, meaning that, among those who practiced infant baptism, the birth and baptismal certificate held tremendous import. Among both Lutherans and Reformed Pennsylvania Germans, baptism served as critical early step on a child's journey in personal faith and marked their membership in Christianity's "visible church." The documents were, much like birth itself, both everyday and extraordinary. They recorded essential personal and family data while celebrating God's miraculous work among his people.

As spiritual artworks, then, the documents possess great significance. They are also of interest from a material standpoint, because in two different ways they offer a revealing contrast to the other types of texts discussed in previous chapters. First, birth and baptismal certificates remained in active use for decades longer than the penmanship sample or hymn tune book did, probably because its primary users were members of the mainstream Lutheran and Reformed denominations whose sacramental traditions and institutions enjoyed stability during the period in question. (Recall that the sectarian rural schools, where penmanship samples and tune books proliferated, evanesced in the mid-nineteenth century, whereas mainstream congregations, and their practice of infant baptism, survived.) Second, the certificates successfully evolved over time from all-manuscript to printed template form, complete with blanks for manuscript inscription, whereas penmanship samples and tune books remained almost entirely manuscript during their years of active use. These points are probably mutually supportive. Greater and more widespread demand for birth and baptism certificates may account for the evolution of the documents from all-manuscript to print-and-manuscript mix. Lutherans and Reformed were, after all, far greater in number than the sectarians. Their attitudes on baptism bear on the documents as visual artworks and material artifacts so are considered in detail here.

Infant baptism played a central role in Lutheran and Reformed religious life and spiritual culture, underscoring why paper-based representations of the act figured so prominently in the Pennsylvania German print and manuscript

enterprise. (Reformed congregations also occasionally employed calligraphy and manuscript illumination in their registries of births and baptisms.)[7] Baptism was one of the two sacraments Lutherans and Reformed practiced, the other being Holy Communion. For both denominations the practice of baptism was a divinely ordained necessity of Christian life that both signified and sealed God's covenant with his people—that is, his guarantee for eternal life for faithful and repentant followers. God invested the waters of baptism with the holy Word and used those waters to wash away sin, open the recipient to grace, and fulfill the Word's promise of salvation to believers.[8] Both groups believed that Christ's covenant required baptism of all members of the flock, including children.[9]

This much both camps more or less agreed on. As Protestants sought to square the external ritual of baptism to the supremacy of the Word and invisible faith in Christian salvation, however, considerable debate opened regarding baptism's nature and impact. Did the water of baptism itself confer salvation, or did the water symbolize a spiritual act? What role did individual faith play in the process of redemption? Differing answers to these and other perplexing questions served as important dividing lines between denominations and church traditions. Suffice to say here that Lutherans tended to believe the waters of baptism played a material role in conferring grace, whereas the Reformed tended to view baptism as symbolic of God's covenant—a seal, so to speak, on something already delivered.[10] Despite the consistently perplexing theological question of what role the material process of baptism played in salvation, both Lutherans and Reformed agreed that the act of baptism alone could not save; the believer must also repent and possess faith (cultivated later in life, if the baptized were a child).[11] As a cleansing and regenerative ritual, baptism delivered both forgiveness and the Holy Spirit, but the recipient thereafter had responsibility to cultivate a lifetime of faith. Baptism was, in essence, a spiritual rebirth.[12]

It makes sense, then, that both birth and baptism found commemoration on Pennsylvania German certificates. Baptism was, after all, nothing short of a regeneration, an "earthly sign" of an infant's entry into the Christian family.[13] The artworks preserved family data and evoked meaningful Christian messaging. The etched and engraved Egelmann print, for example, combines a variety of imagery and iconography, but, like most other Pennsylvania German spiritual texts of the era, some of the document's most important features, included at the very center of the leaf, are the fine engraved Frakturschrift letters, which display Egelmann's calligraphic talent. Egelmann left blank spaces for personal information about the child for whom the certificate was acquired. A scribe, perhaps a member of the Huber family, a skilled

friend, or a paid calligrapher, added handwritten details about the birth of little Sara Anna Huber to Egelmann's engraved writing. The final text reads, "In the Year of our Lord 1835 in the month of January at [an unspecified] hour, Sara Anna Huber was joyfully born, and on the 12th of April 1835 she was baptized by Pastor Hoffmann. The parents are Jonas and Maria Huber, born [i.e., maiden name] Kurtz. The witnesses to the baptism were the grandparents J. Kurtz and his wife Elisabeth. The place of birth was Douglass [Township], M[ontgomery] C[ounty] in the state of Pennsylvania, North America."[14] Little Sara literally finds herself in the middle of the New Testament narratives as presented on this print. The upper third of the print illustrates Christ's own baptism, the Holy Spirit descending on him in the form of a dove. Neoclassical pillars, urns, and cherubs frame the central text, while vast plumes of smoke rise from burning incense on either side of the document. Amid this ancient imagery the American seal stands out, surrounded by an assortment of farm implements. (The letters "L. S.," abbreviating *locus sigillorum*, Latin for "location of the seals," sit nearby, surrounded by wheat, fruit, and barrels.) And, at the bottom of the page, Christ offers his famous words on baptism to his disciples from Matthew 28:19: "Go ye therefore, and teach all nations, baptizing them in the name of the Father, and of the Son, and of the Holy Ghost."[15]

The Pennsylvania German birth and baptismal certificate is to some extent a unique American innovation. No identical practice of birth and baptism commemoration existed in German-speaking Europe, though related forms figure in the document's transatlantic ancestry.[16] The documents played an important role in personal identity formation among Pennsylvania Germans, some of whom had baptismal certificates made long after their own baptisms had occurred. Early examples of Pennsylvania documents commemorating births and baptism exist that were composed entirely of calligraphy and illumination, such as a colorful and intricate certificate made in Berks County for the Lutheran Frantz Paul Seybert, born March 5, 1751.[17] Scribes and printers prepared the documents using various (and often combined) techniques, ranging from all-manuscript versions until around 1780 to printed versions thereafter, which made use of printing technologies including basic letterpress, wood engraving, metal engraving and etching, and even lithography by the mid- to late nineteenth century.[18] Pennsylvania Germans lived in a world in which text-based communication could range from all print to all manuscript, with considerable variation in between these two extremes.

The Pennsylvania German birth and baptismal certificate enjoyed some parallels in Anglo-American communities. An example made for a child

christened into the predominantly Anglo-American Protestant Episcopal church, in Saint Michael's Protestant Episcopal Parish, Maryland, has black-letter type familiar on many ecclesiastical documents and presents key points from scripture that the child should bear in mind, but it otherwise lacks its Pennsylvania German counterparts' rich imagery (fig. 31).[19] Like the other document types discussed previously, the birth and baptismal certificate thus enjoyed some parallels among Anglo-Americans but seems to have had a special affinity among the Pennsylvania Germans—in this case the members of the mainstream Protestant confessions. Crease lines present on many surviving examples of the form suggest that the certificates were frequently stored in family Bibles and other religious texts or stashed away with other important papers and mementos.[20] While Lutherans and the Reformed were well aware that baptism itself was insufficient to guarantee their children's salvation, it was a vital sacrament and sign of a child's membership in the Christian family. In this way a certificate probably served as much to reaffirm the parents' appreciation of the Christian life cycle as the children's, once they were old enough to read and interpret the document.

The Pennsylvania German Birth and Baptismal Certificate:
A Content Analysis

Though printed templates consisted, on the surface, of comparatively little in the way of creative ingenuity, birth and baptismal certificates abound with data about Pennsylvania German spirituality and family life. What is more, scribes tinkered with the visual and textual framework provided by the printed documents to expand and modify the interpretations of religious life the certificates could offer, resulting in artifacts that illustrate how spiritual ideals interacted with lived reality in eighteenth- and nineteenth-century Pennsylvania. Close study of a random sample of fifty birth and baptismal certificates leads to six major interpretive conclusions about the documents and their place in Pennsylvania German spiritual life, which merit summary before delving into details about each one.

The six interpretive conclusions are as follows. First, this document type represents a hybrid form between print and manuscript. Scribes, printers, and families employed the whole spectrum of print and handwriting technologies on the documents, ranging from examples made entirely by hand to some composed entirely of print. Second, the printing technologies employed on the certificates evolved over the course of the eighteenth and nineteenth centuries, ranging from simple woodcuts to intricate steel engravings and

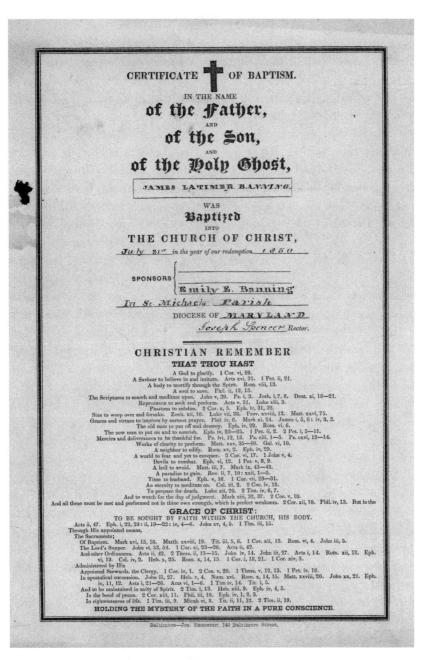

Fig. 31 Birth and baptism certificate for James Latimer Banning, Saint Michael's Protestant Episcopal Parish, Maryland, July 31, 1850. Approximately 8 × 10 in. MS 5061: "Scrapbook, Kept by James L. Banning, President of City Council, 1909, Materaal [sic] to Complete, Not Yet Pasted, from James L. Banning, Dec. 1950, City of Wilmington Paving." Courtesy of the Delaware Historical Society, Wilmington.

even lithography. In these ways the certificates allow for study of changes in the relationship of print to handwriting as the long era of manuscripts slowly came to a close. (Indeed, the comparative longevity of this form compared to penmanship samples and other document types may be due in part its greater reliance on print than manuscript technology.) Third, during the years in which they were made, Pennsylvania German birth and baptismal certificates played an important role in enabling families to inscribe their and their children's names into a prefabricated narrative of Christian life. By means of the texts, imagery, and document design, families quite literally placed children's names, birthdates, baptism dates, and family lineage in the center of archetypal illustrations of the Christian experience. Fourth, despite their supposed focus on the beginning of life, to a remarkable degree birth and baptismal certificates also advise parents and families to remember the constant specter of death, which menaced adults and children alike. The documents admonish the faithful to prepare for fast-approaching death and frequently represented all of life's seasons (birth, baptism, marriage, childbearing, family rearing, and death) on one document alone. Fifth, within this spiritualistic template, the hybridity of the documents allowed for scribes and family owners to shape the meaning of the printed material to their own desires and needs. Though they seem to offer a rigid formulation of Christian family life, the meaning of the documents was not static. And, sixth, chronological review of birth and baptismal certificates suggests that earlier pieces may have been more rooted in scriptural and biblical motifs than later examples, which tend to employ a greater amount of imagery related to pious domesticity.

The random sample of fifty birth and baptismal certificates, drawn from the substantial collection of such documents owned by the Library Company of Philadelphia, ranges in date of use (i.e., the date of birth or baptism handwritten on the forms) from 1781 to 1898. Of course, the year of the printed documents' use does not necessarily correspond to the year of their production; they might have been printed years prior and then acquired and used by new parents thereafter. The certificates survived well beyond the lifespan of pure-manuscript document types discussed in previous chapters, most notably penmanship samples and tune books. Numerous reasons may account for this. First, the form was commonly used by members of the mainstream Lutheran and Reformed confessions. (Nine certificates explicitly note the denomination of the clergyman who performed the baptism as Lutheran or Reformed.)[21] Whereas manuscript forms like penmanship samples and tune books were dependent on sectarian education for their production and use, the birth and baptismal certificate enjoyed greater institutional stability,

given its association with a mainstream Protestant sacrament. Second, the certificates are rarely all manuscript and do not qualify as "manuscript artworks" in the same way as other document types. That the documents for the most part were printed works, which, especially in later years, required minimal manuscript fill-in and hand decoration, may have contributed to their longevity. They also present modern viewers with an overview of evolutions in printing technology over the nineteenth century; early pieces tend to feature woodcuts, metal engravings, type ornament, and letterpress, whereas some later pieces seem to have made use of techniques such as etching and lithography.

Manuscript additions to the documents varied with the technology used to make the birth and baptismal certificate. Earlier pieces often required hand decoration, for example, whereas later pieces came equipped with more intricate artistry. Only seven of the documents feature publication dates, ranging from 1840 to 1855.[22] The forty-eight certificates in the sample that were filled in all feature a year in which the baptism took place, with an average year of use of 1843. Thirty-seven of the documents seem to have been printed in black and white and then hand colored and filled in with manuscript family data.[23] Only eight certificates feature no decoration added by hand beyond the text written on the documents.[24] These range in years of use from 1816 to 1898, suggesting that hand coloring was not tied to date. Two certificates are entirely manuscript, whereas one features printed, added family data and hand decoration.

The documents were printed in important town and city centers across German Pennsylvania. Thirteen were printed in Reading, twelve in Allentown, and ten in Philadelphia.[25] Two certificates in the sample were published in New York City, including one English-language example printed by Currier and Ives and one printed by a New York German-language publisher.[26] While numerous metal-engraved, intricately detailed certificates along the lines of the Egelmann piece appear in the sample, more common are documents composed of mixtures of discrete pieces of type ornament, small individual engraved or relief printing blocks, and letterpress.

Whether all print, all manuscript, or somewhere in between, birth and baptismal certificates shared a common goal of situating an individual birth and baptism into timeless and worldwide Christian metanarrative of spiritual community and explaining to readers the importance of the sacrament of baptism while instructing key Christian values. "I am sunken within Christ, / I am gifted with his spirit," reads a printed poem on one certificate published in Harrisburg in the 1850s, capturing the mood of the pieces.[27] Analysis of the spiritual texts included on certificates by printers reveals two

central themes the documents try to convey. The first seems natural: the importance and positive effects of baptism, communicated mostly through nonscriptural poetry describing the significance of the sacrament. "I am baptized!" reads a verse found on twenty-seven certificates.[28] "Through my baptism I am in covenant with my God! / So I always speak with a happy mouth, / In suffering, in tribulation, fear, and distress. / I am baptized, I am so pleased, the joy will stay eternally!"[29] Forty-five of the certificates included in this study include text that educated readers on the value of baptism.[30] Interestingly, scriptural quotations relating to baptism or book, chapter, and verse references to Bible passages appear relatively infrequently on the documents. Only thirteen quote or directly reference scripture passages.[31] The rest rely on nonscriptural spiritual text to communicate their messages.

The second central spiritual focus of the birth and baptismal certificate—death—may seem inappropriate to a document supposedly concerned with new life. But just as penmanship samples frequently admonished their young readers toward contemplation of the brevity of life, birth and baptismal certificates minced no words in discussing the pending demise of the reader and indeed the child for whom the certificate was acquired. Thirty-one of the documents include language on the fast approach of death, reflective of the ever-present threat of the specter of illness and premature demise during the period.[32] "Oh! With every blink of an eye / Our strength diminishes," reads a familiar birth and baptismal certificate verse. "And with every passing year / We all grow closer to the bier."[33] Twenty-five of the certificates feature this verse.[34] Indeed, printers included ample general warnings of the fast-approaching nature of death on the documents, in the form of verses and images (such as gravestones and even skulls) that reminded viewers of their and their loved ones' coming demise.[35] "The year rolls round and steals away / The breath that first it gave, / Whate'er we do, whate'er we be, / We are traveling to the grave," read one especially somber English-language poem.[36] A German-language verse frequently employed on birth and baptismal certificates notes that death's "cool grave" awaits all, even the young: "From when we are scarcely born is the first step to the cool grave of earth, only a short step."[37]

While on the one hand this pervasive preoccupation with death seems deflating, especially on birth and baptismal certificates, given their otherwise celebratory nature, on the other hand such attention to the beginning *and* end of life reinforces the documents' underlying concern with the entire Christian experience—as do the certificates' frequent admonitions toward living piously in the years separating birth from death. Birth and baptismal certificates thus present a dual focus on the earthly death all mortals face and

the new eternal life in Christ brought about by baptism. They offer instructions on how the Christian vanquishes the despair of death and thus deliver a message of hope grounded in the sacrament. That certificate recipients and their families lived with such artifacts underscores the power of redemption in the context of everyday personal and family religious life. This focus on contemplation of death was by no means unique to the Germans; English Isaac Watts included similar sentiments in his famous *Divine and Moral Songs for Children*: "Why should I say, 'tis yet too soon / To seek for heaven, or think of death? / A flower may fade before 'tis noon, / And I this day may lose my breath."[38] Clearly, a concern with preparing children for their inevitable demise resonated across languages, cultures, and denominational traditions.

The Pennsylvania German birth and baptismal certificate's religious narrative, and the lengths to which the documents went to instruct on the virtues of baptism and the fast approach of death, would be hard to miss on the documents, even if one did not read a word of the text written and printed on them. Spiritual imagery abounds on the forms. Angels, unsurprisingly, are the most common, appearing on thirty-seven of the documents.[39] In many cases two large angels gird either side of a central text block that delivers key information about the birth and baptism. Sometimes the angels are even depicted holding up a scroll containing that important information.[40] Cherubim appear on thirteen certificates.[41] Fourteen documents depict Christ's own baptism, and eight show Christ interacting with children.[42] (A certificate featuring an image of an angel holding a young child features the charming verse: "Behold what condescending love / Jesus on earth displays! / To babes and sucklings he extends / The riches of his grace!)[43] Some go further afield, depicting the Last Supper or Christ's calming of the Sea of Galilee.[44] Numerous other Christian symbols appear on the documents, including the Tables of the Law, the Bible, the Holy Cross, a Holy Communion chalice, and burning incense. The Ten Commandments are an especially prominent theme; four documents quote from, paraphrase, or reference them, and four even feature Moses himself.[45] Fifteen certificates feature images of the Holy Spirit in the form of a dove, in some cases flying above Christ as he receives his own baptism or above the Holy Bible, symbolizing the receipt of grace associated with water baptism.[46]

In addition to explicitly religious iconography, many of the documents include more subtle references to religious life. Some designers and printers used ecclesiastical Gothic architectural elements to structure certificate layout, for instance.[47] Classical motifs including fountains, pillars, tureens, urns, and cornucopias also figure in many birth and baptismal certificate

146 THE WORD IN THE WILDERNESS

designs.[48] More generally, festive decoration common across Pennsylvania German manuscripts and artworks figure prominently on the documents. Flowers appear on nineteen of the documents, whereas birds not of an explicitly religious nature appear on twenty-nine of the certificates.[49] Musical instruments including trumpets, lyres, and harps, which figure on thirteen manuscripts, reflect the birth and baptismal certificate's celebratory message. The American eagle appears on fifteen documents, lending an official air to the certificates.[50] But the documents are unquestionably more centrally focused on the kingdom of heaven than the young American republic, with their rich religious imagery and spiritual texts, hearkening back to chronologically distant eras in church history.

The print-manuscript hybridity of birth and baptismal certificates allowed scribes and the families for whom they wrote to personalize the documents, often expanding, deepening, or outright changing the meaning of the printed documents. At times manuscript alteration reinforced the somber warnings of inevitable death that peppered the document type. A scribe named Simon Snyder altered the certificate of a toddler named Sara Heÿdt, who died on March 2, 1843, aged, as Snyder noted on the certificate, just two years and twenty-six days. Snyder also included in his inscription reporting Sara's death a Bible verse, Ecclesiastes 7:1: "The day of death [is better] than the day of one's birth."[51] It bears observing not just what Snyder wrote but where and how he wrote it—surrounding a block of printed text that hails the power of baptism to offer eternal life and thus prepare the recipient of the sacrament for death. While the open space surrounding this text block may have been the most convenient for recording Sara's death, the handwritten notes' connection to the foreboding message of the printed poem would have been lost on neither scribe nor reader. Indeed, this connection helped the document fulfill its fundamental purpose: linking the joys and travails of a single Pennsylvania German family to a broader narrative of Christian suffering and redemption. Perhaps rendering the details of little Sara's life and death amid a landscape of angels, memorable spiritual texts, and vibrant decoration helped Joshua and Sohnÿa Heÿdt make spiritual meaning out of the loss of their child.[52] Of course, the same traits of manuscript alteration that allowed for the sad addition of Sara's death allowed others to make note of further happy occasions. For example, the well-known scribe Martin Wetzler expanded on the preprinted template of Anna Carolina Dietrich's birth and baptismal certificate to include information about her confirmation in the Lutheran Church in 1855 and marriage to Simon Bauscher in 1863.[53] The longitudinal quality of the certificate suggests the document's importance to Anna and her family. The aesthetics of the printed birth and baptismal certificate, and

to a certain extent its textual and visual contents, evolved from the early days of its use through the mid- to late nineteenth century. By the 1850s, 1860s, and 1870s, it embodied not so much a rural Pennsylvania Dutch as a fanciful Victorian aesthetic, depicting idealized domestic scenes. (Thirteen certificates feature scenes of contemporary domestic life, with an average year of 1873.)[54] See table 5 for a summary of pictorial contents of birth and baptismal certificates.

TABLE 5 Selected imagery commonly found on birth and baptismal certificates

Type of image	Number of birth and baptismal certificates	Percentage of total sample
Angels	37	74
Birds (of a nonreligious nature)	29	58
Wreaths	20	40
Flowers	19	38
American eagle	15	30
Holy Spirit in the form of a dove	15	30
Cherubim	13	26
Musical instruments	13	26
Contemporary infant baptism	12	24
Gothic and ecclesiastical architecture	11	22
Holy tables	11	22
Cross	9	18
Christ with children	8	16
Bible	7	14
Communion chalice	7	14
Pillars	7	14
Contemporary domestic life	5	10
Contemporary marriage	5	10
Cornucopia	5	10
Scene of death	5	10
Hearts	4	8
Ten Commandments: scenes	4	8
Tureens and urns	4	8
Wheat	4	8
Crown	2	4
Pelican feeding young with blood	2	4
Beehive	1	2
Christ as shepherd	1	2
Christ calming the Sea of Galilee	1	2

148 THE WORD IN THE WILDERNESS

TABLE 5 *(continued)*

Type of image	Number of birth and baptismal certificates	Percentage of total sample
Christ in prayer	1	2
Christ on cross	1	2
Christ preaching to disciples	1	2
Christ's birth	1	2
Fountains	1	2
General scene of contemporary childhood	1	2
The Last Supper	1	2
Shepherd's staff	1	2
Tree of Knowledge	1	2

Note: This table is based on a sample of fifty documents. More data about birth and baptismal certificate design and text contents are available on this book's companion website, www.wordinwilderness.com.

Despite an evolution of design and pictorial contents, the birth and baptismal certificate continued to emphasize personal piety and family life cycle. Perhaps no printed birth and baptismal certificate of any period better captures how Pennsylvania's German speakers sought to insert themselves and their families into a narrative of the passing seasons of individual and family life than one printed by Ignatius Kohler in Philadelphia in the mid-1870s. Unlike many earlier pieces, this example is light on text (featuring no spiritual text beyond genealogical data) but heavy on intricate imagery, leaving the document's Christian storytelling to pictures rather than words. And, unlike most early birth and baptismal certificates, this example focuses less on biblical imagery and more on domestic family scenes emblematic of the Victorian era.

The example of the print studied as part of the random sample used in this analysis was carefully colored by hand and filled out for the baby Annora Emma Scheirer in 1871. Four vignettes on the certificate, each depicting archetypes of family life, surround the central text describing the details of Annora's parentage, birth, and baptism. The first vignette shows marriage, with a young bride and groom standing hand in hand at an altar before a clergyman, making the sacramental vows of matrimony. The second depicts a less formal domestic scene, as the young couple, now a loving father and mother, peer over their sleeping newborn baby in a cradle. A dove representing the Holy Spirit flies above the image, adorning the family scene with religious significance. A third vignette pictures the baby's baptism, and a fourth, more

MARCHING TO "STEP AND TIME" 149

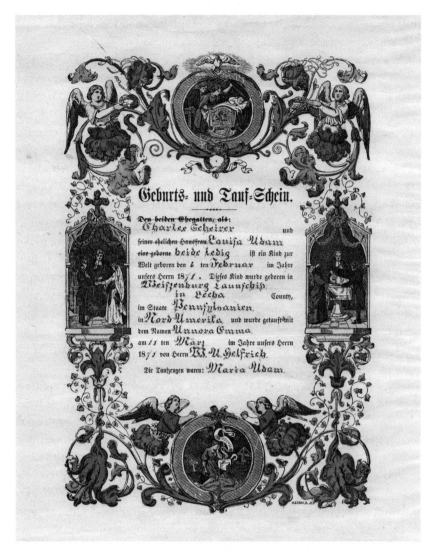

Fig. 32 Geburts und Taufschein for Annora Emma Scheirer, March 11, 1871. 14 × 10½ in. $Am 1871 Geburts 9510.F (Roughwood). Courtesy of the Library Company of Philadelphia.

ominous, image shows a woman (presumably the wife and mother from the other images) weeping over a grave, with a banner reading *aufwiedersehen* (good-bye) waving gently in the wind (fig. 32). This final picture offers a menacing omen for young families, who faced the potential of death around every corner, especially of young children—and a stern reminder to baptize

150 THE WORD IN THE WILDERNESS

children early, even though, according to Lutheran and Calvinist theology, baptism was not by itself a guarantor of salvation.[55]

As a group, the vignettes on Annora's certificates, which are bulwarked by angels, crosses, and Gothic ecclesiastical architecture, place the archetypal family life cycle in a Christian narrative, as similar certificates in German Pennsylvania for generations had already done. But this particular certificate has even more to teach us, about how manuscript inscription can nuance, alter, and even undermine the meaning of a standard printed work. The scribe who prepared the certificate for young Annora crossed out preprinted words that identified a child's mother and father as husband and wife, instead inserting handwritten text that refers to Annora's parents, Charles Scheirer and Louisa Adam, as *beide ledig*, or "both single." These alterations, which appear immediately to the right of the vignette depicting a wedding ceremony, make for a jarring disruption of the print's archetype of pious Christian family life. The hybridity of this printed-and-handwritten document reveals much about the society in which Charles Scheirer, Louisa Adam, and baby Annora lived and how real life could diverge from religious conventions and social expectations.[56]

"The visual culture of nineteenth-century Protestantism participated in a cultural economy in which belief was converted into graphic information and disseminated cheaply over great distances by virtue of a mass-produced medium and an ever-expanding infrastructure of distribution," wrote David Morgan.[57] True as that point may be, the history of birth and baptismal certificates reveals that the dissemination of graphic information was not distinct to the age of print. Nor, for that matter, was print an art and craft entirely divorced from the centuries of manuscript culture that had preceded it. In the case of birth and baptismal certificates, handwriting, illumination, and print technology melded in a fluid and evolving spiritual document type that shaped generations of Pennsylvania Germans' conceptions of self, family, faith, and life cycle—and leaving modern observers with a remarkable record of genealogy and popular piety.

The Pennsylvania German Life Cycle: Other Commemorative Forms

Birth and baptismal certificates were but one way that Pennsylvania Germans recorded family history data. The document genre held special importance to Lutheran and Reformed communities, given baptism's status as a sacrament conferred in infancy in those confessions.[58] Many Pennsylvania Germans— and not just adherents to the Lutheran and Reformed confessions—wrote

family registers on the endpapers of family Bibles and other religious texts, such as Thieleman J. van Braght's *Der Blutige Schau-Platz, oder Martyrer Spiegel* (The bloody spectacle, or martyr's mirror). (A register located on an endpaper in the Mennonite Reist family's copy of the *Martyr's Mirror* features early eighteenth-century family records on one side and notes of a 1744 comet siting on the other.)[59] In fact, Mennonites and other sectarians made especial use of family register practices, more so than their confessional counterparts.[60] Lutheran and Reformed churches kept track of births, baptisms, confirmations, weddings, and deaths in church registers that occasionally featured ceremonial calligraphy.[61] (British Americans also created such registers.)[62]

Pennsylvania German registers quite often were functional in nature, simply lists of names, dates, and notes of filial relationships, not all that different from many Anglo-American examples, except that penmen often inscribed them in Currentschrift. But sometimes the registers reflected the Germans' penchant for stunning calligraphy. One especially revealing example employs a semiotics of color to underscore the joys and sorrows of life and death. Likely crafted in the 1830s or 1840s, the Lädtermann family register reports the marriage of Johannes Lädtermann to Barbara Oberholtzer in 1798 and then lists the names and birthdates of their eight children. The scribe wrote the names in intricate Frakturschrift with bright colors and decorated them with festive flowers. At the time the register was created, six of the Lädtermanns' children survived. For the two who had died, the scribe abandoned bright colors in favor of black ink. The calligraphy, while no less resplendent in its use of the ornament typical to Frakturschrift, lost its accompanying floral imagery. The entry for Sarah Lädtermann, born April 18, 1834, typical with its bright blues, reds, flowers, and vines, is dampened by black text immediately below, which reports her death exactly three months later, on July 18, 1834. Another entry, on a page of its own and written entirely in black Frakturschrift, reads, "A little son was born to us on the 28th of March 1829, who was dead when he came into the world."[63] Compared to the other entries in the family register, the dignified though somber Frakturschrift for this entry communicates something of the Lädtermann family's pain associated with the loss of their *Söhnlein* (little son).

If a birth and baptismal certificate commemorated the beginning of a Christian's life, then an epitaph memorialized the end of one's days. Samuel Bentz crafted a *Grab-Schrift* (epitaph) to mark the passing of Anna Maria Appel in 1846 that combines restrained design with a poem intended to ease the sorrow of Appel's survivors. "Good night all of my children, / Goodnight my beloved husband, / Goodnight all of my siblings, / Good night all of my friends, / Those who know of Jesus' love, / Will not be separated in death,"

the manuscript reads.[64] In Puritan New England, carved grave stones and written elegies "set the self in godly frame," wrote Sally Promey. Such literary and material artifacts—memorials carved on stone—lent coherence and meaning to a Christian life in a cosmological context.[65] The same might be said for Appel's memorial on paper. Germans were not alone in searching for cosmological meaning in death. New Englanders also certainly made use of calligraphy and manuscript illumination to mark moments of tragedy. When Founding Father John Hancock's son George Washington Hancock died in a skating accident in Massachusetts in 1787 at nine years of age, Samuel Adams Dorr made a manuscript tribute in the form of an elegy not very different in layout and sentiment from Pennsylvania German documents, with flowers and comforting religious poetry.[66] The epitaph seems not to have been nearly as common as the birth and baptismal certificate or various pedagogical manuscripts. But between birth and baptismal certificates, family registers, school texts, songbooks, illuminated bookplates, and commemorative pieces such as epitaphs, it is clear that Frakturschrift letters and supporting illuminations could infuse each of the seasons of life with ceremonial and spiritual meaning.

It reveals much of Pennsylvania German culture that records of names, dates, and family events figured right alongside scripture, hymnody, and other devotional literature in the Pennsylvania German manuscript oeuvre.[67] Together they created a theology of the everyday, a literature of the personal. A poem found on the 1844 birth and baptismal certificate of Margaret Elizabeth Wint of Allentown, Pennsylvania, captures the Pennsylvania German spirit of passage through the seasons of life—as well as the comfort and hope offered by Christianity's promise of eternal life.

> Our wasting lives grow shorter still
> As days and months increase;
> And every breathing pulse we tell,
> Leaves but the number less.
>
> Infinite joy or endless woe
> Attends on every breath;
> And yet how unconcern'd we go
> Upon the brink of death.
>
> An inward Baptism of pure fire,
> 'Tis all my longing Soul's desire;
> Kindle in me the living flame;

Baptize me in Jesus' name!
Wherewith to be baptiz'd I have,
This, only this, my Soul can save.

It was the commission of our Lord
To teach the nations and baptize.
The nations have received the word
Since HE ascended to the skies.

Repent, and be baptiz'd, he said,
And thus our sense assists our faith.
And shows us, what his Gospel means,
For the remission of our sins.[68]

Spiritual Life in the Long Era of Manuscripts: The Mennonites of Manor Township

As the large number of surviving examples of Pennsylvania German spiritual manuscripts held by institutions and collectors across Pennsylvania today suggests, there was no dearth of opportunity for early German-speaking residents of the colony-turned-state to collect and read texts either printed or handwritten in Fraktur, including the illuminated spiritual manuscripts that became emblematic of the region's folk art and material culture. And collect they did, especially the Mennonites, Schwenkfelders, and other sectarians for whom illuminated devotional manuscripts seem to have held special spiritual potency. Some even produced their own copies of spiritual literature in manuscript form, wielding color, line, image, and letter as mutually supportive elements of a devotional experience bound up in engaging with meaning-laden texts. Each of the preceding chapters was organized around a particular manuscript genre—penmanship samples, tune books, and birth and baptismal certificates—in an effort to cast light on the cultural environs in which manuscript culture resonated most, namely, schools, churches, and family devotional life based in the home. But in early Pennsylvania, manuscripts did not exist in such tidy analytic categories. To understand the place of the documents in material life and devotional experience requires a more holistic vantage point. Such a perspective can be gained on the banks of the Susquehanna River in Lancaster County, in tiny, agrarian Manor Township, where three interrelated Mennonite farm families stuffed their heirloom Bibles full of devotional prints and manuscripts and created for later generations a

well-preserved cache of literary artifacts that open a window on lived religion in the heart of rural German Pennsylvania. Such manuscripts and related printed documents filled homes across early southeastern Pennsylvania, pulsating with a kind of popular spiritual-devotional sentiment laid bare by the texts that scribes chose to showcase in such artful fashion. Books and documents alone cannot, of course, resurrect the complex spiritual world of the Carli, Hirschi, and Schenck families in eighteenth- and nineteenth-century Pennsylvania. But, if interpreted as a rich artifactual system grounded in religious belief and spiritual devotion, the books and manuscripts evoke the place of neo-Gothic letters and texts in lending color and contour to the experience of Pennsylvania German popular piety.

The Carli, Hirschi, and Schenck families may have lived in the far west of Pennsylvania German country, but their spiritual books and documents suggest that they were well connected within the wider Christian world during the age of evangelical piety in the eighteenth and nineteenth centuries, as well as within a local community of manuscript culture. All three families owned German-language Bibles printed in Switzerland that enjoyed much household use over several generations in Pennsylvania. The practice of treating family Bibles as both record books for family data as well as storage receptacles for collected spiritual documents was common across Christian denomination and sect. The Bibles these families owned—and the collections within the books they curated—thus link them to a well-worn tradition in domestic piety while accentuating the uniqueness of Pennsylvania German typographical, calligraphic, and illuminative practices in their American context.[69] The Carli family, for example, donated their family Bible, a 1744 reprint of the 1536 Christoph Froschauer edition, and the documents housed within it, to the Lancaster Mennonite Historical Society in Lancaster, Pennsylvania, in 1973, more than two hundred years after the family settled in Pennsylvania. Inside the Bible, curators found detailed family records such as elegantly calligraphed endpaper genealogies and manuscript Frakturschrift birth certificates from as late as the 1830s and 1840s. Curators also found two penmanship samples within the Bible's leaves: one for nine-year-old Anna Carli made on March 8, 1775, and one for her ten-year-old brother Johannes made in 1791, reflecting that both boys and girls were exposed to the tenets of spiritual literacy in German Pennsylvania.[70] (A devotional text inscribed to Johannes found in the Bible closely resembles his penmanship sample.)[71] Anna's resplendent sample offered scriptural and apocryphal lessons drawn from the books of Sirach, Psalms, and Revelation before proceeding to a hymn that read, "I am a poor child of man, sick in my heart and blind in eyes,"

touching on the frequent theme of the weakness and fallibility of the human senses.[72]

A host of other printed and manuscript spiritual documents also figured in the Carli family cache and likewise shed light on the Carli family's spiritual world.[73] Small manuscript contemplative pieces combined copious religious text with pictorial imagery to teach Johannes pious lessons.[74] A particularly striking example is a 1791 manuscript that opens with a verse from the Gospel of John, perfectly encapsulating the typical manuscript message of pious living: "If ye know these things, happy are ye if ye do them."[75] Next, resplendent baroque Frakturschrift letters declare, "My hope remains firmly rooted in the living God. He is the best of all who stands with me in all times of need." A verse from the apocryphal wisdom book of Sirach also graces the manuscript, one that echoes the common theme of accessing hidden wisdom through faith in God: "Consider that I laboured not for myself only, but for all them that seek learning."[76] The document's colorful illuminations—including vines, linear patterns, a dove, and an angel, which surround and interlink short texts scattered across the page—lead the eye on a journey of spiritual discovery.

Documents found in the Hirschi and Schenck family Bibles are similar to the Charles materials. Prints and manuscripts found inside the Hirschi volume include a genealogical record, two penmanship samples (including one made in 1808 by well-known schoolteacher and manuscript artist Christian Strenge, when its recipient was twelve years old), a *Briefflein* (short letter) closely resembling a penmanship sample, a marriage certificate from 1836, and broadside featuring lyrics of the hymn "Ein schön Lied zur Aufmunterung eines Christlichen Lebens" (A pretty song for the encouragement of a Christian life).[77] The hymn begins, "He who has ears to hear, mark what I tell you. I want to teach you about my Christ, which may help you a lot."[78] The presence of the printed document intermingled with intricate manuscript copies of religious texts highlights the symbiosis enjoyed by print and manuscript text production during the eighteenth and nineteenth centuries, as well as the fact that both printed and manuscript texts could hold artifactual significance to religious readers. This point is well documented by the prevalence of printed house blessings, intricately designed spiritual games, and other devotionals in Pennsylvania German homes. Like manuscripts, printed texts could, in the words of historian Hermann Wellenreuther, help readers in the process of "learning to be a Christian."[79]

The Schenck family Bible also housed at least two penmanship samples. (One, dated 1767, belonged to eleven-year-old Henrich Schenck, whose father,

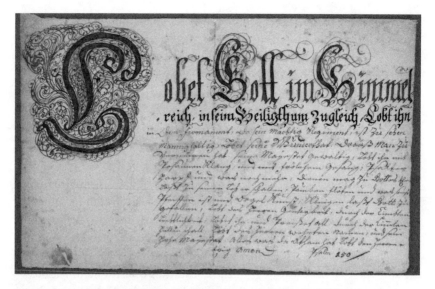

Fig. 33 Manuscript copy of Psalm 150, "Lobet Gott im Himmel-reich," circa 1760. 7½ × 12⅛ in. Shenk (Schenk/Schenck) Family Fraktur Collection, 2006.006. Lancaster Mennonite Historical Society, Lancaster, Pennsylvania. Photo: author.

John, had immigrated to Pennsylvania some years prior.)[80] It also contained uncompleted, penmanship sample–like templates dating to the 1760s as well as an ornately written manuscript copy of Psalm 150.[81] "Praise God in his sanctuary," the psalm reads, urging the faithful to praise God with music: "Praise him with the psaltery and harp."[82] The manuscript's intricate presentation of the biblical text was perhaps its own form of praise—as much a feast for the eyes as the harp was for the ears (fig. 33). The colorful documents tucked into these aged and travel-worn Bibles shed light on a vibrant spiritual world in Manor Township long ago. Their presence in family heirloom Bibles and the association they share with other manuscripts, which we can infer from their shared provenance, renders the assemblages more valuable than the individual books and documents alone would be. Understood simultaneously as word, image, and artifact, the calligraphed Frakturschrift texts of Pennsylvania German religious life went a long way toward constructing the spiritual world their makers and users inhabited. "The significance and power of popular religious imagery resides precisely in its contribution to the social construction of reality," notes David Morgan. "Worlds are constructed of both the ordinary and the extraordinary, and images serve to configure each

aspect of experience."[83] The calligraphed and printed Fraktur texts of Pennsylvania German religious life went a long way toward constructing the literary and spiritual world their makers and users inhabited.

Marching to "Step and Time": The Decline of the Manuscript Tradition

In November 1860 the reverend Dr. Henry Harbaugh, a minister in the German Reformed Church and noted leader of Pennsylvania German cultural life, penned a poem that has become emblematic of the folk literature of the region, titled "The Old School-House at the Creek." In the poem Harbaugh reflects poignantly on his days attending a schoolhouse in the German-dominated rural countryside, reminiscing over his long-vanished classmates and the way of life they had led in the heart of German Pennsylvania.

> My muse has struck a tender vein!
> And asks a soothing flow;
> O Time! what changes thou hast made,
> Since I around this school-house played,
> Just twenty years ago!
>
> Good bye! Old school-house! Echo sad,
> "Good bye! Good bye!" replies;
> I leave you yet a friendly tear!
> Fond mem'ry bids me drop it here,
> 'Mid scenes that gave it rise!
>
> Ye, who shall live when I am dead—
> Write down my wishes quick—
> Protect it, love it, let it stand,
> A way-mark in this changing land—
> That school-house at the creek.[84]

This famous poem has probably resonated so profoundly, and for so long, because it captured what many within and outside of the Pennsylvania German community viewed as the idyllic essence of preindustrial country life, as well as the sense of the fleeting nature of that lifestyle in an era of social change. Harbaugh's innocent existence on the banks of the creek had proven ephemeral. The old schoolhouse he revisited years after his childhood stood

158 THE WORD IN THE WILDERNESS

abandoned. This change spoke to broader social realities; during the years between the poet's youth and his return visit, rapidly modernizing American life had begun to eat away at the edges of the idyllic, insulated German culture the old schoolhouse represented. Harbaugh interpreted this old scene of his youth as a material manifestation of a culture in shift—and an artifact of times gone by that he fervently hoped someone would preserve. Pennsylvania German culture, uniquely situated as it was in nineteenth-century America, nonetheless found itself caught up in the same changes impacting life in the rest of the country, which amounted to nothing less than the emergence of a modernizing American society. The changes in patterns of text production and consumption in the region during the period, which have been commented on in previous chapters, point to broader modernizing forces at work in American culture that held important implications for Pennsylvania German culture.

Many Pennsylvania Germans proved reticent to the economic, social, and cultural shifts that the nineteenth century wrought, but they nonetheless found themselves stuck in the crosshairs of a rapidly evolving society. Penmanship instruction and devotional manuscript making had long represented a meeting point of German Protestant spirituality with the material world of text production and distribution throughout the world. It thus makes perfect sense that, as the economic, social, and cultural context in which the documents had long been made evolved, so too did the tradition of which it was a part. This study has fixated on interpreting the meaning of the religious manuscripts in the era in which they were produced, and it will be left to later scholarship to offer a conclusive interpretation of the decline of the practice and its subsequent reimagination at the hands of collectors and revivalists in the late nineteenth and early twentieth centuries. A few factors seem likely to have exercised especially important influence in the art form's lessening importance, however.

Perhaps the most important reason for the decline of the tradition was the rise of industrial printing. The evolution of printing technology and the publishing business in the nineteenth century was truly phenomenal. For many centuries, between the development of movable type by Gutenberg through the early nineteenth century, bookmaking remained relatively unchanged.[85] Print publishing underwent a massive shift in the nineteenth century, however, as new technologies for the reproduction of texts, as well as new corporate and economic structures, increased the availability and affordability of printed goods. Highly productive iron presses were a nineteenth-century innovation, and numerous aspects of the publishing process became automatized during this period, including the folding of paper, the sewing of a book's

quires, and the adding on of a book's spine.[86] Type could be composed mechanically, no longer requiring the task to be undertaken by hand—a time-consuming enterprise.[87] And methods of text reproduction like stereotyping and electrotyping, which did not even require printing from forms set with movable type to reproduce texts but instead made use of metal casts or chemical processes, upended long-established printing norms.[88] Innovative, chemicals-based image reproduction technologies like lithography and halftone printing continued to develop and alter the visual culture accessible to average Americans.[89] Printing presses themselves came to look, and function, drastically differently from how they had in earlier days. Cylinder presses increased efficiency, and steam technology (often employed in newspaper printing) turned printing presses into high-powered machines fueled by the same force driving locomotives across the American interior.[90] The art of papermaking evolved to meet new demands in light of publishers' increased output.[91] Increased productivity and expanding availability of printed goods allowed for distribution of a cheaper and more abundant product.[92] The most practical reason for hand copying of texts—making them accessible to those without printed versions—became less and less essential as the nineteenth century wore on. As previous chapters have illustrated, Pennsylvania German calligraphy always resonated as much more than a functional means to disseminate texts. But the expansion and sophistication of print technologies as the nineteenth century wore on may have shifted the cultural balance away from the time-consuming, if beautiful, artistic practice of rendering text by hand.[93]

Local politics also likely played a pivotal role in the decline of traditional manuscript culture. A key social and civic reform of the nineteenth century—the public schools movement—held direct ramifications for one of the primary venues in which Germans made and used manuscripts: sectarian country schoolhouses. The English majority in Pennsylvania had a history of trying to convince Germans to join the cultural fold, in terms of their educational opportunities. In the mid-eighteenth century, no less a figure than Benjamin Franklin had joined forces with supporters in Great Britain to encourage the Germans to participate in the foundation of, and attendance at, charity schools sponsored by various patrons in the native country, which ended in the plan's utter rejection by German colonists, who viewed the enterprise as an attempt to encourage assimilation of the Germans into the Anglophone mainstream.[94] Franklin and his compatriots failed because participation in the plan was voluntary; the Anglophone colonial supporters of the plan and their patrons in England lacked the force of law to require German participation in an educational scheme they disliked. Times had changed by the first

decades of the nineteenth century, when the Pennsylvania state legislature possessed the legal authority and, one may assume, a sense of civic duty to make way for free public schools. A common school law passed in 1834, but it took many years for local authorities in German Pennsylvania to acquiesce and establish new schools. In 1854, however, the state passed yet another new law requiring free public schools in all townships, thus bringing a forceful end to any continued reticence.[95] The denomination- and sectarian-based schools that had long functioned as crucibles of devotional manuscript production and exchange no longer figured in the landscape of Pennsylvania German education and spirituality.[96]

Pennsylvania's education politics aside, countless printed books, ephemera, and manuscripts stored in library collections today reveal that American penmanship pedagogy underwent a profound shift in the mid-nineteenth century, in no small part due to the expanding economic opportunities open to Americans and the uses to which penmanship skills could be put. Quickly vanishing were the days when skills with the goose quill (or, in later years, steel nib or fountain pen) were directed primarily toward ideals of beauty and ornament or employed chiefly for the veneration of holy texts. Americans continued to value penmanship, but for profoundly secular reasons, namely, participation in commerce and trade. "There has been no time in the history of this country when Penmanship of all kinds, business and ornamental, was so well appreciated by all classes of people as it is to-day," noted George A. Gaskell in *The Penman's Hand-Book* in 1883. That "all classes" appreciated handwriting in this supposed golden era of penmanship meant that more enjoyed access to education than had in years past and presumably possessed reasons to cultivate a fine script. While Gaskell does mention the popularity of ornamental penmanship, he saves his highest praises for its simpler, more efficient hands. "The easy, graceful pieces of our own American penman will be liked best, no doubt, by all of our younger patrons," Gaskell asserted. "In rapid off-hand work, comprising pen flourishing and practical writing, America leads the world"—just as America increasingly led the world in commerce and industry. "These grace[ful] lines, simple as they may seem to the school boy of our own country, have never been equaled by any of the penmen of Europe. Perhaps it is the air of this free Republic that gives breadth of curve and strength of stroke, and grace, and harmony, and all that make such pictures at all pleasing. Certain it is that the art seems to be native to the soil, and can be found in its perfection nowhere else."[97]

Evolving approaches to handwriting instruction reflected the values and social realities of a new age. A book titled *Theory and Art of Penmanship: A Manual for Teachers*, published in Boston in 1864, outlines appropriate

methods for teaching writing in this era and sheds light on forms of social control associated with the commercialization and industrialization of the American economy. "In teaching writing it will be found of the highest importance to have the class under perfect discipline," the manual noted in a chapter titled "On Drill and Counting." The book continues, "As the mind is very materially influenced by the body, accuracy of position and precision of movement tend greatly to promote it." The manual offered a pointed defense of its method of classroom control. "It has been objected to this, that we cannot expect those who are full of nervous excitement to write at the same rate as those whose temperament is dull and lymphatic," the manual stated, "that it is not right thus to retard the rapid, and urge on so fast the slow; that nature has established certain differences which we ought to respect." The student, the manual explained, "is part of an acting body. . . . There is an immensely powerful and tranquillizing effect upon each member of a disciplined body, owing to the very massiveness of united action." The book featured formulas for the construction of letters that seem more at home in an algebra textbook than a writing manual, noting that students could be taught to act in "step and time" to achieve good penmanship.[98] More closely resembling the drill sergeant or factory supervisor than the compassionate Mennonite Christopher Dock, the writing master in *Theory and Art of Penmanship* ensures the obedience, discipline, and productivity of students. The immensely popular and influential *Spencerian Key to Practical Penmanship*, which dominated handwriting instruction for many years in the mid- to late nineteenth century, advocated "chirythmography," or "application of measured time as an agent in securing regular and free movements in penmanship," as a teaching tool. The book's section on chirythmography is accompanied by a large picture of a metronome.[99]

The young United States' leadership role in a developing penmanship pedagogy that emphasized ease of learning and speed of hand resulted in a delicious irony in the transatlantic history of German and American scripts. A trade group published a "North American rapid writing method" in Germany by 1839, applying principles of austere and efficient penmanship to one of the very German scripts that penmanship samples and other ornate, pious documents had long taught in both central Europe and southeastern Pennsylvania. Like other new penmanship methods in Europe and America, the book emphasized step-by-step instruction in simple, utilitarian letter forms.[100] A German reviewer hailed the book's departure from the increasingly antiquated Vorschrift form that had so long found favor in Europe: "At the minimum, the teacher will be able to better educate his students in penmanship compared to the usual method, where a student is given a penmanship sample

162 THE WORD IN THE WILDERNESS

[Vorschrift], which he or she copies or not, is observed or not, and where the completion or production of the piece is more important or valued than learning to write properly."[101] In visual aesthetic and teaching method, the book, which the author, G. B. Clauß, dedicated to the craftsmen of the German city of Chemnitz, could hardly have been more different from the penmanship samples once made in large number on both sides of the Atlantic.

German-language use also gave way during this period, as Mark L. Louden documents vividly in *Pennsylvania Dutch: The Story of an American Language*. Prominent members of the state's German community had long called for the Germans' adoption of the English language and, to a certain extent, Anglo-American customs that would ease their participation in civic and commercial life in a nation state that employed English. "English is and will remain the language of the country," observed Frederick Augustus Conrad Mühlenberg (1750–1801), the United States' first Speaker of the House of Representatives, as early as 1790. "Even in this state, where the most Germans live, we make up barely a third of the population. By what right or justification may we expect the majority to accommodate us, the much smaller minority?" As time would tell, sectarians (especially the Amish and Mennonites) would hold on to the German language longer than members of the mainstream German Protestant denominations. Descendants of speakers of High German quickly lost the language, though the Anglo-German hybrid "Pennsylvania Dutch" dialect continued to thrive in rural areas.[102] The decline of German language moved especially quickly in the mainstream confessions. In 1817 Anglo-German linguistic tensions flared in the form of a high-profile controversy over the use of English in Lutheran church services in Philadelphia.[103] Even among those who retained use of the German language, its use was confined to religious purposes—a telling development in the Pennsylvania Germans' shifting cultural circumstances. Only learned people in the community employed German as an active tool for composition; typical members of the community used English in their writing. German-language education for children in community schools was spotty. Rural people who sought improvement in their social standing sometimes abandoned their country ways—including the German language and its regional dialect—and went to the cities.[104]

Visual evidence suggests that the decline in language proficiency also impacted penmanship skill and manuscript aesthetics. As German language itself became less familiar, so too did complex Frakturschrift, Cantzlei, and Currentschrift letter forms, as well as the ornamental stylizations that accompanied them. The works of the Mennonite Henry S. Bower, which

date to the period under consideration here, offer fine case studies. Bower, who lived from 1836 to 1908 and in adulthood became a prominent pastor, genealogist, and historian, was just a boy when he made the two penmanship samples pictured here—one in German in the neo-Gothic scripts; the other in English, presented in Graeco-Roman scripts ornamented in a flowery Frakturschrift style.[105] Even in the 1850s they constituted something of a throwback to an earlier moment in Pennsylvania German education when the penmanship sample resonated as an active pedagogical form. Together they represent a pivot point in the history of language and manuscript culture and show how shifts in language, scripture, and culture interacted.

Bower wrote the earlier of the two in Frakturschrift in 1853. It begins, as so many Mennonite penmanship samples of earlier eras had, with a quote from an apocryphal book, in this case the book of Baruch. "Rise up, Jerusalem! stand upon the heights; look to the east and see your children gathered from east to west at the word of the Holy One, rejoicing that they are remembered by God," the document reads.[106] A decorative border bifurcates the document, and Bower offers hymn lyrics below the teaching from Baruch, rendered in Currentschrift. Bower likely drew the text from that famed and omnipresent Mennonite classic, *Das Kleine Davidische Psalterspiel Der Kinder Zions* (The little Davidic psalter of the children of Zion), in which the hymn appeared.[107] Bower cited the source of the hymn he quoted, unlike Mennonite penmanship samples of an earlier period. In most ways the textual content of this work closely resembles its forebears, even if Bower betrayed his scholarly interest by carefully citing his sources.

It is the nature of the calligraphy and illumination, however, that merits special attention. The young Bower's Frakturschrift, while skilled, is shaky, and the floral illuminations only resemble earlier manuscripts in a conceptual sense. The colors on the document vary dramatically from earlier iterations—perhaps a consequence of the art supplies available to the child—and the Frakturschrift letters themselves lack the precision of Pennsylvania's early masters of the neo-Gothic scripts. Its design suggests that this penmanship sample amounts to a resurrection of a form no longer in active use in southeastern Pennsylvania (fig. 34).

An English-language document made by Bower two years later, in 1855, possesses much the same ornamental aesthetic as the German document, minus the neo-Gothic scripts, and illustrates the application of the penmanship-sample form to another language and another type of text. The colors and floral ornament are identical to the German-language, neo-Gothic document. But the hymn, "Hear the Royal Proclamation," was written by the American

Fig. 34 Henry S. Bower, Vorschrift, 1853. 12 × 15⅞ in. 1999.11.12. Courtesy of the Mennonite Heritage Center, Harleysville, Pennsylvania. Photo: author.

Baptist Wilson Thompson and appeared in revivalist hymnals of the nineteenth century.[108] "Here is Wine and Milk and Honey, come and purchase without Money, Mercy like a flowing Mountain, Streaming from the Holy Fountain," the manuscript reads. In Bower the old German baroque aesthetic traditions came face to face with the American evangelical revival (fig. 35). The documents together record a point of fusion of continental early modern German Pietism and American Protestant revivalism in the age of evangelical piety.

The seasons of life come and go, and, as generations pass, old ways fade. Once-vibrant traditions come to an end or evolve to meet the changing times. The calligraphy and manuscript practices common among early German-speaking residents of southeastern Pennsylvania were no exception. Fraktur typography, neo-Gothic scripts, spiritual calligraphy, and text-based folk art never vanished entirely from the region where they took root. The Schwenkfelder Magdalena Schultz Krauss, for example, presented her granddaughter a copy of a book on Caspar Schwenckfeld in 1888 that she had acquired in 1832—a transfer of ownership recoded, celebrated, and preserved for future

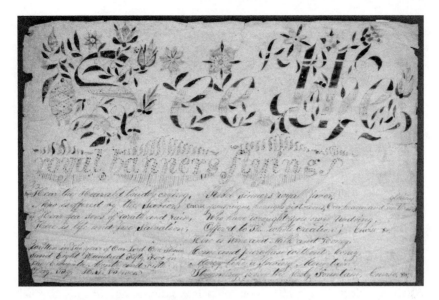

Fig. 35 Henry S. Bower, Vorschrift, 1855. 8 1/16 × 12 1/2 in. 2006.26.1. Courtesy of the Mennonite Heritage Center, Harleysville, Pennsylvania. Photo: author.

generations with two beautifully illuminated calligraphic bookplates.[109] In 1939 Mennonite artist John Derstine Souder created an artwork modeled on an 1835 piece by the Mennonite schoolteacher Samuel Gottschall, one of many such works by Souder that have earned him the reputation as a revivalist artist.[110] The work features the quote from Gerhard Tersteegen's *Geistliches Blumen-Gärtlein* that claims "little flowers" were "planted in the paper."[111] But after 1850 or so, Frakturschrift manuscripts reminiscent of the central European baroque receded from their once-prominent place in Pennsylvania German spiritual life.

CONCLUSION

"Errand into the Wilderness": Making Meaning from Manuscripts

At three o'clock in the afternoon, on a late summer day in 1916, Samuel Whitaker Pennypacker died. The former governor had fallen ill the prior year, after breaking his arm while rolling over in bed. He never fully recovered from that accident and spent months in a hospital and at the famous coastal resort town of Atlantic City, New Jersey, where he retreated to breathe in the sea air. Perhaps sensing a decline in his condition, the statesman, historian, and bibliophile eventually returned home to his ancestral estate of Pennypacker Mills, confined to a wheelchair as he transferred trains on the journey into rural Pennsylvania. Pennypacker's physician released a statement to the press on the evening of August 27, 1916, announcing that the governor was beset with renal failure "and is considered in a critical condition." The *Philadelphia Inquirer* reported the fateful news the next day, running a headline: "S. W. Pennypacker, Former Governor, Dying at His Home."[1] Pennypacker's children and grandchildren descended on the family seat, where, with Pennypacker's wife, Virginia, they awaited the great man's fast-approaching demise. It came on September 2. Thus ended the life, in the words of the *Philadelphia Inquirer*, of "one of the most unique figures of his day and generation in the life of his own State."[2] How fortunate for Pennypacker's historical legacy that he died when he did. Had he lingered much longer, he might well have been labeled a traitor.[3]

During Pennypacker's yearlong illness, the old international order was losing its grip as Europe's great imperial powers battled in a bloody world war, and the specter of coming conflict hung over the United States of America. The last decades of the nineteenth century and the first years of the twentieth had witnessed the rise of the German Empire as a leading political and

military power, one that many Anglo-Americans viewed as a threat.[4] The new German Empire had no real political connection to the legions of early modern German speakers who had poured into the colony a century and a half prior and whose descendants (and the German dialect they spoke) had become widely known as "Pennsylvania Dutch" by the twentieth century.[5] But, as American public sympathies tilted toward the British side of the war, an increasingly ill and feeble Samuel Pennypacker publicly voiced the Germanic pride that had long undergirded his personal identity, scholarly interests, and Pennsylvania German collecting program—expressed now as sympathy for Kaiser Wilhelm's empire and a strong wish that the United States not intervene on the side of the United Kingdom. In a January 15, 1916, *Philadelphia Inquirer* editorial titled "In Defense of Germany," Pennypacker questioned conventional Anglo-sympathetic attitudes about the war. "There has been much written in America concerning the European war, but unfortunately most of the productions upon this subject, like the . . . lurid outbursts of Theodore Roosevelt, are simply emotional appeals based in the main upon such incidents as the overrunning of Belgium, the sinking of the Lusitania and the punishment of Miss Cavell [an English nurse shot by the Germans] for aiding the enemy," Pennypacker wrote, dismissing events still today interpreted as acts of geopolitical aggression.[6]

A deep suspicion of, and antipathy toward, Great Britain undergirded Pennypacker's opinions on world affairs—feelings rooted in the historian's sensitivity to crimes supposedly committed by the British on Americans during the Revolution and the War of 1812. "Spencer and Darwin long ago pointed out that the struggle for existence is most fierce between those species which are closely allied in blood," Pennypacker wrote. "Britain is hostile to us because she knows that we both want the same things. She showed that hostility when she burnt our Capitol." Never before in history had Americans engaged in martial warfare against the Germans, Pennypacker noted. The same could certainly *not* be said of the British, whose interests were, quite literally, burned into America's—or at least Pennypacker's—memory.[7]

This point led Pennypacker to his editorial's most remarkable—and sensational—claim: that a British loss in the ongoing conflict might finally open the door to the United States' acquisition of Canada. "If the Germans win, then in all probability, Canada, with the Great Lakes, the St. Lawrence River, and the Manitoba Wheat fields, which the British wrenched from us in the Democratic days of Polk, will enter the union of the States," Pennypacker, an ardent Republican, proclaimed. "What Charles Carroll [a signer of the Declaration of Independence who worked to persuade the French Canadians to join in the American Revolution] tried to accomplish during

the Revolution and would have succeeded in doing had it not been for the Canadian dislike of the Puritans of New England, will have been realized and the hope of Washington and the patriots who founded the government be fulfilled." Thus the United States might achieve its thwarted destiny, more than 130 years after the Revolution ended. "And we shall owe our disenthrallment upon the seas and our relief from a danger which has often threatened us in the north, not to our own foresight and endeavors, but to those of Germany."[8]

Pennypacker's commentary ignited a political firestorm and nearly resulted in his ouster from the presidency of the Historical Society of Pennsylvania.[9] But the perspective on world affairs that Pennypacker espoused makes perfect sense for a man who, first, was an immensely proud descendant of early German-speaking immigrants to colonial America; second, was convinced that Germans possessed distinctive character attributes that contributed to the United States' civic experiment; and, third, was, by virtue of his lifetime of historical scholarly and collecting pursuits, as much a resident of the era of George Washington as the era of Woodrow Wilson, at least in personality and historical imagination. A sick and frail man in 1916, Pennypacker had been born into the robust early days of the republic, just a few generations removed from the settlement of colonial Pennsylvania by German-speaking sectarians and at the tail end of the renaissance of the spiritual calligraphy and manuscript illumination traditions that he studied. Pennypacker's thoughts and perspectives on the world were shaped by the stories of his ancestors, the artifacts of early German settlement in southeastern Pennsylvania, and the contributions he believed Pennsylvania's Germans had made to the American nation.[10] He simply could not envision a modern world in which a German Empire posed a greater threat to the United States than the British Empire did. So it was fortunate indeed that Pennypacker died in 1916, before he witnessed Germans and Americans at war and before he faced the agonizing decision of choosing where his loyalties and affections would lie.[11]

The story of Pennypacker's dissonant political beliefs shows that the governor's life straddled two interconnected yet remarkably different worlds. The religious and linguistic culture of German Pennsylvania shifted just as dramatically during this period as the United States' political and diplomatic culture had. In 1816 German-speaking residents of early southeastern Pennsylvania, many of whom adhered to separatist religious sects grounded in the theological conflicts of the Protestant Reformation's early days, made religious manuscripts that today seem to exude a decidedly premodern character, with their Gothic scripts and one-dimensional pictorial illuminations. One hundred years later, in 1916, the main events of the twentieth century

were well under way, and a recognizably modern United States of America had begun to take shape. As a historian and collector, Pennypacker documented the decline of a spiritual manuscript culture that lost its hold over German-speaking southeastern Pennsylvanians, as modernity and all it entailed reshaped the region's linguistic and cultural landscape. Industrial printing vitiated the need for manuscript text production.[12] German-language use declined among the descendants of early America's German-speaking immigrants. Separatist religious tendencies tempered among all but the most conservative Pennsylvania Germans, namely, the Amish and Old Order Mennonites.[13] The region's spiritual manuscripts entered a new phase of their existence, becoming historical artifacts rather than active components of spiritual life.

Following Pennypacker's death came the dispersion of much of his collection. The executors of his estate worked with the Philadelphia auction house of Samuel T. Freeman and Company to undertake a sale of many of the late governor's Pennsylvania-related books, manuscripts, artworks, and artifacts, on October 26 and 27, 1920.[14] (The sale of Pennypacker's book collection had already begun years earlier, between 1905 and 1909, when he worked with Davis and Harvey auction house to liquidate his holdings.)[15] Since Pennypacker's day, much has been made of the manuscripts that he and others of his era had made study of: their makers, their design, and their contents.[16] Despite this attention, one area of inquiry has remained sadly underexplored: the manuscripts' meaning.

Men like Samuel Pennypacker and Henry Mercer saw books, manuscripts, and objects of Pennsylvania's German past as raw material for the construction of a narrative of early American history less focused on English influence. The story of Pennsylvania's early ethnic, religious, and linguistic diversity emerged as centrally important to American history as told from Pennypacker's perspective. In recent years, in-depth, microhistorical analyses of Pennsylvania German material culture, and illuminated manuscripts in particular, have contributed greatly to our knowledge of scribes, manuscript recipients, and the makeup of the documents themselves. But studies of that nature have taken precedence over any programmatic consideration of what that manuscript tradition, taken as a whole, really means and why anyone other than specialists in Pennsylvania German artifacts should care about it. Pondering questions of the manuscripts' meaning, religious scholar Peter C. Erb decries the tendency of modern commentators to downplay the artifacts' possible significance beyond just their decorative qualities. "Initially, it might seem to students of folk-art that such reflections are foolish, that one should remain satisfied with description alone, with the work of art for its own sake, that

170 THE WORD IN THE WILDERNESS

there is no need to consider the ends toward which artistic themes were directed," Erb states. "Is it, indeed, possible for contemporary secular appreciation of this art form to make any judgement whatever regarding the 'meaning' of a piece outside of our contemporary cultural context, that is, are we forced to understand the 'value' of these pieces solely in terms of their escalating market cost or as nostalgic indicators of an illustrious cultural ancestry?"[17] Clearly, a need exists for new, critical perspectives on the manuscripts studied in this book, as Erb describes. But how do historians take the step of actually making meaning from Pennsylvania German material culture?

Forging a Pietist and Sectarian Paradigm: Pennsylvania German Manuscripts and Popular Piety

When studied in the context of transatlantic German religious history and the broader manuscript world of the early modern period, Pennsylvania German devotional manuscripts seem far more complex—and far more significant—than most of the current scholarship on the topic might suggest. They record the transmission of mystical, Anabaptist, and pietistic devotional culture from central Europe to the rural hills and woods of colonial Pennsylvania, where it took root and blossomed for a century or more. They are artifacts of the spread of Christian teachings and associated manuscript culture into the wilderness of seventeenth- and eighteenth-century North America. Unencumbered by a Calvinistic fear of ornament, but proud practitioners of a Word-based faith and erstwhile residents of a region of Europe infused with the aesthetics of the Gothic and the baroque, German Pietists reveled in the material form their devotion could assume by means of illuminated manuscripts. Understanding their manuscripts and other religious texts as relics of lived spiritual experience helps us forge a Pietist and sectarian paradigm through which to consider the mid-Atlantic region's religious history, opens the documents to new interpretations, reveals the importance of the Word to manuscript makers' and users' everyday lives, and more effectively illuminates the cultural roots of early American society. The richness of the Pennsylvania German manuscript illumination tradition, and the relevance of those sources to the study of early American religion and society, has been established in the foregoing chapters. But what do these insights offer by way of fabricating a paradigm for historical analysis through which to interpret these documents and other sources of the early American experience?

When viewed from a wide perspective that encompasses the various, closely intertwined evangelical movements afoot in the eighteenth- and early

nineteenth-century Atlantic world, there emerges a certain coherence in the Christian spiritual searching of the era. Continental European pietistic traditions figured prominently within that searching, more so, perhaps, than historians of early American religion have traditionally been inclined to acknowledge.[18] Bringing a broad religious-historical perspective to the study of Pennsylvania German devotional manuscripts allows for valuable comparison of different Protestant groups who searched for spiritual experience during an age of rich evangelical piety. The theological perspective of New England Puritanism, which has often been privileged in the study of Protestant Christianity's impact on American culture, is fundamentally one of human helplessness before God's judgment, and a short-lived corporatist approach to Calvinistic social governance. The story of Pietists in Pennsylvania suggested in this book is one of radical spiritual individualism on the part of religious pioneers who sought emotional, at times mystical, spiritual experience. Pietists, radical sectarians, Quakers, and other spiritualists who lived in the mid-Atlantic frequently bumped into other Christians who practiced faiths different from their own but somehow made do—an experience common in American life for centuries to come. If the Puritan paradigm helps explain the United States' sometime notion of itself as God's country, then the Pietist and sectarian paradigm previews key elements of the American spiritual and social experience like diversity and tolerance, which have reverberated since early days. The historical paradigm pushes beyond the borders of one colony or region, however, to allow for comparison to the religious life in other regions during a time of spiritual revival in the European world. Germans tested out ideas of radical personal spiritual agency rooted in Anabaptism, mysticism, and continental European Pietism that presaged and paralleled the revivalist "awakenings" historians have often studied in relation to Anglo-American communities. The manuscripts made in Pennsylvania provide remarkable firsthand evidence of how ordinary early Americans nourished their spiritual welfare through biblical literature and devotional texts.

How does this approach to the manuscripts contribute to broader conversations about religion in early America? It does so in two ways. First, analyzing the manuscripts as literary-spiritual relics shows how active Pennsylvania Germans were in shaping their own spiritual experiences through calligraphy and manuscript illumination, offering up fascinating sources to compare to other, especially Anglo-American, spiritual communities. Second, acknowledging the importance of European religious-historical context to grasping the aesthetic, social, and spiritual foundations of the documents requires a shift in how historians of early America tend to narrate its religious

history. Plumbing the depths of the literature included on the manuscripts, the designs scribes employed on them, and the pietistic and sectarian spiritual fervor that infused many Pennsylvania German denominations and sects requires centuries of historical context, making the establishment of William Penn's colony and its peopling with German-speaking settlers only one in a lengthy series of the Protestant Reformation's consequences. The establishment of Penn's colony was important to the long history of the Protestant Reformation, for its encouragement of the peaceful coexistence of confessional and sectarian Protestant communities side by side, which allowed the Pennsylvania German manuscript arts to flourish. The makers of German-language spiritual manuscripts in southeastern Pennsylvania lived in an era of immense transition in the material production of texts, as manuscript culture only gradually gave way to print publication, which possessed its own ability to deliver spiritual experience. The documents were thus the products of a unique moment in the history of text production and lived religion that reflect both a centuries-long transatlantic past and the coming of a very different future.

The significance of Pennsylvania in the American story has long been a subject of debate. In a 1910 book titled *Pennsylvania in American History*, Samuel Pennypacker served up a robust argument for why Penn's commonwealth deserved a more prominent position in the United States' national origins story than it had recently been given at the hands of New England's partisans. In a scathing rebuke of Massachusetts's predominance in the cultural history of the United States, Pennypacker reminded readers where American religious tolerance had its true origins—at least in his estimation. "The constitution of the United States provides for the free exercise of religion and against the establishment of any creed by law," Pennypacker observed. "Perhaps no other of its provisions more distinctly marks the divergence between the American idea of the province of government and that of European nations, and more broadly separates the present from the past." He continued: "Where in America did that view of life originate, and when it became a part of fundamental law, which community triumphed and which succumbed? Penn in his frame of government declared that government was 'as capable of kindness, goodness and charity as a more private society,' and he invited to his province people of all creeds," the former governor of Penn's commonwealth observed. "Massachusetts, founded as a theocracy from which all who dissented from the established beliefs were expelled, in accepting the principle embodied in the constitution, abandoned her own ideals and adopted the doctrines inculcated and practiced in Pennsylvania."[19]

CONCLUSION 173

Pennypacker may have balked at the tendency to lift up New England as the cradle of American virtues, but that perspective dominated discussions of American religious history for a few generations after the governor's death. Most notably, Harvard University's Perry Miller hailed the New England Puritans' "errand into the wilderness" for laying the seedbed of American civic culture.[20] Miller's scholarly quest to understand the "architecture of the intellect brought to America by the founders of New England" mattered so deeply to him and others not just because of its innate interest but because it was deemed the cornerstone of the entire American psyche.[21] Today historians of American religion widely recognize the mid-Atlantic region as more representative of the spiritual diversity that later came to characterize American culture than early New England was, but, sadly, Pennsylvania has wanted for as bewitching a chronicler as Miller and his acolytes proved to be for the Puritan colonies.[22] Even today the literary lives and material texts of New England Puritans attract much attention from academic historians and literary scholars, while book-historical scholarship centered on other regions, languages, and spiritual traditions pales by comparison.[23] The perceptive Governor Pennypacker noted that Pennsylvania could "receive due credit for her unequalled influence and achievement" only if the state's "writers and talkers" peered through the divisions and distinctions separating the ethnicities, denominations, and sects that called Pennsylvania home, to advocate for the state's global significance.[24] German-language illuminated spiritual manuscripts offer a powerful tool to craft an engaging story about Pennsylvania's internationally significant early religious renaissance and what that blossoming of religious diversity means in the grand narrative of early America's ethnic, linguistic, and spiritual history. The manuscripts reveal how early modern German speakers transported deep and sophisticated traditions surrounding the Word of God and other holy texts into the Pennsylvania wilderness, where they crafted artworks that today open a window on a long-vanished spiritual world.

The Word in the Wilderness: A New Method for Pennsylvania German Manuscript Study

Achieving a new perspective on early American religious history through handwritten Pennsylvania German spiritual texts requires understanding the nature of manuscript production in early America. The documents can easily be dismissed as provincial folk art or even mindless copies of preexisting religious texts. Both perspectives fail to do justice to the manuscripts'

intellectual sophistication. We have already seen that their literary contents and aesthetic design expand our understanding of how early Americans participated in the construction of their religious and spiritual lives. They also encourage us to take a second look at our assumptions about handwriting and manuscript publication. The most prominent scholars who have explored early American literacy and penmanship instruction agree that the hand copying of preexisting texts represents a form of intellectual oppression. Even a cursory glance at Pennsylvania German illuminated manuscripts suggests otherwise—by showing that proficiency in copying could equip early Americans with creative ability and spiritual agency. Imbued with Pietism's high regard for personal spiritual literacy, writers practiced a form of scribal authorship that allowed them to vest familiar spiritual texts with personal meaning. Understanding Pennsylvania German manuscripts primarily as spiritual artifacts and their composition as a form of creative scribal authorship offers a new path forward in studying the sources.

The social and cultural history of handwriting in early America is an emerging field, but two of its greatest exponents have agreed that penmanship instruction grounded in religious doctrine and commercial training, which was undertaken largely by means of text copying, forced scribes into intellectual and artistic submission. According to E. Jennifer Monaghan in *Learning to Read and Write in Colonial America*, "When children wrote, they were supposed to focus on elegant and exact letter formation while they copied the precepts of others, and when they spelled, it was as if the sole function of spelling were to list letters in a predetermined order. This pedagogy treated writing as if its only purpose were to be the conduit for the thoughts of one's elders," not any sort of creative expression or self-driven intellectual and spiritual exploration."[25] Similarly, in *Handwriting in America: A Cultural History*, Tamara Plakins Thornton notes that the "practice of copying penmanship models shaded into a generalized habit of copying by hand":

> Colonial Americans copied sermons and lectures, passages from medical books and legal writings, poetry and essays. Print copies of these texts were nonexistent, scarce, or expensive, so that copying made practical sense. But the practice of transcription also reinforced the notion of reading as the passive inscription of authoritative texts into one's inner being and of writing as the subsequent copying of those texts. If reading was the internalization of received truths, then writing was simply its reexternalization. Few members of society ever went beyond an understanding of writing as copying or transcribing to the practice of original composition.[26]

These conclusions seem reasonable from a late twentieth-century perspective on the nature of academic freedom and intellectual inquiry, but we ought not to apply more recent pedagogical goals and understandings of authorship to the teachers and scribes of centuries past. Who decides, for example, what constitutes "original composition"? Pennsylvania German manuscripts suggest that hand copying and original composition were not mutually exclusive enterprises during the long era of manuscripts. Pennsylvania German scribes who crafted spiritual manuscripts assembled texts from a variety of sources, exercising a sort of authorial agency in linking scriptural and literary excerpts through calligraphy and illumination.

In a strictly theological sense, Pennsylvania German devotional manuscripts represent an imperfect compromise between unmediated, internal spirituality and the desire for external sensory aids to religious experience—an ornamented approach to text-centric Protestantism. The manuscripts should be interpreted as external artifacts of a fundamentally internal spiritual experience. At the very least, ornamental letter forms and illuminations employed on religious manuscripts served as pedagogical devices, focusing attention on the messages of wisdom and grace delivered by the text selections scribes showcased and embellished. At most, ornamental Frakturschrift letters and supporting illuminations served as devotional images, revealing the wisdom bound up in holy texts through the words' visual grandeur and artifactual presence. The purpose here is not to insist that all Pennsylvania Germans interpreted the documents in one way but rather that the documents themselves figure in a long history of text-based Protestant popular piety and should be studied in this light.

A research agenda grounded in lived religion, intellectual history, and history of the book may seem like quite a change compared to the current state of the Fraktur field, but it has its roots in observations made by celebrated historian and folklorist Don Yoder forty-six years ago. In his 1974 *Mennonite Quarterly Review* article, Yoder called on scholars to look beyond collecting and displaying manuscripts to focus on teasing out their meaning. "I applaud the collecting as a first step," Yoder noted, but to venerate manuscript art primarily for its aesthetic qualities, to "frame it in period frames and hang it on our walls for decorative purposes," did not make full use of its research value. Engagement with the documents as literary and anthropological evidence was in order, Yoder concluded. "The values of the culture of our Mennonite forefathers would become obvious to us from fraktur, even if we had no hymnbooks and prayer-books and other pieces of devotional literature to go by," he noted. Yoder recognized then, as we should today, that "the key to the fraktur lies in the texts." He offered up a tantalizing new question to guide

manuscript study: "What can these silent pieces of fraktur tell us of the Mennonite life, the Mennonite faith, the Mennonite world view of our eighteenth- and nineteenth-century forefathers? This should be our real task."[27] Yoder's question still resonates today because it has not been fully answered, for the Mennonites or other groups. To address it this book has proposed a framework for understanding the Word in early Pennsylvania German life that recognizes, and reckons with, texts' multiple roles as abstract communication systems, visual artworks, and material artifacts.

Analysis of Pennsylvania German illuminated spiritual manuscripts from a religious, book-historical perspective reveals that the artifacts abounded in a creativity reflective of scribes' generally high level of technical skill and literary prowess. The calligraphers were true artists who followed models but imbued creations with distinctive character, perhaps reflective of the recipients' perceived needs and tastes. Given the energy and talent that went into creating ornate and colorful manuscripts, it seems unlikely that scribes intended their documents' readers to engage with the manuscripts simply as an exercise in unthinking obedience. The literature included on the manuscripts and their careful visual composition point to the texts' role in kindling love of God and setting students on interior journeys toward wisdom and grace. For some readers and scribes, such as the Ephrata brothers and sisters, schoolteachers like Christopher Dock, members of the Schwenkfelder Heebner and Schultz families, and the Mennonite residents of Manor Township, copying sustained creative spiritual exploration and artistic endeavor across the life span. Scholarly interpretations of authorship must address historical manuscript cultures grounded in epistemological and spiritual expectations quite different from those of our own time. The preceding chapters have modeled a way to make sense of the documents by linking close study of individual examples to relevant data about the social, cultural, spiritual, and material worlds in which they were made and used. Doing so has revealed the artworks as manifestations of faith that functioned simultaneously as image, text, and material artifact. This simple yet foundational interpretation opens new avenues for scholars to use the documents.[28] "Christianity has created language," wrote German theologian Friedrich Schleiermacher. "From its very beginning it has been a potentiating linguistic spirit."[29] Devotional texts, and the material vessels constructed from ink, pigment, and paper that made those texts accessible to readers, are some of Christianity's most poignant artifacts. If understood as contemplative spiritual artworks culled from diverse literary, scriptural, and visual sources, then Pennsylvania German religious manuscripts likewise seem, in the words of 2 Corinthians 3:3, "written not with ink, but with the Spirit of the living God."

NOTES

PREFACE

1. Vorschrift des Steffen Barandun von Feldis, 1743 (reproduction), Staatsarchiv Graubünden, Chur, Switzerland, B/N 0647.

2. Andreas Kolb, Notenbüchlein for Anna Funck, 1788, MHC, 2016.05.01.

3. Jacob Strickler, Vorschrift, Massanutten, Shenandoah County, VA, February 16, 1794, WM, 1957.1208A.

4. "Writing Exercise," Pennsylvania German Collection of Fraktur Manuscripts and Imprints, Rare Book Department, FLP. English translation provided on the FLP digital collections page.

5. Weiser, *Gift Is Small*, 78.

6. Ussher, *Method for Meditation*, 4–5, 9.

7. Vorschrift des Steffen Barandun von Feldis, 1743. To communicate the verse's rhyming, poetic quality, it has been rendered in translation in rhyming English verse.

8. Vorschrift for Hans Theiß, February 28, 1741, RM, 1971.891.

9. For a systematic and insightful overview of the state of the field, see Minardi, "Fraktur and Visual Culture," in Bronner and Brown, *Pennsylvania Germans*, 264–80.

10. Vorschrift des Steffen Barandun von Feldis, 1743.

INTRODUCTION

1. Erb, "Garden in Schwenkfelder Fraktur," 12; "Fraktur"; Shelley Langdale, email to author, October 11, 2017; Joel Alderfer, email to author, October 10, 2017. The Schwenkfelder Library and Heritage Center and Free Library of Philadelphia, two of the best-known collections of the manuscripts, each own around a thousand examples. The Philadelphia Museum of Art owns four hundred documents, as does the Mennonite Heritage Center in Harleysville, Pennsylvania.

2. See, for example, Yoder, "European Background," in Amsler, *Bucks County Fraktur*, 15–37.

3. Parsons, *Pennsylvania Germans*, 245–46; Swank, introd. to Swank, *Arts of the Pennsylvania Germans*, vii.

4. A good example of a renowned monograph that mentions Pennsylvania German spiritual traditions but does not explore them in depth is Butler, *Sea of Faith*.

5. Pennypacker, *Autobiography of a Pennsylvanian*, title page, 15, 194–260; "S. W. Pennypacker, Former Governor, Dies: Ill for Year; Unique Figure in Pennsylvania Affairs Succumbs at 73 Years," *Philadelphia Inquirer*, September 3, 1916, pp. 1, 6, accessed November 11, 2016, America's Historical Newspapers.

6. Obituary of Samuel W. Pennypacker, *Philadelphia Inquirer*, September 4, 1916, p. 6, accessed November 11, 2016, America's Historical Newspapers.

178 NOTES TO PAGES 2–9

7. Pennypacker, *Annals of Phoenixville*; Pennypacker, *Historical and Biographical Sketches*; Learned and Pennypacker, *Francis Daniel Pastorius*; Pennypacker, *Pennsylvania, the Keystone*; Pennypacker, *Autobiography of a Pennsylvanian*, 15.

8. Carson, *Samuel W. Pennypacker*, 5.

9. Pennypacker, *Autobiography of a Pennsylvanian*, 144–45.

10. Ibid., 16–17.

11. Yoder, introd. to Yoder, *Pennsylvania German Fraktur*.

12. Pennypacker, *Autobiography of a Pennsylvanian*, 114–15, 194–260, 261–438, 162.

13. Ibid., 168.

14. Samuel Pennypacker, manuscript notes in Bible (Heidelberg, 1568), Pennypacker Mills, Schwenksville, PA, object number P99.70.1, manuscript leaves 1–2.

15. Pennypacker, *Hendrick Pannebecker*.

16. Vorschrift for Simon Pannebecker, ca. 1758, Pennypacker Mills, Schwenksville, PA, Samuel W. Pennypacker Book and Manuscript Collection, object number P81.

17. For more on the Pennypacker collection, see Perry, "Pennypacker Fraktur Collection."

18. On the long survival of manuscript culture, see McKitterick, *Search for Order*; Boffey, *Manuscript and Print*; and Ezell, *Social Authorship*.

19. Bultmann, *Essays Philosophical and Theological*, 242.

20. Darnton, "History of Books," in Davidson, *Reading in America*, 31.

21. Material culture studies is a vast and burgeoning interdisciplinary field of scholarship. For insights on its theories and methods, consult Schlereth, *Material Culture Studies*, and Glassie, *Material Culture*.

22. D. Andrews, *Methodists and Revolutionary America*, 5.

23. Miller, *New England Mind: From Colony to Province*, x.

24. E. Morgan, *Gentle Puritan*, 1, 8.

25. Cohen, "Post-Puritan Paradigm."

26. See, for example, Butler, *Sea of Faith*, 175–76; and Schmidt, *Hearing Things*, 52.

27. Atwood, *Community of the Cross*, 2.

28. Leaflet advertising the ninth annual meeting of The Associates of the John Carter Brown Library, May 16, 1952, John Carter Brown Library, Brown University, Providence, RI.

29. "Errand into the Wilderness," in Miller, *Errand into the Wilderness*, 21.

30. Stein, "Some Thoughts on Pietism," in Strom, Lehmann, and Van Horn Melton, *Pietism in Germany*, 23.

31. Middlekauff, *Mathers*, 269.

32. Durnbaugh, "Communication Networks," in Strom, Lehmann, and Van Horn Melton, *Pietism in Germany*, 34.

33. Greene, *Pursuits of Happiness*, 205.

34. Witte, "Ties That Bind"; Fischer, *Albion's Seed*, 23.

35. For more on religious pluralism in Pennsylvania, see Häberlein, *Practice of Pluralism*. For a broad overview of the current state of research on transatlantic German Pietism, see Wellenreuther, Müller-Bahlke, and Roeber, *Transatlantic World*.

36. Lowell, review of *History of New England*, 164 (also published as "New England Two Centuries Ago").

37. MacCulloch, *Reformation*, 525. Pennsylvania German religious historian Aaron Spencer Fogleman expressed similar sentiments in his book *Jesus Is Female*: "Because of founder William Penn's policies, Pennsylvania became the place where toleration, diversity, and opportunity were the most advanced," he asserted, "and it was here that the most religious freedom could be found in the colonial era" (1). See also Dixon, *Protestants*.

38. Bailyn, *Atlantic History*, 80. Bailyn makes a similar observation: "It was in Pennsylvania that the radical messianic utopianism that swept through the Protestant sects—impulses that tended to exhaust themselves in the dense social environment of Europe—bore the most plentiful fruit" (80).

NOTES TO PAGES 10–19 179

39. Weiser, "Piety and Protocol," 19.

40. Morgan and Promey, introd. to Morgan and Promey, *Visual Culture*, 2–3.

41. Stoudt, *Pennsylvania Folk-Art*, 103.

42. Promey, "Religion, Sensation, and Materiality," in Promey, *Sensational Religion*, 4.

43. Promey, "Hearts and Stones," in Brekus and Gilpin, *American Christianities*, 183–84.

44. Van Maanen, *Study Art Worlds*, 207.

45. For more on the Vorschrift and its pedagogical and spiritual aims, see Ames, "Quill and Graver Bound."

46. For more on commonplace books, see Havens, *Commonplace Books*. For more on scrapbooking, see Garvey, *Writing with Scissors*, and Tucker, Ott, and Buckler, *Scrapbook in American Life*.

47. Van der Toorn, *Scribal Culture*, 3–4.

48. Fuchs, "Hermeneutical Problem," in Robinson, *Religious Past*, 277.

CHAPTER 1

1. "Fonthill Castle."

2. Bronner and Brown, "Introduction," in Bronner and Brown, *Pennsylvania Germans*, 6.

3. Mercer, "Survival of the Mediaeval Art," repr. in Amsler, *Bucks County Fraktur*, 6, 13.

4. Stoudt, *Pennsylvania Folk-Art*, 101.

5. See Torii Kiyonaga, *Seven-Year-Old Child Prodigy Minamoto no Shigeyuki Executing Calligraphy*, published by Eijudō, Japan, 1783 (color woodcut, 14⅝ × 9⅝ in.), PMA, Gift of Mrs. John D. Rockefeller Jr., 1946, 1946-51-17.

6. Szewczyk, *Viceroyalty of New Spain*, xviii, 4.

7. See, for example, *Specimen of Calligraphy with Prayers to God and a Hadith, Manuscript Page with Prayers to Allah*, Turkey, 1773–74 (ink and colors on paper, sheet: 9¼ × ⅝ in.), Louis E. Stern Collection, 1963, PMA, 1963-181-216; *Qit'a in Nasta'liq Script*, probably made in Tonk, Rajasthan, India, 1859 (ink and gold on paper, sheet: 12⅜ × 8¼ in.), India Collection, Gift of the British Government, 1878, PMA, 1878-200. For more on Islamic calligraphy, see Khatibi and Sijelmassi, *Splendour of Islamic Calligraphy*; and Schimmel, *Calligraphy and Islamic Culture*, 1.

8. See, for example, Gold, *Sign and a Witness*.

9. Ketubah, made in Bucharest, Romania, July 2, 1840 (manuscript, ink, and paint on paper, 84 × 56 cm), Beinecke Rare Book and Manuscript Library, Yale University, New Haven, CT, Hebrew MSS Suppl. 97 (broadside).

10. Krippner, "Role Played by Mandalas"; White, "Mandala's Dark Fringe," in Patton and Haberman, *Notes from a Mandala*, 200. For examples, see *Naga Mandala Assembly*, eighteenth century (ink on paper, 10⅝ × 11¼ in.), Rubin Museum of Art, NY, C2003.10.1, HAR65235, 65236, accessed August 15, 2018, http://rubinmuseum.org/collection/artwork/nagamandala assembly; *Four Mandalas of the Vajravali Cycle*, ca. 1429–56 (pigments on cloth, 36¼ × 29¼ in.), Rubin Museum of Art, C2007.6.1, HAR81826, accessed August 15, 2018, http://rubinmuseum .org/collection/artwork/fourmandalasofthevajravalicycle.

11. See, for example, Wieck, *Painted Prayers*.

12. Johannes Bard (1797–1861), Fraktur writing sample, Union Township, Adams County, PA, 1819–21, WM, 2011.0028.022.

13. Orsi, "Everyday Miracles," in D. Hall, *Lived Religion*, 7.

14. For more on German religious revival in the Middle colonies, see Frantz, "Awakening of Religion." For more on connections between the Great Awakening and German Pietism, see Lambert, "*Pietas Hallensis*," in Wellenreuther, Müller-Bahlke, and Roeber, *Transatlantic World*, 199–212.

15. For an analysis of similarities shared by German Pietists and Anglo-American revivalists, see Longenecker, *Piety and Tolerance*.

180 NOTES TO PAGES 20—24

16. Cameron, *European Reformation*, 1, 117, 121, 132, 137–38.

17. Eire, *War Against the Idols*, 16; Moeller, "Religious Life in Germany," in Strauss, *Pre-Reformation Germany*, 29; Lawrence G. Duggan, *Britannica Academic*, s.v. "Indulgence," accessed October 6, 2016, http://academic.eb.com.udel.idm.oclc.org/levels/collegiate/article/42357.

18. Cameron, *European Reformation*, 145.

19. Wood, *Captive to the Word*, 129.

20. Cameron, *European Reformation*, 138.

21. Johan Leonhard Tauber, single leaf with Lutheran devotional design, Nuremberg, Germany, 1752, Walters Art Museum, Baltimore, W.728.

22. Cameron, *European Reformation*, 395–96.

23. MacCulloch, *Reformation*, 139, 179; Wood, *Captive to the Word*, 164.

24. Dixon, *Reformation in Germany*, 26.

25. Cameron, *European Reformation*, 140.

26. Dixon, *Reformation in Germany*. The process of confessionalization was swift, as Dixon observes: "Confessional division was one of the most direct and profound consequences of the Reformation. By the end of the century, the Empire was split up into distinct religious groupings. Any hope of religious unity had passed" (142).

27. Lehmann, "Continental Protestant Europe," in Brown and Tackett, *Cambridge History of Christianity*, 33.

28. On Pietism's predecessors, see Shantz, *Introduction to German Pietism*, 15–41. On the later influence of Pietism on Anabaptists and other Pennsylvania Germans, see Longenecker, *Piety and Tolerance*, 47. On mysticism, see Greengrass, *Longman Companion*, 38–39.

29. Shantz, *Introduction to German Pietism*, 16; Weigelt, *Schwenkfelders in Silesia*, 10, 140. Weigelt discusses the Schwenkfelders' strong concept of interior spiritualism. For more on mysticism, see Duggan's "Unresponsiveness," 6–7.

30. Shantz, *Introduction to German Pietism*, 18; Erb, *Pietists, Protestants, and Mysticism*, 5. "He was Piestist, but also fully Lutheran," Peter Erb wrote of Arnold (5).

31. Shantz, *Introduction to German Pietism*, 19. For more on the Philadelphian movement, see Ward, *Protestant Evangelical Awakening*, 52.

32. Shantz, *Introduction to German Pietism*, 28–29, 42, 47; Damrau, *English Puritan Literature*, 74, 193.

33. Shantz, *Introduction to German Pietism*, 50.

34. Ibid., 71, 80; Schneider, *Radical German Pietism*, 187; Strom, "Problem of Conventicles," 4, 6, 8, 11–12.

35. Shantz, *Introduction to German Pietism*, 87, 94, 102–5, 137; Schneider, *Radical German Pietism*, 33. Dutch Calvinism influenced Francke's approach to social work.

36. Middlekauff, *Mathers*, 269.

37. Müller, *Kirche zwischen zwei Welten*, 65.

38. Schneider, *Radical German Pietism*, 187.

39. Atwood, *Community of the Cross*, 28.

40. Strom, *German Pietism*, 1.

41. Atwood, *Community of the Cross*, 40.

42. Lehmann, "Pietism in the World," in Strom, Lehmann, and Van Horn Melton, *Pietism in Germany*. Lehmann writes, "I propose a new typological and historical approach to the history of Pietism that combines an analysis of religious orientation with a study of religious practices and religious activities independent of national traditions of interpretation. I am convinced that the full range, or the full impact, of religious renewals and revivals within the Western world since the seventeenth century can only be grasped if we transcend national boundaries" (18). This study subscribes to Lehmann's modified approach to Pietism as a unit of historical analysis.

43. Juterczenka, *Über Gott*, 18.

44. Häberlein, *Practice of Pluralism*, 31–39. The section of Häberlein's book titled "Pietism and the Search for Order: The Pastorates of Otterbein, Stoy, and Hendel" documents Pietism's omnipresent nature.

45. Häberlein, *Practice of Pluralism*, 139, 239. Häberlein notes the Pietist underpinnings of many Protestant denominations and sects of the period: "The cooperation of Lutheran and German Reformed pastors was certainly facilitated by the pietist inclinations of leading clergymen in both denominations" (139).

46. A succinct overview of the branches of Pietism can be found in Krahn and Dyck, "Pietism."

47. Stoeffler, preface to Stoeffler, *German Pietism*, x.

48. Schneider, *Radical German Pietism*, 1–3.

49. On the Anglicans/Episcopalians in the South, see Nelson, *Blessed Company*; Holifield, *Gentleman Theologians*; and Bell, *War of Religion*.

50. Winship, *Godly Republicanism*, 6.

51. Clark, *English Society*, 45–46.

52. For a summary of the covenant theology, see Witte, "Ties That Bind."

53. Middlekauff, *Mathers*, 269; Grabbe, introd. to Grabbe, *Halle Pietism*, 9. Grabbe calls Pietism the sibling of English Puritanism.

54. Bozeman, *To Live Ancient Lives*, 9–11.

55. Delbanco, *Puritan Ordeal*, 1–2.

56. Bayly, *Practice of Piety*, 135; McKenzie, *Catalog*, 70–84.

57. Winship, *Making Heretics*, 3, 22, 30.

58. Cohen, *God's Caress*, 4, 9.

59. Shantz, *Introduction to German Pietism*, 19.

60. Strom, *German Pietism*, 1, 151–52. Nonetheless, according to Strom, "Religious conversion goes to the heart of the Pietist movement and exemplifies the value it placed on lived experience in the Christian faith. Conversion aimed to distinguish the true Christian from the lukewarm believer, the ardent follower of Christ from the nominal adherent."

61. Winship, *Seers of God*, 4.

62. Hambrick-Stowe, *Practice of Piety*, 286; M. Brown, *Pilgrim and the Bee*, 58.

63. Vogt, "Different Ideas," in Grabbe, *Halle Pietism*, 28; Damrau, *English Puritan Literature*, 1.

64. Miller, *New England Mind: The Seventeenth Century*, viii.

65. Fogleman, *Two Troubled Souls*, 8.

66. Cambers, *Godly Reading*, 8.

67. J. Hall, "Art of Divine Meditation," in Pratt, *Works of the Right Reverend*, 44; McKenzie, *Catalog*, 213–14. Hall's book was originally published in 1606. A German translation appeared in 1631.

68. Ussher, *Method for Meditation*, i–iii.

69. Powell, *Spiritual Experiences*, iii; McKenzie, *Catalog*, 343. Powell described his well-known devotional tract as "sound, spirituall, and savoury." This book was published in German in 1670.

70. Bayly, *Practice of Piety*, 159.

71. Winiarski, *Darkness Falls*, 18.

72. Shantz, *Introduction to German Pietism*, 76.

73. Greene, *Pursuits of Happiness*, 36.

74. *Oxford English Dictionary*, s.v. "evangelical," accessed September 15, 2019, www.oed.com .udel.idm.oclc.org; Bebbington, *Evangelicalism in Modern Britain*, 1.

75. Bebbington, *Evangelicalism in Modern Britain*, 1.

76. Dixon, *Reformation in Germany*, viii, 45, 113; MacCulloch, *Reformation*, 343; Shantz, *Introduction to German Pietism*, xiii; Noll, *America's God*, 49.

182 NOTES TO PAGES 28–32

77. Bebbington, *Evangelicalism in Modern Britain*, 2–3; Ward, *Early Evangelicalism*, 1–4; Heyrman, *Southern Cross*, 4.

78. Hutchinson and Wolffe, *Global Evangelicalism*, 10–11.

79. Noll, *Rise of Evangelicalism*, 53.

80. Hutchinson and Wolffe, *Global Evangelicalism*, 19.

81. Bebbington, *Evangelicalism in Modern Britain*, 43.

82. Kisker, "Pietist Connections," in Shantz, *Companion to German Pietism*, 227; Lehmann, "Transatlantic Migration," in Lehmann, Wellenreuther, and Wilson, *Peace and Prosperity*, 308. Lehmann writes, "In particular, movements of religious revival such as Pietism and Methodism, and in fact all those who were inspired by the teaching of the first and second Great Awakenings, were able to bridge the North Atlantic in both directions. They built networks in which the religious elements supported the political, cultural, social, and economic interests involved in transatlantic exchange" (308).

83. Erb, "Gerhard Tersteegen."

84. Ward, *Protestant Evangelical Awakening*, 3; Bebbington, *Evangelicalism in Modern Britain*, 35, 38; MacCulloch, *Christianity*, 750.

85. Nuttall, "Continental Pietism," in Van den Berg and Van Dooren, *Pietismus und Reveil*, 208, 214–19, 233.

86. *Von Georg Weitfields Predigten*; Ward, *Protestant Evangelical Awakening*, 253.

87. Wiebe, "Boehm, Martin"; Longenecker, *Piety and Tolerance*, 112, 117.

88. Nation, "Fear of the Lord," 402.

89. C. Brown, *Word in the World*, 9. See also Wosh, *Spreading the Word*.

90. Sebastian Hinderle, hand-drawn German bookplate in a Bible for Johann George Bertsch, Philadelphia County, 1768, private collection; *Nürnbergisches Gesang-Buch*, 66. Image of the manuscript bookplate courtesy of David A. Schorsch and Eileen M. Smiles, American Antiques, Woodbury, CT. (Special thanks to Jay Robert Stiefel for sharing the source.)

91. Holifield, *Theology in America*, 29.

92. Ward takes such a perspective in *Early Evangelicalism*.

93. Gillespie and Beachy, introd. to Gillespie and Beachy, *Pious Pursuits*, 16–17.

94. Diekmann, *Lockruf der Neuen Welt*, 3.

95. Müller, *Kirche zwischen zwei Welten*, 52. According to Müller, "Pietistic currents spread early in Pennsylvania; Lutheran Pietism also reached the colony long before Mühlenberg embarked for North America" (52).

96. Ruth, *Maintaining the Right Fellowship*, 36–37, 45–90.

97. Fischer, *Albion's Seed*, 424–35.

98. For more on Penn's travels to the continent in the 1670s, see Dunn et al., *Papers of William Penn*, 425–508. For a succinct summary of Penn's life, see Geiter, *Oxford Dictionary*, s.v. "Penn, William (1644–1718)."

99. Ruth, *Maintaining the Right Fellowship*, 36–37, 45–90. See Ruth for an interesting description of the Penn's connections to the Palatinate.

100. Frantz, "To the New World," in Bronner and Brown, *Pennsylvania Germans*, 37; Silvius, "Valley's Palatine Pioneers."

101. Juterczenka, *Über Gott*, 225–26.

102. Müller, *Kirche zwischen zwei Welten*, 52–53.

103. Ruth, *Maintaining the Right Fellowship*, 132.

104. For more on early Pietist waves of settlement in Pennsylvania, see Lehmann, "Christian People in Europe," in Wellenreuther, Müller-Bahlke, and Roeber, *Transatlantic World*, 12.

105. Fischer, *Albion's Seed*, 461.

106. Fogleman, *Hopeful Journeys*, 6.

107. Wokeck, *Trade in Strangers*, 37.

108. Greene, *Pursuits of Happiness*, 47–48, 50.

NOTES TO PAGES 33–39 183

109. Fogleman, *Hopeful Journeys*, 17, 41, 21, 102, 18–23, 38, 28–30.

110. Häberlein, *Vom Oberrhein zum Susquehanna*, 83.

111. Müller, *Kirche zwischen zwei Welten*, 52–53.

112. Fogleman, *Hopeful Journeys*, 4.

113. For more information on German manuscript culture in the South, see Wust, *Virginia Fraktur*.

114. Fogleman, *Hopeful Journeys*, 4–18.

115. On the Moravians, see Thorp, *Moravian Community*.

116. Bird, *Ontario Fraktur*.

117. McGrail, "Illuminated Documents," 51.

118. Bird, *Ontario Fraktur*, 28.

119. Fogleman, *Hopeful Journeys*, 30–33, 87.

120. Lemon, *Best Poor Man's Country*, 41, 59–60.

121. Fogleman, *Hopeful Journeys*, 6, 30, 81, 98–99.

122. Lemon, *Best Poor Man's Country*, 14; Fogleman, *Hopeful Journeys*, 81.

123. Nolt, *Foreigners in Their Own Land*, 4, 28–29; Fogleman, *Hopeful Journeys*, 80–81; Hippel, *Auswanderung aus Südwestdeutschland*, 25.

124. Fogleman, *Hopeful Journeys*, 103.

125. Fisher, "Prophesies and Revelations."

126. Butler, *Sea of Faith*, 175–76; Durnbaugh, "Pennsylvania's Crazy Quilt."

127. Dixon, *Protestants*, 103.

128. Ward, *Protestant Evangelical Awakening*, 178.

129. Longenecker, *Piety and Tolerance*, 4–53; Durnbaugh, "Pennsylvania's Crazy Quilt"; Shantz, *Introduction to German Pietism*, 16.

130. Nockamixon Reformed Church, financial record book, 1787–1844, folder 12, box 1, RG 370, Nockamixon Reformed Church (Nockamixon Township, PA) records, ERHS.

131. Splitter, "Divide et Impera," in Grabbe, *Halle Pietism*, 45–92.

132. Bronner and Brown, "Introduction," in Bronner and Brown, *Pennsylvania Germans*, 3.

133. Wellenreuther, *Heinrich Melchior Mühlenberg*, 96. Wellenreuther discusses "Wissenstransfer" (the transfer of knowledge and belief systems) to Pennsylvania in the context of Mühlenberg and the German Lutherans.

134. Wilson and Fiske, "Kunze, John Christopher," in Wilson and Fiske, *Appleton's Cyclopaedia*, 578.

135. Carl Heinrich von Bogatzky, *Tägliches Haus-Buch der Kinder Gottes* [. . .] (Halle, Germany: Im Verlag des Waisenhauses, 1766), WL, BV4834 B67; Hess, *Geschichte der drey letzten Lebensjahre Jesu* (Zürich, Switzerland: Orell, Gessner, Fuesslin u. Comp., 1774), WL, BT300 H4 1774 S; Christian Fürchtegott Gellert, *C. F. Gellerts sämmtlicher Schriften* (Berlin: Pauli, 1770), volumes of a multivolume set in WL: PT1883 S19 and PT1883 G31.

136. See, for example, some of Gellert's hymns, which appear in *Gemeinschaftliches Gesangbuch*, 2, 3, 11.

137. Proverbs 12:28 (King James Bible).

138. Kunze, *Ein Wort für den Verstand*, 13.

139. Snyder, *Anabaptist History and Theology*, 86–90, 339; Smucker, "Lifting the Joists with Music," in Blumhofer and Noll, *Singing the Lord's Song*, 140.

140. Ruth, *Maintaining the Right Fellowship*, 210–14.

141. Snyder, "Swiss Anabaptism," in Roth and Stayer, *Companion to Anabaptism*, 49.

142. Snyder, *Anabaptist History and Theology*, 6, 25–29, 62, 67.

143. Smith, *Smith's Story*, 4–5, 81, 78–79, 100.

144. Ruth, *Maintaining the Right Fellowship*, 26, 45–51, 93.

145. Johnson-Weiner and Brown, "Amish," in Bronner and Brown, *Pennsylvania Germans*, 151.

146. Packull, *Mysticism*, 27; Snyder, *Anabaptist History and Theology*, 62.

184 NOTES TO PAGES 39–49

147. Erb, "Anabaptist Spirituality," in Senn, *Protestant Spiritual Traditions*, 87, 94, 114; Snyder, *Anabaptist History and Theology*, 29; Dent, "Anabaptists," in Jones, Wainwright, and Yarnold, *Study of Spirituality*, 352.

148. Snyder, *Anabaptist History and Theology*, 43, 87–88.

149. Weigelt, *Schwenkfelders in Silesia*, 24, 1–3; Snyder, *Anabaptist History and Theology*, 35.

150. Weigelt, *Schwenkfelders in Silesia*, 1, 14–16, 53, 102, 130–31; Ruth, *Maintaining the Right Fellowship*, 112.

151. Abraham Heebner, Vorschrift, ca. 1774, Heebner Family Fraktur Collection, SLHC, 00.261.51.

152. Longenecker, *Piety and Tolerance*, 25; MacCulloch, *Reformation*, 525.

153. Joh. Bunian (John Bunyan), *Eines Christen Reisen ach der seeligen Ewigkeit* [. . .] (Ephrata, PA: Drucks und Verlags der Brüderschafft, 1754), The Rosenbach, Philadelphia, EL2.B942. Ge754, p. 10.

154. *Von Georg Weitfields Predigten*; Longenecker, *Piety and Tolerance*, 72, 113.

155. Frantz, "Religion," in Bronner and Brown, *Pennsylvania Germans*, 144–45.

156. Fogleman, *Jesus Is Female*, 124–26.

157. Stein, *Shaker Experience in America*, 2; E. Andrews, *People Called Shakers*, 142.

158. Sellin, "Shaker Inspirational Drawings," 93.

159. Stein, *Shaker Experience in America*, 192.

160. Sarbanes, "Shaker 'Gift' Economy," 130; Stein, *Shaker Experience in America*, 192. For more on Shaker spirit drawings, see Promey, *Spiritual Spectacles*.

161. Stein, *Shaker Experience in America*, 188–89, 191.

162. Dixon, *Reformation in Germany*, 190.

163. Miller, *New England Mind: The Seventeenth Century*, viii–ix.

164. MacCulloch, *Christianity*, 748–49.

165. Geburts und Taufschein (birth and baptismal certificate) for Maria Taubert, 1838 (Allentown, PA: Blumer und Busch, 1847), LCP, Rare $Am 1847 Tauf Log.1952.F (Allen).

CHAPTER 2

1. Trithemius, *In Praise of Scribes*, 35, 49, 51, 65.

2. Eisenstein, *Printing Revolution*, 10–11.

3. Much of the research presented in this chapter first appeared in my article "Knife of Daily Repentance." I am deeply indebted to the *Mennonite Quarterly Review* and its editor, Dr. John Roth, for allowing reuse of the material here.

4. Love, "Early Modern Print Culture," 51.

5. McKitterick, *Search for Order*, 31; Boffey, *Manuscript and Print*, 57.

6. Ezell, *Social Authorship*, 1, 20, 39.

7. D. Hall, *Ways of Writing*, 29–30.

8. *A B C, Syllabir-und Lesebuch*, 30–59.

9. Boffey, *Manuscript and Print*, 65–66, 70, 74–77, 206.

10. "Gebett Buch welches Morgens Abens vor und nach der Beicht, wie auch bey der H. Communion zu gebrauchen," Gebetbuch 18. Jh. Stiche, Martinus-Bibliothek, Mainz, Germany, Hs 24.

11. Brünner, *Vorschrift*, plate 10.

12. Johann Gottfried Weber, *Allgemeine Anweisung der neuesten Schönschreibkunst des Hochgräflich Lippischen Bottenmeisters und Aktuarius* (Duisburg, Germany: Im Verlag der Helwingschen Universitäts Buchhandlung, 1780), Hill Museum and Manuscript Library, Saint John's University, Collegeville, MN, plate 2; Johannes Bard (1797–1861), Fraktur writing sample, Union Township, Adams County, PA, 1819–21, WM, 2011.0028.022.

NOTES TO PAGES 49–57 185

13. Merken, *Liber Artificiosus Alphabeti Maioris*, 2–3.

14. Ahlzweig, *Muttersprache–Vaterland*, 29, 33.

15. Jones, "Early Dialectology," in Aurous, *Language Sciences*, 2:1105–6.

16. See, for example, a description of an interaction between George Washington and Catherine the Great of Russia on the topic in Calloway, *Indian World*, 311–12.

17. Kilgour, *Evolution of the Book*, 98–113.

18. Hirsch, *Validity in Interpretation*, 216.

19. Trithemius, *In Praise of Scribes*, 59.

20. Wölfflin, *Renaissance and Baroque*, 16–17; Ndalianis, *Neo-Baroque Aesthetics*, 8–9.

21. Hof, *Enlightenment*, 8; Yoder, "European Background," in Amsler, *Bucks County Fraktur*, 15–37; Doede, *Schön Schreiben, eine Kunst*, 10, 12, 56, 77.

22. Eggington, "Problem of Thought."

23. Miroslav, "Emergence of Baroque Mentality," 315–16; Jensen, *Muses' Concord*, xiii, 2, 46–47; Elferen, *Mystical Love*, xx, xxiii–xxiv, 76, 85, 119.

24. Jensen, *Muses' Concord*, 66.

25. Jakob Hutzli, Schreibbuch (writing book), ca. 1690, Burgerbibliothek Bern, Bern, Switzerland, Mss.h.h.LI.169, p. 19.

26. Kress, *Multimodality*, 79, 87.

27. Ndalianis, *Neo-Baroque Aesthetics*, 33, 152; Benjamin, *German Tragic Drama*, 161–67; Maravall, *Culture of the Baroque*, 12.

28. Doede, *Schön Schreiben, eine Kunst*, 56.

29. Vorschrift for Mattheus Schultz, beginning "Meine Augen schließ ich jetzt" (My eyes I close now), January 26, 1788, Collection of Vorschriften, SLHC, 999-11.

30. John Joseph Stoudt's classic work is *Pennsylvania Folk-Art*. On allegory during the baroque era, see Martin, *Baroque*, 119.

31. Weiser, "Piety and Protocol," 43. Over the decades considerable debate has raged in the Pennsylvania German scholarly community regarding the extent to which images should be "interpreted" as part of a document's meaning. Stoudt embraced the idea, whereas others, like Pastor Frederick S. Weiser, shied away from seeking to unlock the meaning of artists' designs. In "Piety and Protocol," Weiser wrote, "No matter what religious roots surrounded the origin of the designs and no matter how frequently references to some of the objects in Pennsylvania folk art occur in Pennsylvania German hymns, there is no evidence, at least on the *Taufschein* of the secular Lutheran and Reformed Christians, that the decoration had anything to say beyond spreading beauty" (43).

32. *Kunstrichtige Schreibart*, 16.

33. Martin, *Baroque*, 121.

34. A thorough and thought-provoking collection of perspectives on the baroque can be found in Hills, *Rethinking the Baroque*.

35. See, for example, the calligraphy on three manuscript documents that reveals some of the common heritage of German and English hands: Lease agreement and indenture for portion of Scrooby Manor, signed by Willm Brewster, February 22, 1604 [1605], Oversize Box 1; Deed, Robert Cuchman [Cushman], yeoman of Withyham Sussex, March 4, 1591, Oversize Box 1; and Winslow/Cromwell Commission, 1654, all on permanent exhibition at Pilgrim Hall, Plymouth, MA.

36. Thomas Earl, *The Marriner's Compass*, exercise book, southwestern New Jersey, ca. 1727, Joseph Downs Collection of Manuscripts and Printed Ephemera, WL, Doc. 735.

37. Catharine Morris, "German Text Alphabet" and "Italic Alphabet," copy books, Philadelphia, 1815–16 (9½ × 7¾ in.), Quaker and Special Collections, Haverford College Library, Haverford, PA, p. 20.

38. Samuel Kidder, school exercise book, March 31, 1795, Joseph Downs Collection of Manuscripts and Printed Ephemera, WL, fol. 348. For the dating of the book, see the manuscript

186 NOTES TO PAGES 57–63

inscription on its cover. For the reference to Virgil and Homer, see page 9; for the odes to Washington and Jay, see page 8; for the Shakespeare quote, see page 15.

39. Fichtenau, *Lehrbücher Maximilians I*, 5–9, 25–30, 38; Doede, *Schön Schreiben, eine Kunst*, 10–12.

40. For more information about the history and development of neo-Gothic types and scripts, see Shaw and Bain, *Blackletter*.

41. For more on the relationship of type, script, and identity, see Shaw and Bain, "Introduction," in Shaw and Bain, *Blackletter*, 10–15; Bertheau, "German Language," in Shaw and Bain, *Blackletter*, 22–31; and Killius, *Antiqua-Fraktur Debatte*.

42. Bebbington, *Evangelicalism in Modern Britain*, 74.

43. Fuchs, "Hermeneutical Problem," in Robinson, *Religious Past*, 278.

44. *Güldene Aepffel*.

45. Ibid., 217–18 (my italics); Neff, "Imbroich, Thomas von."

46. Nation, "Fear of the Lord," 399.

47. Longenecker, *Piety and Tolerance*, 4, 47.

48. On the Schwenkfelder tradition, see Erb, "Garden in Schwenkfelder Fraktur."

49. Bayly, *Practice of Piety*, 135.

50. Wood, *Captive to the Word*, 167–68.

51. Atkinson, *Martin Luther*, 37; Eire, *War Against the Idols*, 16.

52. Weeks, *German Mysticism*, 10–13.

53. *Theologia Deutsch–Theologia Germanica*, 36–37.

54. *Theologia Deutsch* (1851), 54.

55. Tauler, *Sermons and Conferences*, 271. The quotations from Tauler here are taken from an English translation. The Schwenkfelder Caspar Schultz owned a copy of a 1713 edition of Tauler's *Helleleuchtender Hertzens-und Andachts-Spiegel*, which was bound with a prayer book (Tauler 1713, SLHC, L1925.09).

56. Tauler, *Sermons and Conferences*, 77.

57. Atkinson, *Martin Luther*, 41–42; Wood, *Captive to the Word*, 164.

58. Packull, *Mysticism*, 176–77.

59. Arnold, *Gottfrid Arnolds Historie*, 4–6, 34. A 1721 edition of Arnold's *Die Verklärung Jesu Christi in der Seele* descended in the Kriebel family of Pennsylvania (Arnold 1721, SLHC, L1924.06). A 1732 edition of Arnold's *Erste Liebe*, published in Leipzig, has a Montgomery County, PA, provenance (Arnold 1732, SLHC, L2006.0130). Jonas Bechtel acquired a copy published in Germantown in 1796; see Gottfried, *Die Verklärung Jesu Christi in der Seele, aus den gewöhnlichen Sonn-und Fest-Tags-Episteln auf dem Fürstlichen Schlosse zu Allstedt gezeiget durch Sel. Herrn Gottfried Arnold. Nebst dessen kurtzen Anmerckungen über die Paßion* [. . .], 5th ed. (Leipzig, Germany: Walther, 1732), SLHC, L2007.0283.

60. Arnold, *Gottfrid Arnolds Historie*, 108, 406.

61. Weeks, *Boehme*, 6; Shantz, *Introduction to German Pietism*, 31.

62. Weeks, *Boehme*, 33, 39, 46–48.

63. Boehme, *Weg zu Christo*, 201, 191.

64. Böhme, "Sex puncta theosophica," in Schiebler, *Jakob Böhme's sämtliche Werke*, 333.

65. Boehme, *Weg zu Christo*, 165.

66. Kuenning, *Rise and Fall*, 33–35, 44–48; Fogleman, *Jesus Is Female*, 27–29; Atwood, "Hallensians are Pietists," in Wellenreuther, Müller-Bahlke, and Roeber, *Transatlantic World*, 159–96.

67. Kuenning, *Rise and Fall*, 14–18, 82.

68. Franck, *Guide to the Reading*, 1–2, 151, 67.

69. Litzmann, *Textkritik und Biographie*, 86; Wübben, "Ich bin alles," in Heinen and Nehr, *Krisen des Verstehens*, 137–38.

NOTES TO PAGES 63–68 187

70. Musig, *Licht Der Weisheit*, 1:8.

71. Erb, *Pietists, Protestants, and Mysticism*, 102.

72. Lindberg, introd. to Lindberg, *Pietist Theologians*, 6; Shantz, *Introduction to German Pietism*, 29.

73. Lindberg, introd. to Lindberg, *Pietist Theologians*, 6.

74. Shantz, *Introduction to German Pietism*, 25; Ward, *Protestant Evangelical Awakening*, 57, 75.

75. Arndt, *Hocherleuchteten Theologi*.

76. The book went through numerous German-language American editions, still being published in Pennsylvania in the mid-nineteenth century; see Johann Arndt, *Des hocherleuchteten Lehrers Herrn Johann Arndts, weiland General-Superintendenten des Fürstenthums Lüneburg, Sechs Bücher vom wahren Christenthum [. . .] nebst dessen Paradiesgärtlein. Nach den besten Ausgaben aufs sorgfältigste geprüft und von Fehlern gereinigt herausgegeben* (Allentown, PA: Gräter and Blumer, 1833), SLHC, L1923.11. Some copies of Arndt's work descended through families, such as a 1762 Vonnieda family copy; see Arndt, *Des hocherleuchteten Lehrers Herrn Johann Arndts, weiland General-Superintendentens des Fürstenthums Lüneburg, Sechs Bücher vom wahren Christenthum [. . .] nebst dessen Paradiesgärtlein. Nach den accuratesten Editionen aufs neue collationirt und herausgegeben* (Nuremberg, Germany: Endterischen Buchhandlung, 1762), SLHC, L2004.0227.

77. Wallmann, "Johannes Arndt (1555–1621)," in Lindberg, *Pietist Theologians*, 22–30; Erb, *Pietists, Protestants, and Mysticism*, 56.

78. Erb, *Pietists, Protestants, and Mysticism*, 58; Lindberg, introd. to Lindberg, *Pietist Theologians*, 6.

79. Arndt, *Vom wahren Christenthum*, 1751, frontispiece and explanation, bk. 1.

80. Arndt, *Hocherleuchteten Johann Arndts*, 3, 5, 12, 107, 12, 26–29, 50–51.

81. Ruth, *Maintaining the Right Fellowship*, 176; Meier, "Research Note," 591, 597.

82. Meier, "Research Note," 591–92, 596; *Golden Apples*, 255, 342; *Güldene Aepffel*, 255, 342.

83. *Güldene Aepffel*, 460.

84. "Gründliche Anweisung zu einem Heiligen Leben. Von einem Geistlich-gesinneten lang verstorbenen Lehrer. Ubersetzt 1747" (Germanton, PA: Saur, 1748), LCP, Am.1748. Gru.2940.F. Spelling of the name of the Germantown Saur publishing family varies; it is also spelled "Sauer."

85. Behmen, *Concerning the Three Principles*, 49.

86. Arndt, *Vom wahren Christenthum* (1753), 332.

87. Weeks, *German Mysticism*, 161.

88. "Gründliche Anweisung zu einem Heiligen Leben," LCP.

89. Trueman, "1520."

90. Egelmann, *Deutsche und Englische Vorschriften*, leaf 8, SLHC, VSFS 34–269.

91. Plate, "Words," 157–58.

92. Behmen, *Concerning the Three Principles*, 73–74, ii–iii.

93. Fisher, "Prophesies and Revelations."

94. Schmid, *Grammatologia*, 3–10, 74, 80, 107, 111, 129, 143, 147–48, 156.

95. Vorschrift, "Pracht in Gebärden [. . .]," ca. 1800 (ink and watercolor on paper), SLHC.

96. Schriftenvorlagen (writing sample book), 1730 (ink and watercolor on laid paper), RM, VI.53.

97. Calligraphic manuscript, Augsburg, ca. 1720–30 (pen and ink on paper), private collection.

98. Vorschrift/Golden ABC, ca. 1700, RM, VI 30.

99. Tersteegen, *Geistliches Blumen-Gärtlein*, 55.

100. "Im Nahmen der aller heiligsten Dreyfaltigkeit: Das goldene ABC für jedermann, der gern mit Ehren wollt bestehn," ca. 1770–1800, LCP, 9523.F (Roughwood).

188 NOTES TO PAGES 68–78

101. Susanna Heebner, "The Golden ABC (A–M and N–Z)," religious text, Worcester Township, Montgomery County, PA, 1809, Heebner Family Fraktur Collection, SLHC, 2-029a/1920.25.125 and 2-029b/1920.25.126.

102. Behmen, *Concerning the Three Principles*, 49.

103. Welling, *Opus Mago*, 513; Bach, *Voices of the Turtledoves*, 124–27.

104. Arnold, *Erste Liebe*, n.p. [i].

105. Tersteegen, *Geistliches Blumen-Gärtlein*, title-page verso.

106. Bach, *Voices of the Turtledoves*, 141–45.

107. Borneman, *Pennsylvania German Illuminated Manuscripts*, 5; Bach, *Voices of the Turtledoves*, 141.

108. Bach, *Voices of the Turtledoves*, 144–45.

109. Sutton, *Communal Utopias*, 7.

110. For a detailed discussion of the contents and conservation of the *Christian ABC*, see Irving and Choi, "Decision Making and Treatment."

111. Hershey, *This Teaching I Present*, 74, 195; Herman M. Ache, attr., Vorschrift, Skippack/Salford, PA, 1768, MHC, 2013.68.1.

112. Heinrich Brachtheiser, attr., Vorschrift for Philip Markley, Skippack Township, PA, 1787, MHC, 1998.8.1; Matthew 10:16 (New International Version).

113. "Bedencke was du fliehen must [. . .]," religious text, PA, ca. 1800, German Collection V80, HSP, DAMS 12561.

114. Bird, *O Noble Heart*, 63.

115. Luke 2:10–11 (KJB).

116. Jacob Hümmel, Vorschrift, ink and watercolor on laid paper, Skippack Township, Montgomery County, PA, December 31, 1815, WM, 1961.0209 A.

117. For biographical information about members of the Masser family, including Jacob, see *Genealogical and Biographical Annals*, 498–501.

118. Fall-front desk made by and/or for Jacob Maser (also Jakob Masser), Mahantongo/Schwaben Creek Valley, Northumberland County, PA, 1834 (tulip poplar, paint, and brass, 49¼ × 39⅛ × 19 in.), WM, 1964.1518. For more on the desk, see Cooper and Minardi, "Paint, Pattern, and People." More information about the object can be found in the Registration Department Object Files, folders 1–2, WM, 64.1518 [Jakob Masser desk].

119. For an extensive analysis of the powwowing tradition, see Donmoyer, *Powwowing in Pennsylvania*.

120. *Genealogical and Biographical Annals*, 498.

121. Georg F. Helfenstein, *Sympathie: Eine Sammlung vorzüglicher Heilmittel und Rezepte für verschiedens Viehes, und andere Fälle* (New Berlin, PA[?]: Gedruckt für den Herausgeber, circa 1840), housed in a metal box with manuscript materials formerly belonging to Jacob Masser of Upper Mahanoy Township, Northumberland County, PA, loose-leaf hand-numbered 3.

122. For more on artifacts and embodiment, see Promey, "Religion, Sensation, and Materiality," in Promey, *Sensational Religion*, 1.

123. Chest (blanket chest), Berks County, PA, 1785–1810 (white pine, brass, and paint, 28 × 50⅝ × 22¾ in.), WM, 1955.0095.001.

124. Johann Philipp Meurer, diary, 1741–47. BethCong 1012, MAB, JC IV.1, p. 86.

125. Atwood, "Little Side Holes," 65–68. For more on side wound devotion, see Peucker, *Time of Sifting*, 70, 73–81.

126. "Harmonist Labyrinth."

127. Bach, *Voices of the Turtledoves*, 159.

128. Johann Heinrich Otto and Ephrata community printshop, "Geistlicher Irrgarten," Ephrata, PA, 1784 (letterpress, ink, and watercolor on laid paper, 20⅞ × 16⅜ in.), WM, 1958.0120.013 A.

NOTES TO PAGES 78–86 189

129. "Geistlicher Irrgarten: Mit vier Gnaden-Brunnen [. . .]," Reading, PA: Ritter, 1811, #Am 1811, LCP, Geist Log.1868.F (G. Allen); "Geistlicher Irrgarten: Mit vier Gnaden-Brunnen [. . .]," Allentown, PA: Gräter and Blumer, ca. 1833. #Am 1833, LCP, Geist 9515.F (Roughwood).

130. "Stone Inclines to Earth." English translation provided on the FLP digital collections page.

131. Bird, *O Noble Heart*, 110.

132. Promey, "Hearts and Stones," in Brekus and Gilpin, *American Christianities*, 183.

133. Moyer, *Fraktur Writings*, 67–114; Rebuck and Perry, "Fraktur Treasures."

134. Rebuck and Perry, "Fraktur Treasures," 34.

135. Moyer, *Fraktur Writings*, 70–71; Abraham Heebner, Vorschrift, "Gedultig trag dem Creutz auf Erden," ca. 1770 (7¼ × 9 in.), Heebner Family Fraktur Collection, SLHC, 1958.02.102/3-002a.

136. Abraham Heebner, Geburts und Taufschein (birth and baptismal certificate) for Sarah Hübner, 1794, SLHC, 6-100 / 999 740; Heebner, Geburts und Taufschein for Susanna Hübner, 1797, SLHC, 5-10 / D.A. 2573; Heebner, Geburts und Taufschein for David Hübner, 1805, SLHC, 4-106/994 493/1958.02.100; Moyer, *Fraktur Writings*, 73.

137. Heebner, "Gedultig trag dem Creutz auf Erden," SLHC; Promey, "Hearts and Stones," in Brekus and Gilpin, *American Christianities*, 188–89.

138. Rebuck and Perry, "Fraktur Treasures"; Perry, "Pennypacker Fraktur Collection," 34. Rebuck and Perry discuss the significance of female calligraphy and manuscript making.

139. Moyer, *Fraktur Writings*, 96.

140. Rebuck and Perry, "Fraktur Treasures"; Perry, "Pennypacker Fraktur Collection," 34.

141. Moyer, *Fraktur Writings*, 84–87.

142. S. Heebner, "Golden ABC (A–M)," SLHC.

143. Moyer, *Fraktur Writings*, 90.

144. Ibid., 98–113, 95.

145. Rebuck and Perry, "Fraktur Treasures"; Perry, "Pennypacker Fraktur Collection," 33.

CHAPTER 3

1. "1770 Electricity Machine."

2. For more on the international historical records produced by Moravian scribes, see Peucker, *Time of Sifting*, 175–77.

3. Ibid.; "Inventory of the Painting Collection."

4. *Methode, nach welcher in den Neustädtischen Knaben-und Mägdlein-Schulen so wohl publice als priatim im Schreiben informiret wird*, MAB, CongLib 690; "Layritz, Paul Eugen," *McClintock and Strong Biblical Cyclopedia*.

5. Rubin, *Erst und kürzeste Weg*, title page; Gellert, *Professor Gellerts Geistliche Oden*.

6. Malden, *Apocrypha*, 59–60.

7. Murphy, *Tree of Life*, 139; Sir. 24:3 (New Revised Standard Version); Lange, *Apocrypha*, 158.

8. Lange, *Apocrypha*, 158. Lange explains the nature of wisdom as encountered in the Apocrypha: "Wisdom, in this literature, is more than an attribute of the human mind. It is an attribute of God himself and one of the manifestations of his will and power on earth. Eventually it comes to be identified with God's Word, the instrument by which he created the world and keeps it in being, and hence also with Torah, which is the embodiment of the Word" (158).

9. Blenkinsopp, *Sage, Priest, Prophet*, 9.

10. Hirsch, *Validity in Interpretation*, 68.

11. Darnton, "History of Books," in Davidson, *Reading in America*, 30–31.

12. Monaghan, *Learning to Read*, 31, 44–45, 194.

190 NOTES TO PAGES 86–95

13. Ibid., 13, 81–85, 98; for more on the distinction between the primer and the spelling book, see 86–88.

14. Ibid., 4.

15. See, for example, *A B C, Buchstabir-und Lese-Buch*; and *A B C, Syllabir-und Lesebuch*.

16. See, for example, the writing samples presented in Bickham, *Universal Penman*.

17. See, for example, Gould's *Penmanship*.

18. For an example of a Pennsylvania German needlework depicting the alphabet, see Catherine H. Grater (1821–40), sampler, Skippack Township, Montgomery County, PA, 1839, Mennonite Heritage Center, Harleysville, PA, accessed April 25, 2017, http://mennonite heritagecenter.pastperfectonline.com/webobject/5F96961C-D6AB-435D-BB9F-389469 943320.

19. Tuer, *History of the Horn-Book*, 132, 135; Plimpton, *Hornbook and Its Use*, 9.

20. "Just Imported from London, and to Be Sold by B. Franklin [. . .]," advertisement, *Pennsylvania Gazette*, June 24, 1742, p. 4, accessed April 24, 2017, America's Historical Newspapers; "Just Imported in the Last Vessels from London and Liverpool, and to Be Sold by Wharton and Story [. . .]," advertisement, *Pennsylvania Gazette*, August 4, 1757, p. 4, accessed April 24, 2017, America's Historical Newspapers; Monaghan, *Learning to Read*, 84.

21. Tuer, *History of the Horn-Book*, 133; Monaghan, *Learning to Read*, 81–84.

22. Hornbook, possibly of English or American derivation, possibly seventeenth or eighteenth century (4¾ × 2⅝ × ½ in.), Elisabeth Ball Collection of Hornbooks, Rare Book Department, FLP, Hornbook 1.

23. For an example of a European imprint of this type of book, see *Neu eröffnetes in Hundert Sprachen*.

24. *Hoch-Deutsches Reformirtes*; *Hoch-Deutsches Lutherisches*.

25. *Hoch-Deutsches Lutherisches*, 4–5, 6, 9–13, 14–21; *Hoch-Deutsches Reformirtes*, n.p.

26. *Hoch-Deutsches Lutherisches*, 19; *Hoch-Deutsches Reformirtes*, n.p.

27. For a discussion of the meetinghouse, see Hershey, *This Teaching I Present*, 24–25; and Fanella, "Schlatter Bible."

28. Wickersham, *History of Education*, 71.

29. Alderfer, "Kommt Liebe Kinder," 3.

30. Gerhard, "History of Schwenckfelder Schools," 7–8.

31. Alderfer, "Kommt Liebe Kinder," 4–7.

32. Henry C. Mercer, *Deep Run School House with Staves of Music Written on the Beams*, 1897, BCHS photo album, Archaeology/Colonial History, Mercer Museum Library, Bucks County Historical Society, Doylestown, PA, 42. For more information, see McNealy and Amsler, "Pennsylvania German Schools," in Amsler, *Bucks County Fraktur*, 73–95.

33. *Evangelische Lieder-Sammlung*, 322. Scripture translations from the King James Bible.

34. *Altes und Neues*, 387–88.

35. Dock, *Life and Works*, 89, 117.

36. Monaghan, *Learning to Read*, 209–10.

37. Dock, *Life and Works*, 107–9; Monaghan, *Learning to Read*, 209–11.

38. Monaghan, *Learning to Read*, 211.

39. Matthaus Fuchs, Vorschrift for Maria Reist, February 27, 1811, Pennsylvania German Collection of Fraktur Manuscripts and Imprints, Rare Book Department, FLP, accessed March 4, 2019, https://libwww.freelibrary.org/digital/item/6712, 67. Translation is from the FLP digital collections website.

40. *The Scriptural Album with Floral Illustrations* (New York: Riker, n.d.), inscribed by Joseph W. Pierce to Marcella L. Brown, May 12, 1852, AAS, Bindings Coll.D No. 083, bib ID 359291; *Token Album* (New York: Cornish, Lamport, n.d.), AAS, Bindings Coll.D No. 135, bib ID no. 503120, verso leaf 11.

41. Johann Adam Eyer, Vorschrift for Jacob Seitler, "Schreiber an der Tieffronn" (Writer on the Deep Run), 1782, WM, 2013.0031.078.

NOTES TO PAGES 95–104 191

42. *Geistlicher Lieder-Segen,* 1215.

43. Lassenii (Lassenius), *Biblischer Weyrauch,* 243.

44. Psalm 103:15 (KJB); discussed in Martin, *Baroque,* 137.

45. Eyer, Vorschrift for Seitler, WM.

46. Monaghan, *Learning to Read,* 210.

47. Carruthers, *Book of Memory,* 33–34.

48. Alderfer, "Kommt Liebe Kinder," 1.

49. Peucker, "Pietism and the Archives," in Shantz, *Companion to German Pietism,* 400–402.

50. Jakob Hutzli, *Schreibvorlagbuch/Das güldene ABC* (Writing sample/The golden ABC), 1693, Mss. h.h.LI.167, Burgerbibliothek Bern, Bern, Switzerland, leaf 12.

51. Jeremiah 15:16 (KJB); Ezekiel 3:1 (KJB); Revelation 10:9 (KJB).

52. For more on the embodiment and ingesting of spiritual objects, see Flood, "Bodies and Becoming," in Promey, *Sensational Religion,* 460.

53. Georg Heinrich Paritius (1675–1725), *Regensburgische Schreib-Schule: Anweisende die jetziger Zeit üblichsten Schrifften* [...] (Regensburg, Germany, 1710), Newberry Library, Chicago; Wing folio ZW 747.G45, no. 1, hand-numbered plate 93, quoting Sirach 10:27 (10:24 NRSV).

54. Egelmann, *Deutsche und Englische Vorschriften,* leaf 9; *Germantown and the Germans,* 92.

55. German script card, Moravian seminary, Bethlehem, Pennsylvania, ca. 1820 (6¼ × 9¾ in.), MAB, FemSem 273.2, numbered 13 in upper-right corner. See also under German script and penmanship cards, Letters and Numerals, MAB, FemSem 272.1; Words, MAB, FemSem 272.2; and German script cards, MAB, FemSem 273.1.

56. Gould, *Penmanship,* title page. See also copybook of Henry Whittemore, West Cambridge, Massachusetts, 1812, Joseph Downs Collection of Manuscripts and Printed Ephemera, WL, Col. 429, 65x671.

57. For more on the Swiss heritage, see Kunstgewerbemuseum Zürich and Museum für Gestaltung, *Schreibkunst.*

58. Hirsch, *Validity in Interpretation,* 129.

59. For a seminal discussion of the material composition of Pennsylvania German manuscripts, see Carlson and Krill, "Pigment Analysis," 20–23. Other insights on manuscript design were offered by Joan Irving, paper conservator, WM, interview with the author, Winterthur, DE, February 27, 2014.

60. See, for example, two highly similar penmanship samples made by Johann Adam Eyer: Eyer, Vorschrift for Seitler, WM; and Vorschrift for Abraham Oberholtzer, 1782, Mercer Museum Library, Bucks County Historical Society, Doylestown, PA, Sl-58-no-a-15.

61. Promey, "Hearts and Stones," in Brekus and Gilpin, *American Christianities,* 184, 191.

62. The exact figure cited here is 74 percent.

63. Heinrich Brachtheiser (1762–1788), attr., Vorschrift, ca. 1785, Samuel W. Pennypacker Fraktur Collection, SLHC, 00.262.13.

64. Stoudt, *Pennsylvania Folk-Art,* 112.

65. Martin, *Baroque,* 13–14.

66. Gerhardt, "Herr, was hast du im Sinn?"

67. Vorschrift for Martin Dettweiler, Pennsylvania, Pennypacker Fraktur Collection, SLHC, 1788, 00.265.22.

68. Reist Family Record, Reist Family Collection, Landis Valley Museum, Lancaster, PA, FM2012.11.2. This piece, a manuscript insert found inside the second American edition of Braght's *Blutige Schau-Platz,* features a manuscript note on its verso describing the sighting of a comet in eighteenth-century Pennsylvania.

69. Kaufman, *Systematic Theology,* 57.

70. A full 38 percent of penmanship samples in the sample featured scriptural or apocryphal quotations; 14 percent quoted Psalms; 14 percent quoted the Old Testament wisdom books; and 10 percent quoted the New Testament.

192 NOTES TO PAGES 104–109

71. Vorschrift, ca. 1720–30, private collection.

72. For example, 26 percent feature prayers.

73. In the sample 14 percent of manuscripts include such arrangements.

74. Christopher Dock, attr., Vorschrift, ca. 1760–70, SLHC.

75. In the sample 94 percent of the manuscripts feature text in the first- and second-person narrative voices.

76. Estes, *Handbook on the Wisdom*, 221, 280; Crenshaw, *Old Testament Wisdom*, 48, 55.

77. Johns, "Reading the Maccabean Literature," 151; Stayer, "Research Note," 365, 368.

78. One of the books describes wisdom as "mistlike," hovering between the earthly and celestial realms. Murphy, *Tree of Life*, 139; Sirach 24:3 (NRSV): "I came forth from the mouth of the Most High, and covered the earth like a mist."

79. Vorschrift, 1765, Pennypacker Fraktur Collection, SLHC, 18/00.263.36; Vorschrift, 1788, Pennypacker Fraktur Collection, SLHC, 00.265.22.

80. Murphy, *Tree of Life*, 106. Proverbs (Sprüche Salomonis in German), Ecclesiastes (Der Prediger Salomonis), Job (Das Buch Hiob), Wisdom of Ben Sira (Sirach), and Wisdom of Solomon (Weisheit Salomonis) make up the core of the genre. Some scholars consider several of the psalms, the book of Ruth (Das Buch Rut), and Song of Songs (Das Hohelied Salomos) wisdom books, or at least texts open to wisdom interpretations.

81. Ecclesiastes 5:1 (KJB); Vorschrift for Abraham Maÿer, Bethel Township, Dauphin (now Lebanon) County, PA, March 13, 1807, WM, 1956.0040.004. Note that this example was not part of the random sample that resulted in quantitative data for this study.

82. *Hoch-Deutsches Reformirtes*, n.p.; *Hoch-Deutsches Lutherisches*, 17.

83. Joseph Perkins, *Perkins's Small Alphabetical Copies for the Use of Schools* (New York, ca. 1830), AAS, Z825 P449 P832a, bib ID 261776, recto leaf 5.

84. Malden, *Apocrypha*, 63. In the sample 4 percent of manuscripts quote from Sirach.

85. Kaiser, *Old Testament Apocrypha*, 88, 92–96.

86. Sirach, 38:24 (Anchor Bible translation).

87. Kaiser, *Old Testament Apocrypha*, 92; Malden, *Apocrypha*, 59.

88. Sirach 39:7–9 (NRSV).

89. Abraham Heebner, Vorschrift, ca. 1774, Heebner Family Fraktur Collection, SLHC, 00.261.51. The book was quoted on 4 percent of manuscripts in the sample.

90. Malden, *Apocrypha*, 59–60.

91. Of manuscripts made during the baroque period, 45 percent addressed the nature of wisdom, teaching, and learning, and 47 percent made during the baroque revival addressed the nature of the same. No manuscripts in the sample made during the Pennsylvania Dutch period or era of antiquarian enterprise focused on the topic.

92. Scriptural quotations appear on 55 percent of baroque documents. Only 24 percent of baroque samples feature scripture, followed by 36 percent during the Pennsylvania Dutch period, reflecting scribal embrace of a wider array of text sources.

93. Of Vorschriften that feature psalms, 57 percent were made during the baroque period, and 57 percent of Vorschriften featuring wisdom-book excerpts were made during the baroque or modified baroque periods.

94. During the baroque period, 60 percent of manuscripts featured first-person text. The figure dropped to 38 percent during the modified baroque period and 46 percent during the Pennsylvania Dutch period.

95. Monaghan, *Learning to Read*, 365.

96. Iser, *Act of Reading*, 107.

97. Vorschrift, ca. 1810–20, SLHC, 4-131/00.264.42.

98. Kaufman, *Systematic Theology*, 57.

99. Vorschrift, ca. 1775, Pennypacker Fraktur Collection, SLHC, 999810.

100. John 13:35 (NIV).

NOTES TO PAGES 109–119 193

101. Full text of the hymn, as well as attribution to Christian Fürchtegott Gellert, can be found in *Gesangbuch für Kirche*, 287–88.

102. 1 Corinthians 13:13 (NIV).

103. Matthew 10:16 (NIV).

104. Heinrich Brachtheiser, attr., Vorschrift and cover for Philip Markley, Skippack Township, PA, MHC, 1787. Note the variant spelling of the surname; "Markley" is an Anglicization of "Märkel."

105. Van der Toorn, *Scribal Culture*, 29.

106. Arbo, attr., inscriptions in *Methode*, MAB, CongLib 690, p. 6.

CHAPTER 4

1. Zerfass, *Souvenir Book*, 47. For a concise biography of Hopkinson, see "Francis Hopkinson (1737–1791)," *Penn Biographies*.

2. "Selected for the *Berean*," 16.

3. Ephrata community hymnal, *Paradisisches Wunderspiel*, 1754, Hymnals, circa 1747–1850, Ephrata, PA, col. 318, 57.68.4, 65x560, Joseph Downs Collection of Manuscripts and Printed Ephemera, WL, 65x560, recto of leaf 6.

4. "Selected for the *Berean*," 16.

5. Ephrata community hymnal, *Paradisisches Wunderspiel*, 1754, Downs Collection, WL, Col. 318, 57.68.4, 65x560, leaves 3, 4.

6. Ryden, *Story of Christian Hymnody*, 119.

7. Witvliet, series preface to Mouw and Noll, *Wonderful Words of Life*, vii.

8. On this issue, see Watson, *English Hymn*, 1–21.

9. Marini, "From Classical to Modern," in Blumhofer and Noll, *Singing the Lord's Song*, 1.

10. Rogal, *General Introduction to Hymnody*, 1, 2.

11. Ibid., 22; Ryden, *Story of Christian Hymnody*, 59.

12. Rogal, *General Introduction to Hymnody*, 23–28.

13. Ryden, *Story of Christian Hymnody*, 60, 67, 70.

14. Rogal, *General Introduction to Hymnody*, 32; Ryden, *Story of Christian Hymnody*, 139.

15. Ryden, *Story of Christian Hymnody*, 83, 97; Vorschrift for Martin Dettweiler, Pennsylvania, 1788, Samuel W. Pennypacker Fraktur Collection, SLHC, 00.265.22.

16. Ryden, *Story of Christian Hymnody*, 120, 136.

17. Rogal, *General Introduction to Hymnody*, 40; *The Whole Booke of Psalmes Faithfully Translated into English Metre: Whereunto Is Prefixed a Discourse Declaring Not Only the Lawfullnes, but Also the Necessity of the Heavenly Ordinance of Singing Scripture Psalmes in the Churches of God* (Cambridge, MA: Day, 1640), The Rosenbach, Philadelphia, A 640w.

18. Ryden, *Story of Christian Hymnody*, 468.

19. Rogal, *General Introduction to Hymnody*, 36; Marini, "From Classical to Modern," in Blumhofer and Noll, *Singing the Lord's Song*, 4. For more on the Psalms in English-speaking early America, see Ogasapian, *Church Music in America*, 1–22.

20. Marini, "From Classical to Modern," in Blumhofer and Noll, *Singing the Lord's Song*, 6; Crookshank, "We're Marching to Zion," in Mouw and Noll, *Wonderful Words of Life*, 29; MacCulloch, *Christianity*, 750.

21. Watts, "Dr. Watts' Preface," in Cobbin, *Anecdotes and Reflections*, viii.

22. Noll, *Rise of Evangelicalism*, 273.

23. Mouw, introd.; Noll, "Defining Role of Hymns"; and Crookshank, "We're Marching to Zion," all in Mouw and Noll, *Wonderful Words of Life*, xiv, 13, 15, 17.

24. Witvliet, series preface to Mouw and Noll, *Wonderful Words of Life*, viii.

25. Mouw, introd. to Mouw and Noll, *Wonderful Words of Life*, xvii.

194 NOTES TO PAGES 119–128

26. Stein, *Shaker Experience in America*, 190; E. Andrews, *People Called Shakers*, 139–40, 142.

27. Mary Hazard, manuscript songbook, "A Collection of Extra Songs of Various Kinds: Written and Pricked for the Purpose of Retaining Them by Mary Hazard; Beginning February 7th, 1847," New Lebanon, New York, 1839, Edward Deming Andrews Memorial Shaker Collection, WL, ASC 896, pp. 191–92.

28. Thomas Collins, *The Gamut*, manuscript tune book, 1775, Pennsylvania German Collection of Fraktur Manuscripts and Imprints, Rare Book Department, FLP, accessed March 3, 2019, https://libwww.freelibrary.org/digital/item/44166, MS 123.

29. Genette, *Paratexts*, 1.

30. Genette and Maclean, "Introduction to the Paratext," 261.

31. *Neu-vermehrtes nunmehro allervollständigstes Marburger Gesang-Buch, Bestehend in 615. Geistreichen Liedern Hn. D. Martin Luthers und anderer Gottseliger Lehrer* (Marburg: Brönneris, Druckerey, 1792), WM, 1959.2815 A–C; Ephesians 5:19 (KJB).

32. See, for example, "Hermonisches Melodeÿen büchlein Über die bekanste Lieder Im Murburger-Gesang Buch, geschriben den 8ten Februarius A. 1793," SLHC, 00.273.12.

33. *Neu-vermehrtes nunmehro allervollständigstes Marburger Gesang-Buch*, WM; Ephesians 5:19 (KJB). Photos of this item are available on this book's companion website, www.wordinwilderness.com.

34. Johann Adam Eyer, bookplate for Elisabetha Eyer in *Erbauliche Lieder-Sammlung* (Philadelphia: Billmeyer, 1821), Hamilton Township, Monroe County, PA (writing ink and watercolor on laid paper), WM, 2012.0027.012.

35. Maria Hostetter, inscription on front pastedown of *Ein Unpartheyisches Gesang-Buch* (Lancaster, PA: Albrecht, 1804), WL. Translation from the New International Version.

36. Gross and Berg, "Singing It 'Our Way,'" 190.

37. Hershey, "Notenbüchlein Tradition," in Amsler, *Bucks County Fraktur*, 115–17.

38. Gross and Berg, "Singing It 'Our Way,'" 192, 193–95.

39. Hershey discusses this issue in *This Teaching I Present*, 28.

40. Gross and Berg, "Singing It 'Our Way,'" 204.

41. Hershey, "Notenbüchlein Tradition," in Amsler, *Bucks County Fraktur*, 118, 129.

42. Notenbüchlein for Jacob Hunsicker, January 29, 1783, Pennsylvania German Collection of Fraktur Manuscripts and Imprints, Rare Book Department, FLP, accessed March 3, 2019, https://libwww.freelibrary.org/digital/item/7222, MS 23a; Jacob Botz, attr., manuscript hymnal for Johann Jacob Koch, August 23, 1781, Pennsylvania German Collection of Fraktur Manuscripts and Imprints, Rare Book Department, FLP, accessed March 3, 2019, https://libwww.freelibrary.org/digital/item/41624, MS 59. Neither of these examples figures in the random sample described later in detail. Partial English translations are provided on the FLP digital collections webpages.

43. Hershey, "Notenbüchlein Tradition," in Amsler, *Bucks County Fraktur*, 122.

44. Title page of Notenbüchlein for Susana Kassel, September 16, 1792, MHC, IL-97-6.

45. Melchior Schultz, "Kurtze Anweisung zur Coral Music in Frag und Antwort gestellt," 1808, SLHC.

46. Exhibit label for Elisabeth Kolb's Notenbüchlein, permanent Fraktur exhibition, March 1, 2017, Mary Jane Lederach Hershey Fraktur Gallery, MHC.

47. Rae, *Martin Luther*, 442.

48. Henry Johnson, "Noten Buch" for Henry Johnson, 1826, private collection (on deposit at the MHC).

49. Andreas Kolb, Notenbüchlein for Anna Funck, 1788, MHC, 2016.05.01. See the recto of the first leaf for the poem, and pages 1, 7, and 9 for examples of pictorial imagery.

50. Title page of Notenbüchlein for Sarah Schättinger, 1822, MHC, 2001.11.1.

51. Title page of Notenbüchlein for Elisabeth Schwartz, 1784, MHC, 200214.1.

NOTES TO PAGES 128–137 195

52. Title page of Notenbüchlein for Jacob Hunsperger, 1804, MHC, 2012.80.1.

53. Title page of Notenbüchlein for Anna Geissinger, MHC, 2015.37.6.

54. Kolb, Notenbüchlein for Funck, MHC, title page.

55. This accounts for 18 percent of tune books from the sample that included manuscript title pages.

56. Title page of Notenbüchlein for Jacob Meyer, September 12, 1805, SLHC, 00.273.19.

57. This accounts for 11 percent of tune books in the sample with manuscript title pages.

58. Title page of Notenbüchlein for Johannes Friedrich, November 27, 1806, SLHC, 2006.26.1.

59. Title page of Notenbüchlein for Joseph Schleifer, December 5, 1806, SLHC, 1923.02.04.

60. This accounts for 31 percent of the sample featuring title pages.

61. Notenbüchlein for Elisabetha Kolbin (Elisabeth Kolb), 1787, SLHC, 1920.09.124.

62. This accounts for 26 percent of the sample.

63. For heart designs, see "Hermonisches Melodeÿen büchlein," SLHC; for floral patterns, see Notenbüchlein for Maria Bächtel, probably Bucks County, 1788, SLHC, 1920.17.30; for colors, see Notenbüchlein for Johannes Friedrich, November 27, 1806, SLHC, 2006.26.1.

64. See, for example, Notenbüchlein for Elisabetha Kolbin (Elisbeth Kolb), 1787, SLHC, 1920.09.124.

65. Notenbüchlein, ca. 1800 (4¼ × 7¾ in.), SLHC, VD1-11 / 2979.

66. See Hershey, "Notenbüchlein Tradition," in Amsler, Bucks County Fraktur, 127–28, for a discussion of the Schwenkfelder pieces.

67. Notenbüchlein for Isaac Schultz, SLHC, 00.272.9.

68. Sudermann, Hohe geistreiche Lehren / vnd Erklärungen, SLHC, VN 33-12, 35.

69. Song of Solomon 4:1–12 (KJB).

70. At least four other versions of the text are present in the Schwenkfelder Library; see library call numbers VA 2-13, VA 2-13, and V2° Sudermann. Also, the text was reproduced in manuscript; see call number VC 3-4.

71. Brecht, Genealogical Record, 886, 940, 1258.

72. Smucker, "Lifting the Joists," in Blumhofer and Noll, Singing the Lord's Song, 140.

73. Schleiermacher, Hermeneutics, 43.

74. Genette, Paratexts, 4, 11, 407.

75. Sachse, German Sectarians of Pennsylvania, 1.

76. "Selected for the Berean," 16.

CHAPTER 5

1. Vorschrift des Steffen Barandun von Feldis, 1743 (reproduction), Staatsarchiv Graubünden, Chur, Switzerland, B/N 0647.

2. Promey, "Hearts and Stones," in Brekus and Gilpin, American Christianities, 202, 204.

3. Sommer, "German Language Books," in Swank, Arts of the Pennsylvania Germans, 278.

4. Earnest and Earnest, To the Latest Posterity, 3.

5. Wellenreuther, Citizens in a Strange Land, 5–6. Wellenreuther's book brilliantly situates religious and devotional broadsides within the broader context of topics covered on printed documents and describes the state of printed documents' study. "Broadsides are part of the communicative system of the Atlantic world," Wellenreuther states, and "until the last two decades most German scholars viewed these flying leaves as curiosities of interest only to the folklorist" (5–6).

6. Consider, for example, the traditions of Christmas and New Year's broadsides, discussed in Yoder, Pennsylvania German Broadside, 69–85.

NOTES TO PAGES 138–144

7. Nockamixon Reformed Church, book of births and baptisms from November 7, 1773, to October 22, 1854, folder 1, box 1, RG 370, Nockamixon Reformed Church (Nockamixon Township, PA), ERHS.

8. Venema, "Sacraments and Baptism," 21–22; Swain, "Lutheran and Reformed," in Boersma and Levering, *Oxford Handbook*, 366; Tranvik, "Luther on Baptism," 77.

9. Swain, "Lutheran and Reformed," in Boersma and Levering, *Oxford Handbook*, 370–71; Tranvik, "Luther on Baptism," 86.

10. Swain, "Lutheran and Reformed," in Boersma and Levering, *Oxford Handbook*, 367; Spinks, *Reformation and Modern Rituals*, 6, 32; Piepkorn, "Lutheran Understanding of Baptism," in Empie and Murphy, *Lutherans and Catholics*, 30; Tranvik, "Luther on Baptism," 83.

11. Tranvik, "Luther on Baptism," 77.

12. Cullmann, *Baptism in the New Testament*, 21, 48.

13. Tranvik, "Luther on Baptism," 83.

14. Carl Friedrich Egelmann, Geburts und Taufschein (birth and baptismal certificate) of Sara Anna Huber, Reading, Berks County, PA, and Douglass Township, Montgomery County, PA, 1835–1840, WM, 1980.0048.

15. Matthew 28:19 (KJB).

16. Stopp, *Printed Birth*, 15.

17. Ibid., 30, 25; Earnest and Stopp, "Fraktur Referring to Birth," 87.

18. Stopp, *Printed Birth*, 33.

19. Taufschein for James Latimer Banning, Saint Michael's Protestant Episcopal Parish, Maryland, July 31, 1850, in MS 5061, "Scrapbook, Kept by James L. Banning, President of City Council, 1909, Materaal [*sic*] to Complete, Not Yet Pasted, from James L. Banning, Dec. 1950, City of Wilmington Paving," Delaware Historical Society, Wilmington, DE.

20. Of the fifty examples of the form studied for this analysis, twenty exhibited very obvious fold marks, whereas the conditions of the rest made it difficult to determine if they had or had not been folded in previous years. It seems likely that many more were thus folded and stored.

21. This accounts for 18 percent of the sample.

22. This accounts for 14 percent of the sample.

23. This accounts for 77 percent of the sample (excluding the two that were never used).

24. This accounts for 17 percent of the sample.

25. This accounts for 25 percent, 24 percent, and 20 percent of the sample, respectively.

26. Geburts und Taufschein for Oleto Clauser, filled out in 1887 (New York: Currier and Ives, ca. 1870), LCP, \$Am 1870 Tau Log. 2023.F (Oda); Geburts und Taufschein for Anna Helene Dorothea Rapp (New York: Verlag von Ernst Kaufmann, n.d.), LCP, \$Am 1887 Geburts 15127.Q (Roughwood).

27. Geburts und Taufschein for Elizabeth Mack (Harrisburg, PA: Lutz and Scheffer, ca. 1850), LCP, \$Am 1851 Tau 8274.F.

28. This accounts for 54 percent of the sample.

29. See, for example, Geburts und Taufschein for Willi Ketterer, 1865 (Allentown, PA: Leisenring, Trexler, n.d.), LCP, \$Am 1865 Geburts 9635.F (Roughwood).

30. This accounts for 70 percent of the sample.

31. This accounts for 26 percent of the sample.

32. This accounts for 65 percent of the sample.

33. See, for example, Geburts und Taufschein for Nicola Strauss, 1822 (Reading: Ritter, n.d.), LCP, \$Am 1823 Tauf 10057.F.

34. This accounts for 50 percent of the sample.

35. For an example of a skull, see Geburts und Taufschein for Anna Helene Dorothea Rapp, LCP. For an example of a gravestone, see Geburts und Taufschein for Annora Scheirer, 1871 (Philadelphia: Ignatius Kohler, n.d.), LCP, \$Am 1871 Geburts 9510.F (Roughwood).

36. Geburts und Taufschein for Isaac Krick (Reading, PA: "Eagle" Book Store, 1870), LCP, \$Am 1870 Tau Log. 2024.F (Oda).

NOTES TO PAGES 144–154 197

37. Geburts und Taufschein for Lea Taubert (Allentown, PA: Blumer und Busch, 1847), LCP, $Am 1847 Tauf Log. 1952.F (Allen).

38. Watts, *Divine and Moral Songs*, 23.

39. This accounts for 74 percent of the sample.

40. See, for example, Geburts und Taufschein for Willie Carvin Koch (Allentown, PA: Leisenring, Trexler, n.d.), LCP, $Am 1875 Tau Log. 2031.F (Oda).

41. This accounts for 26 percent of the sample.

42. This accounts for 28 percent and 16 percent of the sample, respectively.

43. Geburts und Taufschein for Oleto Clauser, LCP.

44. Geburts und Taufschein for Heinrich Louis Essler, 1828 (n.p.: Rosecker, n.d.), LCP, $Am 1825 Tau Log. 2001.F (Oda).

45. Four documents equates 8 percent of the sample.

46. This equates 30 percent of the sample. For the former, see Geburts und Taufschein for Franklin Hill, 1836 (Reading, PA: Egelmann, n.d.), LCP, $Am 1830 Tauf Log. 1977.F (Allen). For the latter, see Geburts und Taufschein for Maria Eva Haag, 1865 (Reading, PA: Ritter, n.d.), LCP, $Am 1850 Tau Log. 2006.F (Oda).

47. See, for example, Geburts und Taufschein (never used), (Philadelphia: Kohler, 1855), LCP, $Am 1855 Geburts 9643.F (Roughwood).

48. Seven certificates, or 14 percent of the sample, feature classical pillars, four (8 percent) feature urns or tureens, and one features a classically designed fountain.

49. This accounts for 38 percent and 58 percent of the sample, respectively.

50. This accounts for 30 percent of the sample.

51. Ecclesiastes 7:1 (KJB).

52. Geburts und Taufschein for Sara/Sahra Heÿdt, ca. 1841–43 (Allentown, PA: Blumer und Gebrüdern, 1842), LCP, $Am 1842 Tau Log. 2013.F (Oda).

53. Geburts und Taufschein, with confirmation and marriage addenda, for Anna Carolina Dietrich, 1841–63, calligraphed at least in part by Martin Wetzler (Allentown, PA: A. and W. Blumer, 1840), LCP, $Am 1840 Tau Log. 2012.F (Oda).

54. Thirteen certificates account for 26 percent of the sample. One of the thirteen certificates was never filled in, meaning it lacks a year of use. The mean year of use was thus calculated from the twelve remaining examples.

55. On this topic in reference to Lutheranism, see "Baptism in Martin Luther's Theology."

56. Geburts und Taufschein for Annora Scheirer, LCP.

57. D. Morgan, *Protestants and Pictures*, 6.

58. Earnest and Earnest, *To the Latest Posterity*, 19.

59. Braght, *Blutige Schau-Platz*; Reist Family Record, Reist Family Collection, Landis Valley Museum, Lancaster, PA, FM2012.11.2.

60. Earnest and Earnest, *To the Latest Posterity*, 10.

61. See, for example, a frontispiece drawn from the register of the Lower Bermudian Lutheran and Reformed Church, in Glatfelter, *Pastors and People*.

62. See Wulf, "Common Law."

63. Lädtermann family register, ca. 1840, WM, 2012.0036.002, pp. 2, 6.

64. Samuel Bentz, *Grab-Schrift* for Maria Appel, Cocalico Township, Lancaster County, PA, 1846–50, WM, 2013.0031.043.001.

65. Promey, "Self in Frame," 14.

66. Samuel Adams Dorr, elegy for George Washington Hancock, made at the South School, Pleasant Street, Boston, 1787, New England Historic Genealogical Society, Boston, Mss 566.

67. Earnest and Earnest, *To the Latest Posterity*, 5.

68. Geburts und Taufschein for Margaret Elizabeth Wint, 1844 (Allentown, PA: A. Blumer and Brothers, 1842), LCP, Rare $Am 1842 Tauf Log.1947.F (Allen).

69. Promey, "Hearts and Stones," in Brekus and Gilpin, *American Christianities*, 205.

70. *Gantze Bibel*; "Gott der grosse," black and white, ca. 1781, Charles (Carli) Family Record; Charles Family Record (color); "Gott der grosse," ca. 1825; "In Gottes Namen," Christian verse,

198 NOTES TO PAGES 154–160

n.d. (eighteenth or early nineteenth century); birth certificate for John H. Carle, August 13, 1843; Carl F. Seÿbold, birth certificate for David H. Carle, May 27, 1837; Jacob Botz, Vorschrift for Anna Carli/Charles, Lancaster County, March 8, 1775, all in David G. Charles Collection, LMHS; Charles, "Katie's Family Tree," 8–9.

71. Religious text for Johannes Carli, Lancaster County, February 25, 1791, David G. Charles Collection, LMHS.

72. Jacob Botz, Vorschrift for Anna Carli/Charles, LMHS; Riggenbach, *Hieronymus Anoni*, 110.

73. For a printed example, see broadside, folder "Broadside: 'Abschiedsworte des Ehrw. Johannes Geil an seine Gemeinde,' by Johannes Geil. Doylestown, Pa: M. Löb, [November 32, 1852 or later]," David G. Charles Collection, LMHS.

74. Religious manuscript for Johannes Carli, "Meine Hertze," March 5, 1792, David G. Charles Collection, LMHS; Religious manuscript for Johannes Carli, "In diesem Lichte," 1790, David G. Charles Collection, LMHS; Religious manuscript for Johannes Carli, March 2, 1791, "Meine Hoffnung," David G. Charles Collection, LMHS.

75. Religious manuscript for Johannes Carli, March 2, 1791, LMHS; John 13:17 (KJB).

76. Sirach 33:17 (KJB).

77. *Gantze Bibel*; Christian Hershey [Hirschi] Papers (1755–1800), LMHS; Vorschrift for Catharina Huber, April 22, 1775, Hershey Papers, LMHS, box 002, folder "Vorschriften (3); Christian Strenge, Vorschrift for Christian Hershey, 1808, Hershey Papers, LMHS, object 2007.081; "Hershey, Christian, Oct. 20, 1755 (Bible)," genealogy cards, no. 2, "8. Christian, Sept. 30, 1796–Apr. 1, 1836," Hershey Papers, LMHS; Marriage certificate, Hershey Papers, LMHS, box 002, folder "Marriage Certificate: John Appel and Anna Elizabeth Gorges"; broadside, Hershey Papers, LMHS, box 002, folder "Broadside: 'Ein schön Lied'"; "Briefleinn," by or for Abraham Heebner, March 11, 1804," Hershey Papers, LMHS, box 002.

78. Broadside, LMHS, folder "Broadside: 'Ein schön Lied.'"

79. Wellenreuther, *Citizens in a Strange Land*, 140–42, 83–104. Wellenreuther's book is an excellent introduction to broadside study, as is Yoder's *Pennsylvania German Broadside*.

80. Vorschrift by or for Henrich Schenck, Lancaster County, 1767, Shenk (Schenk/Schenck) Family Fraktur Collection, 2006.006, LMHS; Vorschrift by or for Andreas Hirschi/Hirshi, Lancaster County, ca. 1770s, Shenk Collection, LMHS; "Hostetter, Abraham, 1723–1796," genealogy cards, no. 2, "Barbara-m-Henry Shenk, Jan. 2, 1756–Aug. 28, 1853," Shenk Collection, LMHS; "Shenk, Henry, Jan. 2, 1756–, s Immigrant John Shenk," genealogy card, Shenk Collection, LMHS. See also Hoover, "Michael Shenk of Warwick Township."

81. Hans Jacob Brubacher, Vorschrift for John Schenck, Lancaster County, January 19, 1764, Shenk Collection, LMHS; Manuscript copy of Psalm 150, ca. 1760s/1770s, Shenk Collection, LMHS; Religious manuscript for Barbara Hostatern, Shenk Collection, LMHS.

82. Psalm 150:1–3 (KJB).

83. D. Morgan, *Visual Piety*, 17.

84. As quoted in Louden, *Pennsylvania Dutch*, 194–95.

85. Houston, *Book*, 310.

86. Kilgour, *Evolution of the Book*, 98–113, 100; Houston, *Book*, 306–8.

87. Houston, *Book*, 136; Kilgour, *Evolution of the Book*, 108.

88. Kilgour, *Evolution of the Book*, 106; Zboray, "Antebellum Reading," 72.

89. See Houston, *Book*, 219–37.

90. Ibid., 72; Kilgour, *Evolution of the Book*, 102.

91. Kilgour, *Evolution of the Book*, 110.

92. Houston, *Book*, 309.

93. McKitterick, *Search for Order*.

94. Erben, "Educating Germans," in Pollack, *Good Education of Youth*, 123–24, 143–45.

95. McNealy and Amsler, "Pennsylvania German Schools," in Amsler, *Bucks County Fraktur*, 88.

NOTES TO PAGES 160–169

96. Nolt, *Foreigners in Their Own Land*, 132.

97. Gaskell, *Penman's Hand-Book*, 7.

98. *Theory and Art of Penmanship*, 96–97, 98, 147, 96–97.

99. Spencer and Spencer, *Spencerian Key*, 143.

100. Clauss, *Nordamerikanische Schnell-Schreibmethode*.

101. Kersten, "Vortrag über das dem Unterzeichneten," in *Mittheilungen aus dem Oster-lande*, 137–40.

102. Louden, *Pennsylvania Dutch*, 125, 298–300, 129.

103. Baer, *Trial of Frederick Eberle*.

104. Louden, *Pennsylvania Dutch*, 134, 135, 155.

105. Hartzler and Krahn, "Bauer."

106. Henry S. Bower, Vorschrift, 1853, MHC, 99.11.12 (translation from "Baruch," chap. 5).

107. *Kleine Davidische Psalterspiel*, 479.

108. Henry S. Bower, Vorschrift and religious verse, 1855, MHC, 2006.26.1; Thompson, "Hear the Royal Proclamation"; *Autobiography of Elder Wilson Thompson*. The hymn later appeared in Hillman, *Revivalist*, 143.

109. Manuscript artworks for and by Magdalena Schultz Krauss, *Erläuterung für Herrn Caspar Schwenckfeld, und die Zugethanen seiner Lehre, wegen vielen Stücken, beydes aus der Historie und Theologie* [. . .]. 2nd ed. (Sumneytown, PA: Benner, 1830), SLHC, BP 52.

110. Minardi, "Quill and Brush," in Tannenbaum, *Framing Fraktur*, 43.

111. John Derstine Souder, Fraktur ("Die Blumen stehen hier"), 1939, Pennsylvania German Collection of Fraktur Manuscripts and Imprints, Rare Book Department, FLP, accessed March 1, 2019, https://libwww.freelibrary.org/digital/item/5812, item no. 105. The English translation is provided on the FLP digital collection website.

CONCLUSION

1. "S. W. Pennypacker, Former Governor, Dying at His Home; Family Summoned to Bedside of Public Service Commissioner," *Philadelphia Inquirer*, August 28, 1916, p. 2, accessed March 11, 2017, America's Historical Newspapers.

2. "S. W. Pennypacker, Former Governor, Dies: Ill for Year; Unique Figure in Pennsylvania Affairs Succumbs at 73 Years," *Philadelphia Inquirer*, September 3, 1916, pp. 1, 6, accessed November 11, 2016, America's Historical Newspapers.

3. The interpretation of Pennypacker's final days and his political and cultural understandings presented here was inspired by a lecture presented by Iren Snavely: "Samuel W. Pennypacker." I extend my appreciation and thanks to Dr. Snavely for sharing Pennypacker's legacy and helping shape the trajectory of this research.

4. For succinct summaries of the founding of the German nation and empire, see Breuilly, *First German Nation-State*; and Retallack, *Age of Kaiser Wilhelm II*.

5. Louden, *Pennsylvania Dutch*, 2–5.

6. Samuel W. Pennypacker, "In Defense of Germany: What Its Success Would Mean, According to Pennypacker," *Philadelphia Inquirer*, January 15, 1915, p. 10, accessed March 10, 2017, America's Historical Newspapers.

7. Ibid.

8. Ibid.

9. "The Historical Society Presidency," *Philadelphia Inquirer*, April 3, 1916, p. 10, accessed March 10, 2017, America's Historical Newspapers.

10. Pennypacker, "In Defense of Germany."

11. Snavely, "Samuel W. Pennypacker."

12. Kilgour, *Evolution of the Book*, 98–113.

13. Louden, *Pennsylvania Dutch*, 166–67.

200 NOTES TO PAGES 169–176

14. Samuel T. Freeman and Company, *Executors' Sale*.

15. Pennypacker, *Extraordinary Library*. For more information on the auctions held between 1905 and 1907, see auction catalog 943, produced by Davis and Harvey for the sale. The catalog record for this series of publications is complex, but fortunately the sale catalogs are available online from Hathi Trust, accessed September 19, 2019, https://babel.hathitrust.org/cgi/pt?id=coo1.ark:/13960/t65439c81&view=1up&seq=9 and https://babel.hathitrust.org/cgi/pt?id=coo1.ark:/13960/t42r4dm52&view=1up&seq=1.

16. Green, "Looking Backward," in Rossano, *Creating a Dignified Past*, 1–16. See also Axelrod, *Colonial Revival in America*; and Wilson, Eyring, and Marotta, *Re-creating the American Past*.

17. Erb, "Garden in Schwenkfelder Fraktur," 13.

18. Stein, "Some Thoughts on Pietism," in Strom, Lehmann, and Van Horn Melton, *Pietism in Germany*, 23.

19. Pennypacker, "Pennsylvania and Massachusetts," in *Pennsylvania in American History*, 176–77.

20. Miller, *Errand into the Wilderness*, 1.

21. Miller, foreword to *New England Mind: From Colony to Province*, ix.

22. One book that emphasizes the importance of the mid-Atlantic region to the United States' religious history is Haefeli, *New Netherland*.

23. For important examples of New England–based book-historical scholarship, see M. Brown, *Pilgrim and the Bee*; and D. Hall, *Ways of Writing*.

24. Pennypacker, "Pennsylvania Dutchman," in *Pennsylvania in American History*, 309. The essay was first published in the *Pennsylvania Magazine of History and Biography* in January 1899.

25. Monaghan, *Learning to Read*, 365.

26. Thornton, *Handwriting in America*, 18.

27. Yoder, "Fraktur in Mennonite Culture," 308, 310, 309.

28. Morgan and Promey, *Visual Culture*, xii.

29. Schleiermacher, *Hermeneutics*, 50.

BIBLIOGRAPHY

COLLECTIONS OF MANUSCRIPTS, ORIGINAL ARTWORKS, AND ARTIFACTS

American Antiquarian Society, Worcester, Massachusetts
Perkins, Joseph. *Perkins's Small Alphabetical Copies for the Use of Schools.* New York, circa 1830. Z825 P449 P832a. Bib ID 261776.
The Scriptural Album with Floral Illustrations. New York: Riker, n.d. Inscribed by Joseph W. Pierce to Marcella L. Brown, May 12, 1852. Bindings Coll.D No. 083. Bib ID no. 359291.
Token Album. New York: Cornish, Lamport, n.d. Formerly owned by Dorcas M. Cree of Carmichaels, PA. Bindings Coll.D No. 135. Bib ID no. 503120.

Beinecke Rare Book and Manuscript Library, Yale University, New Haven, Connecticut
Ketubah. Made in Bucharest, Romania, July 2, 1840. Hebrew MSS Suppl. 97 (broadside).

Burgerbibliothek Bern, Bern, Switzerland
Hutzli, Jakob. Schreibbuch (writing book). Circa 1690. Mss.h.h.LI.169.
————. *Schreibvorlagbuch/Das güldene ABC* (Writing sample/The golden ABC), 1693, Mss. h.h.LI.167.

Delaware Historical Society, Wilmington, Delaware
Taufschein for James Latimer Banning, Saint Michael's Protestant Episcopal Parish, MD. July 31, 1850. In MS 5061: "Scrapbook, Kept by James L. Banning, President of City Council, 1909, Materaal [sic] to Complete, Not Yet Pasted, from James L. Banning, Dec. 1950, City of Wilmington Paving."

Ephrata Cloister, Ephrata, Pennsylvania
Anonymous scribes. *Der Christen ABC ist Leiden, Dulden, Hoffen, Wer dieses hat gelernt, der hat sein Ziel getroffen.* 1750. Iron gall ink on laid paper. Pennsylvania Historical and Museum Commission.

Evangelical and Reformed Historical Society, Lancaster, Pennsylvania
Nockamixon Reformed Church. Book of births and baptisms from November 7, 1773, to October 22, 1854. Folder 1, box 1, RG 370. Nockamixon Reformed Church (Nockamixon Township, PA).
Nockamixon Reformed Church. Financial record book. 1787–1844. Folder 12, box 1. RG 370. Nockamixon Reformed Church (Nockamixon Township, PA) records.

Free Library of Philadelphia
Ball, Elisabeth, Collection of Hornbooks. Rare Book Department.
Pennsylvania German Collection of Fraktur Manuscripts and Imprints. Rare Book Department.

202 BIBLIOGRAPHY

Hancock Shaker Village, Pittsfield, Massachusetts
Collins, Polly. *A Gift from Mother Ann to the Elders at the North Family.* 1854. Hancock, Massachusetts. Ink and watercolor on paper. 19 x 12 inches. 1963. 114.

Haverford College Library, Haverford, Pennsylvania
Morris, Catharine. "German Text Alphabet" and "Italic Alphabet." Copy books. Philadelphia, 1815–16. Quaker and Special Collections. 975 B.

Hill Museum and Manuscript Library, Saint John's University, Collegeville, Minnesota
Weber, Johann Gottfried. *Allgemeine Anweisung der neuesten Schönschreibkunst des Hochgräflich Lippischen Bottenmeisters und Aktuarius.* Duisberg, Germany: Im Verlag der Helwingschen Universitäts Buchhandlung, 1780.

Historical Society of Pennsylvania, Philadelphia
"Bedencke was du fliehen must [. . .]." Religious text, PA. Circa 1800. German Collection V80. DAMS 12561.

John Carter Brown Library, Brown University, Providence, Rhode Island
"JCBL—Associates—Ninth Annual Meeting—May 16, 1952" (leaflet). Box: "Associates Annual Meetings, 1944–1957."

Lancaster Mennonite Historical Society, Lancaster, Pennsylvania
Charles, David G., Collection.
Hershey [Hirschi], Christian (1755–1800) Papers.
Shenk (Schenk/Schenck) Family Fraktur Collection.

Landis Valley Museum, Lancaster, Pennsylvania
Reist Family Collection, FM 2012.11.

Library Company of Philadelphia
Collection of Geburts und Taufschein.
"Geistlicher Irrgarten: Mit vier Gnaden-Brunnen." Allentown, PA: Gräter and Blumer, circa 1833. #Am 1833. Geist 9515.F (Roughwood).
"Geistlicher Irrgarten: Mit vier Gnaden-Brunnen [. . .]." Reading, PA: Ritter, 1811. #Am 1811. Geist Log.1868.F (G. Allen).
"Gründliche Anweisung zu einem Heiligen Leben. Von einem Geistlich-gesinneten lang verstorbenen Lehrer. Ubersetzt 1747." Germantown, PA: Saur [also spelled Sauer], 1748. Am.1748.Gru.2940.F.
"Im Nahmen der aller heiligsten Dreyfaltigkeit: Das goldene ABC für jedermann, der gern mit Ehren wollt bestehn." Circa 1770–1800. 9523.F (Roughwood).
Roughwood Collection of Pennsylvania German American Folk Culture.
Yeager, Joseph, engraver. *Geographical, Statistical, and Historical Map of Pennsylvania.* Philadelphia: Carey and Lea, 1822. McNeil Map Collection. P.2011.44.82.

Martinus-Bibliothek, Mainz, Germany
"Gebett Buch welches Morgens Abens vor und nach der Beicht, wie auch bey der H. Communion zu gebrauchen." Gebetbuch 18. Jh. Stiche. Hs 24.

Mennonite Heritage Center, Harleysville, Pennsylvania
Ache, Herman M., attr. Vorschrift. Skippack/Salford, PA. 1768. 2013.68.1.
Brachtheiser, Heinrich, attr. Vorschrift for Philip Markley. Skippack Township, PA. 1787. 1998.8.1.

BIBLIOGRAPHY 203

Collection of Notenbüchlein.

Collection of Vorschriften.

Grater, Catherine H. Sampler. Skippack Township, Montgomery County, PA. 1839. Accessed April 25, 2017. http://mennoniteheritagecenter.pastperfectonline.com/webobject/5F96 961C-D6AB-435D-BB9F-389469943320.

Mercer Museum Library, Bucks County Historical Society, Doylestown, Pennsylvania
Mercer, Henry Chapman. Photos of the exterior and interior of a Pennsylvania Mennonite schoolhouse, as well as a child wearing leather spectacles. 1897. BCHS photo album, Archaeology/Colonial History, 42.

Vorschrift for Abraham Oberholtzer. 1782. Sl-58-no-a-15.

Moravian Archives, Bethlehem, Pennsylvania
German script and penmanship cards. Moravian seminary. FemSem 272–73.

Methode, nach welcher in den Neustädtischen Knaben-und Mägdlein-Schulen so wohl publice als priatim im Schreiben informiret wird. CongLib 690.

Meurer, Johann Philipp. Diary, 1741–47. BethCong 1012. JC IV.1.

Newberry Library, Chicago
Paritius, Georg Heinrich. *Regensburgische Schreib-Schule: Anweisende die jetziger Zeit üblichsten Schrifften [. . .].* Regensburg, Germany, 1710. Newberry Library, Chicago; Wing folio ZW 747.G45, no. 1.

New England Historic Genealogical Society, Boston
Dorr, Samuel Adams. Elegy for George Washington Hancock, made at the South School, Pleasant Street, Boston, 1787. Gift of Samuel Swett, August 3, 1859. Mss 566.

Pennypacker Mills, Schwenksville, Pennsylvania
Pennypacker, Samuel W. Book and Manuscript Collection.

Philadelphia Museum of Art, Philadelphia
Qit'a in Nasta'liq Script. Probably made in Tonk, Rajasthan, India, 1859. India Collection. Gift of the British Government, 1878. 1878-200.

Specimen of Calligraphy with Prayers to God and a Hadith, Manuscript Page with Prayers to Allah. Turkey, 1773–74. Louis E. Stern Collection. 1963. 1963-181-216.

Torii Kiyonaga. *Seven-Year-Old Child Prodigy Minamoto no Shigeyuki Executing Calligraphy.* Published by Eijudō, Japan, 1783. Gift of Mrs. John D. Rockefeller Jr., 1946. 1946-51-17.

Pilgrim Hall, Plymouth, Massachusetts
Deed, Robert Cuchman [Cushman], yeoman of Withyham Sussex. March 4, 1591, Oversize Box 1.

Lease agreement and indenture for portion of Scrooby Manor, signed by Willm Brewster. February 22, 1604 [1605]. Oversize Box 1.

Winslow/Cromwell Commission, 1654.

Private Collections
Calligraphic manuscript. Augsburg. Circa 1720–30. Private collection.

Hinderle, Sebastian. Hand-drawn German bookplate in a Bible for Johann George Bertsch. Philadelphia County, 1768. Private collection.

Rätisches Museum, Chur, Switzerland
Schriftenvorlagen (writing sample book). 1730. Ink and watercolor on laid paper. VI.53.

204 BIBLIOGRAPHY

Vorschrift for Hans Theiß. February 28, 1741. 1971.891.

Vorschrift/Golden ABC, ca. 1700, VI 30.

The Rosenbach, Philadelphia

Alzate y Ramírez, José Antonio de. "Memoria sobre la naturaleza, cultibo, y beneficio de la Grana [. . .]." Mexico, 1777. The Rosenbach 755/23.

Bunian, Joh. (John Bunyan). *Eines Christen Reisen ach der seeligen Ewigkeit* [. . .]. Ephrata, PA: Drucks und Verlags der Brüderschafft, 1754. EL2.B942.Ge754.

The Whole Booke of Psalmes Faithfully Translated into English Metre: Whereunto is prefixed a discourse declaring not only the lawfullnes, but also the necessity of the heavenly Ordinance of singing Scripture Psalmes in the Churches of God. Cambridge, MA: Day, 1640. A 640w.

Zionitischer Weyrauchs Hügel oder: Myrrhen Berg, worinnen allerley liebliches und wohl riechendes nach Apotheker-Kunst zu bereitetes Rauch-Werck zu finden [. . .]. Germantown, PA: Sauer, 1739. A 739z.

Rubin Museum of Art, New York City

Four Mandalas of the Vajravali Cycle. Circa 1429–56. C2007.6.1, HAR81826. Accessed August 15, 2018. http://rubinmuseum.org/collection/artwork/four-mandalas-of-the-vajravali-cycle.

Naga Mandala Assembly. Eighteenth century. C2003.10.1, HAR65235, 65236. Accessed August 15, 2018. http://rubinmuseum.org/collection/artwork/naga-mandala-assembly.

Schwenkfelder Library and Heritage Center, Pennsburg, Pennsylvania

Amos H. Schultz Collection, 732:193.

Arndt, Johann. *Des hocherleuchteten Lehrers Herrn Johann Arndts, weiland General-Superintendenten des Fürstenthums Lüneburg, Sechs Bücher vom wahren Christenthum* [. . .] *nebst dessen Paradiesgärtlein. Nach den accuratesten Editionen aufs neue collationirt und herausgegeben.* Nuremberg, Germany: Johann Andreä Endterischen Buchhandlung, 1762. L2004.0227.

———. *Des hocherleuchten Lehrers Herrn Johann Arndts, weiland General-Superintendenten des Fürstenthums Lüneburg, Sechs Bücher vom wahren Christenthum* [. . .] *nebst dessen Paradiesgärtlein. Nach den besten Ausgaben aufs sorgfältigste geprüft und von Fehlern gereinigt herausgegeben.* Allentown, PA: Gräter and Blumer, 1833. L1923.11.

Arnold, Gottfried. *Die Erste Liebe: Das ist; Wahre Abbildung der ersten Christen nach ihrem Lebendigen Glauben und Heiligen Leben, Aus der ältesten und bewährtesten Kirchen-Scribenten eigenen Zeugnissen, Exempeln und Reden, nach der Wahrheit der Ersten einigen Christlichen Religion* [. . .]. 5th ed. Leipzig, Germany: Samuel Benjamin Walther, 1732. L2006.0130.

———. *Die Verklärung Jesu Christi in der Seele, aus den gewöhnlichen Sonn-und Fest-Tags-Episteln auf dem Fürstlichen Schloße zu Allstedt gezeiget durch Sel. Hrn. Gottfried Arnold, Inspect. Nebst deßen kurtzen Anmerckungen über die Paßion* [. . .]. N.p.: n.p., 1721. L1924.06.

———. *Die Verklärung Jesu Christi in der Seele, aus den gewöhnlichen Sonn-und Fest-Tags-Episteln auf dem Fürstlichen Schlosse zu Allstedt gezeiget durch Sel. Herrn Gottfried Arnold. Nebst dessen kurtzen Anmerckungen über die Paßion* [. . .]. 5th ed. Leipzig, Germany: Walther, 1732. L2007.0283.

Collection of Notenbüchlein (manuscript tune books).

Collection of Vorschriften (manuscript penmanship samples).

Heebner Family Fraktur Collection.

"Hermonisches Melodeÿen büchlein Über die bekanste Lieder Im Murburger-Gesang Buch, geschriben den 8ten Februarius A. 1793." 00.273.12.

Manuscript artworks for and by Magdalena Schultz Krauss. *Erläuterung für Herrn Caspar Schwenckfeld, und die Zugethanen seiner Lehre, wegen vielen Stücken, beydes aus der Historie und Theologie* [. . .]. 2nd ed. Sumneytown, PA: Benner, 1830. BP 52.

Pennypacker, Samuel W., Fraktur Collection.

Thauleri, Johannis [Johannes Tauler]. *Helleleuchtender Hertzens-und Andachts-Spiegel* [. . .]. 4th ed. Amsterdam: Bielcken, 1713. L1925.09.

Staatsarchiv Graubünden, Chur, Switzerland
Vorschrift des Steffen Barandun von Feldis. 1743 (reproduction). B/N 0647.

Walters Art Museum, Baltimore
Tauber, Johan Leonhard. Single leaf with Lutheran devotional design. Nuremberg, Germany, 1752.

Winterthur Library, Winterthur, Delaware
Bogatzky, Carl Heinrich von. *Tägliches Haus-Buch der Kinder Gottes* [. . .]. Halle, Germany: Im Verlag des Waisenhauses, 1766. BV4834 B67.
Earl, Thomas. *The Marriner's Compass.* Exercise book. Southwestern New Jersey. Circa 1727. Joseph Downs Collection of Manuscripts and Printed Ephemera. Doc. 735.
Ephrata community hymnal, *Paradisisches Wunderspiel.* 1754. In *Hymnals, Circa 1747–1850.* Ephrata, PA: Ephrata Cloister, circa 1747–1850. Col. 318, 57.68.4, 65x560. Joseph Downs Collection of Manuscripts and Printed Ephemera.
Gellert, Christian Fürchtegott. *C. F. Gellerts sämmtlicher Schriften.* Berlin: Pauli, 1770. PT1883 S19, PT1883 G31.
Hazard, Mary. Manuscript songbook. "A Collection of Extra Songs of Various Kinds: Written and Pricked for the Purpose of Retaining Them by Mary Hazard; Beginning February 7th, 1847." New Lebanon, New York. 1839. Edward Deming Andrews Memorial Shaker Collection. Joseph Downs Collection of Manuscripts and Printed Ephemera. ASC 896.
Helfenstein, Georg F. *Sympathie: Eine Sammlung vorzüglicher Heilmittel und Rezepte für verschiedens Viehes, und andere Fälle.* New Berlin, PA[?]: Gedruckt für den Herausgeber, circa 1840. Housed in a metal box with manuscript materials formerly belonging to Jacob Masser of Upper Mahanoy Township, Northumberland County, PA.
Hess, Johann Jakob. *Geschichte der drey letzten Lebensjahre Jesu.* Zürich, Switzerland: Orell, Gessner, Fuesslin u. Comp., 1774. BT300 H4 1774 S.
Hostetter, Maria. Inscription on front pastedown of *Ein Unpartheyisches Gesang-Buch.* Lancaster, PA: Albrecht, 1804.
Kidder, Samuel. School exercise book. March 31, 1795. Joseph Downs Collection of Manuscripts and Printed Ephemera. Fol. 348.
Whittemore, Henry. Copy book. West Cambridge, Massachusetts. 1812. Joseph Downs Collection of Manuscripts and Printed Ephemera. Col. 429, 65x671.

Winterthur Museum, Winterthur, Delaware
Bard, Johannes. Fraktur writing sample. Union Township, Adams County, PA. 1819–21. 7¾ × 8½. 2011.0028.022.
Bentz, Samuel. *Grab-Schrift* (epitaph) for Maria Appel. Cocalico Township, Lancaster County, PA. 1846–50. Ink and watercolor on wove paper, 9¼ × 7¼. 2013.0031.043.001.
Chest (blanket chest). Berks County, PA. 1785–1810. 1955.0095.001.
Classroom verse and scene. Fraktur. Lancaster County, PA. Circa 1800. 2013.0031.092 A.
Egelmann, Carl Friedrich. Geburts und Taufschein of Sara Anna Huber. Reading, Berks County, PA, and Douglass Township, Montgomery County, PA. 1835–40. 1980.0048.
Eyer, Johann Adam. Bookplate for Elisabetha Eyer in *Erbauliche Lieder-Sammlung.* Philadelphia: Billmeyer, 1814. Hamilton Township, Monroe County, PA. 1821. 2012.0027.012.
———. Vorschrift for Jacob Seitler. 1782. Collection of Pastor Frederick Weiser. 2013 .0031.078.
Hümmel, Jacob. Vorschrift. Skippack Township, Montgomery County, PA. Ink and watercolor on laid paper. 1961.0209 A.
Lädtermann family register. 1795–1841. 2012.0036.002.

206 BIBLIOGRAPHY

Maser, Jacob (Jakob Masser, owner and possibly maker). Fall-front desk. Mahantongo/Schwaben Creek Valley, Northumberland County, PA, 1834. 1964.1518.

Neu-vermehrtes nunmehro allervollständigstes Marburger Gesang-Buch, Bestehend in 615. Geistreichen Liedern Hn. D. Martin Luthers und anderer Gottseliger Lehrer. Marburg, Germany: Brönneris, Druckerey, 1792. 1959.2815 A–C.

Otto, Johann Heinrich, and Ephrata Community printshop. "Geistlicher Irrgarten." Ephrata, PA. 1784. 1958.0120.013 A.

Registration Department Object Files, 64.1518 [Jakob Masser desk], folders 1–2.

Strickler, Jacob. Vorschrift, Massanutten, Shenandoah County, VA. February 16, 1794. 1957.1208A.

Vorschrift of Abraham Maÿer, Bethel Township, Dauphin (now Lebanon) County, PA, March 13, 1807. 1956.0040.4.

PUBLISHED PRIMARY SOURCES AND SECONDARY SOURCES

"The 1770 Electricity Machine." *This Month in Moravian History* 81 (September 2013). Accessed December 30, 2016. www.moravianchurcharchives.org/thismonth/13_09%20electricity%20machine.pdf.

A B C, Buchstabir-und Lese-Buch zum Gebrauche der kleinen Schuljugend in den kurmainzischen Landen [. . .]. Mainz, Germany: Wailandt, 1772.

A B C, Syllabir-und Lesebuch zum Gebrauche der kleinen Schuljugend in den kurmainzischen Landen. Mainz, Germany: Wittwen-und-Waisen-Instituts der kurfürstl/Schullehrer, 1796.

Ahlzweig, Claus. *Muttersprache–Vaterland: Die deutsche Nation und ihre Sprache.* Opladen, Germany: Westdeutscher Verlag, 1994.

Alderfer, Joel. "Kommt Liebe Kinder, Kommt Herbei: Elementary Education in the Mennonite Communities of Southeastern Pennsylvania to 1840." Paper written for the ABCs of German American Education in Pennsylvania symposium, Schwenkfelder Library and Heritage Center, Pennsburg, PA, June 30, 2007.

Altes und Neues, aus dem Lieder-Schatz, der Evangelischen Kirchen, in gute Ordnung zusamen getragen, und in gegenwärtigen Gesang-Buch verfasset [. . .]. N.p., 1749.

Ames, Alexander Lawrence. "'The Knife of Daily Repentance': Toward a Religious History of Calligraphy and Manuscript Illumination in German-Speaking Pennsylvania, ca. 1750–1850." *Mennonite Quarterly Review* 91, no. 4 (2017): 471–510.

———. "Quill and Graver Bound: Frakturschrift Calligraphy, Devotional Manuscripts, and Penmanship Instruction in German Pennsylvania, 1755–1855." *Winterthur Portfolio* 50, no. 1 (2016): 1–83.

Amsler, Cory M., ed. *Bucks County Fraktur.* Vol. 33. Doylestown, PA: Bucks County Historical Society; Kutztown, PA: Pennsylvania German Society, 1999

Andrews, Dee E. *The Methodists and Revolutionary America, 1760–1800: The Shaping of an Evangelical Culture.* Princeton, NJ: Princeton University Press, 2000.

Andrews, Edward Deming. *The People Called Shakers: A Search for the Perfect Society.* New York: Oxford University Press, 1953.

Arndt, Johann. *Des Hocherleuchteten Johann Arndts, weiland General-Superintendenten des Fürstenthums Lüneburg, Sämtliche Bücher vom Wahren Christenthum* [. . .]. Leipzig, Germany: Heinsius, 1753.

———. *Des Hocherleuchteten Theologi, Herrn Johann Arndts, weiland General-Superintendenten des Fürstenthums Lüneburg, Sämtliche Sechs Bücher vom wahren Christenthum* [. . .]. Philadelphia: Fräncklin und Böhm, 1751.

Arnold, Gottfrid [Gottfried]. *Gottfrid Arnolds Historie und beschreibung der Mystischen Theologie oder geheimen Gottes Gelehrtheit, wie auch derer alten und neuen Mysticorum.* Frankfurt: Fritschen, 1703.

BIBLIOGRAPHY 207

Arnold, Gottfried. *Die Erste Liebe, Das ist, Wahre Abbildung Der Ersten Christen, Nach Ihren Lebendigen Glauben Und Heiligen Leben, Aus der ältesten und bewährtesten Kirchen-Scribenten eigenen Zeugnissen, Exempeln und Reden, Nach der Wahrheit, der Ersten einigen Christlichen Religion allen Liebhabern der Historischen Wahrheit und sonderlich der Antiqvität, als in einer nützlichen Kirchen-Historie, Treulich und unpartheyisch entworffen* [. . .]. Frankfurt am Main: Benschen Buchhandlung, 1712.

Atkinson, James. *Martin Luther and the Birth of Protestantism.* Baltimore: Penguin Books, 1968.

Atwood, Craig D. *Community of the Cross: Moravian Piety in Colonial Bethlehem.* University Park: Pennsylvania State University Press, 2004.

———. "'The Hallensians Are Pietists; Aren't You a Hallensian?': Mühlenberg's Conflict with the Moravians in America." In Wellenreuther, Müller-Bahlke, and Roeber, *Transatlantic World,* 159–96.

———. "Little Side Holes: Moravian Devotional Cards of the Mid-Eighteenth Century." *Journal of Moravian History* 6 (Spring 2009): 61–75.

Autobiography of Elder Wilson Thompson [. . .]. Cincinnati: Moore, Wilstach and Baldwin, 1867. Accessed September 18, 2017. https://archive.org/stream/autobiographyofeoothom#page/n7/mode/2up/search/baptist+.

Axelrod, Alan, ed. *The Colonial Revival in America.* New York: Norton; Winterthur, DE: Henry Francis du Pont Winterthur Museum, 1985.

Bach, Jeff. *Voices of the Turtledoves: The Sacred World of Ephrata, Pennsylvania German History and Culture.* University Park: Pennsylvania State University Press; Ephrata: Pennsylvania German Society, 2003.

Baer, Friederike. *The Trial of Frederick Eberle: Language, Patriotism and Citizenship in Philadelphia's German Community, 1790 to 1830.* New York: New York University Press, 2008.

Bailyn, Bernard. *Atlantic History: Concept and Contours.* Cambridge, MA: Harvard University Press, 2005.

"Baptism in Martin Luther's Theology." *Oxford Research Encyclopedias: Religion.* Accessed July 2, 2017. https://oxfordre.com/religion/view/10.1093/acrefore/9780199340378.001.0001/acrefore-9780199340378-e-360.

"Baruch, Chapter 5." United States Conference of Catholic Bishops. Accessed September 18, 2017. www.usccb.org/bible/baruch/5.

Bayly, Lewis. *The Practice of Piety: Directing a Christian How to Walke That He May Please God; Amplified by the Author.* London: Midwinter, 1723.

Bebbington, David W. *Evangelicalism in Modern Britain: A History from the 1730s to the 1980s.* Winchester, MA: Hyman, 1989.

Behmen, Jacob [Jakob Böhme]. *Concerning The Three Principles of The Divine Essence of the Eternall, Dark, Light, and Temporary VVorld. Shewing What the Soule, the Image and the Spirit of the Soule are; as also what Angels, Heaven, and Paradise are* [. . .]. Edited and translated by John Sparrow. London: M. S. for H. Blunden at the Castle in Cornhill, 1648.

Bell, James B. *A War of Religion: Dissenters, Anglicans, and the American Revolution.* New York: Palgrave Macmillan, 2008.

Benjamin, Walter. *The Origin of the German Tragic Drama.* Translated by John Osborne. London: New Left Books, 1977.

Bertheau, Philipp. "The German Language and the Two Faces of Its Script: A Genuine Expression of European Culture?" In Shaw and Bain, *Blackletter,* 22–31.

Bickham, George. *The Universal Penman.* London: printed by the author, circa 1743.

Bird, Michael S. *O Noble Heart/O Edel Herz: Fraktur and Spirituality in Pennsylvania German Folk Art.* Lancaster, PA: Heritage Center Museum, 2002.

———. *Ontario Fraktur: A Pennsylvania German Folk Tradition in Early Canada.* Toronto: Feheley, 1977.

Blenkinsopp, Joseph. *Sage, Priest, Prophet: Religious and Intellectual Leadership in Ancient Israel.* Louisville, KY: Westminster John Knox Press, 1995.

BIBLIOGRAPHY

Blumhofer, Edith L., and Mark A. Noll, eds. *Singing the Lord's Song in a Strange Land: Hymnody in the History of North American Protestantism.* Tuscaloosa: University of Alabama Press, 2004.

Boehme, Jacob [Jakob Böhme]. *Der Weg zu Christo, Verfasset in neun Büchlein.* N.p., 1732.

Boffey, Julia. *Manuscript and Print in London, c. 1475–1530.* London: British Library, 2012.

Böhme, Jakob. "Sex puncta theosophica. Oder: Von sechs theosophischen Punkten Hohe und tiefe Gründung." In *Jakob Böhme's sämtliche Werke*, edited by K. W. Schiebler, 327–410. Vol. 6. Leipzig, Germany: Ambrosius Barth, 1846.

Borneman, Henry S. *Pennsylvania German Illuminated Manuscripts: A Classification of Fraktur-Schriften and an Inquiry into Their History and Art.* 1937. Reprint, New York: Dover, 1973.

Bozeman, Theodore Dwight. *To Live Ancient Lives: The Primitivist Dimension in Puritanism.* Williamsburg, VA: Institute of Early American History and Culture; Chapel Hill: University of North Carolina Press, 1988.

Braght, Thieleman J. van. *Der Blutige Schau-Platz, oder Martyrer Spiegel der Tauffs-Gesinnten, oder wehrlosen Christen, Die um des Zeugnisses Jesu, ihres Seligmachers, willen, gelitten haben, und getödtet worden sind, von Christi Zeit an, bis auf das Jahr 1660 [. . .].* 2nd American ed. Lancaster, PA: Ehrenfried, 1814.

Brecht, Samuel Kriebel. *The Genealogical Record of the Schwenkfelder Families [. . .].* New York: Rand McNally; Pennsburg, PA: Board of Publication of the Schwenkfelder Church, 1923.

Breuilly, John. *The Formation of the First German Nation-State, 1800–1871.* New York: St. Martin's Press, 1996.

Bronner, Simon J., and Joshua R. Brown. "Introduction: Pennsylvania German Studies." In Bronner and Brown, *Pennsylvania Germans*, 1–17.

———, eds. *Pennsylvania Germans: An Interpretive Encyclopedia.* Young Center Books in Anabaptist and Pietist Studies. Baltimore: Johns Hopkins University Press, 2017.

Brown, Candy Gunther. *The Word in the World: Evangelical Writing, Publishing, and Reading in America, 1789–1880.* Chapel Hill: University of North Carolina Press, 2004.

Brown, Matthew P. *The Pilgrim and the Bee: Reading Rituals and Book Culture in Early New England.* Philadelphia: University of Pennsylvania Press, 2007.

Brünner, Jacob, the Elder. *Vorschrift: Zu nützlicher Nachahmung und einer fleißigen Übung [. . .].* Bern, Switzerland: Gottlieb Guttenberger, 1766–67.

Bultmann, Rudolf. *Essays Philosophical and Theological.* New York: Macmillan, 1955.

Butler, Jon. *Awash in a Sea of Faith: Christianizing the American People.* Cambridge, MA: Harvard University Press, 1990.

Calloway, Colin G. *The Indian World of George Washington: The First President, the First Americans, and the Birth of the Nation.* New York: Oxford University Press, 2018.

Cambers, Andrew. *Godly Reading: Print, Manuscript and Puritanism in England, 1580–1720.* New York: Cambridge University Press, 2011.

Cameron, Euan. *The European Reformation.* Oxford, UK: Clarendon Press, 1992.

Carlson, Janice H., and John Krill. "Pigment Analysis of Early American Watercolors and Fraktur." *Journal of the American Institute for Conservation* 18, no. 1 (1978): 19–32.

Carruthers, Mary. *The Book of Memory: A Study of Memory in Medieval Culture.* 2nd ed. New York: Cambridge University Press, 2008.

Carson, Hampton L. *Samuel W. Pennypacker: An Address Delivered Before the Philobiblon Club, October 26, 1916.* Philadelphia: Philobiblon Club, 1917.

Charles, Carolyn L. "Katie's Family Tree." In "Katie Hess Reminisces." By A. Martha Denlinger. *Pennsylvania Mennonite Heritage* 1, no. 4 (1978): 2–9.

Clark, Jonathan Charles Douglas. *English Society, 1660–1832: Religion, Ideology, and Politics During the Ancien Regime.* New York: Cambridge University Press, 2000.

Clauß, G. B. *Nordamerikanische Schnell-Schreibmethode in 84 Vorlegeblättern.* Chemnitz, Germany: Expedizion des Gewerbeblattes für Sachsen, 1839.

BIBLIOGRAPHY 209

Cobbin, Ingram. *Anecdotes and Reflections, Illustrating Watts' Divine and Moral Songs for Children.* Boston: Massachusetts Sabbath School Society, 1849.

Cohen, Charles Lloyd. *God's Caress: The Psychology of Puritan Religious Experience.* New York: Oxford University Press, 1986.

———. "The Post-Puritan Paradigm of Early American Religious History." *William and Mary Quarterly* 54, no. 4 (1997): 695–722.

Cooper, Wendy A., and Lisa Minardi. "Paint, Pattern, and People: A Landmark Exhibition of Furniture from Southeastern Pennsylvania, 1725–1850, Is on View at the Winterthur Museum." *Antiques*, May–June 2011, 160–69.

Crenshaw, James L. *Old Testament Wisdom: An Introduction.* Louisville, KY: Westminster John Knox Press, 1998.

Crookshank, Esther Rothenbusch. "'We're Marching to Zion': Isaac Watts in Early America." In Mouw and Noll, *Wonderful Words*, 17–41.

Cullmann, Oscar. *Baptism in the New Testament.* Translated by J. K. S. Reid. Studies in Biblical Theology. London: SCM Press, 1950.

Damrau, Peter. *The Reception of English Puritan Literature in Germany.* London: Maney/Modern Humanities Research Association and Institute of Germanic and Romance Studies, University of London, 2006.

Darnton, Robert. "What Is the History of Books?" In *Reading in America: Literature and Social History*, edited by Cathy N. Davidson, 27–52. Baltimore: Johns Hopkins University Press, 1989.

Delbanco, Andrew. *The Puritan Ordeal.* Cambridge, MA: Harvard University Press, 1989.

Dent, C. M. "The Anabaptists." In *The Study of Spirituality*, edited by Cheslyn Jones, Geoffrey Wainwright, and Edward Yarnold, 350–54. New York: Oxford University Press, 1986.

Diekmann, Heiko. *Lockruf der Neuen Welt: Deutschsprachige Werbeschriften für die Auswanderung nach Nordamerika von 1680 bis 1760.* Reihe der Universitätsdrucke Göttingen. Göttingen, Germany: Universitätsverlag Göttingen, 2005.

Dixon, C. Scott. *Protestants: A History from Wittenberg to Pennsylvania, 1517–1740.* Malden, MA: Wiley-Blackwell, 2010.

———. *The Reformation in Germany.* Oxford: Blackwell, 2002.

Dock, Christopher. *The Life and Works of Christopher Dock, America's Pioneer Writer on Education, with a Translation of His Works into the English Language.* Translated and edited by Martin G. Brumbaugh. Philadelphia: Lippincott, 1908.

Doede, Werner. *Schön Schreiben, eine Kunst: Johann Neudörffer und seine Schule im 16. und 17. Jahrhundert.* Munich, Germany: Prestel Verlag, 1957.

Donmoyer, Patrick J. *Powwowing in Pennsylvania: Braucherei and the Ritual of Everyday Life.* Annual Publication Series of the Pennsylvania German Cultural Heritage Center. Vol. 6. Kutztown, PA: Kutztown University; Morgantown, PA: Masthof Press, 2017.

Duggan, Lawrence G. "The Unresponsiveness of the Late Medieval Church: A Reconsideration." *Sixteenth-Century Journal* 9, no. 1 (1978): 3–26.

Dunn, Mary Maples, Richard S. Dunn, Richard A. Ryerson, Scott M. Wilds, and Jean R. Soderlund. *The Papers of William Penn.* Vol. 1, *1644–1679.* Philadelphia: University of Pennsylvania Press, 1981.

Durnbaugh, Donald F. "Communication Networks as One Aspect of Pietist Definition: The Example of Radical Pietist Connections between Colonial North America and Europe." In Strom, Lehmann, and Van Horn Melton, *Pietism in Germany*, 33–49.

———. "Pennsylvania's Crazy Quilt of German Religious Groups." In "Pennsylvania Germans, Part One." Special issue, *Pennsylvania History: A Journal of Mid-Atlantic Studies* 68, no. 1 (2001): 8–30.

Earnest, Corinne, and Russell Earnest. *To the Latest Posterity: Pennsylvania German Family Registers in the Fraktur Tradition.* University Park: Pennsylvania State University Press, 2004.

BIBLIOGRAPHY

Earnest, Corinne, and Klaus Stopp. "Early Fraktur Referring to Birth and Baptism in Pennsylvania: A *Taufpatenbrief* from Berks County for a Child Born in 1751." *Pennsylvania Folklife* 44, no. 2 (1995): 84–88.

Egelmann, Carl Friedrich. *Deutsche und Englische Vorschriften für die Jugend.* Reading, PA: Egelmann, circa 1831.

Eggington, William. "The Baroque as a Problem of Thought." *Proceedings of the Modern Language Association* 124, no. 1 (2009): 143–49.

Eire, Carlos M. N. *War Against the Idols: The Reformation of Worship from Erasmus to Calvin.* New York: Cambridge University Press, 1986.

Eisenstein, Elizabeth L. *The Printing Revolution in Early Modern Europe.* 2nd ed. New York: Cambridge University Press, 2005.

Elferen, Isabella van. *Mystical Love in the German Baroque: Theology, Poetry, Music.* Contextual Bach Studies 2. Lanham, MD: Scarecrow Press, 2009.

Erb, Peter C. "Anabaptist Spirituality." In *Protestant Spiritual Traditions*, edited by Frank C. Senn, 80–124. New York: Paulist Press, 1986.

———. "The Garden in Schwenkfelder Fraktur." *Schwenkfeldian* 103, no. 3 (2003): 12–14.

———. "Gerhard Tersteegen, Christopher Saur, and Pennsylvania Sectarians." *Brethren Life and Thought* 20 (Summer 1975): 153–57.

———. *Pietists, Protestants, and Mysticism: The Use of Late Medieval Spiritual Texts in the Work of Gottfried Arnold (1666–1714).* Metuchen, NJ: Scarecrow Press, 1989.

Erben, Patrick. "Educating Germans in Colonial Pennsylvania." In *"The Good Education of Youth": Worlds of Learning in the Age of Franklin*, edited by John H. Pollack, 123–49. Philadelphia: University of Pennsylvania Libraries; New Castle, DE: Oak Knoll Press, 2009.

"Errand into the Wilderness: New England, 1602–1753; An Exhibition Held in the John Carter Brown Library, May 16–September 30, 1952." In *Errand into the Wilderness: An Address by Perry Miller*, 21. Williamsburg, VA: William and Mary Quarterly for the Associates of the John Carter Brown Library, 1952. Available online: *Publications Now Online*, John Carter Brown Library, accessed September 1, 2017, www.brown.edu/academics/libraries/john -carter-brown/events-publications/online-publications.

Estes, Daniel J. *Handbook on the Wisdom Books and Psalms.* Grand Rapids: Baker Academic, 2005.

Evangelische Lieder-Sammlung: Genommen aus der Lieder Sammlung und dem Gemeinschaftlichen Gesangbuch [. . .]. Gettysburg, PA: Johnson, 1834.

Ezell, Margaret J. M. *Social Authorship and the Advent of Print.* Baltimore: Johns Hopkins University Press, 1999.

Fanella, John. "The Schlatter Bible: A Piece of Reformed History." Distributed at Old Goshenhoppen Reformed Church, Harleysville, PA.

Fichtenau, Heinrich. *Die Lehrbücher Maximilians I. und die Anfänge der Frakturschrift.* Hamburg: Gesellschaft, 1961.

Fischer, David Hackett. *Albion's Seed: Four British Folkways in America.* New York: Oxford University Press, 1989.

Fisher, Elizabeth W. "'Prophesies and Revelations': German Cabbalists in Early Pennsylvania." *Pennsylvania Magazine of History and Biography* 109, no. 3 (1985): 299–333.

Flood, Finbarr Barry. "Bodies and Becoming: Mimesis, Mediation and the Ingesting of the Sacred in Christianity and Islam." In Promey, *Sensational Religion*, 459–93.

Fogleman, Aaron Spencer. *Hopeful Journeys: German Immigration, Settlement, and Political Culture in Colonial America, 1717–1775.* Philadelphia: University of Pennsylvania Press, 1996.

———. *Jesus Is Female: Moravians and the Challenge of Radical Religion in Early America.* Philadelphia: University of Pennsylvania Press, 2007.

———. *Two Troubled Souls: An Eighteenth-Century Couple's Spiritual Journey in the Atlantic World.* Chapel Hill: University of North Carolina Press, 2013.

"Fonthill Castle." Mercer Museum and Fonthill Castle. Accessed January 26, 2017. www.mercermuseum.org/about/fonthillcastle/.

"Francis Hopkinson (1737–1791)." *Penn Biographies*. University of Pennsylvania University Archives and Records Center. Accessed July 20, 2018. https://archives.upenn.edu/exhibits/pennpeople/biography/francishopkinson.

Franck, Augustus Herman [August Hermann Francke]. *A Guide to the Reading and Study of the Holy Scriptures*. Translated and edited by William Jaques. 3rd ed. London: Jaques, 1819.

Frantz, John B. "The Awakening of Religion Among the German Settlers in the Middle Colonies." *William and Mary Quarterly* 33, no. 2 (1976): 266–88.

———. "Religion." In Bronner and Brown, *Pennsylvania Germans*, 131–47.

———. "To the New World: Seventeenth and Eighteenth Centuries." In Bronner and Brown, *Pennsylvania Germans*, 36–52.

Fuchs, Ernst. "The Hermeneutical Problem." In *The Future of Our Religious Past: Essays in Honour of Rudolf Bultmann*, edited by James M. Robinson, 267–78. London: Harper and Row, 1964.

Die gantze Bibel das ist alle bücher allts vnnd neuws Testaments de[n] vrsprünglichen Spraachen nach auffs aller treüwlichest verteüschet [. . .]. Zürich, Switzerland: Froschouer, 1536.

Garvey, Ellen Gruber. *Writing with Scissors: American Scrapbooks from the Civil War to the Harlem Renaissance*. New York: Oxford University Press, 2012.

Gaskell, George A. *The Penman's Hand-Book, for Penmen and Students, Embracing a History of Writing [. . .]*. New York: Printed by the author, 1883.

Geistlicher Lieder-Segen in sich haltend 1620: Der besten und erbaulichsten alten und neuen Lieder welche mit Fleiß durchsehen, verbessert und nöthigen Orts mit Anmerckungen erläutert worden nebst einem Vorbericht von D. G. S. 3rd ed. Lobenstein, Germany: Authenrieth, 1769.

Geiter, Mary K. *Oxford Dictionary of National Biography*, s.v. "Penn, William," accessed November 2,3 2019, www.oxforddnb.com/view/article/21857.

Gellert, Christian Fürchtegott. *C. F. Gellerts sämmtlicher Schriften*. Berlin: Joachim Pauli, 1770.

———. *Herrn Professor Gellerts Geistliche Oden und Lieder mit Melodien von Carl Philipp Emanuel Bach*. 3rd ed. Berlin: Ludewig Winter, 1764.

Gemeinschaftliches Gesangbuch, zum Gottesdienstlichen Gebrauch der Lutherischen und Reformirten Gemeinden in Nord-America [. . .]. Reading, PA: Sage, 1827.

Genealogical and Biographical Annals of Northumberland County Pennsylvania, Containing a Genealogical Record of Representative Families, Including Many of the Early Settlers, and Biographical Sketches of Prominent Citizens, Prepared from Data Obtained from Original Sources of Information. Chicago: Floyd, 1911.

Genette, Gérard. *Paratexts: Thresholds of Interpretation*. Translated by Jane E. Lewin. New York: Cambridge University Press, 1997.

Genette, Gérard, and Marie Maclean. "Introduction to the Paratext." In "Probings: Art, Criticism, Genre." Special Issue, *New Literary History* 22, no. 2 (1991): 261–72.

Gerhard, Elmer Schultz. "The History of Schwenckfelder Schools and Education." In "Schwenckfelder Schools and Education." Special issue, *Schwenckfeldiana* 1, no. 3 (1943): 5–21.

Gerhardt, Paul. "Herr, was hast du im Sinn?" *Zeno*. Accessed June 9, 2015. www.zeno.org/Literatur/M/Gerhardt,+Paul/Gedichte/Gedichte/Herr,+was+hast+du+im+Sinn.

Germantown and the Germans: An Exhibition of Books, Manuscripts, Prints, and Photographs from the Collections of the Library Company of Philadelphia and the Historical Society of Pennsylvania, October 1983 to January 1984. Philadelphia: Library Company of Philadelphia; Historical Society of Pennsylvania, 1983.

Gesangbuch für Kirche, Schule und Haus. Berlin: Herausgegeben und verlegt von dem Haupt-Verein für christliche Erbauungsschriften, 1858.

Gillespie, Michele, and Robert Beachy. Introduction to *Pious Pursuits: German Moravians in the Atlantic World*, edited by Michele Gillespie and Robert Beachy, 1–19. New York: Berghahn Books, 2007.

212 BIBLIOGRAPHY

Glassie, Henry H. *Material Culture*. Bloomington: Indiana University Press, 1999.

Glatfelter, Charles H. *Pastors and People: German Lutheran and Reformed Churches in the Pennsylvania Field, 1717–1793*. Vol. 1, *Pastors and Congregations*. Breinigsville, PA: Pennsylvania German Society, 1980.

Gold, Leonard Singer, ed. *A Sign and a Witness: 2,000 Years of Hebrew Books and Illuminated Manuscripts*. New York: New York Public Library; Oxford University Press, 1988.

Golden Apples in Silver Bowls: The Rediscovery of Redeeming Love. Edited by Leonard Gross. Translated by Elizabeth Bender. 1702. Reprint, Lancaster, PA: Lancaster Mennonite Historical Society, 1999.

Gould, Nathaniel D. *Penmanship or the Beauties of Writing Exemplified in a Variety of Specimens*. Boston: Hartford, Andrus and Judd, 1831.

Grabbe, Hans-Jürgen, ed. *Halle Pietism, Colonial North America, and the Young United States*. Stuttgart: Steiner Verlag, 2008.

———. Introduction to Grabbe, *Halle Pietism*, 7–16.

Green, Harvey. "Looking Backward to the Future: The Colonial Revival in American Culture." In *Creating a Dignified Past: Museums and the Colonial Revival*, edited by Geoffrey L. Rossano, 1–16. Savage, MD: Rowman and Littlefield; Albany, NY: Historic Cherry Hill, 1991.

Greene, Jack P. *Pursuits of Happiness: The Social Development of Early Modern British Colonies and the Formation of American Culture*. Chapel Hill: University of North Carolina Press, 1988.

Greengrass, Mark. *The Longman Companion to the European Reformation*. New York: Longman, 1998.

Gross, Suzanne, and Wesley Berg. "Singing It 'Our Way': Pennsylvania German Mennonite Notenbüchlein (1780–1835)." *American Music* 19, no. 2 (2001): 190–209.

Güldene Aepffel in Silbern Schalen Oder: Schöne und nützliche Worte und Warheiten Zur Gottseligkeit; Enthalten In Sieben Haupt-Theilen [. . .]. 1702. Reprint, Ephrata, PA: Verlegt durch etliche Mitglider der Mennonisten-gemeine, 1745.

Gunkel, Hermann. *Introduction to Psalms: The Genres of the Religious Lyric of Israel*. Completed by Joachim Begrich. Macon, GA: Mercer University Press, 1998.

———. *The Psalms: A Form-Critical Introduction*. Philadelphia: Fortress Press, 1967.

Häberlein, Mark. *The Practice of Pluralism: Congregational Life and Religious Diversity in Lancaster, Pennsylvania, 1730–1820*. Max Kade German-American Research Institute Series. University Park: Pennsylvania State University Press, 2009.

———. *Vom Oberrhein zum Susquehanna: Studien zur badischen Auswanderung nach Pennsylvania im 18. Jahrhundert*. Veröffentlichungen der Kommission für Geschichtliche Landeskunde in Baden-Württemberg, Reihe B: Forschungen. Band 129. Stuttgart: Kohlhammer Verlag, 1993.

Haefeli, Evan. *New Netherland and the Dutch Origins of American Religious History*. Philadelphia: University of Pennsylvania Press, 2012.

Hall, David D., ed. *Lived Religion in America: Toward a History of Practice*. Princeton, NJ: Princeton University Press, 1997.

———. *Ways of Writing: The Practice and Politics of Text-Making in Seventeenth-Century New England*. Philadelphia: University of Pennsylvania Press, 2008.

Hall, Joseph. "The Art of Divine Meditation: Profitable for All Christians to Know and Practice: Exemplified with Two Large Patterns of Meditation; the One of Eternal Life, as the End: the Other of Death, as the Way." In *The Works of the Right Reverend Father in God, Joseph Hall, D. D. Successively Bishop of Exeter and Norwich: Now First Collected, with Some Accounts of His Life and Sufferings, Written by Himself*, edited by Josiah Pratt, 41–72. London: Whittingham, 1808.

Hambrick-Stowe, Charles E. *The Practice of Piety: Puritan Devotional Disciplines in Seventeenth-Century New England*. Chapel Hill: University of North Carolina Press; Williamsburg, VA: Institute for Early American History and Culture, 1982.

"Harmonist Labyrinth." *Visit New Harmony.* Accessed September 27, 2017. http://visitnewharmony.com/playexplore_cpt/harmonist-labyrinth-2/.

Hartzler, Harold H., and Cornelius Krahn. "Bauer (Bower, Bowers, Boer, and de Boer) Family." *Global Anabaptist Mennonite Encyclopedia Online.* Accessed September 17, 2017. http://gameo.org/index.php?title=Bauer_(Bower,_Bowers,_Boer,_and_de_Boer)_family&oldid=119500.

Havens, Earle. *Commonplace Books: A History of Manuscripts and Printed Books from Antiquity to the Twentieth Century.* New Haven: Beinecke Rare Book and Manuscript Library, Yale University, 2001.

Hershey, Mary Jane Lederach. "The *Notenbüchlein* Tradition in Eastern Pennsylvania Mennonite Community Schools, in an Area Known as the Franconia Conference, 1780 to 1845." In Amsler, *Bucks County Fraktur,* 114–49.

———. *This Teaching I Present: Fraktur from the Skippack and Salford Mennonite Meetinghouse Schools, 1747–1836.* Studies in Anabaptist and Mennonite History 41. Intercourse, PA: Good Books, 2003.

Hess, Clarke E. *Mennonite Arts: A Schiffer Book for Collectors.* Atglen, PA: Schiffer, 2002.

Heyrman, Christine Leigh. *Southern Cross: The Beginnings of the Bible Belt.* New York: Knopf, 1997.

Hillman, Joseph. *The Revivalist: A Collection of Choice Revival Hymns and Tunes, Original and Selected.* Rev. ed. Troy, NY: Hillman, 1869.

Hills, Helen, ed. *Rethinking the Baroque.* Burlington, VT: Ashgate, 2011.

Hippel, Wolfgang v. *Auswanderung aus Südwestdeutschland: Studien zur württembergischen Auswanderung und Auswanderungspolitik im 18. und 19. Jahrundert.* Industrielle Welt: Schriftenreihe des Arbeitskreises für moderne Sozialgeschichte Herausgegeben von Werner Conze. Band 36. Stuttgart: Klett Verlage, 1984.

Hirsch, E. D., Jr. *Validity in Interpretation.* New Haven: Yale University Press, 1967.

Hoch-Deutsches Lutherisches A B C- und Namen-Büchlein für Kinder welche anfangen zu lernen. Neue und verbesserte Ausgabe. Philadelphia: Schäfer and Koradi, circa 1850.

Hoch-Deutsches Reformirtes A B C- und Namen-Büchlein für Kinder welche anfangen zu lernen. Verbesserte Ausgabe. Philadelphia: Zentler, 1816.

Hof, Ulrich Im. *The Enlightenment.* Translated by William E. Yuill. Cambridge, MA: Blackwell, 1994.

Holifield, E. Brooks. *The Gentleman Theologians: American Theology in Southern Culture, 1795–1860.* Durham, NC: Duke University Press, 1978.

———. *Theology in America: Christian Thought from the Age of the Puritans to the Civil War.* New Haven: Yale University Press, 2003.

Hoover, Joanne K. "Michael Shenk of Warwick Township, Lancaster County, Pennsylvania: His Descendants and Some of Their Lands." *Pennsylvania Mennonite Heritage* 32, no. 4 (2009): 16–27.

Houston, Keith. *The Book: A Cover-to-Cover Exploration of the Most Powerful Object of Our Time.* New York: Norton, 2016.

Hutchinson, Mark, and John Wolffe. *A Short History of Global Evangelicalism.* New York: Cambridge University Press, 2012.

Irving, Joan, and Soyeon Choi. "Decision Making and Treatment of the Ephrata Cloister ABC Book." *Book and Paper Group Annual* 29 (2010): 41–49. Accessed February 1, 2016. http://cool.conservation-us.org/coolaic/sg/bpg/annual/v29/bp29-05.pdf.

Iser, Wolfgang. *The Act of Reading: A Theory of Aesthetic Response.* Baltimore: Johns Hopkins University Press, 1978.

Jensen, H. James. *The Muses' Concord: Literature, Music, and the Visual Arts in the Baroque Age.* Bloomington: Indiana University Press, 1977.

Johns, Loren L. "Reading the Maccabean Literature by the Light of the Stake: Anabaptist Appropriations in the Reformation Period." *Mennonite Quarterly Review* 86, no. 2 (2012): 151–73.

BIBLIOGRAPHY

Johnson-Weiner, Karen M., and Joshua R. Brown. "The Amish." In Bronner and Brown, *Pennsylvania Germans*, 148–63.

Jones, William J. "Early Dialectology, Etymology and Language History in German-Speaking Countries." In *History of the Language Sciences: An International Handbook on the Evolution of the Study of Language from the Beginnings to the Present*, edited by Sylvain Aurous, Ernst Frideryk Konrad Koerner, Hans-Josef Niederehe, and Kees Versteegh, 2:1105–15. New York: De Gruyter, 2001.

Juterczenka, Sünne. *Über Gott und die Welt: Endzeitvisionen, Reformdebatten und die europäische Quäkermission in der Frühen Neuzeit.* Veröffentlichungen des Max-Planck-Instituts für Geschichte. Band 143. Göttingen, Germany: Vandenhoeck und Ruprecht, 2008.

Kaiser, Otto. *The Old Testament Apocrypha: An Introduction.* Peabody, MA: Hendrickson, 2004.

Kaufman, Gordon. *Systematic Theology: A Historicist Perspective.* New York: Scribner's Sons, 1968.

Kersten, F. "Vortrag über das dem Unterzeichneten vom Kunst- und Handwerksverein zur Prüfung übergebene Werk von Claus: 'Nordamaerikanische Schnell-Schreibmethode.'" In *Mittheilungen aus dem Osterlande: Gemeinschaftlich Herausgegeben von dem Kunst- und Handwersk-Vereine, der Natursorschenden und der Pomologischen Gesellschaft zu Altenburg. Dritter Band*, 137–40. Altenburg, Germany: Gedruckt in der Hofbuchdruckerei, 1839.

Khatibi, Abdelkebir, and Mohammed Sijelmassi. *The Splendour of Islamic Calligraphy.* Translated by James Hughes. New York: Thames and Hudson, 1976.

Kilgour, Frederick G. *The Evolution of the Book.* New York: Oxford University Press, 1998.

Killius, Christina. *Die Antiqua-Fraktur Debatte um 1800 und ihre historische Herleitung.* Wiesbaden: Harrassowitz Verlag, 1999.

Kisker, Scott. "Pietist Connections with English Anglicans and Evangelicals." In Shantz, *Companion to German Pietism*, 225–55.

Das Kleine Davidische Psalterspiel Der Kinder Zions [. . .]. Germantown, PA: Saur, 1777.

Krahn, Cornelius, and Cornelius J. Dyck. "Pietism." In *Global Anabaptist Mennonite Encyclopedia Online.* Accessed February 24, 2019. http://gameo.org/index.php?title=Pietism&oldid=146779.

Kress, Gunther. *Multimodality: A Social Semiotic Approach to Contemporary Communication.* New York: Routledge, 2010.

Krippner, Stanley. "The Role Played by Mandalas in Navajo and Tibetan Rituals." *Anthropology of Consciousness* 8, no. 1 (1997): 22–31.

Kuenning, Paul P. *The Rise and Fall of American Lutheran Pietism: The Rejection of an Activist Heritage.* Macon, GA: Mercer University Press, 1988.

Kunstgewerbemuseum Zürich, Museum für Gestaltung. *Schreibkunst: Schulkunst und Volkskunst in der deutschsprachigen Schweiz 1548 bis 1980.* Zurich, Switzerland: Kunstgewerbemuseum der Stadt Zürich; Museum für Gestaltung, 1981.

Kunstrichtige Schreibart Allerhand Versalie[n] oder Anfangs Buchstabe[n] Des Teutschen, Lateinischen und Italiänischen Schrifften aus unterschiedlichen Meistern des Edlen Schreibkunst zusammen getragen. Nuremberg, Germany: Fürsten Kunsthändlern, 1655.

Kunze, Johann Christoph. *Ein Wort für den Verstand und das Herz vom rechten und gebanten Lebenswege.* Philadelphia: Melchior Steiner, 1781.

Lambert, Frank. "*Pietas Hallensis* and the American Great Awakening." In Wellenreuther, Müller-Bahlke, and Roeber, *Transatlantic World*, 199–212.

Lange, Nicholas de. *Apocrypha: Jewish Literature of the Hellenistic Age.* New York: Viking Press, 1978.

Lassenii, Iohannis (Johannes Lassenius), *Biblischer Weyrauch, Zum süssen Geruch Gottseeliger Andachten, Aus H. Schrifft also zusammen gelesen [. . .].* Königsberg: Christoph Gottfried Eckart, 1731.

"Layritz, Paul Eugen." *McClintock and Strong Biblical Cyclopedia.* Accessed January 17, 2017. www.biblicalcyclopedia.com/L/layritz-paul-eugen.html.

Learned, Marion Dexter, and Samuel W. Pennypacker. *The Life of Francis Daniel Pastorius, the Founder of Germantown.* Philadelphia: Campbell, 1908.

Lehmann, Hartmut. "Continental Protestant Europe." In *The Cambridge History of Christianity.* Vol. 7, *Enlightenment, Reawakening and Revolution, 1660–1815,* edited by Stewart J. Brown and Timothy Tackett, 33–53. New York: Cambridge University Press, 2006.

———. "Pietism in the World of Transatlantic Religious Revivals." In Strom, Lehmann, and Van Horn Melton, *Pietism in Germany,* 13–21.

———. "Transatlantic Migration, Transatlantic Networks, Transatlantic Transfer: Concluding Remarks." In *In Search of Peace and Prosperity: New German Settlements in Eighteenth-Century Europe and America,* edited by Hartmut Lehmann, Hermann Wellenreuther, and Renate Wilson, 307–30. University Park: Pennsylvania State University Press, 2000.

———. "The World According to the Christian People in Europe, 1711–1730." In Wellenreuther, Müller-Bahlke, and Roeber, *Transatlantic World,* 3–15.

Lemon, James T. *The Best Poor Man's Country: Early Southeastern Pennsylvania.* 1972. Reprint, Baltimore: Johns Hopkins University Press, 2002.

Lindberg, Carl. Introduction to Lindberg, *Pietist Theologians,* 1–20.

———, ed. *The Pietist Theologians.* Oxford: Blackwell, 2005.

Litzmann, Berthold. *Zur Textkritik und Biographie Johann Christian Günther's.* Frankfurt am Main: Rütten und Loening, 1880.

Longenecker, Stephen L. *Piety and Tolerance: Pennsylvania German Religion, 1700–1850.* Metuchen, NJ: Scarecrow Press, 1994.

Louden, Mark L. *Pennsylvania Dutch: The Story of an American Language.* Young Center Books in Anabaptist and Pietist Studies. Baltimore: Johns Hopkins University Press, 2016.

Love, Harold. "Early Modern Print Culture: Assessing the Models," *Parergon* 20, no. 1 (2003): 45–64.

Lowell, James Russell. Review of *History of New England During the Stuart Dynasty,* vol. 3. By John Gorham Palfrey. *North American Review* 100, no. 206 (1865): 161–76.

MacCulloch, Diarmaid. *Christianity: The First Three Thousand Years.* New York: Penguin, 2011.

———. *The Reformation.* New York: Viking, 2004.

Malden, Richard Henry. *The Apocrypha.* London: Oxford University Press, 1936.

Maravall, José Antonio. *Culture of the Baroque: Analysis of a Historical Structure.* Translated by Terry Cochran. Minneapolis: University of Minnesota Press, 1986.

Marini, Stephen. "From Classical to Modern: Hymnody and the Development of American Evangelicalism, 1737–1970." In Blumhofer and Noll, *Singing the Lord's Song,* 1–38.

Martin, John Rupert. *Baroque.* New York: Harper and Row, 1977.

McGrail, David B. "Late Eighteenth- and Early Nineteenth-Century Illuminated Documents: An Introduction and a Checklist." *New Jersey History* 105, nos. 1–2 (1987): 40–74.

McKenzie, Edgar C. *A Catalog of British Devotional and Religious Books in German Translation from the Reformation to 1750.* New York: De Gruyter, 1997.

McKitterick, David. *Print, Manuscript and the Search for Order, 1450–1830.* New York: Cambridge University Press, 2003.

McNealy, Terry A., and Cory M. Amsler. "Pennsylvania German Schools in Bucks County." In Amsler, *Bucks County Fraktur,* 73–95.

Meier, Marcus. "Research Note: Golden Apples in Silver Bowls and the Relationship of Swiss Anabaptism to Pietism." *Mennonite Quarterly Review* 82, no. 4 (2008): 591–602.

Mercer, Henry C. "The Survival of the Mediaeval Art of Illuminative Writing Among Pennsylvania Germans." 1897. Reprinted in Amsler, *Bucks County Fraktur,* 5–13.

Merken, Johann. *Liber artificiosus Alphabeti Maioris, oder: Neu inventirtes Kunst-Schreib- und Zeichenbuch, bestehend in 56 künstlich gravirten Kupferstichen, nebst beigefügter Abhandlung der darinn enthaltenen nützlichen [. . .] Wissenschaften, etc.* Mülheim am Rhein, 1782–85.

Middlekauff, Robert. *The Mathers: Three Generations of Puritan Intellectuals, 1596–1728.* 1971. Reprint, Berkeley: University of California Press, 1999.

216 BIBLIOGRAPHY

Miller, Perry. *Errand into the Wilderness.* Cambridge, MA: Belknap Press of Harvard University Press, 1964.

———. *The New England Mind: From Colony to Province.* Cambridge, MA: Harvard University Press, 1953.

———. *The New England Mind: The Seventeenth Century.* 1939. Reprint, Cambridge, MA: Harvard University Press, 1982.

Minardi, Lisa. "Fraktur and Visual Culture." In Bronner and Brown, *Pennsylvania Germans,* 264–80.

———. "Quill and Brush: An Introduction to Pennsylvania German Fraktur." In Tannenbaum, *Framing Fraktur,* 25–45.

Miroslav, John Hanak. "The Emergence of Baroque Mentality and Its Cultural Impact on Western Europe after 1550." *Journal of Aesthetics and Art Criticism* 28, no. 3 (1970): 315–26.

Moeller, Bernd. "Religious Life in Germany on the Eve of the Reformation." In *Pre-Reformation Germany,* edited by Gerald Strauss, 13–42. New York: Harper and Row, 1972.

Monaghan, E. Jennifer. *Learning to Read and Write in Colonial America.* Amherst: University of Massachusetts Press; Worcester, MA: American Antiquarian Society, 2005.

Morgan, David. *Protestants and Pictures: Religion, Visual Culture, and the Age of American Mass Production.* New York: Oxford University Press, 1999.

———. *Visual Piety: A History and Theory of Popular Religious Images.* Berkeley: University of California Press, 1998.

Morgan, David, and Sally M. Promey. Introduction to *The Visual Culture of American Religions,* edited by David Morgan and Sally M. Promey, 1–25. Berkeley: University of California Press, 2001.

Morgan, Edmund S. *The Gentle Puritan: A Life of Ezra Stiles, 1727–1795.* New Haven: Yale University Press, 1962.

Mouw, Richard J. Introduction to Mouw and Noll, *Wonderful Words of Life,* xii–xx.

Mouw, Richard J., and Mark A. Noll, eds. *Wonderful Words of Life: Hymns in American Protestant History and Theology.* Calvin Institute of Christian Worship Liturgical Studies Series. Grand Rapids: Eerdmans, 2004.

Moyer, Dennis K. *Fraktur Writings and Folk Art Drawings of the Schwenkfelder Library Collection.* Pennsylvania German Society 31. Kutztown: Pennsylvania German Society, 1997.

Müller, Thomas J. *Kirche zwischen zwei Welten: Die Obrigkeitsproblematik bei Heinrich Melchior Mühlenberg und die Kirchengründung der deutschen Lutheraner in Pennsylvania.* Transatlantische Historische Studien. Vol. 2. Stuttgart: Steiner Verlag, 1994.

Murphy, Roland E. *The Tree of Life: An Exploration of Biblical Wisdom Literature.* 3rd ed. 1990. Reprint, Grand Rapids: Eerdmans, 2002.

Musig, Martin. *Licht Der Weisheit, In denen Nöthigsten Stücken der wahren Gelehrsamkeit Zur Erkänntniß Menschlicher und Göttlicher Dinge* [. . .]. Vol. 1. 3rd ed. Frankfurt, 1726.

Nation, Mark Thiessen. "The 'Fear of the Lord' Is the Beginning of Anabaptist Wisdom." *Mennonite Quarterly Review* 84 (July 2010): 397–416.

Ndalianis, Angela. *Neo-Baroque Aesthetics and Contemporary Entertainment.* Cambridge, MA: MIT Press, 2004.

Neff, Christian. "Imbroich, Thomas von (1533–1558)." *Global Anabaptist Mennonite Encyclopedia Online.* Accessed August 16, 2018. https://gameo.org/index.php?title=Imbroich,_Thomas _von_(1533–1558).

Nelson, John K. *A Blessed Company: Parishes, Parsons, and Parishioners in Anglican Virginia, 1690–1776.* Chapel Hill: University of North Carolina Press, 2001.

Der Neue, gemeinnützige Landwirthschafts Calender, auf das Jahr, nach der heilbringenden Geburt unsers Herrn Jesu Christi, 1794 [. . .]. Lancaster, PA: Gedruckt und zu haben bey Johann

BIBLIOGRAPHY 217

Albrecht und Company in der neuen Buchdruckerey, in der Prinz-Strasse, das zweyte Haus, nördlich vom Gefängniss, [1793?].

Neu eröffnetes in Hundert Sprachen bestehendes A.b.c. Buch, Oder Gründliche Anweisung [. . .]. Leipzig, Germany: Geßner, 1743.

Noll, Mark. *America's God: From Jonathan Edwards to Abraham Lincoln.* New York: Oxford University Press, 2005.

———. "The Defining Role of Hymns in Early Evangelicalism." In Mouw and Noll, *Wonderful Words*, 3–16.

———. *The Rise of Evangelicalism: The Age of Edwards, Whitefield and the Wesleys.* Vol. 1, *A History of Evangelicalism: People, Movements and Ideas in the English-Speaking World.* Downers Grove, IL: Intervarsity Press, 2003.

Nolt, Steven M. *Foreigners in Their Own Land: Pennsylvania Germans in the Early Republic.* Publications of the Pennsylvania German Society. Pennsylvania German History and Culture Series 2. Vol. 35. University Park: Pennsylvania State University Press, 2002.

Nürnbergisches Gesang-Buch Darinnen 1230. auserlesene sowol alt als neue Geist-Lehr-und Trostreiche Lieder [. . .]. Nürnberg: Spörlin, 1690.

Nuttall, Geoffrey Fillingham. "Continental Pietism and the Evangelical Movement in Britain." In *Pietismus und Reveil*, edited by Jan van den Berg and Jan Pieter van Dooren, 207–36. Leiden: Brill, 1978.

Ogasapian, John. *Church Music in America, 1620–2000.* Macon, GA: Mercer University Press, 2004.

Orsi, Robert. "Everyday Miracles: The Study of Lived Religion." In D. Hall, *Lived Religion*, 3–21.

Packull, Werner O. *Mysticism and the Early South German-Austrian Anabaptist Movement, 1525–1531.* Scottdale, PA: Herald Press, 1977.

Parsons, William T. *Pennsylvania Germans: A Persistent Minority.* Collegeville, PA: Chestnut Books, 1985.

Pennypacker, Samuel Whitaker. *Annals of Phoenixville and Its Vicinity: From the Settlement to the Year 1871, Giving the Origin and Growth of the Borough with Information Concerning the Adjacent Townships of Chester and Montgomery Counties and the Valley of the Schuylkill.* Philadelphia: Bavis and Pennypacker, 1872.

———. *The Autobiography of a Pennsylvanian.* Philadelphia: Winston, 1918.

———. *The Extraordinary Library of Hon. Samuel W. Pennypacker [. . .].* 2 vols. Philadelphia: Henkels/Davis and Harvey, 1905–9.

———. *Hendrick Pannebecker: Surveyor of Lands for the Penns, 1674–1754; Flomborn, Germantown and Skippack.* Philadelphia: printed by the author, 1894.

———. *Historical and Biographical Sketches.* Philadelphia: Tripple, 1883.

———. "Pennsylvania and Massachusetts." In Pennypacker, *Pennsylvania in American History*, 172–94.

———. "The Pennsylvania Dutchman and Wherein He Has Excelled." In Pennypacker, *Pennsylvania in American History*, 309–18.

———. *Pennsylvania in American History.* Philadelphia: Campbell, 1910.

———. *Pennsylvania, the Keystone, a Short History.* Philadelphia: Sower, 1914.

Perry, Candace Kintzer. "The Samuel W. Pennypacker Fraktur Collection at the Schwenkfelder Library and Heritage Center." *Der Reggeboge/The Rainbow: Journal of the Pennsylvania German Society* 47, no. 2 (2013): 2–69.

Peucker, Paul. "Inventory of the Painting Collection." Moravian Archives. 2004. Accessed July 18, 2018. www.moravianchurcharchives.org/documents/PC.pdf.

———. "Pietism and the Archives." In Shantz, *Companion to German Pietism*, 393–420.

―――. *A Time of Sifting: Mystical Marriage and the Crisis of Moravian Piety in the Eighteenth Century.* Pietist, Moravian, and Anabaptist Studies. University Park: Pennsylvania State University Press, 2015.

Piepkorn, Arthur Carl. "The Lutheran Understanding of Baptism: A Systematic Summary." In *Lutherans and Catholics in Dialogue,* edited by Paul C. Empie and T. Austin Murphy, 27–60. Vols. 1–2. Minneapolis: Augsburg, 1974.

Plate, S. Brent. "Words." In "Key Words in Material Religion." Edited by Birgit Meyer, David Morgan, Crispin Paine, and S. Brent Plate. Special issue, *Material Religion: The Journal of Objects, Art and Belief* 7, no. 1 (2011): 156–62.

Plimpton, George A. *The Hornbook and Its Use in America.* Worcester, MA: American Antiquarian Society, 1916.

Powell, Vavasor. *Spiritual Experiences, of Sundry Beleevers, Held Forth by Them at Severall Solemne Meetings* [. . .]. London: Ibbitson, circa 1651–53.

Promey, Sally M. "Hearts and Stones: Material Transformations and the Stuff of Christian Practice in the United States." In *American Christianities: A History of Dominance and Diversity,* edited by Catherine A. Brekus and W. Clark Gilpin, 183–213. Chapel Hill: University of North Carolina Press, 2011.

―――. "Religion, Sensation, and Materiality: An Introduction." In Promey, *Sensational Religion,* 1–21.

―――. "Seeing the 'Self in Frame': Early New England Material Practice and Puritan Piety." *Material Religion: The Journal of Objects, Art and Belief* 1, no. 1 (2005): 10–47.

―――, ed. *Sensational Religion: Sensory Cultures in Material Practice.* New Haven: Yale University Press, 2014.

―――. *Spiritual Spectacles: Vision and Image in Mid-Nineteenth-Century Shakerism.* Bloomington: Indiana University Press, 1993.

Rae, John. *Martin Luther: Student, Monk, Reformer.* London: Hodder and Stoughton, 1896.

Rebuck, Deborah M., and Candace Kintzer Perry. "Fraktur Treasures from the Schwenkfelder Library and Heritage Center." *Folk Art,* Spring 2003, 30–37.

Retallack, James. *Germany in the Age of Kaiser Wilhelm II.* New York: St. Martin's Press, 1996.

Riggenbach, Johann, ed. *Hieronymus Anoni: Ein Abriß seines Lebens sammt einer Auswahl seiner Lieder, bearbeitet durh Ehr. Joh. Riggenbach, Prof.* Basel, Switzerland: Verlag christlicher Schriften [für den Buchhandel bei G. Detloff], 1870.

Rogal, Samuel J. *A General Introduction to Hymnody and Congregational Song.* Metuchen, NJ: American Theological Library Association; Scarecrow Press, 1991.

Rubin, Johann. *Der erste und kürzeste Weg zu Glückseligkeit für Jugend zu Stadt und Land, von der Schul und Unterweisung an* [. . .]. Bern, Switzerland, 1799.

Ruth, John L. *Maintaining the Right Fellowship: A Narrative Account of Life in the Oldest Mennonite Community in North America.* Scottdale, PA: Herald Press, 1984.

Ryden, Earnest Edwin. *The Story of Christian Hymnody.* Rock Island, IL: Augustana Press, 1959.

Sachse, Julius Friedrich. *The German Sectarians of Pennsylvania, 1708–1742: A Critical and Legendary History of the Ephrata Cloister and the Dunkers.* 2 vols. Philadelphia: printed by the author, 1899.

Samuel T. Freeman and Company, Auctioneers. *Executors' Sale: Estate of Samuel W. Pennypacker, Deceased. Rare Books and Manuscripts Autographs Also Two Paintings by Benjamin West, and Other Historical Portraits. The Collection of the Late Hon. Samuel W. Pennypacker. Tuesday and Wednesday, Oct. 26 and 27, at 2 P.M. Each Day, in Our Art Galleries, Nos. 1519–1521 Chestnut Street.* Philadelphia: Freeman, 1920.

Sarbanes, Janet. "The Shaker 'Gift' Economy: Charisma, Aesthetic Practice and Utopian Communalism." *Utopian Studies* 20, no. 1 (2009): 121–39.

BIBLIOGRAPHY 219

Schimmel, Annemarie. *Calligraphy and Islamic Culture*. New York: New York University Press, 1984.

Schleiermacher, Friedrich. *Hermeneutics: The Handwritten Manuscripts*. Edited by Heinz Kimmerle. Translated by James Duke and Jack Forstman. American Academy of Religion Texts and Translations 1. Missoula, MT: Scholars Press for the American Academy of Religion, 1977.

Schlereth, Thomas J., ed. *Material Culture Studies in America*. Nashville: American Association for State and Local History, 1982.

Schmid, Ignatio Dominico [Ignatius Dominicus Schmid]. *Grammatologia, oder hinlängliche Untersuchung der Geheimnißvollen Buchstaben-Wissenschaft, wie solche aus den bewährtesten Philologis und Historicis entdecket worden*. Regensburg, 1773.

Schmidt, Leigh Eric. *Hearing Things: Religion, Illusion, and the American Enlightenment*. Cambridge, MA: Harvard University Press, 2000.

Schneider, Hans. *Radical German Pietism*. Translated by Gerald T. MacDonald. Lanham, MD: Scarecrow Press, 2007.

"Selected for the *Berean*: From a Young Man to the Principal of the Society Called Dunkers, in Consequence of a Visit He Had Paid Him, and the Conversation Which Passed at That Time." *Berean: A Religious Publication* 2 (April 1825–June 1826): 16. Wilmington, DE: Merrihew, 1826.

Sellin, David. "Shaker Inspirational Drawings." In "The Shakers: Their Arts and Crafts." Special issue, *Philadelphia Museum of Art Bulletin* 57, no. 273 (1962): 93–99.

Shantz, Douglas H., ed. *A Companion to German Pietism, 1660–1800*. Leiden: Brill, 2015.

———. *An Introduction to German Pietism: Protestant Renewal at the Dawn of Modern Europe*. Young Center Books in Anabaptist and Pietist Studies. Baltimore: Johns Hopkins University Press, 2013.

Shaw, Paul, and Peter Bain, eds. *Blackletter: Type and National Identity*. Princeton, NJ: Princeton Architectural Press, 1998.

———. "Introduction: Blackletter vs. Roman; Type as Ideological Surrogate." In Shaw and Bain, *Blackletter*, 10–15.

Silvius, Don. "The Valley's Palatine Pioneers." *Shenandoah County, Virginia*. Accessed January 22, 2017. www.vagenweb.org/shenandoah/cem/palatine.html.

Smith, C. Henry. *Smith's Story of the Mennonites*. 5th ed. Revised by Cornelius Krahn. Newton, KS: Faith and Life Press, 1981.

Smucker, David Rempel. "Lifting the Joists with Music: The Hymnological Transition from German to English for North American Mennonites, 1840–1940." In Blumhofer and Noll, *Singing the Lord's Song*, 140–70.

Snavely, Iren. "Samuel W. Pennypacker, Legacy of His Writings on Pennsylvania." Lecture, Eighth Annual Thomas R. Bendle Folklife Symposium: "Studying the Pennsylvania Dutch: Scholars of the Oral, Written and Material Culture." Cosponsored by the Goschenhoppen Historians and the Schwenkfelder Library and Heritage Center, Pennsburg, Pennsylvania, November 2, 2013.

Snyder, C. Arnold. *Anabaptist History and Theology: An Introduction*. Kitchener, Ontario: Pandora Press, 1995.

———. "Swiss Anabaptism: The Beginnings, 1523–1525." In *A Companion to Anabaptism and Spiritualism, 1521–1700*, edited by John D. Roth and James M. Stayer, 45–82. Boston: Brill, 2007.

Sommer, Frank. "German Language Books, Periodicals, and Manuscripts." In Swank, *Arts of the Pennsylvania Germans*, 265–304.

Spencer, H. C., and Platt R. Spencer. *Spencerian Key to Practical Penmanship Prepared for the "Spencerian Authors."* Philadelphia: Lippincott, 1869.

220 BIBLIOGRAPHY

Spener, Philipp Jakob. Dr. *Philipp Jacob Spener's Pia Desideria oder herzliches Verlangen nach gottfefälliger Besserung der wahren evangelischen Kirche, nebst einigen dahin abzweckenden christlichen Vorschlägen*[. . .]. 1675. Reprint, Leipzig: Köhler, 1841.

Spinks, Bryan D. *Reformation and Modern Rituals and Theologies of Baptism from Luther to Contemporary Practices.* Liturgy, Worship and Society. Burlington, VT: Ashgate, 2006.

Splitter, Wolfgang. "Divide et Impera: Some Critical Remarks on Halle Missionaries' Formation of a Lutheran Church in Pennsylvania." In Grabbe, *Halle Pietism*, 45–92.

Stayer, James. "Research Note: The Varieties of Anabaptist Biblicism; The Weight of the Old Testament and the Apocrypha in Several Sixteenth-Century Anabaptist Groups." *Mennonite Quarterly Review* 88, no. 3 (2014): 365–72.

Stein, Stephen J. *The Shaker Experience in America: A History of the United Society of Believers.* New Haven: Yale University Press, 1992.

———. "Some Thoughts on Pietism in American Religious History." In Strom, Lehmann, and Van Horn Melton, *Pietism in Germany*, 23–32.

Stoeffler, F. Ernest. *German Pietism During the Eighteenth Century.* Studies in the History of Religions (Supplements to *Numen*) 24. Leiden, Netherlands: Brill, 1973.

———. Preface to Stoeffler, *German Pietism*, ix–xi.

Stopp, Klaus. *The Printed Birth and Baptismal Certificates of the German Americans.* Vol. 1, *General Part, Forms Anonymously Published: Pennsylvania; Allentown–Bath.* East Berlin, PA: printed by the author, 1997.

Stoudt, John Joseph. *Pennsylvania Folk-Art: An Interpretation.* Allentown, PA: Schlechter's, 1948.

———. "Symbol, Image and Literary Expression." In Stoudt, *Pennsylvania Folk–Art*, 101–19.

Strom, Jonathan. *German Pietism and the Problem of Conversion.* Pietist, Moravian, and Anabaptist Studies. University Park: Pennsylvania State University Press, 2018.

———. "The Problem of Conventicles in Early German Pietism." *Covenant Quarterly* 61 (November 2004): 3–16.

Strom, Jonathan, Hartmut Lehmann, and James Van Horn Melton, eds. *Pietism in Germany and North America, 1680–1820.* Burlington, VT: Ashgate, 2009.

Sudermann, Daniel. *Hohe geistreiche Lehren vnd Erklärungen: Vber die fürnembsten Sprüche desz Hohen Lieds Salomonis von der Liebhabenden Seele das ist der Christlichen Kirchen vnd ihrem Gemahl Jesu Christo* [. . .]. Frankfurt: Von der Heyden, 1622.

Sutton, Robert P. *Communal Utopias and the American Experience: Religious Communities, 1732–2000.* Westport, CT: Praeger, 2003.

Swain, Scott R. "Lutheran and Reformed Sacramental Theology: Seventeenth-Nineteenth Centuries." In *The Oxford Handbook of Sacramental Theology*, edited by Hans Boersma and Matthew Levering, 362–79. New York: Oxford University Press, 2015.

Swank, Scott T., ed. *Arts of the Pennsylvania Germans.* New York: Norton for Henry Francis du Pont Winterthur Museum, 1983.

Szewczyk, David M., comp. *The Viceroyalty of New Spain and Early Independent Mexico: A Guide to Original Manuscripts in the Collection of The Rosenbach Museum and Library.* Edited by Catherine A. Barnes and David M. Szewczyk. Philadelphia: The Rosenbach Museum and Library, 1980.

Tannenbaum, Judith. *Framing Fraktur: Pennsylvania German Material Culture and Contemporary Art.* Philadelphia: Free Library of Philadelphia, 2015.

Tauler, Johannes. *The Sermons and Conferences of Johannes Tauler* [. . .]. Translated by Walter Elliott. Washington, DC: Apostolic Mission House, 1910.

Tersteegen, Gerhard. *Geistliches Blumengärtlein.* Edited by Karl-Maria Guth. 1729. Reprint, Berlin: Hofenberg, 2017.

———. *Geistliches Blumen-Gärtlein Inniger Seelen: Oder kurtze Schluß-Reimen Betrachtungen und Lieder Ueber allerhand Warheiten des Inwendigen Christenthums; Zur Erweckung,*

Stärckung, und Erquickung in dem Verborgenen Leben mit Christo in Gott. Nebst der Fromen Lotteri. Germanton [*sic*], PA: Saur, 1747.

Theologia Deutsch: Die leret gar manchen lieblichen underscheit gotlicher warheit und seit gar hohe und gar schone ding von einem volkomen leben [. . .]. Stuttgart, 1851.

Theologia Deutsch–Theologia Germanica: The Book of the Perfect Life. Translated and edited by David Blamires. New York: Alta Mira Press, 2003.

Theory and Art of Penmanship: A Manual for Teachers, Containing a Full Statement of Payson, Dunton, and Scribner's Celebrated Method of Teaching [. . .]. Boston: Crosby and Nichols; New York: Felt, 1864.

Thompson, Wilson. "Hear the Royal Proclamation." *Hymnary.* Accessed September 18, 2017. https://hymnary.org/text/hear_the_royal_proclamation.

Thornton, Tamara Plakins. *Handwriting in America: A Cultural History.* New Haven: Yale University Press, 1996.

Thorp, Daniel B. *The Moravian Community in Colonial North Carolina: Religious Pluralism on the Southern Frontier.* Knoxville: University of Tennessee Press, 1989.

Toorn, Karel van der. *Scribal Culture and the Making of the Hebrew Bible.* Cambridge, MA: Harvard University Press, 2007.

Tranvik, Mark D. "Luther on Baptism." *Lutheran Quarterly* 13, no. 1 (1999): 75–90.

Trithemius, Johannes. *In Praise of Scribes (De laude scriptorum).* Edited by Klaus Arnold. Translated by Roland Behrendt. Lawrence, KS: Coronado Press, 1974.

Trueman, Carl R. "1520." Lecture 7, part of course titled "The Reformation." Westminster Theological Seminary, Princeton, NJ, 2014. Available on iTunes, 12:28–14:10. Accessed March 17, 2018. https://itunes.apple.com/us/podcast/the-reformation/id924126015?mt=2.

Tucker, Susan, Katherine Ott, and Patricia P. Buckler, eds. *The Scrapbook in American Life.* Philadelphia: Temple University Press, 2006.

Tuer, Andrew White. *History of the Horn-Book.* New York: Scribner's Sons, 1896.

Ussher, James. *A Method for Meditation or a Manuall of Divine Duties, Fit for Every Christians Practice.* London: T. W., 1651.

Van Maanen, Hans. *How to Study Art Worlds: On the Societal Functioning of Aesthetic Values.* Amsterdam: Amsterdam University Press, 2009.

Venema, Cornelis P. "Sacraments and Baptism in the Reformed Confessions," *Mid-America Journal of Theology* 11 (2000): 21–86.

Vogt, Peter. "Different Ideas about the Church: The Theological Dimension in the Transfer and Adaptation of German Religious Groups to the Pennsylvania Environment, 1683–1740." In Grabbe, *Halle Pietism*, 17–43.

Von Georg Weitfields Predigten, Der Dritte Theil, Bestehend aus drey Sermonen [. . .]. Germanton [*sic*], PA: Saur, 1740.

Wallmann, Johannes. "Johannes Arndt (1555–1621)." In Lindberg, *Pietist Theologians*, 22–30.

Ward, William Reginald. *Early Evangelicalism: A Global Intellectual History, 1670–1789.* New York: Cambridge University Press, 2006.

———. *The Protestant Evangelical Awakening.* New York: Cambridge University Press, 1992.

Watson, John Richard. *The English Hymn: A Critical and Historical Study.* New York: Oxford University Press, 1997.

Watts, Isaac. *Divine and Moral Songs for Children.* Boston: American Tract Society, n.d.

———. "Dr. Watts' Preface." In Cobbin, *Anecdotes and Reflections*, vii–ix.

Weeks, Andrew. *Boehme: An Intellectual Biography of the Seventeenth-Century Philosopher and Mystic.* Albany: State University of New York Press, 1991.

———. *German Mysticism from Hildegard of Bingen to Ludwig Wittgenstein: A Literary and Intellectual History.* Albany: State University of New York Press, 1993.

Weigelt, Horst. *The Schwenkfelders in Silesia.* Pennsburg, PA: Schwenkfelder Library, 1985.

BIBLIOGRAPHY

Weiser, Frederick S. *The Gift Is Small, the Love Is Great: Pennsylvania German Small Presentation Frakturs.* York, PA: York Graphic Services, 1994.

———. "Johann Christian Strenge, Self-Taught Genius: Treasures from the American Folk Art Museum." American Folk Art Museum. Accessed January 7, 2017. http://selftaught genius.org/reads/johann-christian-strenge.

———. "Piety and Protocol in Folk Art: Pennsylvania German Fraktur Birth and Baptismal Certificates." *Winterthur Portfolio* 8 (1973): 19–43.

Wellenreuther, Hermann. *Citizens in a Strange Land: A Study of German-American Broadsides and Their Meaning for Germans in North America, 1730–1830.* Max Kade German-American Research Institute Series. University Park: Pennsylvania State University Press, 2013.

———. *Heinrich Melchior Mühlenberg und die deutschen Lutheraner in Nordamerika, 1742–1787: Wissentransfer und Wandel eines atlantischen zu einem amerikanischen Netzwerk.* Atlantic Cultural Studies, Band 10. Berlin, Germany: Lit Verlag, 2013.

Wellenreuther, Hermann, Thomas Müller-Bahlke, and A. Gregg Roeber, eds. *The Transatlantic World of Heinrich Melchior Mühlenberg in the Eighteenth Century.* Halle, Germany: Verlag der Franckeschen Stiftungen; Harrassowitz Verlag in Kommission, 2013.

Welling, Georgii von [Georg von Welling]. *Opus Mago–Cabbalisticum et Theosophicum, darinnen der Ursprung, Natur, Eigenschaften und Gebrauch des Saltzes, Schwefels und Mercurii, in dreyen Theilen beschrieben* [. . .]. Frankfurt: Fleischerischen Buchhandlung, 1760.

Wertkin, Gerard, ed. *Encyclopedia of American Folk Art.* New York: Routledge, 2004.

White, David Gordon. "At the Mandala's Dark Fringe: Possession and Protection in Tantric Bhairava Cults." In *Notes from a Mandala: Essays in the History of Indian Religions in Honor of Wendy Doniger,* edited by Laurie L. Patton and David L. Haberman, 200–223. Newark: University of Delaware Press, 2010.

Wickersham, James Pyle. *A History of Education in Pennsylvania, Private and Public, Elementary and Higher: From the Time the Swedes Settled on the Delaware to the Present Day.* Lancaster, PA: Inquirer, 1886.

Wiebe, Victor G. "Boehm, Martin (1725–1812)." *Global Anabaptist Mennonite Encyclopedia Online.* Accessed June 1, 2018. http://gameo.org/index.php?title=Boehm,_martin_(1725 –1812)&oldid=143136.

Wieck, Roger S. *Painted Prayers: The Book of Hours in Medieval and Renaissance Art.* New York: Braziller; Pierpont Morgan Library, 1997.

Wilson, James Grant, and John Fiske, eds. "Kunze, John Christopher." In *Appleton's Cyclopaedia of American Biography,* edited by James Grant Wilson and John Fiske, 578. Vol. 3, *Grinnell–Lockwood.* New York: Appleton, 1898.

Wilson, Richard Guy, Shaun Eyring, and Kenny Marotta, eds. *Re-creating the American Past: Essays on the Colonial Revival.* Charlottesville: University of Virginia Press, 2006.

Winiarski, Douglas L. *Darkness Falls on the Land of Light: Experiencing Religious Awakenings in Eighteenth-Century New England.* Williamsburg, VA: Omohundro Institute of Early American History and Culture; Chapel Hill: University of North Carolina Press, 2017.

Winship, Michael P. *Godly Republicanism: Puritans, Pilgrims, and a City on a Hill.* Cambridge, MA: Harvard University Press, 2012.

———. *Making Heretics: Militant Protestantism and Free Grace in Massachusetts, 1636–1641.* Princeton, NJ: Princeton University Press, 2002.

———. *Seers of God: Puritan Providentialism in the Restoration and Early Enlightenment.* Baltimore: Johns Hopkins University Press, 1996.

Witte, John, Jr. "Blest Be the Ties That Bind: Covenant and Community in Puritan Thought." *Emory Law Journal* 36, no. 2 (1987): 579–601.

Witvliet, John D. Series preface to Mouw and Noll, *Wonderful Words,* vii–ix.

Wokeck, Marianne S. *Trade in Strangers: The Beginnings of Mass Migration to North America.* University Park: Pennsylvania State University Press, 1999.

Wölfflin, Heinrich. *Renaissance and Baroque*. Translated by Kathrin Simon. Ithaca, NY: Cornell University Press, 1964.

Wood, A. Skevington. *Captive to the Word: Martin Luther, Doctor of Sacred Scripture*. Grand Rapids: Eerdmans, 1969.

Wosh, Peter J. *Spreading the Word: The Bible Business in Nineteenth-Century America*. Ithaca, NY: Cornell University Press, 1994.

Wübben, Yvonne. "'Ich bin alles, was da ist': Zur Auslegung der Isis-Inschrift bei Schiller und Reinhold." In *Krisen des Verstehens um 1800*, edited by Sandra Heinen and Harald Nehr, 135–51. Würzburg, Germany: Königshausen und Neumann, 2004.

Wulf, Karin. "Bible, King, and Common Law: Genealogical Literacies and Family History Practices in British America." *Early American Studies: An Interdisciplinary Journal* 10, no. 3 (2012): 467–502.

Wust, Klaus. *Virginia Fraktur: Penmanship as Folk Art*. Edinburgh, VA: Shenandoah History, 1972.

Yoder, Don. *Discovering American Folklife: Essays on Folk Culture and the Pennsylvania Dutch*. 1990. Mechanicsburg, PA: Stackpole Books, 2001.

———. "The European Background of Pennsylvania's Fraktur Art." In Amsler, *Bucks County Fraktur*, 15–37.

———. "Fraktur in Mennonite Culture." *Mennonite Quarterly Review* 48, no. 3 (1974): 306–42.

———. Introduction to *Pennsylvania German Fraktur and Color Drawings*. 1969. Reprint, Lancaster, PA: Landis Valley Museum; Acorn Press, 1989.

———. *The Pennsylvania German Broadside: A History and Guide*. University Park: Pennsylvania State University Press; Philadelphia: Library Company of Philadelphia; Kutztown: Pennsylvania German Society, 2005.

Zboray, Ronald J. "Antebellum Reading and the Ironies of Technological Innovation." In "Reading America." Special issue, *American Quarterly* 40, no. 1 (1988): 65–82.

Zerfass, Samuel Grant. *Souvenir Book of the Ephrata Cloister: Complete History from Its Settlement in 1728 to the Present Time* [. . .]. Lititz, PA: Zook, 1921.

INDEX

Note: page numbers in italics refer to figures; those followed by t refer to tables. Those followed by n refer to notes, with note number.

ABC books
 and, letter forms as devotional images, 67–68, 71, 80, *81*
 golden (acrostic alphabets), 67, 68, 80, *81*
 and literary education in German-speaking schools, 88
Ache, Herman M., 4, 11–12, 72–73, *73*, 97t
Adam, Louisa, 150
"An Admonishment to Youth" (Egelmann), 99
adult baptism
 as Anabaptist belief, 38
 controversy surrounding, 33, 38
Albrecht, Johann, 121
Alderfer, Joel, 89
allegorical imagery
 baroque style and, 51–52, 52t
 in *Fraktur* illuminations: debate on meaning of, 185n31; and letter forms as devotional images, 69–73, *70*, *73*, *74*, *75*
 and labyrinths as image of spiritual journey, 77–78
 in *Vorschrift*, 72–73, *73*, *74*, *75*, 102, 102–3, 103t
alphabetic method in education, 86–87
 See also ABC books
American culture, German contribution to
 debate on, 172
 German manuscript culture as doorway to understanding, 170–71
 as under-studied, 173
American Philosophical Society, 15, 44, 83
Ames, William, 31
Amish
 among German-speaking migrants to Pennsylvania, 35
 longer survival of German language among, 162, 169
 and manuscript tradition, limited interest in, 39
 origin of, 39
 and Pennsylvania religious tolerance, 40
Ammann, Jakob, 39
Anabaptists
 among German-speaking migrants to Pennsylvania, 35
 beliefs of, 35, 38–39
 and evangelicalism, 19
 focus on spiritual introspection, 39
 German Pietist and sectarian traditions and, 8, 19
 importance of hymn singing to, 117
 and manuscript illumination in Pennsylvania, 35, 36
 migration to Pennsylvania, 39
 and mysticism, 61
 as part of larger evangelical movement, 44
 persecution in homeland, 38
 and Pietism, 7, 8, 22, 24, 35
 Swiss, 39
 three European groups of, 39
 See also Amish; German Pietist and sectarian traditions; Mennonites
angels
 on birth and baptismal certificates, 145
 on *Fraktur*, *74*, *75*
 on hymn tune book title pages, 129–30
Anglicans
 in diversity of early Christian America, 40
 and manuscript culture, lack of interest in, 41
Appel, Anna Maria, 151–52
Arbo, Johann, 83–84, 111
Arndt, Johann, 22–23, 63–64, 65
Arnold, Gottfried, 22, 62, 69
art system, *Fraktur* composition within, 11
Asbury, Francis, 40
Atwood, Craig D., 23, 77

Bach, Jeff, 78
Banning, James Latimer, 139–40, *141*
baptism
 debate on nature and impact of, 138
 importance in Pennsylvania German culture, 137–38
 See also birth and baptismal certificates
Bard, Johannes, 49

baroque style
and allegory, 51–52, 52t
arousal of affect as goal of, 51
and *Fraktur* script, 50–52, 170; aesthetic theory underlying, 51; and allegory, 51–52; association with German language, 57; divergence of English-language script styles from, 52–57
multimodality of, 51
period of, 50–51
as response to "problem of thought," 51
Baxter, Richard, 26
Bayly, Lewis, 26, 27
Bay Psalm Book (1640), 117, *118*
Bebbington, David W., 28, 57
"Bedencke was du fliehen must . . ." (c. 1800), 73–74, *75*
Beissel, Conrad, 71
Ben Sira, 107
See also Sirach, Book of
Bentz, Samuel, 151–52
Berean (periodical), 112–13, 133
Bertsch, Johann George, 29–30
Bibles and other devotional texts, storage of documents in, 154–56
birth and baptismal certificates, 135–40, *136*
as artistic and spiritual texts, not legal records, 135
as both celebration and record, 137
of Carli family, 154
for child of unmarried parents, 150
content analysis of, 140–50
continued use after end of other manuscript types, 137, 142–43
importance of, 146
and importance of baptism in Pennsylvania German culture, 137–38
later addition of important events to, 146
and linking of child to larger Christian community, 134, 139, 140, 142, 143–45, 150
parallels in Anglo-American community, 139–40, *141*
and personal identity formation, 139
printed templates: consistency over time of messages in, 148; eventual replacement of hand-done manuscripts, 137, 139; evolution of style and content, 146–47; evolution of technology for, 140–42; iconography of, 147, 147t–48t; locations of printing, 143
printed templates' adornment with calligraphy and illumination, 139, 140–50; iconography of, 145–46; and reshaping of document's meaning, 142, 146–47, 150; varying degrees of, 143

reminders of death in, 142, 144–45, 146, 148–50
scribes of, 135
storage of, 140
as unique American innovation, 139
use by Lutherans and Reformed Church, 137–38, 142–43, 150
widespread demand for, 137
blackletter, as term, 57
Der Blutige Schau-Platz, oder Martyrer Spiegel (van Braght), 151
Boehm, Martin, 29
Böhme, Jakob, 22, 62, 65, 66, 68–69
Bower, Henry S., 162–64, *164*, *165*
Brachtheiser, Heinrich, 73, *74*, 97t, *102*, 102–3, 109–11
broadsides, use by Pennsylvania Germans, 137, 195n5
Brönner, Henrich Ludwig, 120–21
Brown, Marcella L., 93–95
Brunner, Jacob, 49
Bunny, Edmund, 26
Bunyan, John, 26, 40

calligraphy
as activity inspired by Holy Spirit, 98
as expression of deep personal experience of text, 44, 48, 58
functions of, as not explicitly addressed, 58
German tradition of, as factor in denominations making spiritual manuscripts, 19, 41, 44
power to awaken reader to text's meaning, 58
power to open hearts to salvation, xi, xii, xv
prestige of, 18
support of engraving for, 49
See also letter forms; manuscript illumination and calligraphy
calligraphy, comparisons to farming, xi–xvi
in English Puritan literature, xi–xii
in European manuscripts, xi, xii–xiv, 134
in manuscripts of German-speaking North Americans, xi, *xii*, *xiii*
in Pennsylvania German hymn tune books, 127
Calvin, John, 20, 25
Cantzleischrift (*Kantzleischrift*)
definition and history of, 57
uses of, 95, 100–101
Carli, Anna, 154–55
Carli, Johannes, 154, *155*
Carli family of Manor Township, documents preserved by, 154–55
Carroll, Charles, 167–68
Carruthers, Mary, 96–98

226 INDEX

Cassel, Huppert, 79, 97t
Charles, Christian, xi
China, calligraphy in, 17
chirythmography, in penmanship instruction of nineteenth century, 161
Der Christen ABC ist Leiden, Dulden, Hoffen, Wer dieses hat gelernt, der hat sein Ziel getroffen (1750), 71, 72
Christianity, potentiating linguistic spirit in, 176
Church of the Brethren, among German-speaking migrants to Pennsylvania, 35
classicism, English-speakers' turn to, and divergence of script from German Gothic style, 54–57
Clauß, G. B., 162
Cohen, Charles Lloyd, 26
"A Collection of Extra Songs of Various Kinds" (Hazard), 120
collectors of *Fraktur* and religious texts. *See* Mercer, Henry Chapman; Pennypacker, Samuel Whitaker
Collins, Polly, 41, 42
Concerning the Three Principles of the Divine Essence (Böhme), 66–67
conversion experience, importance to both British and German evangelicals, 26, 181n60
covenant theology, Puritanism and, 25
Currentschrift (Kurrentschrift)
definition and history of, 57, 95
uses of, 95, 100–101, 110, 151

Däthweihler, Marthin, 104
death, evocations of
in English-language texts for children, 145
in German birth and baptismal certificates, 142, 144–45, 146, 148–50
in German hymn tune book title pages, 128
in German *Vorschrift*, 95, 105
decline of manuscript culture of Pennsylvania Germans, 157–65
avenues for future scholarship on, 158
dramatic cultural changes of nineteenth century and, 168
emergence of modern American society and, 158
evidence of, in declining quality of *Fraktur*, 162–64, 164, 165
German assimilation into English-language culture and, 162, 163–64, 169
Harbaugh poem on, 157–58
lingering remnants of, 164–65
Pennypacker's documentation of, 169
and public schools, forced attendance at, 159–60

rise of industrial printing and, 158–59, 169
and utilitarian business-related penmanship, turn to, 160–62
Deep Run Mennonite Schoolhouse, 91
De laude scriptorum (Trithemius), 46
Denck, Hans, 61
Diet of Worms, 20
Dietrich, Anna Carolina, 146
diversity
of European homeland of German-speaking migrants, 33
of German migrants to Pennsylvania, 33, 34–35
of mid-Atlantic region, Protestant dissenters' diaspora and, 30
diversity of early American religious experiences
broad categories of faiths in, 40–41
Fraktur and, 1–2, 19
German Pietist and sectarian traditions and, 7, 8–9
Pennsylvania's tolerance of, 9, 30, 31–32, 40
diversity of Pennsylvania
and cross-pollination between cultures and religions, 40
early migration to Philadelphia area and, 34–35
Pennypacker's interest in, 3
Quaker religious tolerance and, 8, 9, 30, 31–32, 40
Divine and Moral Songs for Children (Watts), 145
Divine wisdom as hidden from view, 60
fear of God as necessary for accessing, 60
and God's creative power hidden within the Word, 66–67
as principle underlying manuscript interpretation, 60, 62
representation of search for, in textual arrangement, 60
See also language, in Pennsylvania German religious life; spiritual meaning underlying *Fraktur* texts; the Word
Dixon, C. Scott, 43
Dock, Christopher, 90–93, 95–98, 97t, 105, 176
Dorr, Samuel Adams, 152
Dunkers, among German-speaking migrants to Pennsylvania, 35
Dyke, Daniel, 26

Earl, Thomas, 54, 55
early Christian spiritualist traditions, interest in, and splinter sects in early modern Europe, 30
Ecclesiastes, verses from, in *Vorschrift*, 106

INDEX 227

education among Pennsylvania Germans
 alphabetic method in, 86–87
 importance of the Word in, 11–12
 and issue of agency in salvation, 88–89
 See also ABC books; schools in German-
 speaking Pennsylvania; school-
 teacher-scribes in Pennsylvania German
 schools
Egelmann, Carl Friedrich, 66, 99, 135, 136,
 138–39
Eggington, William, 51
Eine Einfältige und gründlich abgefaßte Schul-
 Ordnung (Dock), 90–93
Eister, Johannes, 121
English calligraphy, divergence from German
 Gothic script, 52–57, 185n35
English-language schools
 instructional materials beyond traditional
 books, 87–88
 penmanship instruction in, 87
 spiritual literacy instruction in, 86–87
English-language songbooks, manuscript illu-
 mination and calligraphy in, 120
English-speaking colonies
 and church registers, 151
 cross-pollination with Germans in Pennsyl-
 vania, 40
English-speaking community
 birth and baptismal certificates in, 139–40, 141
 and death, instruction preparing children
 for, 145
 See also Puritanism
engraving, support for calligraphic activity, 49
Ephrata community
 Hopkinson poem on, 112–13, 133
 meditation on God, through prayer, hymn
 singing, calligraphy, and manuscript illu-
 mination, 113
 and Pennsylvania religious tolerance, 40
Ephrata manuscripts
 creative spiritual exploration in, 176
 creative use of textual arrangement in, 60
 hymn manuscript illumination and calligra-
 phy, 113, 114, 115
 hymn manuscripts, large number of, 113
 hymn manuscripts as window into worship
 practices of, 133
 and labyrinth as allegorical image of spiritual
 journey, 77–78
 and manuscript culture, 36
 residents' covering of walls with, 71
 spiritual significance of calligraphy and illu-
 minations in, 69–71
 time spent creating, 71

epitaphs
 for Pennsylvania Germans, 134, 151–52
 in Puritan New England, 152
Erb, Peter C., 169–70
Erbauliche Lieder-Sammlung (1821), 122
"Errand into the Wilderness" (Miller), 6
Die Erste Liebe (Arnold), 69, 70
European homeland of German-speaking
 migrants
 diversity of, 33
 growth of Pietism and apocalyptic move-
 ments in, 33
 lack of strong central political or religious
 authority in, 32–33
 migrants from, Eastern Europe as primary
 destination of, 34
 overpopulation and outmigration, 33
 political and economic oppression in, 34
 and Protestant hymn-writing tradition, 117
 regions included in, 32
 and Thirty Years' War, devastation of, 33, 117
 See also German migrants to Pennsylvania/
 Colonial America
European roots of Fraktur theology, 1
 components of, 2
 and Fraktur sophistication, 16, 82, 170,
 171–72
 recognition by early scholars, 15
 Reformation and, 19–20, 43
 as under-studied, 15–16
 Vorschrift and, 99
evangelical, as term, 27–28
evangelicalism
 blossoming between seventeenth and nine-
 teenth centuries, 19
 characteristics of, 28
 diversity of early Christian America and,
 40–41
 importance of hymns in, 116
 Puritan and Pietist roots of, 27–29
 rise of, and splintering of Church into sects,
 47–48
 shared belief across groups, 44
 as single movement across linguistic bound-
 aries, 30
 and textually defined community, 29
 trans-national networks of evangelicals,
 28–29, 182n82
Eyer, Elisabetha, 121, 122
Eyer, Johann Adam, 89, 95–96, 96, 97t, 121, 122

family registers
 in Bibles and other devotional texts, 134,
 150–51, 154

228 INDEX

family registers (*continued*)
 calligraphy in, 151
 characteristics of, 151
farming, comparisons of calligraphy to, xi–xvi
 in English Puritan literature, xi–xii
 in European manuscripts, xi, xii–xiv, 134
 in manuscripts of German-speaking North
 Americans, xi, *xii, xiii*
 in Pennsylvania German hymn tune books, 127
fear of God as necessary for accessing Divine
 truth, 60
Fogleman, Aaron Spencer, 32, 33
folk art, characterization of *Fraktur* as, 16
Fox, George, 30
Fraktur of Pennsylvania Germans
 avenues for comparative study of, xvi
 binding of community through, 84
 as both pragmatic communication and artis-
 tic embodiment of faith, 12
 characteristics of, 1
 characteristics *vs.* similar Anglo-American
 forms, 94–95
 as compromise between guided and personal
 internal spirituality, 175
 in context of early Modern German spiritu-
 ality, 111
 in context of other cultures' manuscript illu-
 minations: as indication of importance as
 cultural artifacts, 43–45; as indication of
 sophistication, 16, 82, 170–72
 declining quality with decline of manuscript
 culture, 162–64, *164, 165*
 and diversity of early American religious
 experience, 1–2, 3
 and efforts to verbally express God's mes-
 sage, 68–69
 as evidence of everyday spiritual practice, 44
 Gothic baroque style of, 50–52, 170; aesthetic
 theory underlying, 51; and allegory, 51–52;
 association of script with German lan-
 guage, 57; divergence of English-language
 script styles from, 52–57
 illumination as secondary to text in, 10
 as important part of American folk-art prac-
 tices, xvi
 key concepts in understanding of, 12–13
 large number of, 1, 4, 153
 and material dimension of spiritual experi-
 ence, 11, 18
 meaning of term, xvi
 and millennia-old story of Christian spiritual
 practice, 43–44
 nourishing of religious life by, 7, 10, 44, 69,
 82, 85, 105, 111, 171
 origin of name, 49

pedagogical images or emblems in, 52, 53
period of production, 1
place in everyday life, 153–57
as product of international evangelical com-
 munity, 44
as products of personal spiritual devotion,
 44, 48, 58
role in devotional life, 111
scholarship on, xvi, 1, 169
scholars' over- and under-interpretations of,
 16
scripture or hymnals as typical sources for
 quotations on, 67–68
skill and effort involved in making, 100
and social construction of reality, 156–57
sophistication of, as underappreciated,
 170–72
as source of spiritual experiences, 10
spiritual messages typical of, 155
supplies used to create, 100
texts of *Fraktur*, as assembled excerpts of
 other texts, 10–11
as under-studied, 1–2
use as rewards for good students: in English-
 speaking schools, 93–95; in German
 schools, 93, 94
as window into Pennsylvania German Pietist
 and sectarian culture, 9–10, 153–57, 173
See also European roots of *Fraktur* theology;
 Gothic script in *Fraktur* (*Frakturschrift*);
 hymn manuscript illumination and callig-
 raphy; manuscript culture of Pennsylvania
 Germans; manuscript illumination and
 calligraphy; religious experience of Penn-
 sylvania Germans; spiritual meaning
 underlying *Fraktur* texts; *Vorschrift* (pen-
 manship sample)
Frakturschrift. See Gothic script in *Fraktur*
Fraktur Writings and Folk Art Drawings of the
 Schwenkfelder Library Collection (Moyer),
 xxiv, 79
Franck, Sebastian, 65
Francke, August Hermann, 23, 29, 63
Francke, Michael, 95
Franklin, Benjamin, 63, 87, 159
Friedrich, Johannes, 128
Froschauer, Christoph, 154
Fuchs, Ernst, 13, 58
Fuchs, Matthaus, 93, 94
Funck, Anna, xi, 126–27
furniture, pasting of *Fraktur* pages on, 77

Gaskell, George A., 160
Geburts und Taufschein of Sara Anna Huber
 (Egelmann), 135–37, *136*, 138–39

INDEX 229

Geissinger, Anna, 128
Geistliches Blumen-Gärtlein Inniger Seelen (Tersteegen), 69, 78, 165
Gellert, Christian Fürchtegott, 109
Genette, Gérard, 120
Gerhardt, Paul, 104, 117
German decorative arts, gaps in scholarship on, 5–6
German language
 claims of ancient or primeval origins of, 49–50
 declining use with German assimilation into English-language culture, 162, 1 63–64, 169
 longer survival among sectarians, 162
German Lutheran Church, elements of Pietism in, 24
German migrants to Pennsylvania/Colonial America
 diversity of, 33, 34–35
 embrace of tolerance in Pennsylvania, 40
 first wave of, 31, 33
 and manuscript culture, varying importance to different groups, 35–36
 migration out of Pennsylvania, 34
 motives for migration: difficult conditions in native lands, 32; economic opportunity, 33–34; overpopulation of home regions, 33; political and economic oppression, 34; Quaker religious tolerance, 31–32; recruiting by colonial agents, 33, 34, 39
 number of, from 1683 to 1775, 32
 second wave of, 33–34
 sects included in, 35
 texts used to transfer beliefs, 37–38
 third wave of: as largest, 34; relatively few Pietists among, 34
 See also European homeland of German-speaking migrants
German Pietist and sectarian traditions
 and diversity in American religious history, 7, 8–9, 40
 focus on individual experience, 7, 8, 10, 19
 Fraktur as window into, 9–10, 153–57, 173
 influence on Pennsylvania manuscript culture, 4–5, 7
 as infused into Pennsylvania German life, 9, 18
 long intellectual and aesthetic tradition underlying, 9–10
 manuscript culture of Pennsylvania Germans as part of, 18
 vs. New England Puritan traditions, value of comparing, 8–9
 as overshadowed by English religious traditions, 5–6

Penn's recruitment for Pennsylvania colony and, 31, 39
 as percentage of German-speakers in Pennsylvania, 35
 pivotal role in German dissenters' population of Pennsylvania, 30
 Quaker religious tolerance and, 30, 31, 40
 sects included within, 5–6, 8
 spiritual literacy as essential skill in, 12
 and survival of early modern spirituality into nineteenth century, 9
 as underlying all German protestant denominations, 7
 value of recognizing, in study of American history, 7, 8–9
 See also European roots of *Fraktur* theology; Pietism
German protestant denominations
 general agreement on broad beliefs, 37
 German Pietist and sectarian tradition underlying, 7
Germans in Pennsylvania
 belief in Heaven as true home, 29–30, 127
 cross-pollination across cultures and religions, 40
 English-speakers' names for, 35
 lack of German national identity, 35
 political influence of, 35
 as predominantly Lutheran or Reformed Church, 35
 prestige of calligraphy among, 18
 Quaker religious tolerance and, 30, 31–32, 40
 recent scholarship on, 169
 religious ethos, components of, 7
 sense of spiritual pilgrimage pervading culture of, 45
 and text-based Protestant spiritual community, creation of, 29
A Gift from Mother Ann to the Elders at the North Family (Collins), 41, 42
golden ABCs. *See* ABC books, golden
Gothic script in *Fraktur* (*Frakturschrift*), 1
 aesthetic theory underlying, 51
 association with German language, 57
 characteristics of, 57
 development of, 57
 divergence of English-language script styles from, 52–57
 engraved samples for students, 49
 as marker of importance texts, 57
Gottschall, Jacob, 97t
Gottschall, Samuel, 165
Grammatologia, oder hinlängliche Untersuchung der Geheimnißvollen Buchstaben-- Wissenschaft (Schmid), 67

230 INDEX

Great Awakening
English and German nonconforming traditions and, 24
German evangelists in, 40
German Pietist and sectarian roots of, 24
Greene, Jack, 32
"Gründliche Anweisung zu einem Heiligen Leben" (Sauer), 64–65
A Guide to the Reading and Study of the Holy Scriptures (Francke), 63
Güldene Aepffel in Silbern Schalen (1745), 59, 64
Gutenberg, Johannes, 46, 158

Häberlein, Mark, 24
Hall, Joseph, 26
Halle, Germany
as center of German Pietism, 23
John Wesley's visit to, 29
Halle, University of
and appointment of colonial clergy, 37, 62–63
books published by, 37
Francke and, 23, 29, 63
mysticism of Pietists at, 62
Hancock, George Washington, 152
Hancock, John, 152
hand copying of preexisting texts
common view of as discouraging creativity, 174–75
as creative spiritual exercise for German manuscript scribes, 174, 175–76
handwriting. See penmanship
Handwriting in America (Thornton), 174
Harbaugh, Henry, 157–58
Harmonists, and labyrinth as allegorical image of spiritual journey, 77
Hazard, Mary, 119–20
Heebner, Abraham, 79–80, 82
Heebner, Abraham W., 82
Heebner, David, 82
Heebner, Hans Christopher, 79
Heebner, Henry, 82
Heebner, Maria, 82
Heebner, Susanna, 79, 80–82, 81
Heebner family, Schwenkfelder Fraktur by, 79–82, 81, 130, 176
Helfenstein, Georg F., 76
Helleleüchtender Herzens-Spiegel (Tauler), 80
Hershey, Mary Jane Lederach, xxiv, 96, 97t
Heÿdt, Joshua and Sohnÿa, 146
Heÿdt, Sara, 146
Hinderle, Sebastian, 29–30
Hirsch, E. D., Jr., 50, 86
Hirschi family of Manor Township, documents preserved by, 154, 155
Historical Society of Pennsylvania, 2, 168

Hoch-Deutsches Reformirtes A B C-und Namen-Büchlein für Kinder welche anfangen zu lernen (1816), 88
Hohe geistreiche Lehren/vnd Erklärungen (Sudermann), 131–32
Holy Roman Empire, and neo-Gothic scripts, 57
Hopkinson, Francis, 112–13, 133
hornbooks, 86, 87–88
Hostetter, Maria, 121
Huber, Jonas and Maria, 135–37, 136, 138–39
Huber, Sara Anna, 135–37, 136, 138–39
Hümmel, Jacob, 74, 75, 97t
Hut, Hans, 61
Hutchinson, Mark, 28
Hutzli, Jakob, 68, 98
hymn books
advice on use contained in, 120, 121, 124
bindings, decoration of, 120–21
decoration of, as indication of venerable place of music in worship, 121
inscriptions and bookplates in, 121, 122
printed, lyrics without tunes in, 123
as symbolic of membership in community, 120
totemic qualities of, 120, 121
as window into Pennsylvania Germans' worship practices, 121
hymn manuscript illumination and calligraphy
in English-language songbooks, 120
in German community, 113–16, 119; at Ephrata, 113, 114, 115; shaping of German Protestant community by, 113–16; and transformation of manuscripts into objects of spiritual significance, 114–16, 120, 133; as type of paratext, 120
by Shakers, 119–20
totemic qualities of, 120, 121
as window into Pennsylvania Germans' worship practices, 121, 132–33
See also hymn tune books (Notenbüchlein)
hymnody in Protestant tradition, 116–25
burst of, in age of evangelical piety, 117
and Reformation turn to hymn singing by laypersons, 116–17
and sharing of hymns across nations and denominations, 117–19
as source material to investigate lived religion, 116, 119
hymns
for children, 119
congregational, definition of, 116
definition of, 116
and difficulty of evaluating ephemeral aural culture, 132–33
importance to evangelical Protestants, 116

lyrics of, in *Fraktur*, 29–30, 57, 67, 90, 93, 95, 104, 109, 110, 113, 119
preservation in family Bibles, 155
use in schools for spiritual literacy, 121, 123
See also hymn tune books; musical notation
hymn singing
at Ephrata, as type of meditation, 113
Puritans and, 117
hymns in Pennsylvania German worship
importance of, 113, 117
range of sources for, 119
as source material for religious life, 119
See also hymn manuscript illumination and calligraphy
hymn tune books (*Notenbüchlein*), 122–25
advice on use contained in, 124
binding structures: decoration of, 123–24, 125, 126, 127; range of quality in, 123–24
as both artworks and musical texts, 125
content analysis of, 125–32
cost to students, 123
design of, variations in, 124
as documentation of musical changes over time, 123
gaps in knowledge of, 125
illumination and calligraphy in, 124–25, 129–32; spiritual significance of, 129–30; typical design elements, 130, 131t
inside cover notations, 125
introductory pages explaining scales and notation, 130
musical notation in, 123
Notenbüchlein for Anna Funck (Kolb), xi
Notenbüchlein for Elizabetha Kolbin, 129, 129
as part of larger manuscript-making culture, 132
quotations in, 126
of schoolteachers, as larger and more ornate, 125–26
of students: as slimmer and less-ornate, 126–27; undecorated paper covers of, 127–28
teachers' addition of hymns to, 123
three elements of design of, 123–25
title pages, 128–29; illumination and calligraphy on, 124, 129, 129–30; inscriptions on, 128–29; personalization for individual students, 124, 129
use as gifts from teachers, 122–23
use for literacy instruction, 127
use for musical literacy, 123
use for spiritual literacy, 121, 123, 126–27
hymn writing, explosion of, after Reformation, 117

Imbroich, Thomas von, 58–59, 64
"In Defense of Germany" (Pennypacker), 167–68
India, calligraphy-like practices in, 18
individualism in Pennsylvania culture
as more important source than Puritanism for modern American values, 171–73
support of Pennsylvania culture for, 8
industrial printing, rise of, and decline of manuscript culture, 158–59, 169
In Praise of Scribes (Trithemius), 46
Iser, Wolfgang, 108
Israel, ancient, sages of
as model for Pennsylvania German educator-scribes, 85, 86
and wisdom as occupying realm between earthly and divine, 85, 86

Jäkel, Matthüs, 132
Japan, calligraphy in, 17
Jewish culture, calligraphy in, 18
Johnson, Henry, 125–26
Juterczenka, Sünne, 24

kabbalah, and Pietist mysticism, 66–67
Kantzleischrift (*Cantzleischrift*)
definition and history of, 57
uses of, 95, 100–101
Karlstadt, Andreas, 39
Kaufman, Gordon, 104, 109
Kidder, Samuel, 54–57, 56
Das Kleine Davidische Psalterspiel Der Kinder, 163
Kohler, Ignatius, 148–50, 149
Kolb, Andreas, xi, 97t, 126–27
Krauss, Magdalena Schultz, 164–65
Kunze, Johann Christoph, 37–38
Kurrentschrift (*Currentschrift*)
definition and history of, 57
uses of, 95, 100–101, 110, 151

labyrinth (maze), as allegorical image of spiritual journey, 77–78
Lädtermann, Johannes, 151
Lädtermann, Sarah, 151
Lancaster Mennonite Historical Society, 154
Lange, Nicholas de, 189n8
language, in Pennsylvania German religious life
Divine wisdom underlying, 67, 68–69, 105, 108
as necessary part of spiritual cultivation, 68
See also Divine wisdom as hidden from view; spiritual meaning underlying *Fraktur* texts
Layritz, Paul Eugen, 84
Leade, Jane, 22

232 INDEX

Learning to Read and Write in Colonial America (Monaghan), 108, 174
Lehmann, Hartmut, 24, 180n42, 182n82
letter forms
 as devotional images, 65–77; and allegorical illuminations, 69–73, 70, 73, 74, 75; and devotional ABC Books, 67–68, 71, 80, 81; and display of *Fraktur* pages, 76, 77; and display of text in churches, 77; function as windows into text, 71; and intertwining of image and text, 73; kaballah and, 66; and magical power of text itself, 76–77; and power of holy words, 69–71; use to stimulate penetration to underlying truth, 65–67
 historical, cultural, and spiritual significance of, 49–50
Licht Der Weishert (Musig), 63
life-passages
 documents marking, 134, 137, 150; as historical sources, 135, 137; and linking of individuals to larger Christian world, 134
 Pennsylvania German views on, 152–53
 See also birth and baptismal certificates; epitaphs; family registers
Lindsey House, London, display of text in chapel of, 77
lived religion
 Fraktur as window into, 9–10, 153–57, 173
 hymnody in Protestant tradition as source material on, 116, 119
 rethinking of religion required to understand, 18
Louden, Mark L., 162
Lowell, James Russell, 8
Luther, Martin
 on authority to interpret scripture, 22
 depiction in Brönner's *Marburg Hymnal*, 121
 emphasis on personal religious experience, 43
 and hymn singing by laypersons, 116–17
 as hymn writer, 117
 and mysticism, 39, 61
 quotations from, in hymn tune books, 126
 and Reformation, 20
 Schwenckfeld and, 39
 and *sola scriptura* doctrine, 39
 on the Word, 66
Lutherans
 and baptism, importance of, 137, 138
 and church registers, 151
 limited appeal of manuscript culture to, 36
 migrations out of Pennsylvania, 34
 scriptural focus of, 20
 use of birth and baptismal certificates, 137–38, 142–43, 150

MacCulloch, Diarmaid, 9
magic charms, Pennsylvania Germans' use of, 76
Malden, Richard Henry, 85
Manor Township Mennonites, documents of, 153–57, 176
Manuductio ad lectionem Scripturae Sacrae (Francke), 63
manuscript culture of German immigrants in New York and North Carolina, 34
 as rural, 37
manuscript culture of Pennsylvania Germans
 as contrast to Puritans' somber culture, 8
 creative freedom of scribes in, 50
 decline of, after 1850, 50
 flourishing of, 1750-1850, 48
 and German Pietist and sectarian traditions, influence of, 4–5
 long lineage of manuscript culture underlying, 43
 meaning of, as difficult for secular scholarship to grasp, 169–70
 origin in linguistic and cultural traditions, 19, 41, 44
 as part of German pietist and sectarian tradition, 18
 as part of larger surviving manuscript culture in Europe and Americas, 16
 sects especially prominent in, 38
 Shakers and, 41–43, 42
 and theology of the everyday, 152–53
 as tool for highlighting Pennsylvania German contributions to American culture, 170–71
 as transitional point in history, 172
 understanding as lived spiritual experience, as new paradigm for approaching roots of American culture, 170–71
 varying importance to different groups, 35–36
 See also decline of manuscript culture of Pennsylvania Germans; *Fraktur* of Pennsylvania Germans
manuscript illumination and calligraphy
 declining quality over time, 162–64, 164, 165
 at Ephrata, as type of meditation, 113
 historical studies of, 18
 and holy Word made into visual art, 47, 84
 in hymn tune books, 124–25
 Pietists' emphasis on emotion and, 27
 power to open hearts to salvation, xi
 as practiced in many cultures, 16–18, 43
 Puritans' lack of interest in, 27
 skill required for, xiv
 as slow, deliberate process, xiv
 spiritual and cultural resonances of, 50
 as spiritual practice, 50
 stylistic evolution of, 50–57

See also calligraphy; *Fraktur* of Pennsylvania
Germans; hymn manuscript illumination
and calligraphy; manuscript culture of
Pennsylvania Germans
manuscript production
decline of, after 1850, 50
and print publishing: benefits of manuscript
production over, 47; complementary func-
tions of, 48–49, 155; continuation of
manuscript production despite, xiv–xv, 5,
16, 46–47, 48
and social authorship, 48
Marburg Hymnal, Brönner edition of, 120–21
The Mariner's Compass (Earl), 54, 55
Markley, Philip, 73, 74, 109–11
Martin, John Rupert, 103
Masser, Jacob, 76
Maximilian I (Holy Roman Emperor), 57
Maÿer, Abraham, 106
maze. *See* labyrinth
meaning of texts, and scribes as intermediaries
between text and reader, 50
medieval Roman Catholicism, and manuscipt
illumination, 18
meditation
Book of Sirah on, 48
creation of *Fraktur* as type of, xi, 46, 113
as means of unlocking *Fraktur* texts, 60,
65–66, 78, 105
Pietism and, 48
in Puritan devotional practice, 26
Mennonite Heritage Center, 125
Mennonite hymnals
favorite volumes, 120
totemic qualities of, 121
See also Mennonite tune books
(*Notenbüchlein*)
Mennonites
among German-speaking migrants to Penn-
sylvania, 35
and family registers, 151
Fraktur of, 72–74, 73, 74, 75
and illuminated documents, importance of,
153
longer survival of German language among,
162, 169
of Manor Township, documents of, 153–57
and manuscript illumination in Pennsylva-
nia, importance of contribution to, 35
migrations out of Pennsylvania, 34
migrations within Europe, 39
migration to Pennsylvania, 39
origins of, 39
Penn's recruitment for Pennsylvania colony,
31, 39

and Pennsylvania religious tolerance, 40
persecution in homelands, 58–59
quasi-clerical role of schoolteachers, 126
and schools, collaboration with other
denominations to build, 89
strained relations with Quakers, 31
Mennonite schools
display of musical notation in, 123
typical buildings for, 90, 91
use of *Fraktur* in, 86
use of music in: for musical literacy, 123; for
spiritual literacy, 123
Mennonite tune books (*Notenbüchlein*)
inscriptions in, 129
large number of, 121
quantitative analysis of, 127
See also hymn tune books
Mennonite *Vorschrift*, origin in Swiss styles, 99
Mercer, Henry Chapman
as collector of *Fraktur* and religious texts,
15–16, 44, 169
interest in Middle Ages, 16
life and career of, 15
and narrative of American history less
focused on English influence, 169
on origin of manuscript culture, 20, 44–45
photo of the Deep Run Mennonite School-
house by, 91
Merken, Johann, 49–50
Merrihew, S. E., 112
*Methode, nach welcher in den Neustädtischen
Knaben-und Mägdlein-Schulen so wohl pub-
lice als priatim im Schreiben informiret wird*
(Layritz?), 84
Methodism, Puritan roots of, 29
methodology of approaching manuscripts as
cultural and spiritual artifacts
new avenues for reseach opened by, 173–76
sophistication of manuscripts and, 173–74, 176
in this study, xxiii
Yoder on need for, 175–76
Mexico, calligraphy in, 17, 17
Meyer, Jacob, 128
Middle colonies, emphasis on individual free-
dom over communalism in, 32
Middle East, calligraphy in, 17–18
millennialists, migration to Pennsylvania, 35
Miller, Perry, 6, 26, 44, 173
Monaghan, E. Jennifer, 96, 108, 174
Moravians
among German-speaking migrants to Penn-
sylvania, 35
display of text in churches, 77
hymns, entry into Anglo-American canon, 119
importance of hymn singing to, 117

234 INDEX

Moravians (*continued*)
 influence on Wesleys, 28–29
 itinerant preachers of, 40
 manuscript records in support of missionary
 work, 83
 migrations out of Pennsylvania, 34
 and Pennsylvania religious tolerance, 40
 side hole cards made by, 77
 training of scribes, 83–84
Morgan, David, 150, 156
Morgan, Edmund, 6
Morris, Catharine, 54
Mouw, Richard J., 119
Moyer, Dennis K., xxiv, 79, 82
Mühlenberg, Frederick Augustus Conrad, 162
Mühlenberg, Henry Melchior, 62–63
Müller, Thomas J., 23
Müntzer, Thomas, 39
musical notation
 in hymn tune books, 123
 as kind of written language, 120
Musig, Martin, 63
mysticism
 access to higher truth through, 62
 as controversial among mainstream church
 authorities, 62
 German pietist and sectarian traditions and,
 8, 14, 19
 and God as indwelling in Nature, 62
 in Middle Ages, 61
 notable figures in, 22–23
 as part of larger evangelical movement, 44
 and Pietism, 22
 and spiritual meaning underlying texts, 59,
 61–65
 See also German pietist and sectarian
 traditions

nature, creation of, through same power hidden
 within scripture, 66–67
neo-Gothic scripts, 57
*Der Neue, gemeinnützige Landwirthschafts Cal-
 ender, xv, xv*
New England colonies
 characteristics *vs.* Pennsylvania colony, 32
 divergence of script from German Gothic
 style, 54–57
 historians' overemphasis of influence on
 American culture, 171–73
 schools, curriculum in, 86–87
 See also Puritanism; *entries under* English
New Harmony, Indiana, 77
New York, German immigrants in, and manu-
 script culture, 34

Nockamixon Reformed Church financial
 record book, 36, 36–37
North Carolina, German immigrants in, and
 manuscript culture, 34
Notenbüchlein. See hymn tune books

Oberholtzer, Barbara, 151
Oberholtzer, Jacob, 88–90
"The Old School-House at the Creek" (Har-
 baugh), 157–58
Old Testament wisdom books, verses from, in
 Vorschrift, 104, 106–7
"On the Fear of God from Where True Wisdom
 Is Attained," 88, 106
Orsi, Robert, 18
orthodox Lutheran confessions
 connections to Pietism, 37
 use of *Fraktur* script, 36, 36–37

Palatine, Princess Elizabeth, 31
Pannebecker, Hendrick, 4
Pannebecker, Simon, 4, 11–12
Paradisisches Wunderspiel (1754), 113, 114
Paratexts (Genette), 120
Paritius, Georg Heinrich, 99
The Penman's Hand-Book (Gaskell), 160
penmanship instruction
 in English-language schools, 87
 mid-nineteenth century turn to utilitarian
 business focus in, 160–62
penmanship instruction books
 mix of print and handwritten text in, 84
 and transmission of dogma and devotional
 praxis, 84
penmanship instruction in German-language
 schools, 93
 and calligraphic scripts as devotion art, 87,
 174, 175–76
 common view of copying of preexisting texts
 as discouraging creativity, 174–75
 and creativity encouraged by *Fraktur* study,
 108–9
 importance to sustenance of Pennsylvania
 German culture, 84
 teachers of, 83–84
 and transmission of dogma and devotional
 praxis, 84
penmanship samples. *See Vorschrift*
Penn, William
 conversion to Quakerism, 30
 and founding of Pennsylvania colony, 31
 recruitment of German nonconformists for
 Pennsylvania colony, 31, 39
 and religious tolerance, 31–32

Pennsylvania colony
 characteristics *vs.* New England colonies, 32
 contribution to American culture: debate on,
 172; German manuscript culture as
 approach to understanding, 170–71; as
 under-studied, 173
 emphasis on individual freedom in, 32
 individualist ideology in, 8, 171
 Penn's founding of, 31
 religious toleration in, 8, 9, 30, 31–32, 40
 roots of modern American values in, 171–73
 See also diversity of Pennsylvania
Pennsylvania Dutch dialect, 162
Pennsylvania Dutch rustic style, as decadent
 late-period style, 101, 110
*Pennsylvania Dutch: The Story of an American
 Language* (Louden), 162
Pennsylvania Germans/ Pennsylvania Dutch,
 as English name for Germans in Pennsyl-
 vania, 35
Pennsylvania in American History (Penny-
 packer), 172
Pennypacker, Samuel Whitaker
 as book and manuscript collector, 2–4
 career of, 2
 collection of *Fraktur* and religious texts, 3–4,
 11–12
 designs on annexation of Canada, 167–68
 documentation of manuscript culture
 decline, 169
 final illness and death of, 166
 German sympathies during World War I,
 166–68
 historical research by, 2
 and narrative of American history less
 focused on English influence, 169
 Pennsylvania in American History by, 172
 and Pennsylvania's diversity, interest in, 3
 perspective of, as shaped by his historical
 interests, 168
 sale of his collection after death, 169
 sixteenth-century family Bible recovered by, 4
Pennypacker Mills, 2, 4, 166
Peucker, Paul, 77
Philadelphia Inquirer, 166, 167
Philadelphian Movement, 22
Philobiblon Club, 3
Pia Desideria (Spencer), 23
Pierce, Joseph W., 93–95
Pietism
 in America, diverse groups constituting, 23
 beliefs unifying, 23
 calls for trans-boundary study of, 24, 180n42
 church *vs.* radical forms of, 23

as component of Pennsylvania Germans' reli-
 gious ethos, 7
connections to orthodox Lutheran confes-
 sions, 37
desire for greater Christian practice in daily
 life, 23
doctrine of, 7
elements of, in all German-American
 denominations, 24, 181n45
emotion-laded daily devotion in, 26
emphasis on personal relationship with God,
 23
in European homeland of German-speaking
 migrants, 33
and evangelical revival movements, 27–29
on faith, 38
focus on introspective spiritual experience,
 26
and formation of splinter sects, 30
and hymn writing, 117
influence on American origins, as underap-
 preciated, 171–73
influence on German-speaking world and
 beyond, 7
origins of, 22–23
as part of larger evangelical movement, 44
and Puritanism:comparison of, 25–29; cross-
 pollination and similarities of, 25–26, 40;
 parallel origins of, 24; Pietism's greater
 emphasis on emotion, 27, 28; Pietism's
 greater emphasis on Holy Spirit, 27
and Quakerism, beliefs shared with, 30, 31
as term, scholars' efforts to limit reach of, 24
transatlantic impact of, as subject of debate,
 24
and trans-national neworks of evangelicals,
 28–29, 182n82
See also German pietist and sectarian
 traditions
The Pilgrim's Progress (Bunyan), 40
Plate, S. Brent, 66
"powwowing" tradition of Pennsylvania Ger-
 mans, 76
The Practice of Piety (Bayly), 26
prayer, as means of unlocking texts, 60
print publishing
 detractors of, 46–47
 development of, 46
 and manuscript production: benefits over
 print production, 47; complementary
 functions of, 48–49, 155; continuation
 despite print revolution, xiv–xv, 5, 16,
 46–47, 48
Promey, Sally, 152

236 INDEX

Protestantism
dissenters, diaspora of, and diversity of mid-Atlantic region, 30
German pietist and sectarian traditions underlying, 7
imperative for personal engagement with scripture, 88–89, 96, 97t
See also hymnody in Protestant tradition
Protestant Reformation
British, French, and Dutch contributors to, 23
and European roots of *Fraktur* theology, 19–20, 43
impact on North American settlers, 19–20
issues driving splintering in, 22
movement of spiritual agency from church officials to everyday believers, 117
origin and issues of, 20
Penn's colony as consequence of, 172
and Pietism, development of, 22–23
scriptural focus of, 20
and splintering of Church into sects, 20–22, 30, 47–48
and turn to hymn singing by laypersons, 116–17
Psalms
verse 150, manuscript copy of, 156, *156*
verses from, in *Vorschrift* and other instructional texts, 106, 154
public schools, forced attendance at, and decline of manuscript culture, 159–60
Puritanism
Calvinist asceticism of, 26–27
and covenant theology, 25
in diversity of early Christian America, 40
domination of American historical scholarship, 6
emotion-laded daily devotion in, 26
epitaphs and, 152
and evangelical revival movements, 27–29
focus on introspective spiritual experience, 26
historians' overemphasis of influence on American culture, 171–73
and hymn singing, 117
as ill-defined term, 25
lack of interest in calligraphy and manuscript illumination, 27
and manuscript culture, lack of, 41
opposition to Quaker spiritualism, 31
and Pietism: comparison of, 25–29; cross-pollination and similarities of, 25–26, 40; parallel origins of, 24; Pietism's greater emphasis on emotion, 27, 28; Pietism's greater emphasis on Holy Spirit, 27

practical bent of, 27
psalter of, 117, *118*
and Puritan paradigm of American history, 7–8
as reaction against High-Church Anglicanism, 25
reform *vs.* separatist factions of, 25
tight controls of forms of worship, 8
and trans-national networks of evangelicals, 28–29, 182n82, 29
Pursuits of Happiness (Greene), 32

Quakerism
beliefs of, 30
beliefs shared with Pietism, 30, 31
divergence of script from German Gothic style, 54
in diversity of early Christian America, 40
in Holland and German Palatinate, 31
and manuscript culture, lack of, 41
Mennonites and, 31
tolerance of religious diversity, 9, 30, 31–32, 40
Quenstedt, Johannes Andreas, 60

reading, meditative, as means of unlocking texts, 60
The Reformation in Germany (Dixon), 43
Reformed Church
and baptism, importance of, 137, 138
and church registers, 151
elements of Pietism in, 24
and manuscript culture, 36, 36–37
use of birth and baptismal certificates, 137–38, 142–43, 150
religion as inward experience
and meditation as means of unlocking *Fraktur* texts, 60, 65–66, 78, 105
and Pietist focus on spiritual introspection, 7, 14, 26, 35, 39
as principle underlying manuscript interpretation, 60, 64
See also Divine wisdom as hidden from view; spiritual meaning underlying *Fraktur* texts
religious experience of Pennsylvania Germans
experimentation with various forms of piety, 19
Fraktur manuscripts as record of, as focus of this book, xvi
as importance facet of American religious and literary life, 6–7
nourishing of, by *Fraktur*, 7, 10, 44, 69, 82, 85, 105, 111, 171
parallels to Anglo-American revivalism, 19

religious knowledge as Divine truth, as principle underlying manuscript interpretation, 60, 62

religious tolerance in Pennsylvania
and diversity of religious experiences, 9, 30, 31–32, 40
as source for modern American values, 171–73
William Penn and, 31–32
Revelation, verses from, in *Vorschrift* and other instructional texts, 154

Sachse, Julius Friedrich, 133
Samuel T. Freeman and Co., 169
Sauer, Christoph, 64–66, 113, 115, 117
Schättinger, Sarah, 128
Scheirer, Annora Emma, 148–50, 149
Scheirer, Charles, 150
Schenck, Henrich, 155–56
Schenck, John, 155–56
Schenck family of Manor Township, documents preserved by, 154, 155–56
Schleiermacher, Friedrich, 176
Schleifer, Joseph, 128
Schmid, Ignatius Dominicus, 67
schools, English-language
instructional materials beyond traditional books, 87–88
penmanship instruction in, 87
spiritual literacy instruction in, 86–87
schools in German-speaking Pennsylvania
calligraphy posted on walls of, 91
class groups in, 91–93
closing of, with forced attendance at public schools, 159–60
curriculum in, 85
disappearance of, Harbaugh poem on, 157–58
early interdenominational collaboration to build, 89
Fraktur depicting classroom activities, 90, 92
instructional materials beyond traditional books, 87–88
instruction in both English and German, 90, 99
and religious identity formation, 86
sectarian rural schools, decline in mid-nineteenth century, 137
simultaneous transmission of literacy skills and religious values, 88–93, 95–99
spiritual literacy instruction in, 85–86, 89
standard progression in literacy education, 88
subscription contracts for, 89–90
typical buildings for, 90, 91
use of *Fraktur* in, 85–86, 88; as active tools of personal piety, 111; and Christian tradition

of visual cues to memory, 96–98; creativity encouraged by, 108–9; and Protestant imperative for personal engagement with scripture, 88–89, 96, 97t; as rewards for good students, 93; for simultaneous transmission of literacy skills and religious values, 86, 88, 95–99; and students' exposure to wide range of texts, 98
See also Vorschrift (penmanship sample)
schoolteacher-scribes in Pennsylvania German schools
ancient Israel's sages as model for, 85
creation of *Vorschrift* for students, 99–100
gifting of tune books to excellent students, 122–23
greater theological flexibility than clergy, 88–89
noteworthy examples of, 95–96, 97t
quasi-clerical role of, 85, 126
religious and moral education as goal of, 85
Schultz, Christopher, 89
Schultz, Isaac, 130–31, 132
Schultz, Melchior, 125, 130, 132
Schultz family, hymn tune books and, 130–31, 176
Schütz, Johann Jakob, 23
Schwenckfeld, Caspar von, 22, 39–40, 164–65
Schwenkfelder Library, 79, 82, 132
Schwenkfelders
among German-speaking migrants to Pennsylvania, 35
arrival in colonies, 34, 40
beliefs of, 39
hymn tune books, 125, 127, 130–31, 133
and illuminated manuscripts: creative use of textual arrangement in, 60; cultural importance of, 35–36, 38, 40, 153; by Heebner family, 79–82, 81; spiritual exploration in, 40, 176
origin of, 39–40
and Pennsylvania religious tolerance, 40
persecution in homeland, 40
and schools: collaboration with other denominations to build, 89; importance of spiritual literacy and, 89; use of *Fraktur* in, and religious identity formation, 86
Sudermann's *Hohe geistreiche Lehren/vnd Erklärungen* as popular text among, 132
Vorschrift, origin in Swiss styles, 99
scribal publication, 48
scribes of *Fraktur*
and concept of authorship, evolution of, 12–13
and copying as creative spiritual exercise, 174, 175–76

238 INDEX

scribes of *Fraktur* (*continued*)
and copying as meditation, 46, 113
and creative freedom in Pennsylvania manuscript culture, 50, 108–9
creativity of, 10–11, 12, 100
expertise of, 100, 178
Heebner family as, 79–82, *81*
as instruments of divine communication, 111
as intermediaries between text and reader, 50
lacing of manuscripts with traces of their search for the divine, 13
longevity of works by, 46
for Moravians' manuscript records, training of, 83–84
and scribal authorship as key concept, 13
self-references by, 93, *94*
targeting of spiritual needs of readers, 12
work of, as interpretation, 79
See also schoolteacher-scribes in Pennsylvania German schools
The Scriptural Album with Floral Illustrations, 93–95
scriptural texts as direct revelations from God, in German Protestants' view, 66
Scrooby Manor, lease agreement and indenture (1604), 185n35
Seitenhöhlchenkarten. See side hole cards
Seitler, Jacob, 95–96, *96*
senses, as obstacle to perceiving truth, as principle underlying manuscript interpretation, 60
See also spiritual meaning underlying *Fraktur* texts ("spirit of the letter")
settlers, non-English-speaking, as under-studied, 30
Seybert, Frantz Paul, 139
Shakers
concerns about religious imagery, 41
gift and spirit drawings of, 41–43, *42*
hymn manuscript illumination and calligraphy by, 119–20
side hole cards (*Seitenhöhlchenkarten*), Moravians' use of, 77
"Die Sieben Regeln Der Weisheit" (Heebner), 80–82
Simons, Menno, 29, 39
singing, meditative, as means of unlocking texts, 60
Sirach, Book of
history and content of, 107
verses from, in *Vorschrift* and other instructional texts, 99, 106, 107, 154, 155
Snyder, Simon, 146
social authorship, manuscript production and, 48

Song of Solomon, images from, in hymn tune books, 130–32
Souder, John Derstine, 165
sources consulted for this study, xxiii
spelling books, 86, 91, 106
Spencerian Key to Practical Penmanship, 161
Spener, Philipp Jakob, 23
spiritual literacy
colonial English-language schools' instruction in, 86–87
as goal of *Fraktur* production, 12
as goal of Pennsylvania German schools, 85–86, 89
as key concept in understanding *Fraktur*, 13
use of hymn tune books (*Notenbüchlein*) for, 121, 123, 126–27
spiritual meaning underlying *Fraktur* texts ("spirit of the letter"), 58–65
admonitions to seek, 59, 60, 63–65
exploration process to uncover, 60
five functions of the Word as key concept for uncovering, 13
influence of Pietism on, 59
inward turn required to perceive, 61
and language as cryptological key, 67, 68–69, 105, 108
and letters as stimulation to penetrate to underlying truth, 65–67
mysticism and, 59, 61–65
necessity of reconstructing worldview of Pennsylvania Germans to grasp, 13–14, 18, 58
ornate script as stimulation to penetrate to, 63–67
as parallel to created world as covering of spiritual truth, 62
revelation through Holy Spirit rather than logic, 63
six principles for interpreting, 59–61
visual composition as means of revealing, 60
and the Word as cover obscuring underlying truth, 62, 63–65
See also Divine wisdom as hidden from view
Steiner, Melchior, 38
Stoeffler, F. Ernest, 24
storage of documents, use of Bibles and other devotional texts for, 154–56
Stoudt, John Joseph, 16, 51–52, 52t, 102–3, 185n31
Strenge, Christian, 97t, 155
Strickler, Jacob, xi, *xii*
Sudermann, Daniel, 130–31
Swiss Anabaptists, 39

Tauber, Johan Leonhard, 20, *21*
Tauler, Johannes, 22, 61, 80

Tersteegen, Gerhard, 69, 78, 117, 165
texts, spiritual
 importance in Pennsylvania German religious practices, 10
 as object, magical power of, 76–77
 See also Fraktur of Pennsylvania Germans; the Word
textual arrangement, creative use of, to demonstrate search for wisdom, 60
Textura script, *Frakturschrift* as newer form of, 57
Theologia Deutsch, 22, 61
theology of the everyday, manuscript culture of Pennsylvania Germans and, 152–53
Theory and Art of Penmanship: A Manual for Teachers (1864), 160–61
Thirty Years' War, 33, 117
This Teaching I Present (Hershey), xxiv
Thornton, Tamara Plakins, 174
Trithemius, Johannes, 46–47, 50, 82, 83
Trueman, Carl R., 66

Ussher, James, xii

van Braght, Thieleman J., 151
van der Toorn, Karel, 12, 111
Vom wahren Christenthum (Arndt), 22–23, 63–64, 65, 187n76
Vorschrift (penmanship sample)
 allegorical imagery in, 72–73, 73, 74, 75, 102, 102–3, 103t
 of Carli family, 154–55
 ceremonial veneration surrounding, 99, 111
 circular designs in, 100
 content of, 103–9; addressing of communication output, 105; addressing of sensory input, 105; alphabet and number lines, 104–5, 106; consistency of general theme over time, 104; and constant theologizing, 104; and decline over time in believe in unlocking wisdom through meditative reading and writing, 107–8; decline over time in discussion of wisdom, 107, 192n91; decline over time in prescriptive nature of, 107; descriptions of occasions for awarding of, 93, 94; importance of analyzing, 104; more-frequent first-person narration in eighteenth century samples of, 94, 107; move over time from scripture to more general spiritual experience, 104, 107–8, 192n92, 192nn92–93; and pious life, admonitions for living of, 105, 110; popular devotional literature, 104; preference for Old rather than New Testament verses, 104, 106; scribes' modification copied

content, 104; simplification for younger audiences, 105; texts on links between literacy, piety, and wisdom, 105; as under-studied, 103
declining quality over time, 162–64, 164, 165
disappearance of, around 1850, 108
English-language versions of, 163–64, 165
of Heebner family, 79–80
of Hirschi family, 155
mixed types of neo-Gothic scripts in, 100–101
Pennypacker's collection of, 4
as prominent form of *Fraktur*, 84
replacement by modern teaching methods, 161–62
sample reading of, 109–11
of Schenck family, 155–56
and simultaneous transmission of literacy skills and religious values, 86, 88, 95–99, 105, 110
skill and effort involved in making, 100
spiritual ABCs on, 68
teachers' creation for students, 99–100
and traditional view of early American literacy education, 108
use as rewards for good students, 93, 94
visual design of, 98–103; change over time, 101–3; decline in religious content and artistic sophistication, 101–2, 109–11; European origins of, 99; five standard types of, 100–101; four stylistic periods, 101; as indication of instructional logic in schools, 99–100; mix of letter forms and morally uplifting texts as basic organizing principle, 98; sample analysis of, 109–11
Vorschrift (Strickler), xi, *xii*
Vorschrift beginning "By this everybody will know" (unsigned), xi, *xiii*
Vorschrift des Steffen Barandun von Feldis, (1743), xi, xii
Vorschriften für die Jugend (Egelmann), 66
Vorschrift for Hans Theiß, xii, *xiv*
Vorschrift for Jacob Seitler (Eyer), 95–96, 96
Vorschrift for Maria Reist (Fuchs), 93, 94
Vorschrift for Philip Markley (Brachtheiser), 73, 74, 109–11

Wagner, Christina, 80
Watts, Isaac, 119, 145
website companion of this book, xxiii–xxiv
Weiser, Frederick S., 10
Wellenreuther, Hermann, 155, 195n5
Welling, Georg von, 69
Wesley, Charles, 28–29, 119

240 INDEX

Wesley, John, 28–29
Wetzler, Martin, 146
Whitefield, George, 29, 40, 87, 119
The Whole Booke of Psalmes Faithfully Translated into English Metre (Bay Psalm Book, 1640), 117, *118*
Wint, Margaret Elizabeth, 152–53
wisdom, divine *vs.* human, 63
Wisdom Books
 Biblical books included in, 106, 192n80
 images from, in hymn tune books, 131
 use in Pennsylvania German schools, 85, 88
 use in *Vorschrift*, 99, 106–7
Witvliet, John D., 116
Wokeck, Marianne S., 32
Wolffe, John, 28
the Word in Pennsylvania German religious life
 balancing truth of with evocative power of images: as goal of *Fraktur*, 12; as issue throughout Christian history, 12
 central importance of, 10
 as cover of underlying truth, 62, 63–65; and letters as stimulation to penetrate to underlying truth, 65–67; and mystical meaning underlying text, 61
 as creative of its truth here on earth, 10
 five functions of, 10, 11, 13
 as focus of Protestant Reformation, 20
 Fraktur as means of engaging with, 11
 God's creative power hidden within, 66–67
 importance in education, 11–12
 interpretation of, as central focus of devotional practice, 66

 knowledge of (theological knowledge), as requirement of Pennsylvania German religious life, 10, *11*, 18
 printed forms of, as artifacts of social exchange, 10, *11*
 as revelation, 10, *11*
 as seed to be planted within, 64
 as sign system requiring interpretation, 10, *11*
 truth within, as identical to God's creative power used to create reality, 66m 189n8
 use as visual art, 10, *11*
world, external, shutting out of
 as necessary for godly life, 26, 61
 as necessary to perceive spiritual meaning underlying texts, 61, 105
 See also religion as inward experience
worldview of Pennsylvania Germans
 components of, 18
 necessity of reconstructing to understand *Fraktur*, 13–14, 18, 58
World War I, Pennypacker's German sympathies and, 166–68
Ein Wort für den Verstand und das Herz (Kunze), 38
writing, meditative, as means of unlocking texts, 60
written word as source of wisdom, as principle underlying manuscript interpretation, 60

Zinzendorf, Count von, 40, 77
Zionitischer Weyrauchs Hügel oder: Myrrhen Berg (Sauer), 113, *115*
Zürich Reformation, 39
Zwingli, Ulrich, 20, 39